The Arts of Kashmir

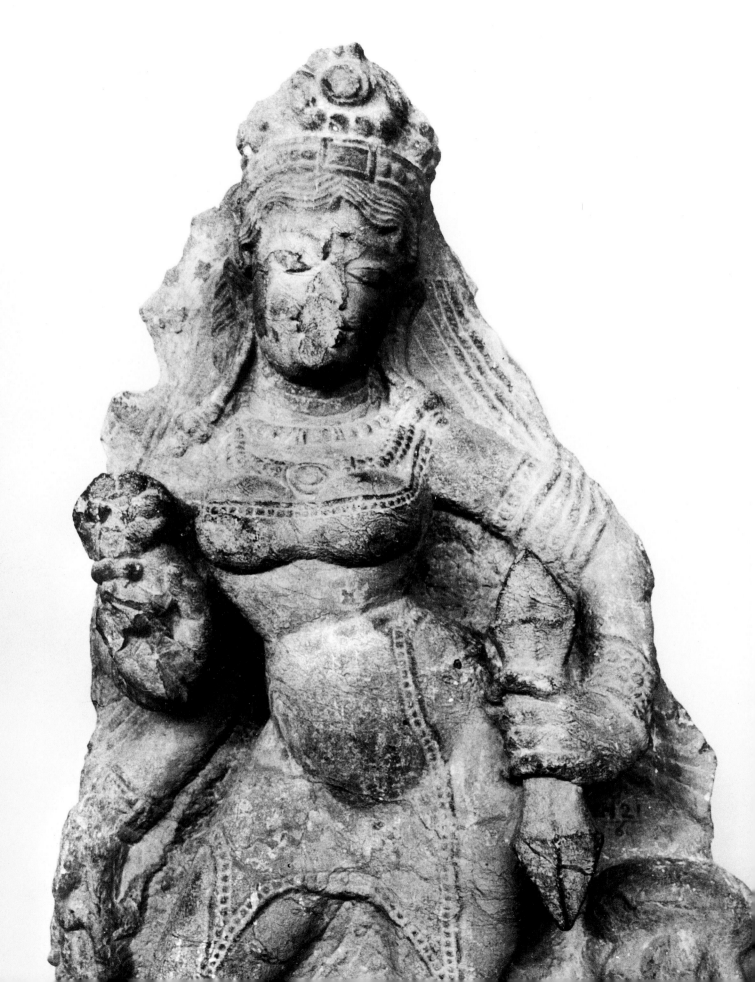

The Arts of Kashmir

BY PRATAPADITYA PAL

WITH CONTRIBUTIONS BY
FRANK AMES, SIMON DIGBY,
GERALD JAMES LARSON,
AND JOHN SIUDMAK

Published on the occasion of the exhibition
The Arts of Kashmir,
organized by the Asia Society.

Asia Society and Museum
New York, New York
October 1, 2007 through January 6, 2008

Cincinnati Art Museum
Cincinnati, Ohio
June 28 through September 21, 2008

Critical support for this project comes
from The Partridge Foundation,
a John and Polly Guth Charitable Fund.

Major support for this exhibition has also been
provided by E. Rhodes and Leona B. Carpenter
Foundation, The Lee and Juliet Folger Fund, Amita
and Purnendu Chatterjee, Dr. Nirmal Mattoo
and Tina Mattoo, The Coby Foundation, Ltd.,
and the Irfan Kathwari Foundation.

We also appreciate the support of the National
Endowment for the Arts, and the National
Endowment for the Humanities.

NATIONAL
ENDOWMENT
FOR THE ARTS
A great nation
deserves great art.

NATIONAL
ENDOWMENT
FOR THE
HUMANITIES

Any views, findings, conclusions,
or recommendations expressed in this book
do not necessarily reflect those of the National
Endowment for the Humanities

Project Manager
Marion Kocot

Coordinator and In-house Curator
Adriana Proser

Asia Society Museum Fellow
Kristy Phillips

Copyeditor
Snigdha Koirala

5 CONTINENTS EDITIONS

Editorial coordination
Laura Maggioni

Art Director
Lara Gariboldi

Layout
Daniela Duminuco and Annarita De Sanctis

Color Separation
Eurofotolit, Cernusco sul Naviglio (Milan), Italy

Printed in July 2007
by Conti Tipocolor, Calenzano (Florence), Italy

ISBN Asia Society: 978-0-87848-107-1
ISBN 5 Continents Editions: 978-88-7439-408-1
Library of Congress Control Number: 2007931893

www.fivecontinentseditions.com

Frontispiece
Dancing mother goddess Indrani,
seventh century
Sri Pratap Singh Museum, Srinagar
(detail)

Front Cover
Foliated tray, nineteenth century
Copper gilt
Victoria & Albert Museum

Back Cover
God Indra visits Buddha Shakyamuni,
eighth to ninth century
Ivory
Asia Society, New York:
Mr. and Mrs. John D. Rockefeller
3rd Collection

All objects featured in this book are believed
to be from the region of Jammu and Kashmir
unless otherwise stated.

The ❀ denotes objects from
The Arts of Kashmir exhibition.

Diacritics appear in this book sparingly in
the interest of accessibility and ease of reading.
However, individual authors have included
diacritics to highlight the names of texts
and specific terminology in Sanskrit, Arabic,
and Persian.

Table of Contents

Preface

Vishakha N. Desai
President
Asia Society

For most people in the United States, Kashmir is often equated with conflict and is referred to as "a troubled region of the world" or, less frequently, as a beautiful location; but this very special valley in the Himalayas is not as well known for the important cultural bridge it provides between the Indian subcontinent and regions to the west and east.

The Kashmir Valley covers an area the approximate distance from Los Angeles to Santa Barbara, and at its widest point measures about 15.5 miles. Yet remarkably, despite its small size and a history of disruptive change over two millennia, the valley of Kashmir has remained a vibrant hub of intellectual and artistic activity for its Buddhist, Hindu, and Muslim populations over that long span of history.

Visual arts of the valley of Kashmir—from Buddhist sculptures and Hindu temples to great Islamic gardens—vividly tell this unique story. This exhibition of superlative works, covering almost two thousand years, is designed to celebrate the rich cultural heritage of Kashmir and in the process alter current perceptions about this region.

Through the exhibition, "The Arts of Kashmir," this publication, and related programs, we hope readers and viewers will come to understand and appreciate the significance of the location of the Kashmir Valley as a natural meeting place for the finest intellectuals, artists, and religious leaders from India, central Asia, Iran, and China. To understand the objects in the exhibition in the context of their geographical setting is to recognize the role that the land played and continues to play in the cultural history of the region.

Right from the beginning, we wanted to work with both Muslim and Hindu communities of Kashmiris to help us develop a comprehensive cultural program to accompany the exhibition and raise much-needed funds to support our ambitious agenda. I am most grateful to Farooq Kathwari, Rakesh Kaul, and Bharat Wakhlu for their committed support of this endeavor. Special thanks are also due to Anjum Ahmed, Asmat Ashai, Sundeep Bhan, Jeffrey Campbell, Sharda Cherwoo, Bal Das, Amir Dossal, Dr. Kalim Irfani, Farah Kathwari, Rafique Kathwari, Pradman Kaul, Rajiv Kaul, Dr. Sushma Kaul, Daisy Khan, Trish Malloch Brown, Daniel Mariaschin, Dr. Nirmal Mattoo, Ravi Mattu, Henny Sender, Shafaq Vakil, and Frank G. Wisner.

Such projects are invariably complex and need the cooperation of many individuals and organizations; their critical support is acknowledged elsewhere in this publication. We are especially grateful to the Indian government for agreeing to lend several key art-works—most of which have never been seen outside of India—for presentation in this exhibition. I would like to express my thanks to the many government officials who have helped make this exhibition and catalogue possible. We would like to offer special gratitude

to Ms. Ambika Soni, Minister of Tourism and Culture; Dr. Karan Singh, honorary Member of Parliament; Mr. Ashok Angurana, IAS, Principal Secretary, Higher and Technical Education, Culture, Youth Services, and Sport, Jammu and Kashmir Government; Chief Minister Ghulam Nabi Azad, Jammu and Kashmir Government; Mr. Badal Das, Secretary, Ministry of Culture; Nina Ranjan, former Secretary for Culture, Department of Culture; His Excellency Ronen Sen, embassy of India to the U.S.; Shri Jaipal Reddy, former Minister for Culture, government of India; as well as the Honorable R. Nicholas Burns, Under Secretary, Political Affairs, U.S. Department of State; and the Honorable David Campbell Mulford, American embassy, India.

We hope that this initiative, along with the rich array of related programs, will create a greater awareness of Kashmiri arts and culture in the United States. It should remind our visitors that the name *Kashmir* need not be equated only with conflicts or cashmere shawls, but also with a culture dedicated to producing works of great beauty.

FOREWORD

Melissa Chiu
Museum Director
Asia Society

In the years preparing for *The Arts of Kashmir* there were many occasions when, after I described the exhibition, people would launch into a reverie based on their own visit to Kashmir. My first surprise was how many people had visited the region, and how vivid their memories were of the spectacular lakes, gardens, and mountains. It was the natural beauty and advantageous geographical location that attracted artists and artisans, intellectuals and royalty alike from at least the third century, which is the earliest date of the objects in the exhibition. One of the motivations for this exhibition is to recognize the historic artistic importance of the Kashmir Valley and its role in the development of intellectual life in South Asia. The exhibition and this accompanying book contribute to our understanding of Kashmir as a site of dynamic artistic production for over 2,000 years. Its multiple influences of Buddhist, Hindu, and Islamic cultures across the fields of sculpture, painting, calligraphy and the decorative arts, have fostered a unique environment of artistic diversity and religious coexistence. This understanding of Kashmiri cultural heritage is crucial for all of us, especially because it tends to be overly simplified in today's reportage on the region.

As the first-ever exhibition on this subject, we faced many challenges. I would like to thank Dr. Pratapaditya Pal for his curatorial expertise in assembling such an impressive selection of objects from around the world. As one of the few scholars in the field up to this task, he took it on with great enthusiasm. Marg Publications in Mumbai has been particularly helpful in assembling this catalogue. I want to thank those of the Kashmiri community in New York who assisted with discussions and advice on related programming. We are grateful for their stewardship throughout the process. Early in the planning of the exhibition we also assembled a group of scholars from Europe and the United States to advise on the content and presentation of the exhibition and book. I thank Frank Ames, Simon Digby, Gerald Larson, and John Siudmak for the insightful and accessible essays that they have contributed to this volume, and Navina Haider for her time and valuable comments in shaping this project from its inception. In general, we would like to acknowledge the encouragement this exhibition and catalogue received with the generous help of: Shibu Barua, Marg Publications; Dr. Sheila Canby, The British Museum; Dr. Stan Czuma; Jay Gam, Getty Library; Dr. Amin Jaffer and Rosemary Crill, Victoria and Albert Museum; Christine Knoke, Norton Simon Museum; Steven Kossak; Sabyasachi Mukherjee, Director of the Chhatrapati Maharaj Shivaji Vastu Sangrahalaya, Mumbai; Simon Ray; Carlton Rochell, Jr.; Dr. Barbara Schmitz; and Nancy Sutherland, Los Angeles County Museum Library.

This exhibition contains one hundred and thirty six objects drawn from public and private lenders in Europe, India, and the United States who are listed on page 13. I would like to thank all of the lenders for generously agreeing to include their objects in the exhibition. We look forward to its final presentation at the Cincinnati Art Museum from June 28 to September 21, 2008. At this institution, we acknowledge Aaron Betsky, Director; Stephen Bonadies, Deputy Director of Exhibitions and Public Programs; and Dr. Glenn E. Markoe, Curator of Classical and Near Eastern Art, and their roles in presenting the exhibition in Cincinnati.

We are so grateful for the financial support of this exhibition and book with lead sponsorship from The Partridge Foundation, a John and Polly Guth Charitable Fund. Major support was also provided by E. Rhodes and Leona B. Carpenter Foundation, The Lee and Juliet Folger Fund, Amita and Purnendu Chatterjee, Dr. Nirmal Mattoo and Tina Mattoo, The Coby Foundation, Ltd., and the Irfan Kathwari Foundation.

Additional support was provided by Sunita and Pradman Kaul, Rakesh Kaul and Dr. Sushma Kaul, Sundeep Bhan, Sharda Cherwoo, Anne Bleecker Corcos, Simi Ahuja, Paul F. Walter, Doris Wiener, Ramesh Kapoor, Navin Kumar, Michael Phillips, Steven M. Kossak, Narendra L. Parson, Marilynn Alsdorf, David R. Nalin, and Robert S. Walzer.

In the museum, I would like to thank Marion Kocot, Assistant Director, for managing the project including this publication and Dr. Adriana Proser, John H. Foster Curator of Traditional Asian Art, and Dr. Kristy Phillips, Asia Society Museum Fellow, who have coordinated this exhibition with great diligence and curatorial insight. Clare McGowan, Collections Manager and Senior Registrar, oversaw the many registrarial complications inherent in exhibitions of this scale. Perry Hu, exhibition designer, and Clayton Vogel, Museum Installation Manager, have provided us with an engaging space in which to view these art works in their best light. Nancy Blume, Head of Museum Education Programs, and Hannah Pritchard, Administrative Assistant, have also worked in different capacities on the exhibition regarding docent training and museum education and coordination, respectively. Others at Asia Society who should be thanked for their continued support include Dr. Vishakha Desai, who initiated the exhibition in her capacity as former Museum Director; Jamie Metzl, Executive Vice President; Rachel Cooper, Director of Performing Arts and Public Programs, and Helen Koh, Assistant Director Cultural Programs; the Development staff of Todd Galitz, Julie Lang, Alice Hunsberger, and Emily Moqtaderi for their fundraising efforts; and Deanna Lee, Jennifer Suh, Elaine Megurian, and Ashley Eiler for their work on publicity and marketing.

Curator's Foreword

Pratapaditya Pal
Curator

This book about the arts, crafts, and architecture of the Vale of Kashmir in the Himalayas has a dual purpose: it is meant to serve as a catalogue for a temporary exhibition as well as a more lasting narrative of the rich visual culture of Kashmir.

The idea of an exhibition on the arts of Kashmir was conceived at a dinner in the fall of 2003 when Dr. Vishakha Desai invited me to be the guest curator. In the following spring, at a planning session supported by the National Endowment for the Humanities and held at the Asia Society where all the contributors to this book were present, it was unanimously decided that instead of an exhibition catalogue, a book should be produced that would include the distinctive architecture and other cultural expressions of Kashmir, thus having a wider readership. The task was not easy, for a catalogue and a book are two very different things. As it happens this is the first overview of the tangible and ostensible expressions of the aesthetic and artistic traditions of Kashmir. It tells the story of generations of Kashmiris who excelled in producing art in a wide variety of media, not only the shawls that have become almost synonymous with Kashmir.

Between about 500 and 1300 CE the artists of the relatively small valley created temples and sculptures for both Hindu and Buddhist patrons. These visual forms exerted a strong influence on the artistic traditions of regions far beyond its geographical boundaries—in Tibet, Central Asia, and China. With the introduction and spread of Islam from the fourteenth century, the direction of the artistic tradition changed radically. Mosques replaced temples, arabesques and Islamic calligraphy replaced anthropocentric art, and many new crafts were introduced. Responding to the new ideas, Kashmiri artists and artisans channeled their energies into both new and traditional forms with equal aplomb. Privileged to live in one of the most arcadian landscapes on earth, despite the political and natural obstacles that have characterized their lives for the last millennium and a half, the creative spirit of the Kashmiris has remained undiminished.

Such a major project cannot be accomplished without the goodwill and support of a large number of people. Additional individuals and institutions have been thanked elsewhere in this publication for their gracious cooperation. I would be remiss in my duty, however, if I did not take this opportunity to express my appreciation to a few colleagues and associates. First among them are Dr. Vishakha Desai and the staff of the Asia Society who have been involved with this project and to Marg Publications in Mumbai for their enthusiastic cooperation in many ways. To all my fellow contributors I remain indebted for their collegiality and forbearance. Among others, I must mention specially Dr. Kristy Phillips at the Asia Society Museum; in Srinagar, Dr. Aijaz Bandey of the Central Asia

Museum, Dr. Jamshed Ahmad of the Sri Pratap Singh Museum, and Mr. M. S. Zahid of the J & K Department of Archaeology; and in Los Angeles, Dr. Amy Pederson and Ms. Suzanne Im for taking care of all my computer needs. For scholarly help I am indebted to Mr. Robert Skelton and Dr. Asok Kumar Das, two of the most eminent scholars of Mughal art in my generation.

Since the early seventeenth century when the Mughal emperor Jahangir first projected a romantic image of Kashmir, countless visitors have sung the praises of, and many photographers have captured, the valley's natural charms. One such photographer is Karoki Lewis, whose images in this book were taken especially for this project under the auspices of Marg in the spring of 2006. They have contributed much to enhance the visual appeal of the book. I would also like to thank Jaroslav Poncar, Thomas J. Pritzker, and Ulrich von Schroeder for sharing their photo archives generously.

Los Angeles, May 2007

LIST OF LENDERS

List of lenders who have contributed works to this exhibition, *The Arts of Kashmir:*

INSTITUTIONS

Central Asian Museum, Srinagar
Cincinnati Art Museum
Department of Archives, Archaeology,
 Museums and Antiquities,
 Old Secretariat, Srinagar
Los Angeles County Museum of Art
Musée des Arts Asiatiques-Guimet, Paris
Museum für Indische Kunst, Berlin
Museum of the City of New York
National Museum of India, New Delhi
The Art Institute of Chicago
The Ashmolean Museum, Oxford
The Cleveland Museum of Art
The Metropolitan Museum of Art,
 New York
The Morgan Library and Museum,
 New York
The Walters Art Museum, New York
Royal Asiatic Society, London
Rubin Museum of Art, New York
San Diego Museum of Art
Sri Pratap Singh Museum, Srinagar
University of Pennsylvania Museum
 of Archaeology and Anthropology,
 Philadelphia
Victoria & Albert Museum, London

PRIVATE LENDERS

Frank Ames
Anthony D'Offay
Amrita Jhaveri
Ramesh Kapoor
Steven K. Kossak
Jason Nazmiyal
Mr. and Mrs. Thomas J. Pritzker
Simon Ray
David and Elizabeth Reisbord
Mr. and Mrs. Chino Roncoroni
Mr. R.H. Swali
Paul F. Walter
Drs. Ann and Robert Walzer

We also acknowledge with gratitude
those lenders who prefer to remain
anonymous.

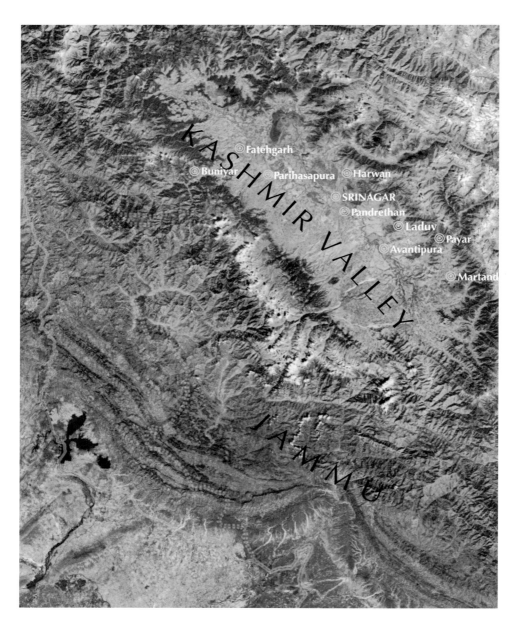

KASHMIR VALLEY

◎Fatehgarh

◎Buniyar ◎Parihasapura ◎Harwan

◎SRINAGAR
◎Pandrethan
◎Laduv
◎Payar
◎Avantipura

◎Martand

JAMMU

LEFT
Topographical map
of the Kashmir Valley
and surrounding area

RIGHT
Map of Jammu and Kashmir
and surrounding area

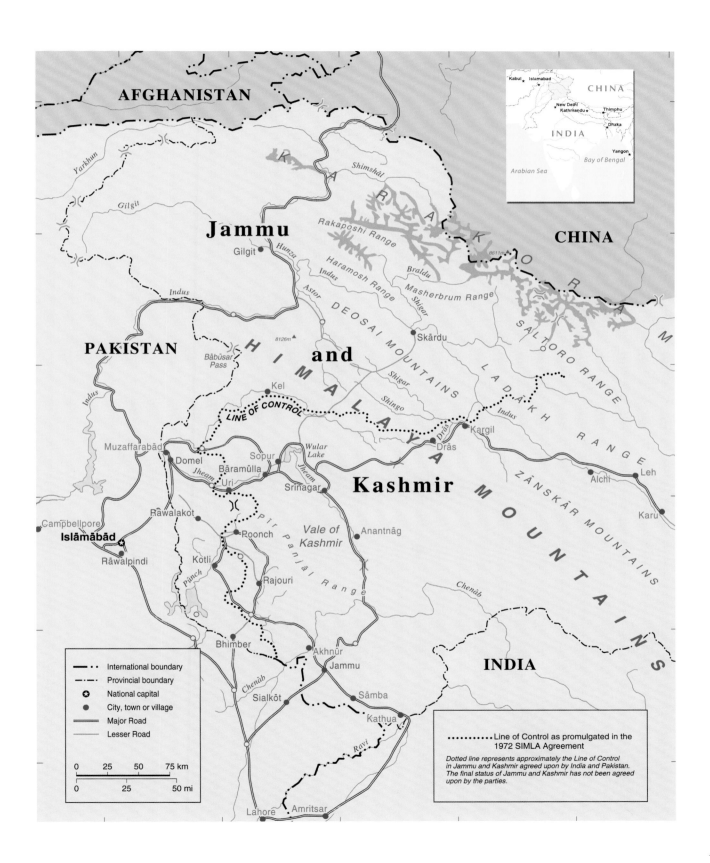

AFGHANISTAN

CHINA

Yarkhun

Gilgit

Jammu

Gilgit

Hunza

Indus

Rakaposhi Range

Shimshāl

8611m

CHINA

Haramosh Range

Braldu

Shigar

Masherbrum Range

PAKISTAN

Indus

Indus

Bâbûsar Pass

8126m▲

and

Skârdu

Shigar

Shingo

Kel

LINE OF CONTROL

Indus

Drâs

Kargil

Muzaffarabâd

Domel

Jheam

Sopur

Wular Lake

Uri

Bāramūlla

Jheam

Srinagar

Drâs

Indus

Alchi

Leh

Karu

Kashmir

Rāwalakot

Pīr Panjal Range

Vale of Kashmir

Anantnâg

Poonch

Indus

Campbellpore

Islāmābād

Rāwalpindi

Kotli

Pûnch

Rajouri

Chenâb

Bhimber

Akhnūr

Jammu

INDIA

Chenâb

Sialkôt

Sâmba

Kathua

Ravî

Lahore

Amritsar

Legend

- – · – International boundary
- – · – Provincial boundary
- ✪ National capital
- ● City, town or village
- ═══ Major Road
- ─── Lesser Road

0 25 50 75 km

0 25 50 mi

·········· Line of Control as promulgated in the 1972 SIMLA Agreement

Dotted line represents approximately the Line of Control in Jammu and Kashmir agreed upon by India and Pakistan. The final status of Jammu and Kashmir has not been agreed upon by the parties.

Inset map: Kabul, Islamabad, CHINA, New Delhi, Kathmandu, Thimphu, Dhaka, INDIA, Yangon, Arabian Sea, Bay of Bengal

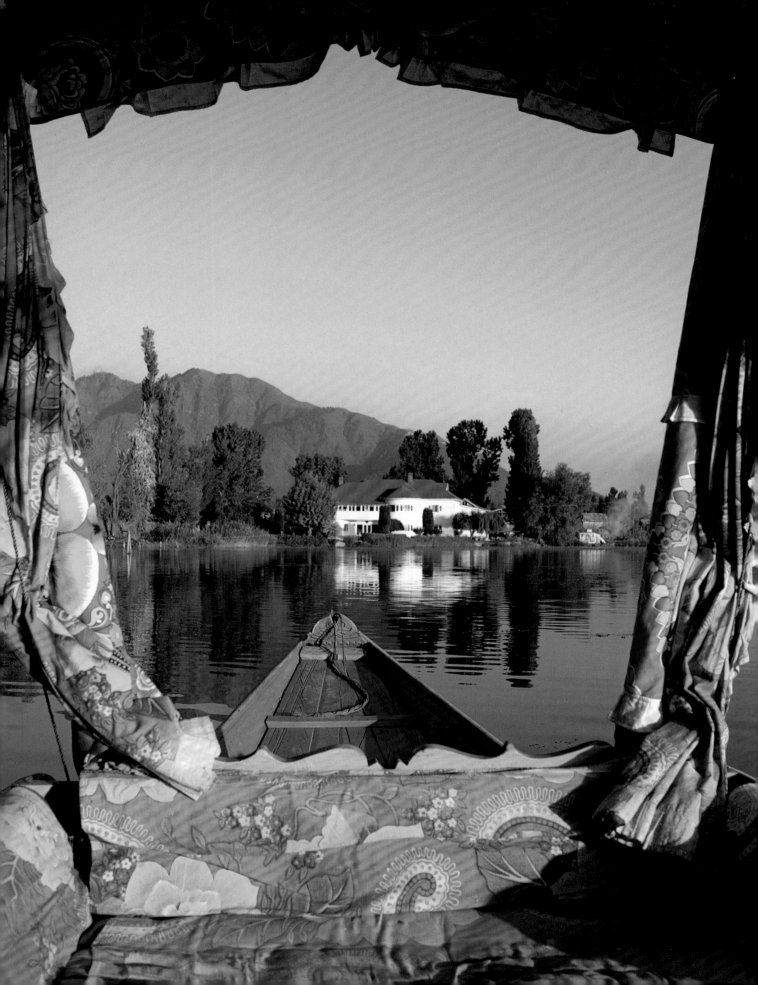

Introduction

By Pratapaditya Pal

Full of gardens and pleasure-groves and resounding with the sounds of drums and lutes, it [Kashmir] is always crowded with people fond of drinks and is dear to the hearts of good men.

Laden with various types of flowers, fruits, trees, creepers and medicinal herbs, it is full of hosts of wild beasts and is enjoyed by the Siddhas [celestials] and the Caranas [bards].

Nīlamatapuraṇa[1]

[As] far as the eye could reach flowers of various hues were blooming, and in the midst of the flowers and verdure beautiful streams of water were flowing: one might say it was a page that the painter of destiny had drawn with the pencil of creation.

Emperor Jahangir[2]

"Cashmere Cashes in on Cool" is the title of a magazine article on the "butter-soft" wool that has continued to be popular across the globe since its introduction to the West in the eighteenth century.[3] The wool derives its name from the western Himalayan valley of Kashmir, once the principal commercial source of the material. Although the material is not native to the valley, it was used to make the shawls that are arguably still its most famous man-made product (fig. 1), while the fragrant and precious spice, saffron, and the deep blue sapphire[4] (fig. 2) are its most well-known and desirable natural products.

A roughly oval-shaped valley in the Western Himalayas, Kashmir is set at an average altitude of 6,000 feet above sea level. Surrounded by mountains, some snowcapped and as high as 15,000 feet, it is difficult to access except in the west at Baramula where the river Jhelum or Vitasta escapes through a narrow gorge to the plains of the Punjab. Within the ring of mountains, the entire landmass of Kashmir is a little less than 4,000 square miles. With its lakes and rivers, springs and streams, its plains and plateaus, known locally as *udar* and *karewa*, its woods of deodar (in higher elevations), chinars and willows and abundant fruits and flowers, the "Vale of Kashmir" is physically one of the most attractive habitats of the Indian subcontinent. This book is about the artistic achievements of the people of this arcadian valley.

Today the valley is part of the Jammu and Kashmir state of the Indian Republic. Until 1948 when the last ruler of the Dogra dynasty, Hari Singh, acceded to the union of India, the state

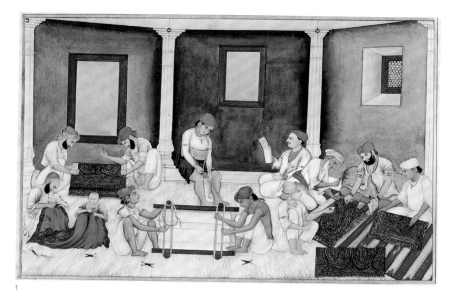

1

<<
View of Dal Lake from a shikara

FIG. 1 ❋
Kashmiri shawl weavers, about 1866
Lahore
Opaque watercolor and gold on paper
H. 12 5/8 x W. 15 3/4 in. (32 x 40 cm)
Private collection

FIG. 2 ❋
Turban ornament in two parts,
about 1757
Gold set with diamonds, rubies,
a sapphire, an emerald and a pearl
H. 8 1/8 in. (20.6 cm)
Victoria & Albert Museum
IS. 3–1982

FIG. 3 ❋
Maharajah Gulab Singh of Jammu
and Kashmir, about 1846
Opaque watercolor and gold on paper
H. 11 11/16 x W. 9 3/16 in. (29.7 x 23.4 cm)
Victoria & Albert Museum
IS. 194–1951

was larger by about one-third more landmass in the north, including the Swat valley and the Gilgit region, both now occupied by Pakistan. This greater Kashmir state was created in 1846 by a treaty between the British and Gulab Singh who was the Sikh governor of the territories (fig. 3). In exchange, Gulab Singh agreed to pay the British a lump sum of Re. 7,500,000 and an annual tribute of "one horse, twelve perfect shawl goats of approved breed (six male and six female), and three pairs of Kashmir shawls."[5] Neither the modest size of the valley nor the difficult terrain has deterred streams of settlers and visitors, nor discouraged Kashmiris from venturing abroad for trade or literary and Buddhist missionary activity. Throughout its history, Kashmir has welcomed people from Persia, Central Asia, China, Tibet, and, of course, the Indian subcontinent to the south. This has resulted in an ethnic mix in the population, free exchange of ideas and acculturation, thereby enriching the valley's cultural fabric.

The earliest evidence of human settlement in the valley goes back to the Neolithic period. We do not know who the people were, but they probably spoke a non-Indo-European language called *Burushaski* that was also spoken in the Hunza area of Pakistan. The Kashmiri language relates to what is known as the *Dardic* language group, which is related to the Indo-Iranian branch of the Indo-European family of languages to which Sanskrit also belongs. At least from the fifth or sixth century BCE, the elite language of ancient Kashmir was Sanskrit. During the first millennium of the Common Era, Kashmir was renowned in the subcontinent and beyond as an important center of Sanskrit learning and of Brahmanical and Buddhist spirituality. Chinese monks began arriving from about 400 CE to learn about Buddhism and to acquire texts. In the seventh century, the Tibetan rulers sent emissaries to Kashmir to adapt both Buddhism and a script. Again in the 980s, the king of Guge in western Tibet sent the young monk Rinchen Sangpo to the valley to study Buddhism.

The principal purpose of the book is to provide the general reader, through the evidence of visual culture, with insights into the rich and diverse aesthetic heritage of the Kashmiris; the spiritual aspirations of the Brahmanical and Buddhist teachers during the ancient period; the arrival of Islam in the valley, the subsequent Islamicization of the population, and the consequent innovations of artistic and aesthetic ideas; the Mughal emperors' enchantment with the valley as a salubrious resort, imitated later by the British; and, finally, the formation of the romantic image of Kashmir.

The history of Kashmir can be divided conveniently into two broad periods. The earlier period was dominated by Sanskritic culture. Sanskrit was the court language while the

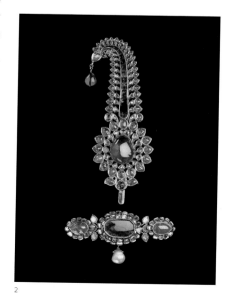

2

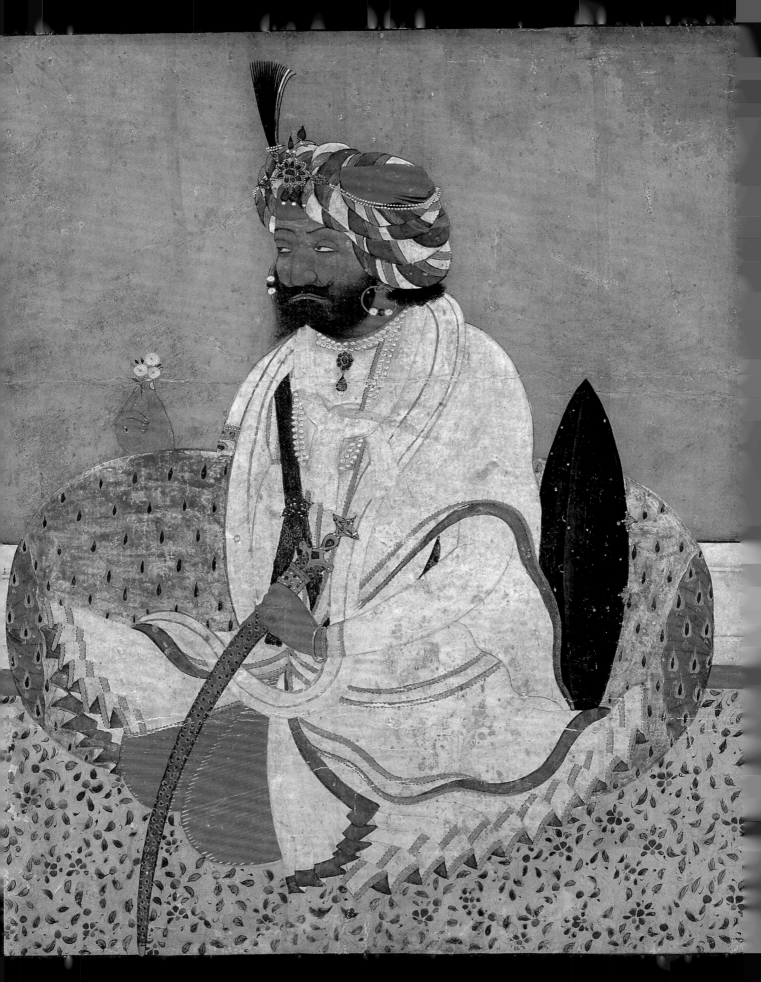

common people used both Prakrit and Kashmiri. The second period began in the first half of the fourteenth century with the establishment of an Islamic Sultanate and the end of the long Brahmanical/Buddhist period. The process of Islamicization was slow but steady and by the time the British handed over the throne of Kashmir to the Hindu Dogra raja of Jammu in 1846, the vast majority of Kashmiris had adopted the Islamic way of life.

The Age of Brahmanical Dynasties (500–1200 CE)

As early as the third century BCE, Kashmir along with parts of Afghanistan likely formed part of the Mauryan Empire under Ashoka Maurya (273–232 BCE). Thereafter, it may have been ruled by some of the Indo-Greek kings of Bactria, especially Menander (r. 155–130 BCE). In the early centuries of the Common Era it was part of the Kushan Empire and was closely related politically and culturally to Gandhara in the northwest. By this time, not only was Buddhism well established in the valley where one of the major Buddhist councils was said to have gathered under the patronage of the Kushan emperor Kanishka I (about 100 CE)

Fig. 4
Detail showing the Kashmiri Monk/Scholar Shakyashribhadra, about 1300
Tibet, Shakya Monastery
Watercolor on cotton
H. 33 x W. 25 1/4 in. (83.8 x 64.3 cm)
Private collection

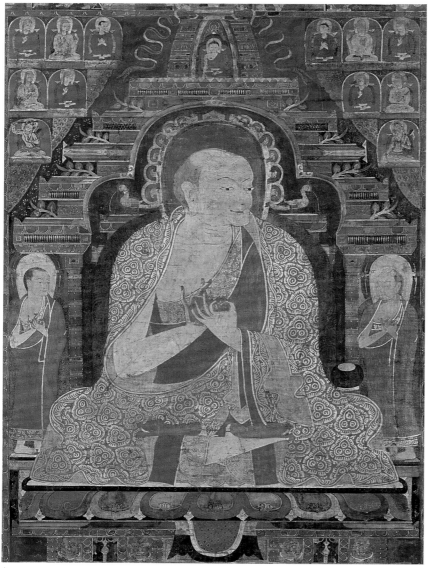

4

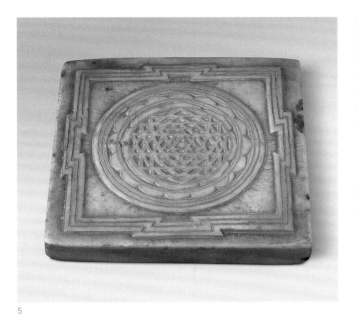

5

Fig. 5 ❊
Yantra with design on top,
fourteenth century
Marble
H. 6 5/16 x W. 6 11/16 x D. 7/8 in.
(16 x 16.9 x 2.3 cm)
Anthony d'Offay, London

sometime in the first quarter of the second century, but Kashmiri Buddhist monks had introduced the religion to the kingdom of Khotan in Central Asia. By about 400, along with Gandhara, Kashmir's reputation as a center of Buddhist learning had brought the young Kumarajiva (the future translator of the Lotus Sutra into Chinese) from the Silk Route kingdom of Kucha for his education and the first Chinese pilgrim, Faxian, had arrived. There is no evidence that Kashmir was part of the Gupta Empire (320–550), but around 530 the valley was occupied by the Hun Mihirakula and his successors. It is only with the establishment of the Karkota dynasty by Durlabhavardhana (r. about 626–662) that the chronicle of Kashmiri kings, *Rājataraṅgiṇī*, completed by the historian Kalhana in 1145, becomes reliable.[6] It was during Durlabhavardhana's reign that the most famous of Chinese pilgrims, Xuanzang, visited Kashmir and spent two years (631–633) studying Buddhism with the encouragement of the king.[7]

As is usually the case with dynastic chronicles, Kalhana's narrative is interwoven with myths and legends, romance and poetic imagination. He is more reliable when discussing the period from the foundation of the Karkota dynasty up to his own times, though the story is bogged down in details of court intrigues and political shenanigans that sometimes make dreary reading. What is interesting for us is that Kalhana is as much concerned in recording the mundane affairs of the state as he is of the spiritual aspirations of the rulers and the nobility. Thus, he mentions the major commissions of religious establishments many of which, even in their ruinous condition, can still be identified today.

Building religious edifices provided employment and also earned spiritual merit for the patron. Indeed, both the public religious institutions and personal acts of piety with ancillary needs, such as images and ritual implements, food and flowers, priests and other personnel, formed a substantial part of the economy. Another activity that helped the economy was the practice of establishing townships or settlements with palaces, mansions, and gardens by the monarchs and affluent ministers. Usually, like the temples and monasteries, they were named after their patrons, many of whom can still be identified today in the names of various localities in Srinagar and elsewhere in the valley. Such projects were financed principally by revenue from land and agricultural products, trade and commerce, at which the Kashmiris were particularly deft and enterprising (and still are), as well as taxes and duties of various kinds. While generous in endowing religious establishments, some rulers were not averse to raiding the temple treasuries.

While Buddhism appears to have been a strong presence at least from the time of the Mauryan emperor Ashoka, whose stupas were seen in the seventh century by Xuanzang, by and large, the Kashmiri kings were followers of the Brahmanical faiths. However, this did not prevent them from patronizing Buddhist establishments. A classic instance is the cordial reception extended by Durlabhavardhana to Xuanzang. Or again, Lalitaditya Muktapida (724–761) not only built a temple for a colossal brass image of the Buddha but imported another made in copper all the way from Magadha (present-day Indian state of Bihar) on an elephant.[8] According to Kalhana many of the queens were strong supporters of Buddhism and established monasteries.[9]

Considering the fact that Buddhism continued to flourish until the thirteenth century, the remnants of Buddhist architecture are remarkably sparse.[10] Buddhist sculptures, however, are more plentiful, especially in metal and ivory, having been piously preserved in Tibetan

6

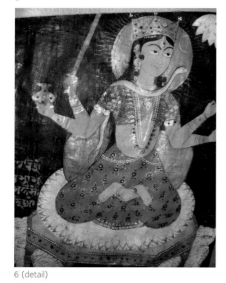

6 (detail)

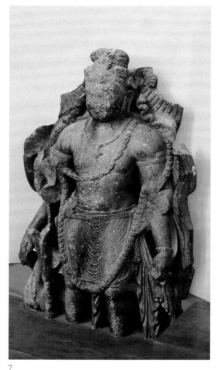

7

FIG. 6 ✤
Painting with representations of Devi,
including Sharika, early eighteenth century
Colors on cloth
H. 52 x W. 14 in. (132.1 x 35.6 cm)
Sri Pratap Singh Museum, Srinagar
2975/2

FIG. 7
Kumara, the divine General,
with peacock, 400–450
Bijbehara
Grey chlorite
Sri Pratap Singh Museum, Srinagar

monasteries.[11] Indeed, Kashmir was an important source for the spread of Buddhism to Tibet as well as to Central Asia and China. Scores of Kashmiri monks traveled to these distant lands as well as to other regions of the subcontinent to spread the teachings of the Buddha.[12] In Tibet and China large numbers of Kashmiri monks were involved in translating Buddhist texts, one of the latest being Shakyashribhadra (1145–1244) whose posthumous Tibetan portrait (fig. 4) gives us a rare glimpse of a Kashmiri *pandit*, as he was known in Tibet. He went there in 1204, and after a decade returned to Kashmir to live almost another three decades.

Apart from the Buddha, who was the principal focus of Buddhist piety, surviving images indicate that Bodhisattvas Avalokitesvara and Tara, embodying the concepts of compassion, were particularly popular as savior deities. Some of the finest poetical eulogies to Tara were composed by Kashmiri poets such as Sarvajnamitra.[13] Some of the most dynamic expressions of both sculptural and painted forms surviving in Kashmiri art are of Buddhist Tantric deities. Fortunately, the murals of temples in Himachal Pradesh, such as Alchi and Tabo in Ladakh, not only provide us with the complex diversity of Vajrayana Buddhist imagery as it developed in Kashmir, but also with its distinguished aesthetic tradition. These temple murals are a rich source of Buddhist mandalas as well. Fortunately, two three-dimensional stone representations of their Brahmanical counterparts, known as *yantra*, though more simplified (fig. 5), reveal convergences of the two religions through similar Tantric ritual practices.

Artistic evidence indicates that both Shivaism and Vaishnavism were prevalent by the early centuries of the Common Era. This is also corroborated by such texts as the *Nīlamatapurāṇa* and the *Vishṇudarmottarapurāṇa*, scriptures that were compiled no later than the eighth century CE. The former text deals exclusively with the worship and festivals of the valley, while the latter, of a much broader thematic range, reflects religious and social practices as well as philosophical and aesthetic speculations of the wider Gandhara/Kashmir region. Both these texts are of enormous importance for the study of the Brahmanical art and religion of Kashmir.

FIG. 8
Shiva Maheshvara, about 550
Fatehgarh
Grey limestone
H. 60 5/8 in. (154 cm)
Archaeological Shed, Fatehgarh

Shiva was by far the preeminent deity, as is the case in the Kathmandu Valley in Nepal and was also in ancient Cambodia. The annual pilgrimage to sight the natural Shiva-linga in the cave of Amarnath still attracts thousands of pilgrims to Kashmir from all over India, as is the case with the temple of Pashupatinath in Nepal on the annual festival of Shivaratri.

While undoubtedly Shivaism dominated Kashmir's religious landscape, surviving sculptures and the textual evidence clearly indicate that all the major Brahmanical deities were worshipped. Vishnu was not far behind Shiva and played an important role in royal cosmology and consecration at least from the ascendancy of the Pancharatra sect around the seventh century.[14] The goddess was also a significant part of Kashmiri piety and, in the forms of Sharada (Sarasvati, goddess of knowledge) and Sharika (fig. 6 detail), was particularly venerated. Curiously no representation of Sharada has yet been identified but the images of the goddess that have survived (figs. 78, 79, 85, ch. 4) clearly demonstrate iconographic variations peculiar to the valley.

The early sculptural evidence in Kashmir distinctly reveals its stylistic and iconographical linkages with Gandhara, rather than with the southerly plains of the subcontinent. However, by the seventh century, Kashmir had established discrete theological traditions and formal expressions. While sculptures such as the magnificent fourth century Bijbehara Kumara (fig. 7) demonstrates close associations with Gandhara, the sixth century Fatehgarh Shiva (fig. 8) reflects complex and distinctive theological ideas peculiar to the valley. Along with the eighth century Martand dancing mother goddesses (fig. 25, ch. 3), these sculptures attest to the complete mastery of the material and an unmatched aesthetic sensibility. The four-headed Vishnu image with the personified attributes and the earth goddess between the god's feet, reflects the ideology of Pancharatra theology and was a signature icon of Kashmiri Vaishnavism.

Curiously, the greatest temple built in the valley, at least as far as surviving structures demonstrate, was dedicated to the sun-god Surya known as Martanda (fig. 31, ch. 3). Kalhana mentions Lalitaditya as its builder, but why the monarch was keenly attracted to the sun-god remains a mystery. According to Kalhana, "The liberal [king] built the wonderful [shrine] of Martanda, with its massive walls of stone within a lofty enclosure (*prasadantar*), and its town swelling with grapes."[15] Incidentally, it is this fruit that may shed some light on the question. We do not know when the cultivation of grapes began in Kashmir, but it could have been introduced by the Indo-Greeks or under the Kushan dynasty, perhaps originating in Persia. There is a tradition in India of Maga brahmans, or the Magi, coming from Persia to worship the sun-god, and Multan in Pakistan was a famous center of sun-worship.[16]

The Karkota dynasty, founded by Durlabhavardhana, and whose greatest king was Lalitaditya Muktapida, came to an end in 855 with the establishment of a new dynasty called Utpala. The first king of this dynasty, Avantivarman (855–883), was also its most enlightened ruler (fig. 9). The dynasty was short-lived, terminating in 1003. Noteworthy is the fact that two queens of this dynasty, Sugandha (904–906) and Didda (about 980/1–1003), became sovereigns of the kingdom. Didda, a Lohara princess, was a particularly ruthless and colorful queen. Didda's nephew Samgramaraja (1003–1028) began a new dynasty called Lohara, which provided a great many ineffective rulers until an Islamic dynasty was founded in 1339.[17]

Kalhana's chronicle of the century and a half from the death of Queen Didda until 1148 or 1149 is a detailed but wearisome narrative of intrigues and violence, of feudal rivalries and general instability with few royal personalities that are worthy of mention. What is remarkable, however, is that natural disasters, such as floods or famines, and the social disarray caused by the follies and foibles of the court and courtiers and ambitious feudal and bureaucratic groups such as Damaras, Kayasthas, and Lavanyas, encouraged neither foreign invasion nor the cessation of cultural and intellectual activities. Although patronage

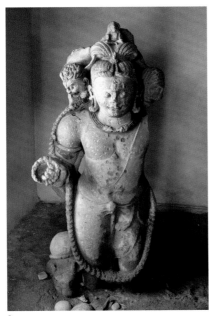

8

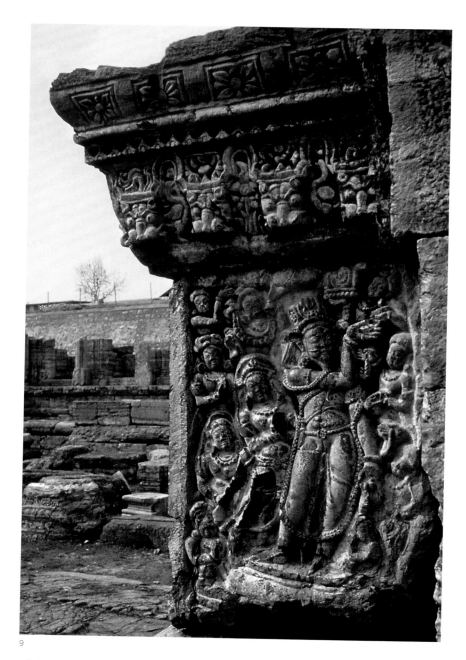

9

FIG. 9
King Avantivarman with his queen (?),
850–855
Avantishvar Temple
Avantipur
Grey limestone

of the arts was not as prolific as during the reign of the Karkota and Utpala dynasties, the intellectual firmament of Kashmir continued to sparkle with brilliant poets and writers like Somadeva, Bilhana, Damodaragupta, Kshemendra, Mankha, and Kalhana, as well as philosophers and rhetoricians such as Bhamaha, Udbhata, Anandavardhana, Abhinavagupta, Jayanta Bhatta, and Mammata, to name only a few.[18]

Among the later kings, Harsha (1089–1101) has received a great deal of attention from Kalhana.[19] Despite the monarch's shortcomings, he is said to have brightened the cultural life of his court. For instance, he introduced innovations in sartorial matters for both men and women of his court, and, as an accomplished musician, he liked to immerse himself in music. "He passed the nights," wrote Kalhana, "in the assembly-hall, which was illuminated by a thousand lamps, attending meetings of learned men, musical perform-ances and dances."[20] In fact, music and dancing appear to have been favorite pastimes at

the Kashmir court and the indulgence of many rulers, but dancing girls and courtesans often had disastrous effects on the affairs of state.[21]

Although limited, the artistic remains of Kashmir clearly demonstrate the discrete character of the valley's Brahmanical and Buddhist religions. Stylistically as well they vindicate the seventeenth century Tibetan scholar Taranath's claim that distinctive sculptural and painting traditions prevailed in ancient Kashmir.[22]

Sultanate Period

By the time of Harsha's death, Muslims were already a strong presence in the Punjab and in the plains of India. Although Mahmud of Ghazni did not invade the valley as he did other parts of the subcontinent, the Turushkas mentioned by Kalhana as being present at Harsha's court must have been Muslim Turks from Central Asia. Be that as it may, Islam was introduced neither suddenly nor by the sword in Kashmir. In fact, the first Muslim king, Rinchana, who ruled for three years between 1320 and 1323, was a Ladakhi Buddhist prince who converted to Islam after meeting Bulbul Shah or Sayyid Sharafu'd-Din of the Suhrawardiya Order of Sufis. For fifteen years after Rinchana his widow, Kota Rani, was the de facto ruler, but ultimately the throne was seized by a Shah Mir, a foreigner of mysterious origin.[23] So began the rule of the Shah Mir dynasty that lasted until 1555 when a nobleman called Ghazi Chak began a new dynasty. The Chak dynasty's rule was turbulent and short-lived. In 1589 the last independent ruler of Kashmir Yakub Shah (1586–1589) surrendered to the Mughal emperor Akbar.

As was the case with the early period, the Sultanate period was also dominated by a few outstanding rulers. Undoubtedly the greatest sultan of the Mir Shah dynasty was Zain-ul-Abidin (1420–1470), who is still remembered fondly by Kashmiris simply as *badshah* (king). An enlightened and tolerant monarch, his contribution to the intellectual and cultural life of Kashmir is unmatched. Fluent in Kashmiri, his native tongue, and Persian, Sanskrit, and Tibetan, he was a great patron of the arts and architecture, of literature and music, and in the conservation and preservation of Kashmir's heritage, irrespective of his religious affiliation. In fact, all the accomplishments of material culture that one associates with Kashmir had their origins generally in the Sultanate period and specifically in the reign of Zain-ul-Abidin.[24] For example, the seven wooden bridges over the Jhelum for which Srinagar was once famous were all built by the sultans. Unfortunately, only one remains today and is a legacy of Zain-ul-Abidin, as its name, Zainakadal, testifies (fig. 10). The only enduring example of a major brick edifice is the tomb that the sultan raised for his mother, a monument that casts a shadow over the modest structure in which he himself was buried. It was also he who completed the construction of the Jama Masjid begun by his father, Sikander Shah (1389–1413). A romantic and an aesthete, Zain-ul-Abidin also built artificial islands in both the Dal lake and the Wolur lake, which was visited by the Mughal emperor Jahangir as is recorded in a beautiful Mughal painting (fig. 163, ch. 8). Indeed, the only other Muslim ruler on the subcontinent who can be compared to Zain-ul-Abidin for his liberality, his intellectual curiosity, his love of learning as well as music, and for introducing and nourishing a wide range of crafts and arts and architecture is the Mughal emperor Akbar (1556–1605).

Like the kings of the earlier period, the sultans too continued the tradition of building palaces and towns bearing their own names. Sultan Aalaud-Din (1343–1354) founded the town of Alauddinpur (now part of Srinagar) and several buildings in Andarkot. His son and successor Shihabud-Din (1354–1373) was an ambitious monarch who expanded the political boundaries of Kashmir well beyond the valley, although accounts of his conquest are much exaggerated by the court historian, Jonaraja.[25] He

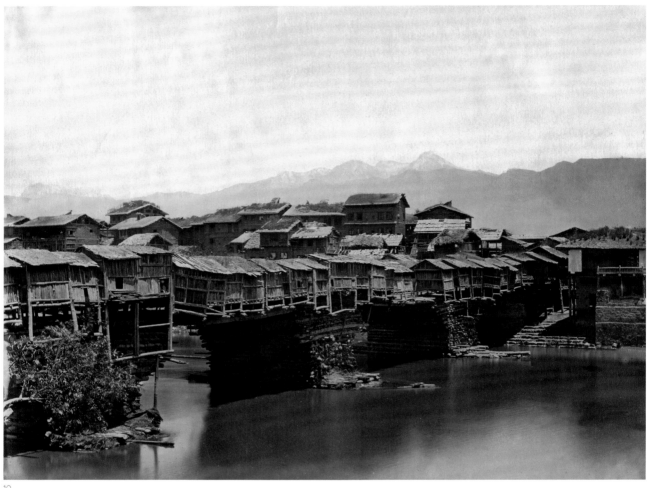

10

was even a more ambitious builder than his predecessors, and built several towns, mosques, and monasteries.

 Much of the administration of the early Sultanate period was carried out by brahman ministers. Moreover, matrimonial alliances between the Muslim royal families and the neighboring Hindu rulers were quite common. Although there were occasional conflicts and persecutions as well as instances of iconoclasm, by and large, the urban landscape in Kashmir did not change radically or dramatically. While new forms of religious structures—the mosque, the mausoleum, and the hospice—were introduced, as will be discussed elsewhere, the construction materials themselves were familiar. Certainly, the palaces and secular buildings, none of which unfortunately exist today, continued the native tradition of timber architecture. Wooden bridges across the rivers and canals were, however, an innovation. In the earlier period, floating bridges comprised of boats tied together were the norm. The replacement of birch bark with paper, whose manufacture was introduced by Zain-ul-Abidin, was also new as was the idea of the bound book. As already mentioned, new ideas were introduced in the textile industry and in the modes of dress. And of course, the Sultanate period saw the replacement of Sanskrit by Persian as the court language. However, it was during the Sultanate rule that the native Kashmiri language began to blossom. Novel musical forms, as well as instruments, were imported from Persia and Central Asia because of the personal interests of particular rulers.

FIG. 10
Unknown photographer, 1860s
Srinagar, Bridge of Shops
Albumen print
H. 7 1/2 x W. 9 in. (19 x 24 cm)
The Alkazi Collection of Photography

The most significant event that contributed to the spread of Islam in the valley was the arrival of Sayyid Ali Hamadani (1314–1385) in 1372 during the reign of Sultan Qutbud-Din (1373–1389). The roles of Ali Hamadani, regarded by Mohibbul Hasan as "one of the most remarkable personalities of the fourteenth century Muslim world," and his son Muhammad in the expansion of Islam in Kashmir have been extensively discussed by Simon Digby in chapter six.[26] The Shah Hamadan mosque on the Jhelum above the Zainakadal (fig. 125, ch. 6), one of the most imposing religious structures in Srinagar, remains a highly popular Islamic devotional site in the valley.

The fourteenth century witnessed an enormous influx of sayyids from Persia and Central Asia due partly to the hostility of the Mongols and their leader, Timur, and also because of the natural attraction of the valley and the receptivity of its sultans. The sayyids have always been highly regarded in Islamic society because of their believed direct connection to Muhammad. Apart from serving as dispensers of justice, these sayyids became spiritual preceptors as well as landowners, which enabled them to bring Islam to the rural areas.

The most influential were the Sufis whose saints or spiritual masters and followers wielded enormous power in the social, religious, and cultural life of the valley. Apart from well-known foreign Sufi orders such as Qadiriya, Suhrawardiya, and Naqshbandiya, Kashmir developed its own distinctive order called Rishi. The adoption of the Sanskrit word *rishi*, meaning "sage," is one indication of the syncretic nature of the order. The order was founded in 1377 by Nurud-Din (1376–1438), a native-born and related to the ruling family of Kishtwar. Greatly influenced by Brahmanical asceticism, Nurud-Din renounced his wife and children, unlike other Sufis, and lived an abstemious life of prayer and meditation. He had a large following and his tomb at Char is a popular pilgrimage site.

Nurud-Din was himself influenced by the mystic poet known popularly as Lalla Ded (about 1320–1389). Her original name was Lalleshwari and she was married at an early age to a Bhat brahman. Brought up in a learned Shaiva family, Lalla acquired knowledge of the distinctive Shaiva philosophy of Kashmir known as *Trika* and of Tantric yoga. However, Lalla's genius was her ability to write simple poems in the Kashmiri language, vividly expressing her spiritual realizations and beliefs. These poems became known as *vaakh*, from the Sanskrit *vāk*, an epithet of the absolute in Vedic ontology. The following is an example of a typical *vaakh*, which demonstrates Lalla's syncretic attitude and anticipates the teachings of the better-known fifteenth-century saint Kabir:

> The Lord pervades everywhere,
> There is nothing like Hindu or Musalaman,
> All distinctions melt away;
> If thou art wise, know thyself
> Seek the Lord within.[27]

Whether or not Nurud-Din was a direct disciple of Lalla, the following verse—written in the poetic form called *shruk*—is filled with his unstinting praise for her and reveals her strong influence in his spiritual beliefs and in his own compositions in Kashmiri:

> The Lalla of Padampur,
> She drank her fill of divine nectar,
> She was indeed an Avatar of ours
> Oh God, grant us the self same boon.[28]

No wonder that two centuries or so later the mystical Mughal prince Dara Shikoh would be drawn to Kashmir.

It would be foolish to deny the social tensions that occurred as the population converted to Islam and the Brahmanical community, despite its involvement in governance, began to diminish in number. Some old religious structures were destroyed and their sacred

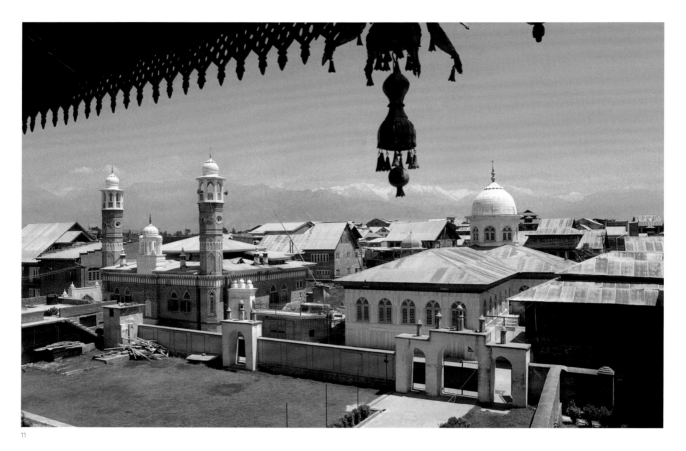

11

Fig. 11
View of mosque and dargah at Pampore,
near Srinagar

sites appropriated for new religious establishments, similar to the Christian destruction of
Roman temples in Europe (fig. 11). In Kashmir, however, while the visible symbols of the
ancient faiths disappeared, many of the traditions, especially of the prehistoric folk beliefs
in *naga* shrines at the sacred springs, did not. By the Mughal period all signs of Buddhism
vanished and a small group of brahmans maintained their faith and customs. It is inter-
esting to read Mughal emperor Jahangir's (r. 1605–1628) comments about brahmans, as
he is the earliest and most perceptive observer of the valley:

> There is a body of Brahmans living from old in this country, who still remain there and
> talk in the Kashmiri tongue. Outwardly one cannot distinguish them from
> Mussulmans . . . They have, however, books in the Sanskrit language, and read them.
> They carry into practice whatever relates to the worship of idols. The lofty idol temples
> which were built before the manifestations of Islam are still in existence . . .[29]

Elsewhere in his memoirs, Jahangir mentions the famous and ancient festival of lamps
that he himself observed from a boat on the Jhelum, just as Zain-ul-Abidin had done two
centuries earlier.[30] Further attesting to the syncretic environment that flourished and in
striking contrast to dietary practice in most of the subcontinent, Kashmiri brahmans are
not strict vegetarians, and from the beginning of the Sultanate period no beef was sold
or eaten by the Muslims.[31] The *rishi*-s, as Jahangir observed, "eat no flesh."[32]

Mughal and Later Periods

From the time of the Huns in the sixth century until the sixteenth, despite protracted
periods of political instability and internal discords, the Mughals of Delhi were the first
outsiders to conquer the valley. The desire for occupying the arcadian land began with

Fig. 12
Bichitr, about 1620–1635
Muhammad Riza Kashmiri
Minto Album; 7 A.9
Chester Beatty Library

Fig. 13
Jean Auguste Dominique Ingres (1780–1867)
Mme. Philibert Riviere
Oil on canvas
H. 45 11/16 x W. 35 7/16 in. (116 x 90 cm)
Louvre, Department of Peintures, Paris, France
MI 1446

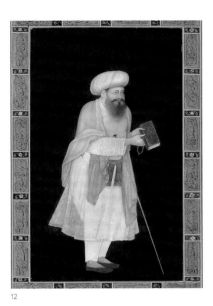

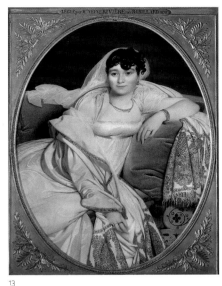

12 13

the founder of the dynasty, Babur (r. 1526–1530), but it was not accomplished until 1589 by Emperor Akbar (r. 1556–1605). However, a cousin of Babur on his mother's side, Mirza Haidar Dughlat (b. about 1499), of Tashkent in Central Asia, did attack Kashmir and became a de facto ruler between 1533 and 1550. A liberal man culturally, in religious matters he was fanatically orthodox. While he contributed to the architectural landscape of the valley, he remained impervious to its natural charms and pined for his native land.[33]

Under the Mughals, Kashmir enjoyed almost a century of peace and prosperity. Four generations of Mughals—Akbar, Jahangir with his Queen Nurjahan, Shah Jahan and his son Dara Shikoh—visited Kashmir many times and enriched the valley's architectural heritage with buildings and gardens, which remain among its most popular tourist attractions. Indeed, it is because of the Mughals that Kashmir's famous shawl and other crafts, as well as its romantic, paradisiacal image spread across the subcontinent and abroad.

During Mughal rule, many Kashmiris joined the Mughal court as courtiers or the imperial harem as wives. One of the finest Mughal portraits by the courtier Bichitr, now in the Chester Beatty Library, Dublin, is of Riza Kashmiri (fig. 12).[34] Unfortunately, we do not know who he was but the book and rosary in his hands would indicate a spiritual personality. What is interesting is that Riza Kashmiri wears a native shawl which is remarkable for its superfine quality. Shawl manufacture was particularly encouraged by the Mughals and a nexus developed between Kashmir and Lahore in Punjab which became a major center of shawl weaving (see chapter 10). Kashmiri calligraphers and painters too were recruited to the Mughal court. In fact, the greatest calligrapher gracing Akbar's court was Muhammad Husayn Kashmiri. Thanks to a surviving portrait we know what he looked like as well (fig. 185, ch. 8). The names of about half a dozen or so Kashmiri artists who worked in the imperial atelier are known. However, at least one talented foreign artist from Samarqand settled in Kashmir during the reign of Shah Jahan (1628–1658). The artist, Muhammad Nadir, was obviously an admirer of the natural beauty of Kashmir, for in one of his works he too compares it with paradise.[35]

The death of Emperor Aurangzeb in 1707 signaled the gradual disintegration of the Mughal Empire. While Kashmir fortunately escaped the invasion of the Persian Nadir Shah in 1738, it succumbed to the marauding Afghans in 1753. Harsh and oppressive, the sixty-six years of Afghan rule were a period of great hardship for the Kashmiris. While the Afghan governors built some forts and buildings, unlike the Mughals they made no

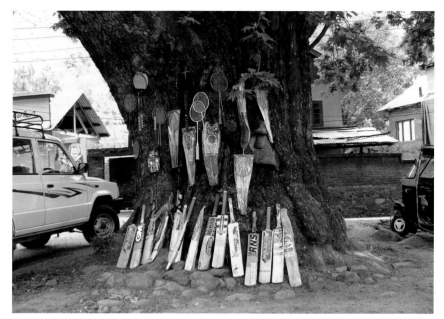

14

Fig. 14
Cricket bats for sale placed below
a tree on the road to Harwan, Kashmir

noteworthy contribution to Kashmir's architecture. However, paintings and manuscripts continued to be produced during the eighteenth century despite the rough political and economic conditions. The exuberant and striking painted ceilings of buildings with the dominant shawl designs were probably created in the eighteenth century and remained popular in the next century, reflecting the continued vitality of Kashmiri aesthetic.[36]

In 1819 the Sikh dynasties took over the administration of the valley but their reign lasted only 27 years. The Sikh ruler Ranjit Singh (r. 1801–1839) was a great admirer of Kashmiri shawls and owned a vast collection himself. The shawl industry therefore flourished and the craze for shawls captured Europe, especially France (fig. 13).[37] Kashmiri painters also worked for Sikh patrons, as is clear from a fine example of an illustrated Guru Granth Sahib in the National Museum, New Delhi (fig. 176, ch. 8).

The Sikhs lost Kashmir to the British in the first Anglo-Sikh war. Promptly, by the treaty of Amritsar in 1846, the valley was transferred to the Dogra Raja Gulab Singh of Jammu without the consent of the population. By this time, Kashmir had a Muslim majority. The cavalier and insensitive imposition of a Hindu monarchy by the British seeded the discontent that continues to haunt the "paradise" of Jahangir and Muhammad Nadir Samarqandi.

No new noteworthy architectural form or artistic movement distinguished the Dogra period. However, the second monarch, Ranbir Singh (r. 1856–1885), was a patron of art and learning.[38] His successor, Pratap Singh (r. 1885–1925), soon after his accession founded an eponymous museum in one of his palaces in Lalmandi, Srinagar. Among other treasures, it houses the finest collection of stone sculptures recovered from the various sites in the valley.[39]

Today Kashmir continues to be one of the most productive centers of shawls, other woolen products, and a variety of crafts in diverse media. The only new product of the second half of the twentieth century is the cricket bat made from local willow, which is admired generally in the cricketing world (fig. 14).[40] Thus, despite political conflicts and tensions, the creative ingenuity of the Kashmiris is far from exhausted.

1. Kumari, *The "Nīlamatapurāṇa,"* p. 6.

2. As quoted in Findly, *Nurjahan, Empress of Mughal India*, p. 254.

3. Christian M. Chensvold, *Los Angeles Times Magazine*, Jan 8, 2006, p. 23.

4. Connoisseurs consider the saffron (*crocus sativus*) produced in the Pampore region as the best in the world but nothing is known of the antiquity of the cultivation of this plant, whose flower is much admired both for its bouquet and as a colorant. The sapphire mined in Kashmir is universally admired for its quality. Although most sapphires in jewelry are said to be from a mine discovered in Padar in 1882, the Victoria & Albert Museum's turban ornament with a central sapphire was given to Admiral Watson in 1757. Indeed, sapphires used as centerpieces in pearl necklaces from the Gupta period could have been mined in Kashmir as well.

5. As quoted in Keenan, *Travels in Kashmir*, p. 57. This book is a very readable and lively introduction to Kashmir. This deal is almost as ridiculous as the purchase of Manhattan by European settlers from the native population.

6. Two English translations of the *Rājataraṅgiṇī* exist, one by Stein (1892) and the other by Pandit (1958).

7. Again in 642, Durlabhavardhana went to Und in Pakistan to meet Xuanzang. By and large, the chronology followed in this book is that reconstructed by John Siudmak (1994).

8. Stein, vol. 1, p. 147. The image was still in worship in Kalhana's time.

9. That Jainism was a minor presence in the valley though no material evidence has surfaced is clear from *"Āgamaḍambara" (Much Ado About Religion)* by Bhatta Jayanta counselor of King Shankaravarman (r. 883–902). As the translator Csaba Dezsö writes in his introduction, the work "is a unique satirical college-drama, in which Bhatta Jayanta presents the contemporary affairs of various religious schools and their relations to politics of the ruling sovereign of Kashmir . . ." (p. 15)

10. Although there is literary evidence of some Buddhist shrines existing during the Sultanate period, interestingly Abu'l Fazl, Akbar's historian, in the sixteenth century makes no mention of Buddhist shrines in his list of "idol temples."

11. See von Schroeder's *Buddhist Sculptures*, vol. 1, for a remarkable array of Kashmiri bronzes preserved in Lhasa.

12. See Nadou, *Buddhists of Kashmir*. Also Soper, 1959. However, there is controversy among scholars whether the Chinese expression *Ji-bin* (*Chi-pin* in Soper) means just *Kashmir* or the larger Gandhara-Kashmir region.

13. See Willson, *In Praise of Tara*, pp. 259–70. Sarvajnamitra's teacher Suryagupta, also a Kashmiri, composed a poetical eulogy to Tara as well. Ibid., pp. 238–50. Sarvajnamitra was famous enough to be remembered by Kalhana who informs us that the monk lived in Kayyavihara built by Lalitaditya Muktapida (See Stein, vol. 1, 143).

14. See Inden "Imperial Puranas."

15. Stein, vol. 1, p. 141. In the extensive note to this distich Stein states that the deity in the temple is really Vishnu-Surya.

16. J. N. Banerjea, *The Development of Hindu Iconography*, pp. 430–31. The temple at Multan in western Punjab, said to have been founded by Shamba, Krishna's grandson, was already famous as described by Xuanzang a century before Lalitaditya.

17. In fact, Stein begins a second Lohara dynasty from the reign of King Uchchala (1101–1111 CE).

18. See Banerji 1965, Ray 1969, pp. 185–211 and Gnoli 1968, pp. xiv–lii.

19. Kalhana's father, Chanpaka, was an important functionary of Harsha's court. See Stein, vol. 2, p. 6ff for Kalhana's biography.

20. Stein, vol. 1, p. 341. Like Shankaravarman, who destroyed Lalitaditya's Parihasapur to build his own city, Harsha too smashed the Vishnu image of Parihasakesava temple. Thus, all the blame for the ruinous condition of Kashmir's ancient monuments cannot be laid on the iconoclasm of the Muslims.

21. Apart from Kalhana's history, the importance of courtesans in the Kashmiri court is reflected by authors such as Shyamalika, Kshemendra, and Damodaragupta.

22. Chimpa and Chattopadhyay, *Taranatha's History of Buddhism in India*, p. 348.

23. The best history of Sultanate Kashmir is still that by Mohibbul Hasan (*Kashmir Under the Sultans*) published almost half a century ago but reprinted in 2005.

24. As discussed elsewhere in the book he is credited with the introduction of paper, silk, carpet, and shawl manufacture to Kashmir by inviting craftsmen from central Asia. However, it should be noted that Kalhana mentions the weaving of wool cloths in the reign of Shankaravarman (Stein, vol. 1, p. 207). Sericulture was also familiar in ancient Kashmir. Zain-ul-Abidin certainly introduced new techniques of weaving wool and silk that produced carpets and shawls.

25. The chronicles of Kashmiri kings were continued by a number of brahman poets beginning with Jonaraja who served as royal panegyrics. See Dutt, *Rājataraṅgiṇī of Jonaraja*, 1986.

26. Hasan, p. 57.

27. R. N. Kaul, *Kashmir's Mystic*, p. 13.

28. Ibid., p. 2.

29. Jahangir, *Tuzuk*, vol. 2, p. 150.

30. See Hasan, pp. 92–93, for a discussion of the monarch's participation in Hindu festivals.

31. See Lawrence, *The Valley of Kashmir*, pp. 248–301, for extensive discussions of the social and religious life of the two communities, based on his personal observations in the late 1880s. In fact, for an overall account of Kashmir's geology, flora and fauna, agriculture, industries and occupations, this is still a very useful work.

32. Jahangir, *Tuzuk*, vol. 2, p. 150.

33. See Hasan , pp. 137–59, and also ch. 8.

34. Leach, *Mughal and Other Indian Paintings from the Chester Beatty Library*, vol. 1, pp. 392–93.

35. Ibid., vol. 2, p. 934.

36. See ch. 9.

37. See ch. 10.

38. Ranbir Singh was enthusiastic about his kingdom's industries and especially encouraged viticulture and sericulture but was not very successful in reviving either. In order to establish a wine industry he first introduced vines from Bordeaux in France but when they failed he imported American vines. See Lawrence. pp. 351–52, 367–69.

39. It is a shame that this building is today rapidly disintegrating and endangering the art housed within.

40. It is interesting that Lawrence (p. 81) had noted how the Kashmiris did not know how best to use their abundant supply of willow and recommended that the timber could readily be employed for furniture.

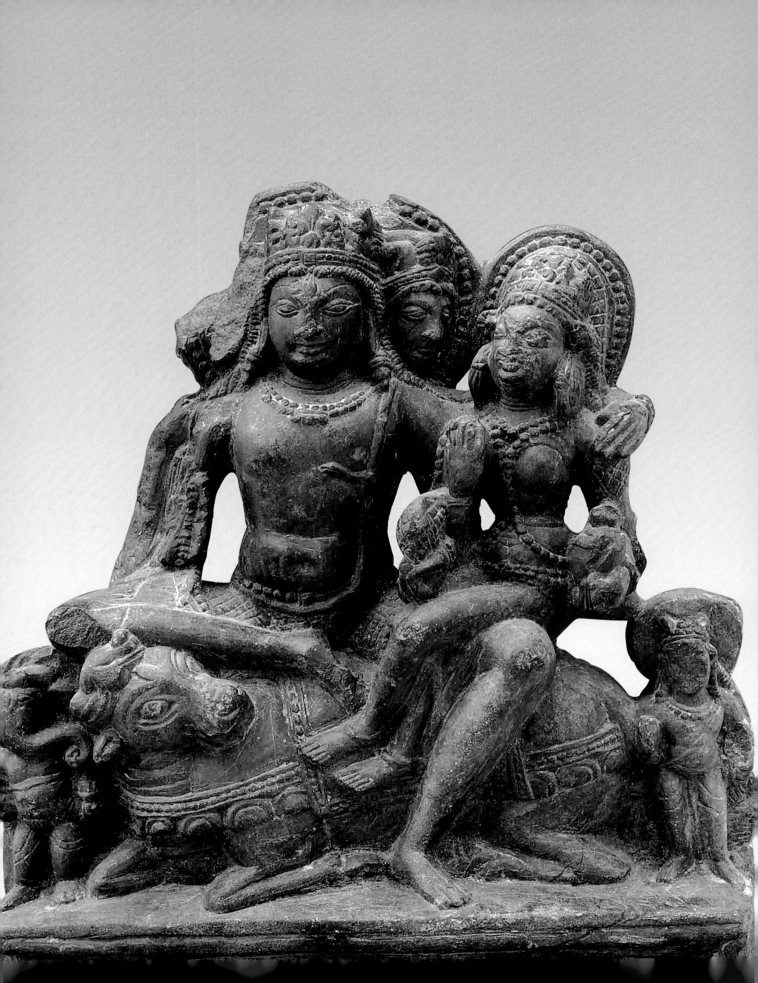

NAGAS, MONKS, TANTRIKS, AND POETS:
THE INTELLECTUAL AND RELIGIOUS FOUNDATIONS FOR THE ARTS OF KASHMIR IN THE ANCIENT PERIOD (300–1400)

By Gerald James Larson

Introduction

> Reverence to Shiva, who like the great tree of life, is transcendent and contains all those merged in eternal peace, agreeably bathed in the reflected jewel-light coming from the expanded, ornamented hood of the serpent.
>
> *Kalhana*

This is the first verse of the first book of Kalhana's famous *Rājataraṅgiṇī*, the most extensive (and often reliable) history of Kashmir surviving from the ancient period.[1] It is a simple verse (*śloka*) highlighting the author's identity as a devotee of Shiva. Of greater interest, however, is the second verse of Kalhana's invocation, in the ornate *kāvya*-style of classical Sanskrit poetry. The verse again is in praise to Shiva, but now in his form as Ardhanarishvara (the lord whose half is woman) (fig. 15). In other words, it is that form of Shiva in which his left (female) side is the great goddess, Parvati, and in which his right (male) side is Shiva in his typical masculine identity. The Sanskrit verse is a double entendre (in which each phrase has two meanings, one pertaining to the left side and the other to the right side). It is nearly impossible to render such a double entendre in the medium of English, and my rendering below is at best a clumsy attempt. The verse can only be fully appreciated by the Sanskritist.

> Let there be joyous glory either for your left side, who is none other than the great goddess, or your right side, you, whose characteristic companion is the bull—first, your left side,
> [having] a forehead adorned by the beauty mark of saffron,
> ear-lobes decorated with playfully dangling earrings,
> a lovely neck translucent with the color of an ocean-born (shell),
> and breasts covered with a splendid bodice.
> or, second, your right side,
> [having] a forehead marked with the insignia of fire (of your third eye),
> ear-lobes adorned with writhing, open-mouthed snakes,
> a neck tinged by the color (blue) from the ocean-born (poison),
> and a chest covered by snakes.[2]

I begin with this verse from the *Rājataraṅgiṇī* for several reasons. First, the author, Kalhana, is making clear that he is writing his "history" as a poet, but not just a casual

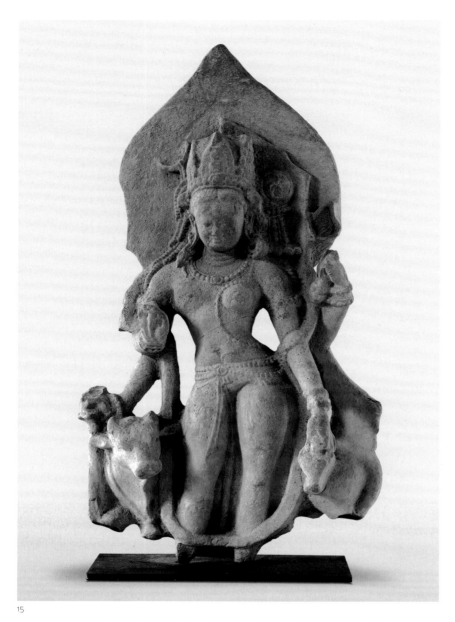

15

<<
Detail of fig. 21, ch. 2

FIG. 15 ❁
Ardhanarishvara, seventh century
Stone
H. 20 1/16 x W. 11 x D. 4 3/4 in.
(51 x 28 x 12 cm)
Private collection

or amateur poet, but rather one highly trained in Sanskrit poetics and aesthetic the-
ory. Second, the author is indicating that he is a devotee of Shiva, but, again, not sim-
ply a casual devotee, but rather one fully aware of the sophisticated androgynous
male-cum-female form of Shiva.[3] This androgynous form is important not only in the
Trika philosophy of Kashmiri Shaivism but fundamental also in the complex Tantra tra-
ditions of Kashmir. Third, the author is surely aware that such a poetic verse will call
to mind the numerous representations in temple sculptures, statues, and paintings in
the presence of which devotees perform their ritual actions. The verse, in other
words, nicely brings together those components that help us to identify the intellec-
tual contours of a cultural tradition. These include the historical chronicles of a given
region, the literature, the aesthetic sensibilities, the philosophical presuppositions, the
religious impulses and ritual behaviors, and finally, the visual representations in sculp-
ture, architecture, and painting that give tangible, external form to the structures of
the culture.

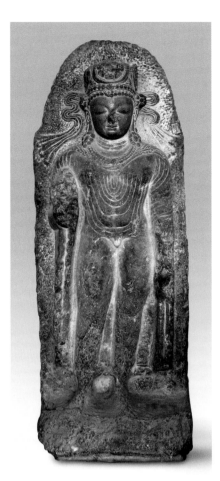

16

FIG. 16 ✤
Buddha, eighth century
Limestone
Parihasapura
H. 52 3/8 x W. 23 1/4 x D. 10 1/4 in.
(133 x 59 x 26 cm)
Sri Pratap Singh Museum, Srinagar
1897

The Major Periods in Kashmir's Intellectual History

As quoted at the outset, Kalhana completed his work in the middle of the twelfth century. His text, organized in eight books, can be divided into three distinct segments, which even now provide a useful periodization for discussing Kashmir's intellectual history in the ancient period.[4]

Books One–Three

The first segment is for the most part legendary due to Kalhana's treatment of his material because the poet's sources were exceedingly limited and historically unreliable. This ancient period of the first segment, however, ranging roughly from the fourth century BCE through the first centuries of the Common Era, is nevertheless exceedingly important in terms of laying the foundations for the later intellectual history. While Kashmir was just beginning to emerge as an identifiable region, the northwestern area was already an important crossroads. Kalhana's "history," however, begins with references, first of all, to the legendary "time" of the *naga*-s (book 1, vss. 28ff.), or serpents, and their leader, Nila. Kalhana also refers to the *pishacha*-s (book 1, vss. 184ff.), malevolent demons from which the land must be rescued for the sake of human habitation. Here Kalhana is using as his main source a text called *Nīlamatapurāṇa*, which characterizes the original inhabitants of the Kashmir valley as serpents and demons. These creatures had to be propitiated or, in the case of the demons, had to be removed or conquered if the area were to become suitable for human habitation. Most likely these legendary figures refer to early tribal inhabitants of the Kashmir region who were involved in serpent worship and demonolatry and whose languages were either non-Aryan or early middle-Indic Prakrits.[5] The archaic practice of serpent worship was absorbed by later Buddhist, Shaiva, and Vaishnava religious traditions and still survives in place names such as Anantanag and Verinag.

Of greater importance historically, however, was the introduction of Buddhism in this ancient period. The Buddhist tradition apparently made its appearance in the time of the Maurya emperor Ashoka (third century BCE), as a result of the missionary work in the Kashmir valley of the monk Majjhantika (in Sanskrit, *Madhyantika*). Buddhist traditions over the next several centuries developed into a variety of intellectual movements or schools, reaching a high point during the reign of the Kushan emperor, Kanishka (about 100 CE) and the great Buddhist council that he convened in Kashmir (fig. 16).[6] The Buddhist schools of the Sarvastivadins and the Sautrantikas were strong in the Kashmir region, and the philosophy of the Abhidharma was developed there. The *Mahāvibhāshā*, the massive compendium of Buddhist technical philosophy, was composed by the Sarvastivadins in Kashmir, and the great Vasubandhu, author of the *Abhidharmakośa* and the *Abhidharmakośa-bhāshya* studied in Kashmir for four years in the fourth century (342–346) in order to master the Abhidharma.[7] Also in the early centuries of the Common Era, Mahayana, including Tantric Vajrayana, made its appearance in Kashmir and may have even originated there. Again, the name of Vasubandhu is important, since it is likely that, in addition to his work in Abhidharma philosophy, he was also one of the early exponents of the Mahayana philosophy known as *Yogāchāra* (practice of yoga) or *Vijñānavāda* (doctrine of consciousness-only). Monks from the Kashmir region played a major role in the spread of Mahayana and Vajrayana into Tibet, central Asia, and China.[8]

Running parallel with the development of Buddhist traditions in these centuries were both early Vaishnava and Shaiva spirituality. These incipient Vaishnava traditions eventually result in a rich Sanskrit Vaishnava literature, including such texts as the *Pāñcharātra-saṃhitā*-s (especially the *Ahirbudhnya-saṃhitā)*, the *Vishṇudarmottarapurāṇa*, and the

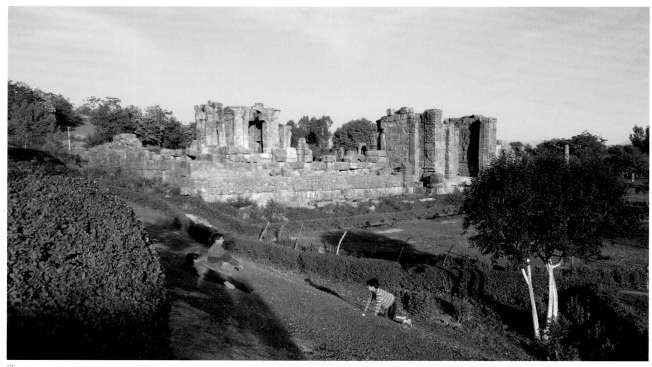

17

Nīlamatapurāṇa.[9] This is also the period in which the early Shaiva texts known as *āgama*, such as the *Vijñānabhairava* and the *Mālinivijaya* appear.[10] There is considerable evidence, in other words, even for this early period before Kashmir clearly emerges into the critical light of history, to suggest that, in spite of its geographical isolation, the region was unusually cosmopolitan. Buddhist, Vaishnava, Shaiva, Central Asian, and even Mediterranean cultural traditions intermingled and cross-fertilized one another.

Book Four

The second segment includes Kalhana's treatment of the Karkota dynasty, which most scholars recognize as the beginning of Kashmir's history proper.[11] The period begins with the reign of Durlabhavardhana in the seventh century, reaches its high point in the reign of Muktapida Lalitaditya in the early eighth century, and continues to the middle of the ninth century with the rise of the new Utpala dynasty. Here Kalhana is on much firmer ground historically. His treatment of chronology has been questioned, but his portrayal of the period overall has been shown to be remarkably accurate.[12] It was a period of political expansion and economic prosperity.[13] This was the period when the Chinese Buddhist pilgrim, Xuanzang, spent two years (631–633) in Kashmir studying Buddhist Abhidharma and collecting manuscripts. While noted for its Sarvastivada tradition, the Sautrantika and Mahayana branches of Buddhism were also familiar to the region.

Among the various rulers of the Karkota dynasty, the reign of Lalitaditya was especially salient for the development of Kashmir's intellectual life despite the monarch's political ambitions and preoccupation with territorial expansion. He invited scholars and artists from around India to come to Kashmir. The great Shaiva philosopher, Abhinavagupta, comments in one of his texts that his ancestor, Atrigupta, came to Kashmir in this period at the invitation of Lalitaditya.[14] The king not only encouraged Shaiva traditions, he was equally interested in Vaishnava, Buddhist and Jaina thoughts. As mentioned earlier, a vast body of Sanskrit

FIG. 18
Relief images at the Avantishvar temple,
Avantipur

devotional and theological literature was developing in Kashmir among followers of Shaiva, Vaishnava, and Buddhist traditions. Lalitaditya was also a patron of Sanskrit learning, including literature and philosophy, and the arts in general. He was likewise a great builder of towns and monuments, including Buddhist monasteries and Brahmanical temples such as the great sun-temple of Martand (fig. 17). In short, more than any other ruler, it was Lalitaditya who made Kashmir one of the major centers of intellectual life on the subcontinent.

Books Five–Eight

The third segment of Kalhana's history deals with the Utpala and most of the subsequent Lohara dynasties, as the book was completed between the years of 1148 and 1150 in the reign of Jayasimha.[15] This third segment begins on a positive note, namely, the remarkable accomplishments of Avantivarman, the founder of the Utpala dynasty.[16] Continuing Lalitaditya's legacy, Avantivarman was a major supporter of Shaiva, Vaishnava, and Buddhist traditions as well those of Indian philosophy and Sanskrit studies, especially Sanskrit grammar and poetics (fig. 18).[17] The aesthetic theoretician, Anandavardhana (active 860–890 CE), worked in the court of Avantivarman, producing his important work, *Dhvanyāloka*, which sets forth the theory of *dhvani* (implicit resonant meaning in poetry) in Sanskrit aesthetics.[18]

This is also the period in which the sophisticated monistic philosophy of Kashmiri Shaivism begins to be formulated.[19] There is the work of Vasugupta, the exponent of *spanda-śāstra* (the doctrine of consciousness as vibration) and the work of Somananda, the exponent of *pratyabhijña-śāstra* (the doctrine of the recognition of one's own experience as that of Shiva), both of whom worked in the ninth century. The Kashmiri Shaiva philosophical monism grows out of the older Shaiva Tantric ritualism as found in the ancient Shaiva *Agama* texts. It is also to some degree a reaction against the monistic Advaita Vedanta of the great Shamkaracharya (about eighth century CE), which Kashmiri Shaiva thinkers found to be insufficiently responsive to the fullness of both human experience and the nature of the divine experience. In any case, many of these intellectual developments reach their fullest expression in the tenth and early eleventh centuries in the work of Kashmir's greatest mind, Abhinavagupta (about 975–1025).[20] The Kashmiri Shaiva monistic reflection of Abhinavagupta synthesizes Tantric ritual, the aesthetic theory of *dhvani*, and a sophisticated theory of mind and consciousness. It is one of the great intellectual achievements in the history of Indian philosophy and religion.[21]

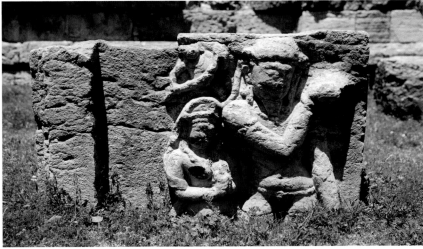

18

Interestingly enough, Abhinavagupta produces his grand synthesis during the chaotic political period of the infamous Queen Didda (980–1003), which marks the end of the Utpala dynasty and the beginning of the Lohara period.[22] It was also in these troubling times that Tibetans arrived in Kashmir in the hopes of reinvigorating Buddhism in their own country. The contribution of Kashmiri monks and scholars to the reestablishment of Buddhism in Tibet, especially the Vajrayana, cannot be overemphasized.

FIG. 19
Avalokiteshvara with two Taras, 989 (dated)
Bronze
H. 9 7/8 in. (25 cm)
Sri Pratap Singh Museum, Srinagar

Conclusion: Kashmir's Contribution to Ancient India's Intellectual Life

In this brief survey of the salient periods of the ancient history of Kashmir, I want to conclude by mentioning four subject areas in which the valley has made unique contributions to the intellectual heritage of India. These are the following: Buddhist technical philosophy; Sanskrit poetics or aesthetic theory; the Trika philosophy of Kashmir Shaivism; and the Tantric perspective in Shaiva, Vaishnava, and Buddhist Vajrayana traditions. Let me offer a brief characterization of each one of these subject areas.

[1] It is hard to exaggerate the importance of the Kashmir region for the development of Buddhist philosophy, both for the older schools of the Theravada (in Sanskrit, *Sthaviravāda*) and the major schools of the Mahayana (fig. 19). The Kashmir Valley became the major home for the Sarvastivada school of Buddhist thought, and it was the Sarvastivadins who compiled the first massive compendium of technical Buddhist thought in a text entitled *Mahāvibhāshā*. The school's name breaks down as *sarva-asti-vāda* (the doctrine that all exists), based on its treatment of the notion of time in Buddhist thought. The Sarvastivadins accepted the original Buddhist insight of radical momentariness (*kshaṇika-vāda*), but they were also persuaded that some provision had to be made regarding the issue of continuity. They therefore argued that the constituents (called *dharma*-s or "momentary flashes of energy") that make up our experience of the world exist not only in present time but in past time and future time as well. Hence, the name of the school, "the doctrine that all exists" (*Sarvāstivāda*).

There are "moments" that are yet to occur (future or potency-moments), "moments" that are currently occurring (present moments), and "moments" that have already occurred (past or residual moments). Moments in all three modalities fully exist, hence allowing for a kind of continuity within the Buddhist philosophy of momentariness. In addition, the Sarvastivadins developed elaborate technical lists of different kinds of "moments" or constituents together with elaborate discussions of the causes and conditions that operate among the constituents. These sorts of discussions became the basis for the technical Buddhist philosophizing known as the Abhidharma and were finally compiled into the text known as the *Mahāvibhāshā*.

Clearly the Sarvastivada predilection for technical lists of constituents that persist through the modalities of time could easily tip over into a quasi-substantialism as well as an arid scholasticism, and other Buddhist schools were quick to point out precisely these weaknesses. Nevertheless, monks frequently traveled to the Kashmir region in the first centuries of the Common Era to learn about this technical philosophizing. As already mentioned earlier, it is no accident that the great Vasubandhu studied in Kashmir for four years in order to master the Abhidharma. He then composed his summary of this sort of Abhidharma philosophizing in his important work, the *Abhidharmakośa*, as well as his critique of this sort of Abhidharma in his *Abhidharmakośa-bhāshya*. His own point of view in the *Bhāshya* follows the Sautrantika school, a school that calls into question the elaborate scholasticism of the Abhidharma and hearkens back, instead, to the original sutras (discourses) of the Buddha

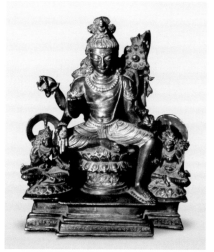

19

20

FIG. 20
Shivalinga worship in temple depicted
on the dhoti of Avalokiteshvara, early
thirteenth century
Sumstek temple
Alchi, Ladakh

(hence the expression, *sautrāntika*, or "follower of the sutra"). Likewise, it is no accident that Xuanzang spent two full years in Kashmir in order to master the Abhidharma philosophy. Also, the Mahayana Buddhist philosophizing of the Madhyamika (the school of the "new middle way"), the Yogacara or Vijnanavada (the school of "consciousness-only"), and the Vajrayana (the Buddhist Tantric school of the "thunderbolt") all begin their respective philosophical trajectories from these Abhidharma traditions in Kashmir (fig. 20).[23]

[2] Distinctive in the area of Sankrit poetics, of course, is the work of Anandavardhana in his *Dhvanyāloka* (Light on the Theory of "*Dhvani*") and the work of Abhinavagupta (active about 975–1025) in his *Dhvanyāloka -lochana* (Illuminating the Light on the Theory of "*Dhvani*," or simply, A Commentary on the "*Dhvanyāloka*").[24] Also, Abhinavagupta composed a commentary on Bharata's *Nāṭyaśāstra*, entitled *Abhinavabhāratī*.[25] Sanskrit poetics in earlier centuries had revolved around the theory of eight aesthetic "tastes," or *rasa*-s, that are aroused in the portrayal of emotional feelings in poetry and drama. The aesthetic "taste" is obviously not the literal emotion (of sexual arousal, sorrow, anger, and so forth) but rather the generalized aesthetic experience emerging out of the literal emotion. In addition, Sanskrit poetics involved the study of the figures of speech, metaphors, similes, and ornamentations *(alamkāra)* that the poet or dramatist might use in generating the various "tastes." Anandavardhana and Abhinavagupta in the Kashmir tradition of Sanskrit poetics add to these older theories two important innovations, namely, a theory of what might be called "implicit resonance" (*dhvani*) and the introduction of a ninth "taste" known as the "taste of spiritual release," "spiritual resignation," or "spiritual tranquility" (*śānta-rasa*). Regarding the theory of "implicit resonance" (*dhvani*), Anandavardhana and Abhinavagupta argue that in addition to the literal, metaphorical, and purposeful or intentional use of language, there is also a level of "secondary suggestion" (*vyañjanā*), or "implicit resonance" (*dhvani*). This is a subtle over-plus of meaning, not directly expressed in any of the words being used in a poem or drama. It is a level of meaning which is merely implicit in the words used, but which is nevertheless the essence of aesthetic "tasting" (*rasa-dhvani*). Regarding the issue of a ninth *rasa*, Abhinavagupta is able to argue that the religious experience (*śānta-rasa* as *brahmasvāda*) is analogous to the aesthetic experience (*rasasvāda*). The two are not identical, since the ultimate experience of spiritual release cannot be reduced to an aesthetic experience. There is, however, a close parallel between the two types of experience. What is accomplished by these two innovations, that is, the theory of *rasa-dhvani* and the notion of a ninth *śānta-rasa*, is an opening up of the discussions about poetic experience or aesthetic experience. Discussions are no longer limited to the mechanical construction of ornate figures of speech (*alamkāra-śāstra*) in order to evoke the standard eight "tastes." With the new theories it is possible to focus on the endless suggestibility in language and the capacity of poetic language (and the arts) to bring one to the threshold of profound religious experience. Interestingly enough, it should be noted finally that Kalhana in the first book of his *Rājataraṅgiṇī*, (1.23) refers to *śānta-rasa* as the "crowning sentiment" of his poem: ". . . *mūrdhābhiṣekaḥ śānta-sya rasasya atra vichāryatām*."[26]

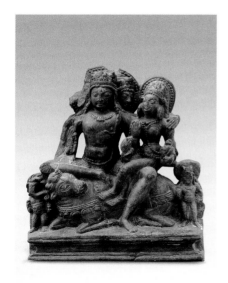

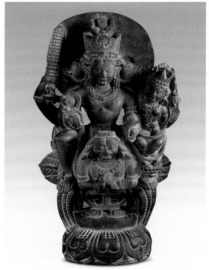

21

22

FIG. 21
The Holy Family Shiva, Parvati/Uma, Kumara
and Ganesh, tenth to eleventh century
Greenish chlorite
H. 6 7/8 in. (17.5 cm)
Private collection

FIG. 22
Vishnu and Shri Lakshmi on Garuda,
eleventh century
Phyllite
H. 23 x W. 11 1/2 x D. 5 1/2 in.
(58.42 x 29.21 x 13.97 cm)
Los Angeles County Museum of Art,
From the Nasli and Alice Heeramaneck
Collection, Museum Associates Purchase

FIG. 23 ❀
Vajrasattva and consort, eleventh century
Brass with silver and stone inlay
H. 5 5/8 in. (14.3 cm)
Mr. and Mrs. Chino Roncoroni

[3] The term *Trika* means "threefold" or "forming a triad" and usually refers either to the triad, Shiva, Shakti, and Anu or the triad, *pati, pāśa*, and *paśu*. The former triad, of course, refers to the supreme Lord, Shiva, his inherent power (or consort), Shakti, and the devotee or "soul" (Anu). The latter triad refers to the Lord (*pati*), the fetters that bind (*pāśa*), and the souls that are bound (*paśu*). This is a complex philosophical tradition involving a variety of thinkers over many centuries, the greatest exponent of which was Abhinavagupta. What Abhinavagupta accomplishes in his formulation of the Trika philosophy is a remarkable synthesis of older traditions of Indian philosophy such as Samkhya-yoga, Nyaya, Vedanta, and even the various traditions of Buddhist philosophy in the Kashmir region, with traditions of linguistic theorizing, Sanskrit poetics, and Tantric rituals. The result is a monistic philosophical vision that is unique in the intellectual history of India. It is not possible within the frame of this essay to lay out the details of Abhinavagupta's monistic vision of Shiva.[27] Suffice it to say that it is a system of 36 principles (*tattva*) ranging from the transcendent pure consciousness of Shiva (*chit-shakti*) down through the gross elements of the manifest physical world and all forms of embodiment. Everything is a manifestation of Shiva, and spiritual liberation occurs as a result of "recognizing" (*pratyabhijñā*) that our true nature is none other than Shiva (fig. 21). Even our gross embodiment, if properly understood and ritually sanctified, can be utilized in achieving this "recognition" of our true nature. Unlike so much of traditional Indian philosophy and religion, which negates the reality of our sensuous and physical embodiment, Abhinavagupta's Kashmiri Shaiva philosophy invites the practitioner to appreciate the fullness and particularity of physical existence as a positive dimension of the spiritual life. Hence, in the Trika philosophy, the aesthetic experience (*rasāsvāda*) in poetry, drama, music, and the arts becomes a pathway, and even a mirror reflection (*ābhāsa*), of the ultimate religious experience (*brahmasvāda*). This incorporation of the arts into the conceptual framework of Indian philosophizing is truly unique in the intellectual history of India (fig. 22).

[4] Whether Tantrik traditions originate wholly or in part in the Kashmir region, it is nevertheless clear that the Tantric perspective becomes a dominant style of spiritual practice as reflected in the Shaiva *Agama*-s, the Vaishnava Pancharatra texts (*Saṃhitā*), and the Buddhist Vajrayana traditions in the valley. Scholarship in Indology is only beginning to understand the scope and meaning of the Tantric perspective.[28] The focus in this form of spiritual practice is predominantly on varieties of ritual performance that link up the

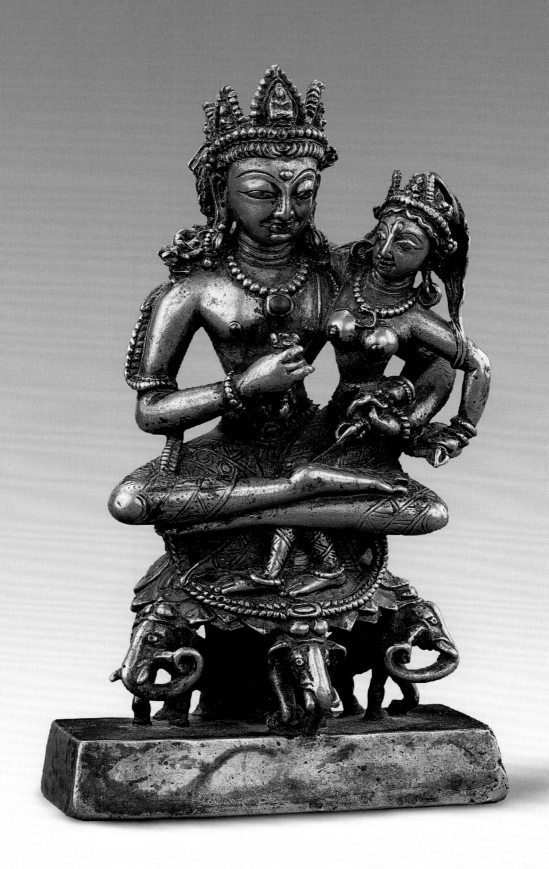

psycho-physical embodiment (microcosm) of the practitioner with the larger cosmic environment of the manifest world (macrocosm). Undoubtedly this sort of spiritual practice has archaic roots in fertility rituals and traditions of magic that go back to time immemorial. When Tantric ritual is assimilated into mainstream Shaiva, Vaishnava, and Buddhist Vajrayana traditions, however, a distinctive shift in spiritual orientation appears to be taking place. To be sure, ritual performance always lends itself to the possibility of abuse in terms of mechanical manipulation (magic), obsessive-compulsive behaviors, eccentric sexual practices, and any number of superstitious tendencies. Unfortunately, much European scholarship on Tantric spirituality has focused, perhaps excessively, on some of these sorts of practices. Likewise, mainstream elite groups in Asian societies, whether Hindu or Buddhist, have also often taken a dim view of Tantric spirituality.

Perhaps a somewhat better way of examining Tantric spirituality is to compare and contrast it with the other major type of spirituality that develops at about the same time as the rise of the Tantric beliefs, namely, bhakti spirituality. Both types of spirituality arise out of dissatisfaction with older elite religious traditions. Both types likewise turn away from philosophical conceptualizations or doctrinal formulations in their respective traditions in search of more immediate and easier techniques. Both types, moreover, have a much more favorable attitude towards the body and towards involvement with the physical world. Both types of spirituality incorporate gender symbolism of male and female in contrast to older traditions of spirituality that focus more on some sort of neuter Absolute or Ultimate. Finally, both types of spirituality take seriously the aesthetic components in human experience.

The two types of spirituality differ principally in their behavioral attitudes regarding the experience of the divine. For bhakti spirituality, god is a loving person, and the devotee experiences god as a trustworthy friend, a beneficent parent, an aroused lover, or as a servant in the presence of a kindly master (to use some of the common metaphors in Krishna bhakti spirituality). Personal love is central in this sort of spirituality, and finally the experience of god as a loving person is greater even than the old Atman or Brahman of the Upanishads. Moreover, the personal relationship that the believer has with Krishna overcomes or sets aside all prescribed patterns of behavior or hierarchy. The believer encounters Krishna directly and immediately, and the outpouring of spontaneous emotion through singing and dancing cuts through all conventional behavior. The believer is ravished by the personal love of Lord Krishna.

Tantric spirituality, on the other hand, has a very different tonality. For the Tantrik, ritual is everything, and Shiva (in Shaiva Tantric practice) or Vishnu (in Pancharatra Tantric practice) or the Diamond Body of the Buddha (in Buddhist Vajrayana) is never personal in the sense that Krishna is personal. Shiva and/or Vishnu is utterly transcendent (viśvottīrṇa or anuttara), and there are carefully prescribed ritual hierarchies both microcosmically (in terms of the body) and macrocosmically (in terms of cosmic emanation) that one must follow under the careful guidance of a meditation master or spiritual lineage. Spontaneity of the believer is increasingly ruled out in favor of the spontaneity (svātantryaśakti) of the transcendent Shiva with his Shakti or the transcendent Vishnu with his Lakshmi or the Cosmic Buddha Vajrasattva with his spouse symbolizing supreme wisdom (prajñā) (figs. 21–23). System and structure are fundamental in Tantric spirituality and, hence, the great cosmic emanation systems of Kashmiri Shaivism or Pancharatra Vaishnavism or Buddhist Vajrayana are hardly an accident. To be sure, in Tantric spirituality the purely philosophical abstractions of the older systems of Indian philosophy are set aside, but the systems return with a vengeance in the uncompromising rigor of hierarchical ritual performance. In other words, ritual largely replaces philosophical abstraction, but the fascination with elaborate system-building remains. Likewise, with the Tantric focus on ritual practice, the crafted image plays a central role, both in terms of external, artistic form as well as in interiorized meditation (dhyāna) and verbalized mantra incantation.

1. *bhuśā-bhogi-phaṇā-ratna-rochiḥ-sichaya-chārave namaḥ praṭīna-muktāya hara-kalpa-mahīruhe.*

 For the Sanskrit text, see Stein, *Rājataraṅgiṇī*, vol. 1, p. 1. For this verse as well as the following, second verse, two translations into English are available. First, there is Stein, (1903), and Pandit (1148), pp. 1–3. My own rendering differs considerably from both translations, but I suspect that such would be the case for any attempt at translation.

2. The Sanskrit is as follows:
 bhālaṃ vahni-śikhāṅkitaṃ
 dadhad adhiśrotaṃ vahan,
 saṃbhṛta-krīḍat-kuṇḍali-jṛmbhitaṃ,
 jaladhijacchāyācchakaṇṭhacchaviḥ,
 vakṣo bibhrad-ahīna-kañcukitaṃ,
 baddhāṅganārdhasya vo bhāgaḥ
 puṃgava-lakṣmaṇo 'stu yaśase
 vāmo 'tha vā dakṣiṇaḥ

 Regarding the difficult mixed-meter of this verse, the first two lines appear to be simply a half-*śloka* (two *pāda*s of eight-syllabled *anushṭubha*). Lines three, four, and five are eleven-syllabled *trishṭubha*. The final two lines appear to be a twenty-six–syllabled verse-form known as a *bhujaṃga-vijṛmbhitam* (a species of the *utkṛti* meter). For a good overview of the meters of classical Sanskrit poetry, see A. Berriedale Keith, *A History of Sanskrit Literature* (London: Oxford University Press, 1920), pp. 417–21.

3. The *Rājataraṅgiṇī* contains eight books, each called a *taraṅga* (wave), and Kalhana introduces each of the eight waves with an ornate *kāvya* verse in honor of Ardhanarishvara.

4. Stein, *Rājataraṅgiṇī*, vol. 1, p. 68.

5. The best evidence regarding the *naga*-s is to be found in the *Nīlamatapurāṇa*. See Kumari's version, especially vol. 1, pp. 46–71 for a useful survey of scholarly views regarding the *naga*-s and *pishacha*-s. Evidence that *Paishachi-bhasha* (the Pishachi language) is a middle Indic-Prakrit derives from the wonderful story in the *Kathāsaritsāgara* (*The Ocean of Rivers of Stories*), a collection of old tales in Sanskrit compiled by Somadeva some time between 1063 and 1081 in Kashmir, that describes how the stories were originally in Pishachi and later rendered into classical Sanskrit. Every first or second year Sanskrit student has read the tale found in Charles Rockwell Lanman, *A Sanskrit Reader* (Cambridge: Harvard University Press, 1959, reprint of original edition from 1884), pp. 53–56, 331–34, 338–39.

6. One of the best recent treatments of the early history of the Buddhist tradition in India is Hirakawa Akira, *A History of Indian Buddhism: From Śākyamuni to Early Mahāyāna*, trans., Paul Groner (Honolulu: University of Hawaii Press, 1990), pp. 223–55. For the later history of Buddhism in the Kashmir region, see Nadou, *Buddhists of Kashmir.*

7. For recent discussions of the *Mahāvibhāshā*, see Karl H. Potter, ed., *Abhidharma Buddhism to 150 A.D.*, Encyclopedia of Indian Philosophies, vol. 7 (Delhi: Motilal Banarsidass, 1996), pp. 511–68. For detailed treatment of the work of Vasubandhu, see Karl H. Potter, ed., *Buddhist Philosophy from 100 to 350 A.D.*, Encyclopedia of Indian Philosophies, vol. 8 (Delhi: Motilal Banarsidass, 1999), pp. 483–649. For detailed discussions of Buddhist philosophy in Kashmir in the medieval period and the spread of Buddhism through central Asia and Tibet, see Naudou, pp. 78–202.

8. Ibid.

9. The best discussion of Pancharatra literature and the *Ahirbudhnya-saṃhitā* in particular is to be found in F. Otto Schrader, *Introduction to the Pāñcarātra and the Ahirbudhnya Saṃhitā* (Madras: Adyar Library, 1916), pp. 2–26. Schrader thinks that much of Pancharatra literature comes from the north and that the *Ahirbudhnya* was clearly written in Kashmir. Useful discussions of the *Vishnudarmottarapurana* are to be found in Kusum Kumari Gupta, *A Socio-Religious Study of Viṣṇudharmottara Purāṇa* (New Delhi: Harman Publishing House, 1994), pp. 2–9. She dates the *purana* to about the fourth or fifth century and suggests that it appears to be from Kashmir. See Kumari's The *"Nīlamatapurāṇa,"* Also, the following should be consulted: Ikari, *A Study of the Nilamata.*

10. The best treatment of the Shaiva Agama canon may be found in Mark S. G. Dyczkowski, *The Canon of the Saivāgama and the Kubjikā Tantras of the Western Kaula Tradition* (Albany: State University of New York Press, 1988), *passim.*

11. Stein, *Rājataraṅgiṇī*, vol. 1, book 4; vss. 1–371, pp. 120–56.

12. For useful discussions of the chronology, see ibid., vol. 1, pp. 66–80; Bamzai, *A History of Kashmir*, pp. 108–110; and Naudou, pp. 21–24, 266–67.

13. For Kalhana's description of the Karkota period, see Stein, vol. 1, pp. 120–85, and for Muktapiḍa Lalitaditya in particular, see ibid., pp. 130–56. For Stein's own discussion of the Karkota dynasty, see vol. 1, pp. 87–97. For a useful summary of the achievements of Lalitaditya, see Bamzai, pp. 111–22.

14. Gerald J. Larson, "The Aesthetic (*rasāvāda*) and the Religious (*brahmāsvāda*) in Abhinavagupta's Kashmir Saivism," *Philosophy East and West* vol. xxvi, no. 4, October 1976, p. 372.

15. For Kalhana's actual words, see Stein, *Rājataraṅgiṇī*, vol 1, book 1, vs. 52 and vol. 2, book 8, vs. 3404, and for Stein's interpretation of Kalhana's comment, see ibid., vol. 1, p. 42.

16. Stein, *Rājataraṅgiṇī*, book 5, vss. 1–127, pp. 186–202.

17. For helpful summaries of the reign of Avantivarman, see Bamzai, pp. 122–25. See also Romila Thapar, *Early India: From the Origins to AD 1300* (Berkeley: University of California Press, 2004), pp. 415–17.

18. Larson, 1974, "The Sources for Śakti in Abhinavagupta's Kashmir Saivism: A Linguistic and Aesthetic Category," *Philosophy East and West*, vol. xxiv, no. 1 January 1974, pp. 49–56.

19. Ibid.

20. Larson, "The Aesthetic (*rasavāda*) and the Religious (*brahmasvāda*)," pp. 376–84.

21. Ibid.

22. From Stein's *Rājataraṅgiṇī*, book 6, vss. 176–368, pp. 249–66.

23. For bibliographical details, see notes 6, 7, and 8.

24. See Larson, 1974, and Larson, 1976. [see notes 18 and 14 for bibliographical details.]

25. For a useful discussion of this text, see Gnoli, *The Aesthetic Experience According to Abhinavagupta* (Varanasi: The Chowkhamba Sanskrit Series Office, 1968), pp. xxxv–lii.

26. Stein, *Rājataraṅgiṇī*, vol. 1, Sanskrit text, p. 2.

27. For a full discussion of the Trika system, see the two essays mentioned in notes 18, 20, and 24.

28. For a good discussion of the evolution of Tantric literature, see P. C. Bagchi, "Evolution of the Tantras," in *Studies on the Tantras* (Calcutta: The Ramakrishna Mission Institute of Culture, 1989), pp. 6–24. See also Dysckowski, *The Canon of the Saivāgama and the Kubjikā Tantras of the Western Kaula Tradition*, see note 10 for bibliographical details. For the Pancharatra Vaishnava Tantric tradition, see Otto Schrader, *Introduction to the Pāñcharātra and the Ahirbudhnya Saṃhitā*, pp. 1–26, and see note 9. For a good discussion of Buddhist Vajrayana, see Snellgrove *Indo-Tibetan Buddhism*, vol. 1 (Boston: Shambala, 1987), pp. 128–34. See also Naudou, pp. 116–154, and see note 6 for bibliographical details. Also of great interest for Tantric studies, see Andre Padoux, *Vāc: The Concept of the Word in Selected Hindu Tantras* (Albany: State University of New York Press, 1990), pp. 30–85; Sanderson, 1985, pp. 191–216; and finally, Raffaele Torella, *The Īśvarapratyabhijñā-kārikā of Utpaladeva with the Author's Vṛtti*, especially the Introduction (Delhi: Motilal Banarsidass, 2002), pp. IX–LIV.

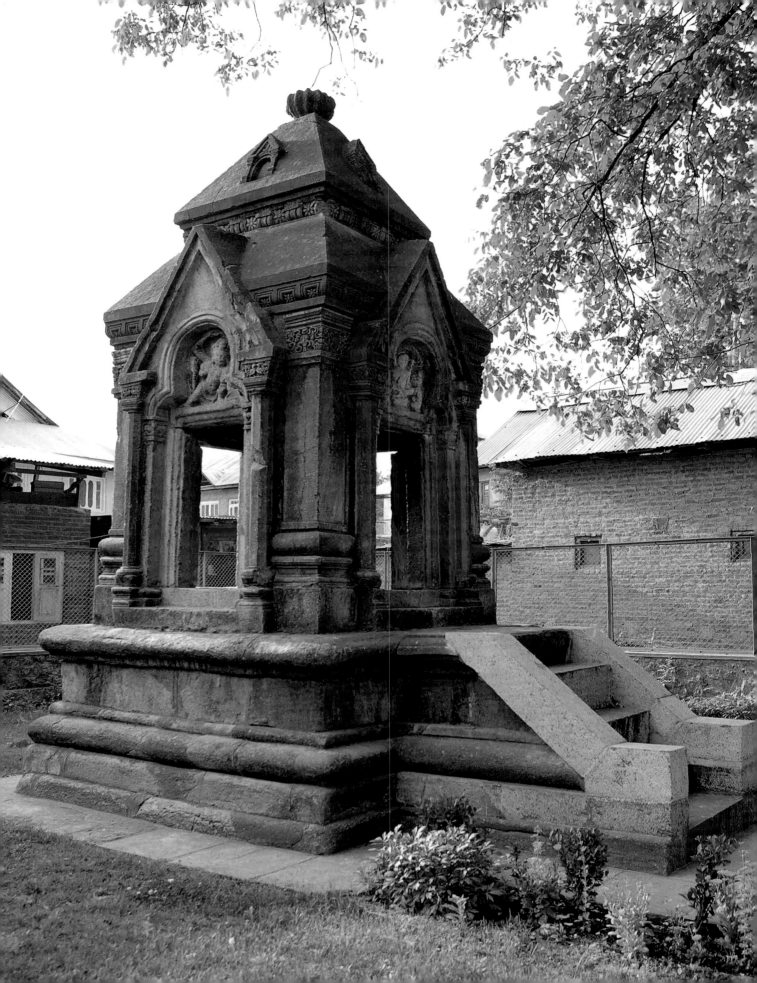

RELIGIOUS ARCHITECTURE
(500–1200)

By John Siudmak

Brahmanical Temples

In parallel with its distinctive style of sculpture, Kashmir developed an equally impressive form of architecture. Both arts probably attained maturity together sometime around the mid-seventh century and continued relatively unchanged for the rest of the millennium. Kalhana's *Rājataraṅgiṇī* records a rich heritage of countless royal donations of Hindu temples and *maṭha*-s, Buddhist stupas and *vihāra*-s, but only about thirty sites can be recognized today in various states of disrepair. There was already a sharp decline in temple building by the tenth century, and though in the last quarter Queen Didda is recorded as having built sixty-four new religious foundations and repaired others,[1] few new constructions were undertaken thereafter, mostly due to continual strife and insufficient financial resources. The pace was hastened during the period of the Islamic conversions of the fourteenth and fifteenth centuries when many Brahmanical and Buddhist buildings either fell into disuse or were converted into mosques and *ziarats*.[2]

While many of the remaining buildings lie in ruins, their scale and grandeur can still be marveled at, and the original appearance of grand temple complexes such as Martand and Avantisvamin can be recreated with the help of smaller temples that have survived intact. About one third of the corpus can be identified and dated from notices in the *Rājataraṅgiṇī*. Most of the buildings were constructed of grey limestone ashlar blocks usually bonded in fine lime mortar, some of enormous size and often held by metal clamps.[3] The main form of heavy transport was by water-craft along the rivers, lakes, and canals, and the logistical problem of transporting and lifting these huge blocks, many of which are more than four meters long, must have been formidable. Most of the sanctuaries originally stood within a walled compound or a cellular quadrangle with a large double-chambered entrance gateway.

The form of architecture that evolved in Kashmir was partly inspired by the Buddhist structures of neighboring Gandhara, but it also developed its own regional characteristics through the innovation and genius of its architects and the demands of the climate. The typical temple construction is of a tall though sturdy stone building usually facing east, though some face west or in other directions, of which the small Payer Shiva temple is an almost complete example (fig. 24). It is usually of square plan, and set on a high single- or double-storied rectangular plinth for ritual circumambulation. The height of the temple is generally twice the width. The high-pitched pyramidal roof was adapted to the harsh winter months when most of the valley is under snow. The superstructure is

usually divided in two tiers by an ornamental frieze, the tall pediments on each elevation reaching to the top of the first tier. The Payer temple has a dormer window on the upper section, which was probably a common feature as was the *āmalaka*, a ribbed, spherical motif crowning the roof. There is either a single entrance with portico, or the temple is open on all sides, as in this example. In one rare case with two entrances,[4] the main doorway is approached by a flight of steps. The interior space forms the inner sanctum (*garbha gṛiha*), usually without ornament, where the main image of the deity was placed.

The most conspicuous feature of the architectural design is the unique combination of rounded arches and triangular pediments supported by a variety of pilasters and columns which decorate the elevations and roofs of the buildings, including the prominent corner pilasters. The pedimented trefoil arch (fig. 25) is a hallmark of the style and is used in many permutations. On the larger monuments it is of very imposing form. Like the roof, the pediment is often split or interrupted horizontally in the middle, forming a pentagon capped by a triangle divided by strap work or other moldings. The trefoil arch was almost certainly copied from a late Gandhara architectural model, such as the trilobed niches on the walls of chapel twenty-six at Takht-i-Bahi.[5] The cornice has a prominent treatment and is often decorated with square panels of rosettes or *kīrttimukha* (face of glory) motifs. In the larger and grander structures, the architectural ornament of the elevations is supplemented by extensive relief sculpture. In smaller structures, such as Payer and the other Shiva temple of Pandrethan (fig. 26), near Srinagar, different sculptural forms of the temple deity were set in niches over the four doorways.

Another distinctive feature of Kashmiri architecture and unique in the subcontinent is the ubiquitous use of the Classical Greek fluted column, particularly in the peristyle, of which examples with twelve, sixteen, twenty, and twenty-four flutes are recorded. The free-standing columns are carved in one piece while the engaged columns are built in sections. Though cylindrical columns are common in Gandhara relief sculpture in an architectural setting, a fluted half section of an engaged column with an acanthus Corinthian capital from Taxila is the sole example to have been found in the northwest region in the Gandhara period.[6] Thus it is very unlikely that the influence came from there. It is more likely that the fluted column survives from a lost Hellenizing tradition in Kashmir than that it was introduced by displaced Byzantine artists, as suggested by Goetz, though his theory has romantic appeal. A group of unique Hellenistic-style terra-cotta figurines of the Kushan period or earlier found in Semthan, near Bijbehara in the south of the valley, as well as extensive finds of Indo-Greek coins, offer evidence of a strong earlier Greek cultural influence.[7] However, as one scholar has pointed out, no typically Greek ornaments such as acanthus or bead-and-reel have been found, whereas mainstream Indian motifs are plentiful.[8]

Though all the surviving ancient monuments in Kashmir were constructed of stone, most of the earlier architecture was undoubtedly built of wood, of which many structural features later survive in stone, such as a cornice of beam ends, either plain or decorated by lion heads, and the elaborate arches and pediments. Another architectural element, probably reflecting timber prototypes, is the lantern ceiling, which can be seen to advantage in the Pandrethan temple. Here the square opening of the ceiling is gradually reduced by the placing of twelve square slabs of diminishing size in overlapping groups of four, eight of the angles carved with flying celestials (*vidyādhara*), a final slab decorated with a lotus medallion closing the remaining aperture. This type of construction is also found in the early medieval wood architecture of Chamba, which was influenced by Kashmiri forms. The lantern ceiling, domical, and corbelled ceilings are also known in the region.

<<
Fig. 24
Payer Shiva temple, eighth to ninth century

Fig. 25
Example of pedimented trefoil arch with deity, Martand temple, second quarter of the eighth century

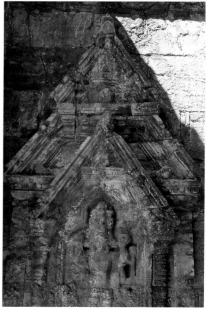

25

FIG. 26
Pandrethan temple, eighth
to ninth century

FIG. 27
Laduv temple, sixth century

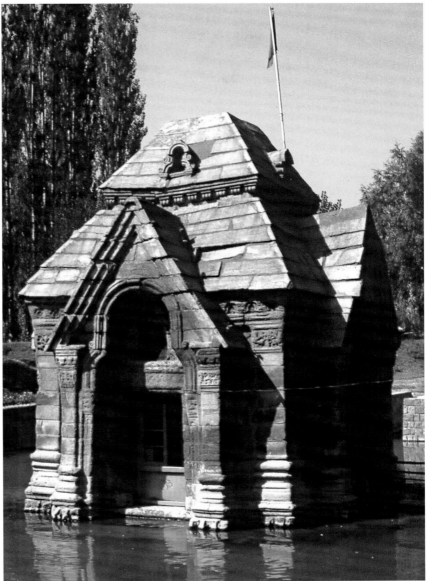

26

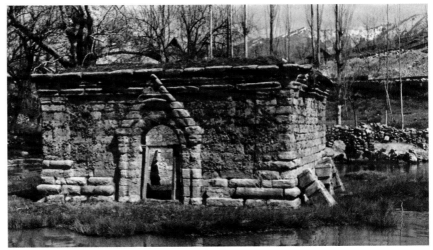

27

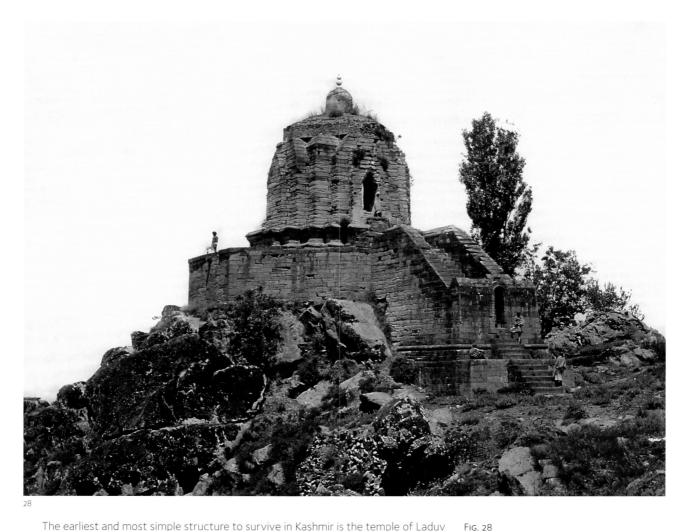

28

The earliest and most simple structure to survive in Kashmir is the temple of Laduv (fig. 27), set picturesquely in a rectangular tank fed by a spring, like the Pandrethan temple. It may date from as early as the late fifth or early sixth century. The French archaeologist Foucher first noted its close resemblance to the late Gandhara *vihāra* of Guniyar in Swat (Pakistan) in its external square ground plan and circular interior.[9] The beginnings of the pedimented arch are clearly seen in the entrance with rounded arch overlaid by a low relief trefoil blind arch and a tall triangular pediment supported on plain pilasters, which extends to the top of the splayed triple molded cornice, and it can be seen as prototypical of the more elaborate ornament which follows. The other elevations are plain apart from the wide corner pilasters and their bases and capitals set on the protruding low plinth. This building too, though of squat proportions, must have originally had a pyramidal roof. A smaller related temple nearby has a more clearly defined pedimented trefoil arch, and Kak noted that the rectangular capitals of its corner pilasters were carved in relief with addorsed pairs of animals, probably lions.[10]

Another temple of comparable date and simplicity, which has been heavily restored and has lost its original roof, is the Shankaracharya temple (fig. 28) on the top of the Takht-I-Suleiman hill (ancient Gopadri hill) facing to the east and away from Srinagar sprawled out below. It must be the Jyesthesvara temple erected by King Gopaditya at Gopadri and recorded by Kalhana, as many scholars have proposed.[11] This temple too has a circular interior and is built on a square plan, but with two projecting facets on each side.

FIG. 28
Shankaracharya temple,
sixth century

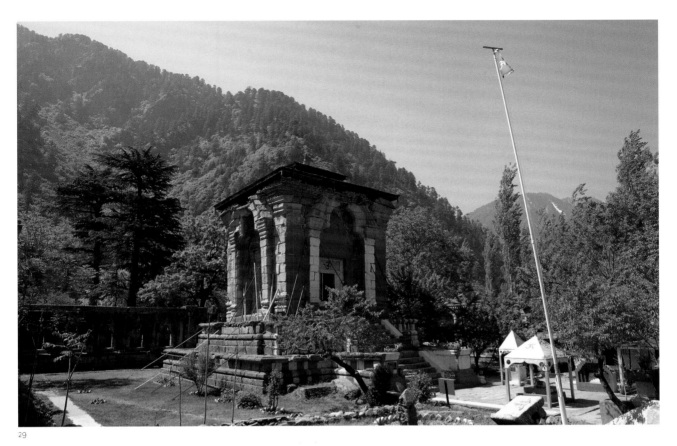

29

Fig. 29
Buniyar, Vishnu temple,
ninth to tenth century

It stands within a walled octagonal terrace, and is approached by three flights of steep steps. The entrance to the sanctum is through a gabled doorway overlaid by a triangular pediment. A trefoil arch is conspicuously missing.

The better-preserved Buniyar Vishnu temple (fig. 29) in the Baramula gorge, probably dating from the late ninth century, uniquely retains its peristyle as well as much of its imposing gateway, and gives a good sense of the original form of a fully developed temple complex in Kashmir.[12] The temple faces west, is open on four sides, and is built on a high double storey plinth with two ambulatory passages reached by a double flight of staircases. In front of the temple are the remains of a platform where a column with Garuda (*garuḍastambha*) once stood.[13] The jambs of the rectangular doorways of the temple support a multiple molded lintel with blind trefoil panel above, and are framed by a shallow portico with a pedimented trefoil arch that originally extended above the cornice to overlap the lower storey of the pyramidal roof. The tall corner pilasters support a multiple projecting cornice, upon which the original pyramidal roof was set. The raised entrance gateway, which is of similar dimensions, though more elaborate, is divided into two equal chambers, one half duplicating the other and divided by a wall with door, and is approached by an identical flight of steps on both sides, the standard arrangement of Kashmir temple gateways. At both entrances a pair of engaged columns and pair of free-standing cylindrical pillars with double capitals, their flutes worn out, support a pedimented blind trefoil arch. Framing this is a pair of towering corner pilasters, originally supporting a projecting cornice of *kīrttimukha*-s alternating with small arches, of which a small portion remains, and the pyramidal roof above, the lower storey partly overlaid by the central pediment. The interior walls of the quadrangle contain fifty-three cells set on a high plinth, each niche with a pedimented trefoil arch resting on engaged pilasters, a row of fluted columns with plain capitals and basements standing

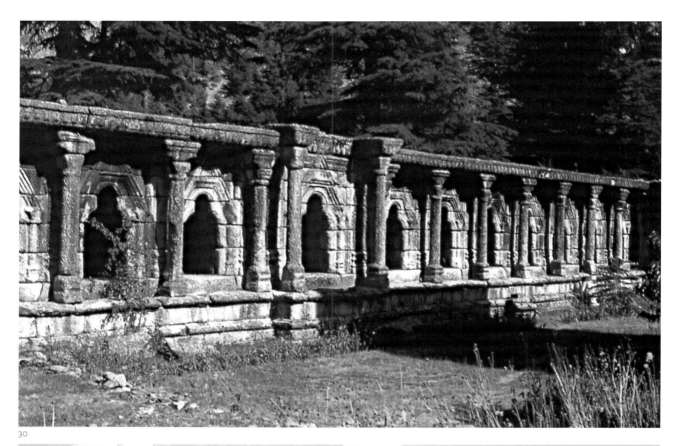

30

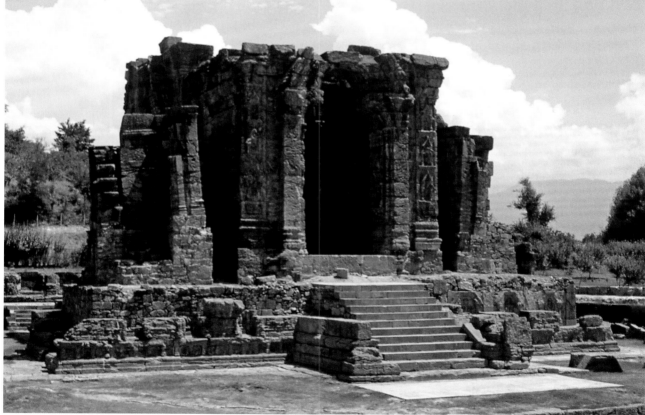

31

FIG. 30
Vishnu temple peristyle, Buniyar,
ninth–tenth century

FIG. 31
Martand temple and detail
of ornamental soffit,
second quarter of the eighth century

31 (detail)

before them in an elegant colonnade (fig. 30). These are connected to the pilaster capital by traverse beams. The Kashmir peristyle clearly develops from the Buddhist cellular quadrangle of Gandhara, but rather than provide monastic accommodation, the Kashmir cell, greatly reduced in size, contained images of the deity. In this case, the niches would have had sculptures of various aspects of Vishnu, many in his three-headed form.

Undoubtedly, the most impressive example of ancient temple architecture in Kashmir is the magnificent ruin of the Martand temple (fig. 31), dedicated to Surya, the sun god, in the south of the valley. Built by King Lalitaditya in the second quarter of the eighth century, it consists of a large central shrine facing west with two side wings, which stands in a rectangular quadrangle entered through a massive raised gateway. The walls of the gateway and the elevations of the temple itself are extensively decorated with figural and decorative relief work, though much is in poor condition. There were four subsidiary shrines in the corners, three facing the main shrine, the fourth facing a stepped water tank midway between the gateway and the temple, of which their basements now only remain. The setting is remarkable. The sanctuary stands on the top of an alluvial plateau looking out across the valley floor over a patchwork of fields and villages, and lakes and rivers against a background of distant snowy peaks. Alexander Cunningham, an early explorer in the region, was not known for hyperbole, but was clearly enchanted by the beauty of the valley when he described it as perhaps the finest view in the known world.[14]

The main building is set on a high two-storied plinth, the wall of its upper storey decorated with a row of niches with ornamental columns containing sculptures of the principal Hindu deities, the river goddesses, and *dikāpalā*-s (guardians of the directions), while the smaller niches of the lower wall contain divine couples, minor deities, dancers, and musicians framed by pilasters. A staircase leads to the pedimented trefoil arched entrance, the entablature supported by huge pilasters. These are framed by the even larger corner pilasters, their shafts carved with three niches with pedimented arches enclosing relief sculpture of deities, now heavily mutilated. Standing apart on the same plinth and flanking the hall are two projecting lateral double-chambered wings, which probably contained images of Surya or his consorts. The temple entrance opens into the square entrance hall or *maṇḍapa*; its walls are carved with multiheaded forms of Shiva and Vishnu and other deities including the river goddesses, who always appear framing the doorways of Hindu

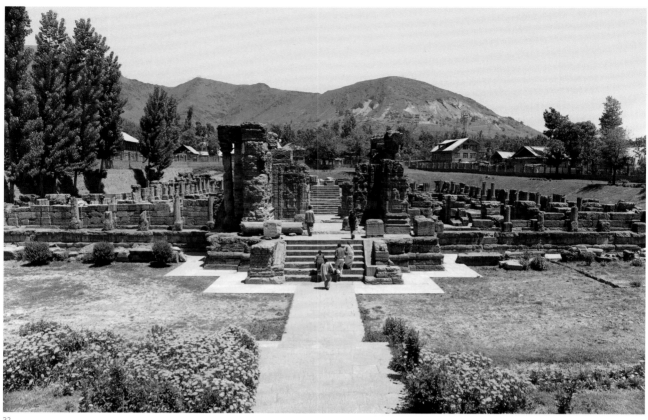

32

temples in Kashmir like in the rest of north India. Another tall arched doorway with ornamental soffit leads to the rectangular vestibule (*antarāla*) of the innermost sanctum beyond, also of rectangular form, where the principal deity was once installed. In external plan the temple widens behind the *maṇḍapa*, with massive pedimented trefoil blind arches standing on broad pilasters on the north, east, and south walls.

The heavily damaged double-chambered gateway is the same width as the rear part of the temple and is entered by a staircase on both sides through a doorway framed by massive twin pilasters. The large rectangular peristyle has twenty-five cells on both sides along its length, nineteen at the eastern end, and twelve at the entrance end, each with pedimented trefoil arched niches preceded by a colonnade of fluted columns. The central cells of the side and end walls are larger with projecting columns. Images of Surya and other deities were originally installed on pedestals in these niches, though nothing survives. Before its destruction, the building must have been extraordinary, its *maṇḍapa*, and auxiliary wings, the main temple, the gateway, and the subsidiary shrines all with soaring pyramidal roofs.

A building of similar plan with peristyle, but smaller, is the Vishnu temple of Avantisvamin (fig. 32). Facing west and situated on the right bank of the Jhelum twenty-eight kilometers southeast of Srinagar, it stands on the main road to Bijbehara, which historically gave it great military importance. The fortress-like strength of this and other temples is illustrated by an incident dating from Kalhana's day when royal officers of Jayasimha successfully withstood a siege here by the Damaras (feudal barons). The temple was built by Avantivarman just before his accession in 855 CE. It is the most lavishly-decorated religious shrine to survive in Kashmir due largely to the fact that the compound was fortuitously filled up with silt as high as its superstructure in the thirteenth and fourteenth centuries. Henry Cole's

FIG. 32
Avantishvar temple,
mid-ninth century

Fig. 33
Avantishvar temple buried beneath silt

Fig. 34
Kamadeva relief, Avantishvar temple,
mid–ninth century

33

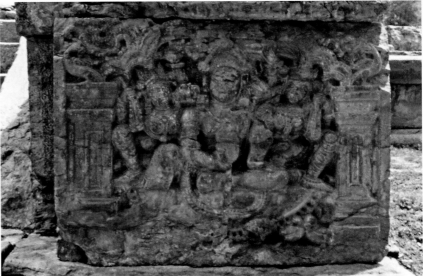

34

photograph of 1868 (fig. 33) shows the quadrangle buried up to the top of its peristyle. A series of subsequent excavations uncovered the complex down to the floor level bringing to light several beautiful relief panels, including a pair of panels depicting Kamadeva and his consorts (fig. 34) decorating the parapet of the temple staircase, as well as a great variety of ornamental pillars on the peristyle. Many freestanding fragmentary sculptures, mostly of the multiheaded form of Vishnu, which were originally set in the cells of the peristyle, were also recovered.[15]

The central temple, of which almost nothing remains, was single-celled and stood on a two-storey terrace with a double flight of stairs. An open pillared *maṇḍapa* originally stood before it with the remains of the base of a *garuḍastambha*. The basements of four auxiliary shrines are symmetrically arranged in the corners with two further shrines against the eastern wall of the enclosure. While the masonry of the roof of the gateway has been removed by predators in the past, the remaining elevations are fairly well preserved and are extensively decorated with panels of animals, dwarf acolytes (*gaṇa*-s), and other

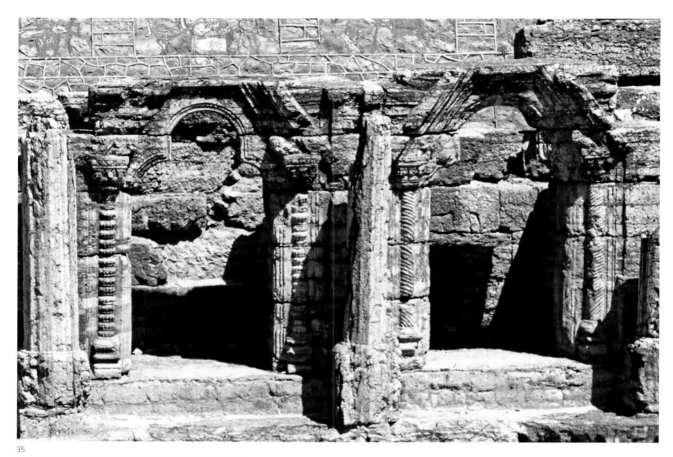

35

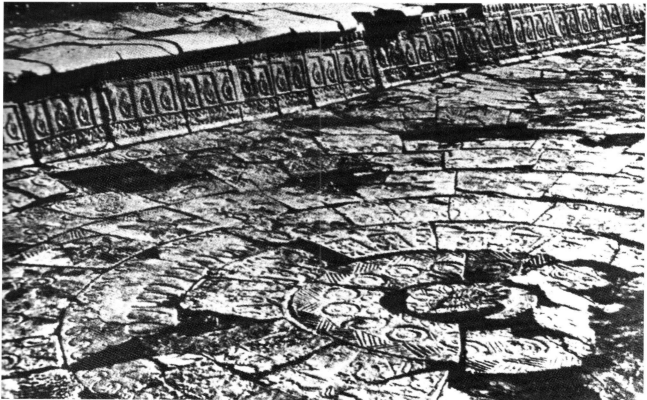

36

37

FIG. 35
Ornamental columns at the Avantishvar temple, mid-ninth century

FIG. 36
View of the tiled floor and wall of the Buddhist site at Harwan, fourth to fifth century

FIG. 37
Harwan stupa plaque, fifth century

FIG. 38 ❋
Tile with human figures, fourth century
Harwan
Terra-cotta
H. 18 3/4 in. (47.5 cm)
The Walters Art Museum, Baltimore; promised gift of John and Berthe Ford
F.352

divine beings, including the river goddesses, some standing within trefoil-pedimented arched shrines and divided by plain moldings and bands of ornament including scrolling leafy vine, roundels, panels of rosettes, and *kīrttimukha* motifs. The peristyle consists of sixty-nine cells, each cell framed by a pair of ornamental pillars preceded by a colonnade of slender columns in the usual manner. The pillars show a wide variety of designs (fig. 35), including twisted, beaded fluting, alternating lobed motifs, beaded lozenge trellises containing flower heads, and pearl roundels containing floral motifs, human figures, animals, and birds, and chevron and bead design. The same decorative and architectural motifs are found in both Hindu and Buddhist sculpture, and presumably were extensively reproduced in the lost tradition of painting.

Buddhist Architecture

Despite the popularity of Buddhism, especially in the first half of the millennium, little Buddhist architecture survives. This is surprising since we know from the testimony of Xuanzang, the Chinese pilgrim and translator who visited Kashmir between 631 and 633 that there were four Ashokan stupas still standing and a hundred monasteries still active at that time.[16] Although Kashmir was occupied by the Kushan dynasty and was almost certainly within the artistic orbit of Gandhara, no structure survives from that period. However, we may presume that stupas, monasteries, and shrines (*chaitya*) in the Gandharan style were built in the valley. The earliest surviving Buddhist site is at Harwan, near the Mughal Shalimar Gardens, probably dating from the fifth century and of Hephthalite patronage, and mostly known for its terra-cotta tiles impressed with figural and floral designs used to decorate a large circular terrace on the hillside, which was destroyed by an earthquake (fig. 36). Two tiles illustrated here, one molded with a standing male holding a spear and a standing female holding up a flower vase (fig. 38), and another (fig. 52, ch. 4) with two crouching ascetics, originally formed part of this terrace where they were set in concentric rows. Similar terraces have been found elsewhere in the valley; the most extensive at the site of Hutamura, in the Lidder valley. Their religious affiliation still remains a mystery. However, excavations of a rectangular courtyard in a

lower terrace uncovered the triple basement of a stupa, a number of cells, and several terra-cotta figural fragments and three plaques impressed with stupa images (fig. 37). These plaques allow us to ascertain the form of a stupa in fifth-century Kashmir, which was probably made of wood. All three have a triple basement with three flights of steps, the drum with a line of beading, and plain moldings with plain dome. A row of projecting brackets makes up the *harmikā*, above which is a succession of eleven umbrellas of diminishing size, with fluttering ribbons tied at the very top. At both corners of the top terrace is a tall column with sejant lion. The stupas on the Harwan plaques compare closely

38

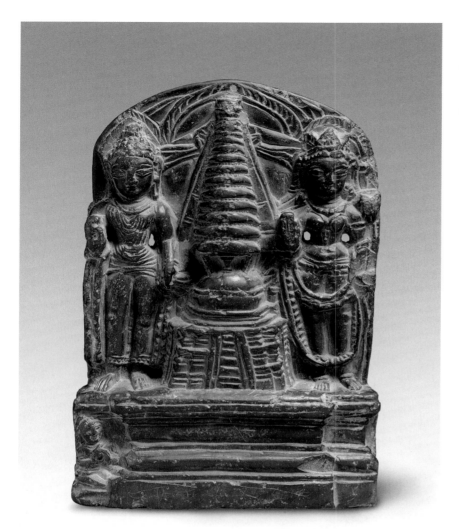

FIG. 39
Relief with stupa flanked by two
bodhisattvas, about ninth century
Grey chlorite
H. 6 13/16 x W. 4 3/4 x D. 1 3/8 in.
(17.3 x 12 x 3.4 cm)
Anthony d'Offay, London

39

with three Gandhara bronze examples, one also with columns at the corners, and confirm a Gandhara influence.[17]

Evidence from sculpture dating from the eighth century demonstrates that the form of the stupa had not greatly changed in the intervening centuries. The pair of stupas framing the seated Cosmic Buddha (fig. 43, ch. 4) in the Rockefeller collection, dated by inscription to 714 CE, are of similar basic form to that of the Harwan plaques, and columns still occupy the angles of the upper terrace. Further evidence comes from a number of stone plaques depicting the Buddhist trinity on one side and a stupa on the reverse, including one example in the British Museum.[18] The stupa on the Buddhist plaque (fig. 39) from a private collection, dating from the ninth century, depicts the same basic model.

According to the *Rājataraṅgiṇī* a number of important Buddhist foundations were built during the reign of Lalitaditya, mostly in the court capital of Parihasapura. The site reduced to rubble was cleared and excavated by Sahni, who identified three Buddhist structures.[19] The great stupa erected by the king's minister, Chankuna, is the best preserved. It is of square plan, measuring 74.5 meters on each face and built on two terraces with ambulatory passages approached by a double flight of staircases on all four sides. The parapets of the lower staircases each had a pair of seated figures,

FIG. 40
Chankuna's stupa, Parihasapura,
second quarter of the eighth century

FIG. 41
Ivory panel with seated Buddha, bodhisattvas
and retinue, set in a polychrome wood
architectural frame, eighth century
Kanoria Collection, India

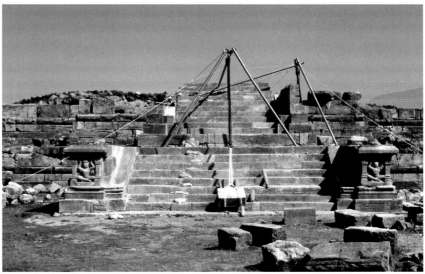

40

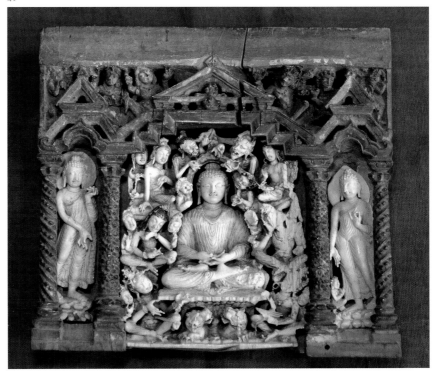

41

Atlas-like in function, some of which are still in situ (fig. 40), while larger standing fig-
ures occupied the same position on the upper staircase. The various complete and
fragmentary seated and standing Buddha figures found in the rubble would originally
have been set in niches around the drum of the structure. The other two monuments
were built by the king: the monastic Rajavihara, a cellular quadrangle consisting of
twenty-six cells, and a *caitya* hall. The latter is of square plan and set in the center of
a square courtyard. The entrance facing east had a pedimented trefoil arch, which
must have been repeated on the other three sides, and the roof was almost certainly
of pyramidal form. The sanctum contains a single block of stone, upon which the
sacred Buddha image was placed.

42

Finally, although no Buddhist build-ings survive, the miniature painted wood architectural settings of some of the corpus of sumptuous Kashmir ivory Buddhist plaques now distributed amongst public and private collections worldwide provide insight into how they would have looked. The ivories are usually attributed to the eighth cen-tury or earlier, but their ornamental columns are very similar to those of the peristyle at the Avantisvamin temple (fig. 35). The British Museum shrine has trefoil and cinquefoil arches enclosed by split pediments, which are sup-ported by two pairs of columns, one with *āmalaka*-like motif, the other with beaded chevron design. The Kanoria example (fig. 41) has a similar arrangement, though here the columns are of twisted, beaded fluting and pearl roundels enclosing rosettes. Finally, a wood panel of the eleventh century, probably from Kinnaur, or Spiti, or related areas in Himachal Pradesh, depicting a standing Tara within a shrine (fig. 42), demon-strates the powerful influence of the arts of Kashmir on neighboring Buddhist kingdoms in the late tenth and eleventh centuries. However, by this stage the wooden or timber architectural elements are heavily stylized and no longer functional.

FIG. 42 ❖
The Buddhist Savioress Tara of the Eight Dangers, tenth to eleventh century
Wood with pigments; gilt bronze ring on reverse
H. 17 3/4 x W. 8 5/8 in. (45.1 x 21.9 cm)
The Metropolitan Museum of Art, Gift of The Kronos Collections, 1994
1994.488

1. Stein, *Rājataraṅgiṇī*, book 6, vs. 299–307.

2. Others were systematically destroyed by Sikanadar Butshikan (1389–1413), the "idol breaker," and his minister, the Hindu convert, Suhabhatta (Saifu'Din), who according to the fifteenth-century chronicler Jonaraja (Dutt, 1998, p. 60) left no temple undamaged in his destructive path. Further depredation followed in the nineteenth century when huge quantities of ancient masonry were used as ballast for newly constructed roads.

3. Although many earlier authorities claimed that it was rarely if ever used, Agrawal (1998, p. 104) notes the invariable use of lime mortar in the course of his extensive conservation of monuments in Kashmir.

4. The Jyesthesvara temple at Naranag. Michael Meister, M.A. Dhaky, and Krishna Deva (eds.), 1988. "Karkotas and Utpalas of Kashmir" in *Encyclopedia of Indian Temple Achitecture*, (Oxford: AIIS/Oxford University Press), pl. 765.

5. See Tissot 1985, fig. 65.

6. Marshall 1951, 3, pl. 214, no. 25.

7. Siudmak 1989, pl. 21 illustrates an ex voto female figurine in Greek dress.

8. Agrawal 1998, p. 102.

9. Foucher 1905, fig. 49.

10. Kak 1933, *Ancient Monuments of Kashmir*, p. 118.

11. Stein, *Rājataraṅgiṇī*, book 1, vs. 341.

12. The complex was damaged in the 2004 earthquake, and serves to remind us of the power of natural forces as well as human agency in the destruction of the ancient buildings of Kashmir over the years.

13. As in Nepal, *Garuḍastambha*-s must have been a common feature of Vishnu temples in Kashmir, but are only occasionally found elsewhere in north India. The *Rājataraṅgiṇī* (Stein, *Rājataraṅgiṇī* book 4, vs. 199) mentions the tall column 55 hands high raised by Lalitaditya before the temple of Govardhana at his court capital of Parihasapura.

14. Cunningham 1948, p. 268.

15. Several spouted pedestals for the images were also found, including one with the spout decorated with a Garuda head from the shrine in the south-west corner. See Deva, pl. 753.

16. Beal, S. 1905. *Si-yu-ki Buddhist Records of the Western World*. (London: Tr bner & Co), p. 148.

17. Fisher 1989, pls. 3, 4, 5, three examples in the Peshawar Museum.

18. Ibid., pl. 2.

19. Sahni 1918, pp. 58–61.

FAITH AND FORM:
RELIGIOUS SCULPTURE IN ANCIENT KASHMIR

By Pratapaditya Pal

Most temples and monasteries mentioned by the historian Kalhana in the twelfth century are now in ruins. However, surviving artworks are sufficient to reconstruct a fairly complete history of sculpture in Kashmir.[1] Some of the sculptures can be associated with the religious establishments mentioned by Kalhana, but by and large their exact architectural context cannot be ascertained. While a considerable number of stone and terra-cotta sculptures have been found in the valley, very few metal objects have actually emerged from the soil.

Other than a few names, we know very little about the sculptors themselves. At least one Kashmiri sculptor is characterized as a brahman, but otherwise no information is available about their social status or economic condition.[2] Almost certainly they were professionals, mostly male, and worked in familial groups, as craftsmen still do. It is also likely that they were not specialists but worked in multiple media, such as stone, metal, and wood. Ivoryworkers, however, may have been specialists, as is the case elsewhere on the subcontinent.[3] From Kalhana's accounts it is clear that both kings and queens were equally active with religious commissions. Both from the *Rājataraṅgiṇī* and from dedicatory inscriptions, we learn that apart from members of the royal families, not only of Kashmir but of neighboring kingdoms, such as Gilgit (now in Pakistan) and Guge in western Tibet, patrons included ministers, merchants, and monks. For instance, two of the more elaborate metal sculptures illustrated here (figs. 43, 44) were commissioned by members of the Gilgit royal family.[4] On the other hand, a brass Buddha of impressive proportions and an art-historical document of immense importance was dedicated in mid-seventh century by the monk Priyaruchi (fig. 45).[5] Now in Lhasa, the bronze once was in the personal collection of Prince Nagaraja (about 1000 CE) of Guge. Such information, however, is rare for Kashmiri art history.

Most surviving sculptures were created to serve a religious purpose. They therefore depict divinities and myths of Buddhism, Vaishnavism, and Shaivaism. Although Jainism was known in ancient Kashmir, no artistic evidence is available. More Vaishnava and Shaiva stone sculptures have survived than Buddhist. The corpus of Buddhist metal sculptures is more plentiful because a large number was taken out of the country, especially to Tibet, where they have been piously preserved.[6] Occasionally, Kalhana provides some interesting information. For instance, King Lalitaditya had two Vishnu images made, one in gold and the other in silver, and a third in copper for the Buddha, which were of colossal size and were installed as principal deities in the temples he built for them.[7] Using metal figures in the main shrine appears to have been a peculiarity of Kashmir and, perhaps under Kashmiri

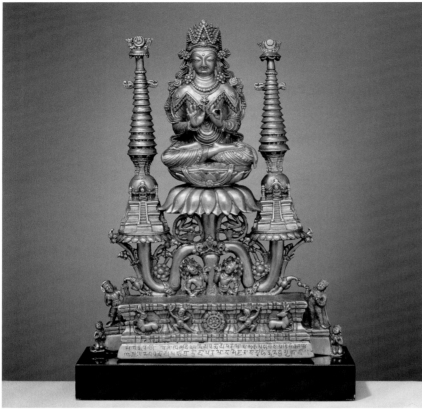

43

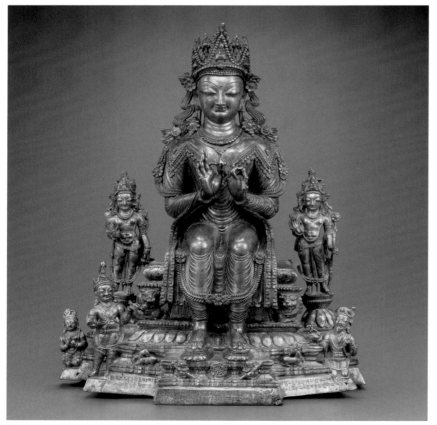

44

<< ❖
Mandala of Vishnu with four goddesses
and Garuda, ninth century
Bronze
H. 9 1/16 x W. 5 1/8 in. (23 x 13 cm)
Department of Archives, Archeology,
Museums and Antiquities, Old Secretariat

FIG. 43 ❖
Crowned Buddha Shakyamuni,
eighth century
Brass with inlays of copper,
silver, and zinc
H. 12 1/4 in. (31.1 cm)
Asia Society, New York:
Mr. and Mrs. John D. Rockefeller
3rd Collection
1979.44

FIG. 44 ❖
Buddha with Bodhisattvas and Royal
Attendants, 715
Brass with silver
H. 14 1/2 in. (36.8 cm)
Pritzker Collection
230

FIG. 45
Buddha, about 730
Kashmir
Brass with inlay and colors
H. 29 15/16 in. (76 cm)
Photo: Ulrich von Schroeder, 1994.
Potala Collection.
Lima Lhakhang; inv. no. 407.
Published: Ulrich von Schroeder, 2001.
Buddhist Sculptures in Tibet, vol. 1,
India & Nepal, pp. 126–129, pls. 28 A–D

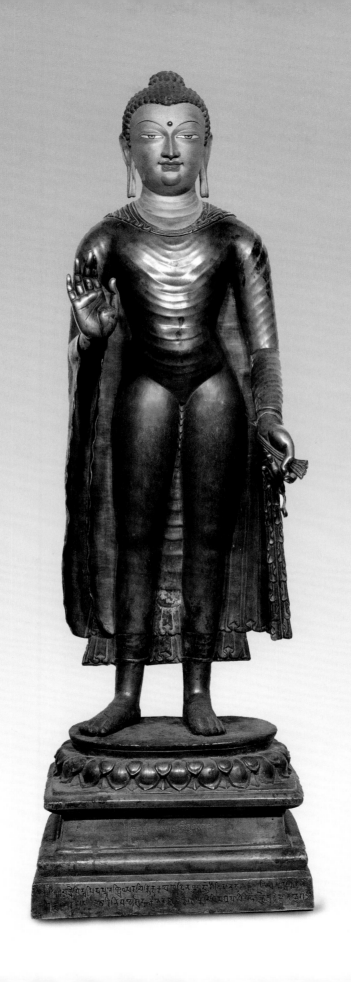

FIG. 46
Shiva and Parvati with bull, about 1025
Guari–Shankar Temple (#10),
Chamba Town (Himachal Pradesh)
Brass
Shiva only: H. 62 in. (160 cm)

FIG. 47
Avatar frame, about tenth century
Devsar
Bronze
H. 73 in. (186 cm)
Sri Pratap Singh Museum, Srinagar

FIG. 48 ✤
Relief with horserider and Sharada
inscription, dated 1506
Limestone
H. 15 x W. 18 7/8 x D. 2 3/4 in. (38 x 48 x 7 cm)
University of Pennsylvania Museum
of Archeology and Anthropology
29–64–248

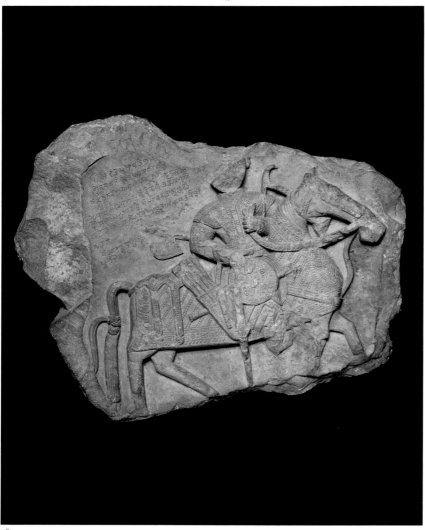

49

50

FIG. 49 ❊
Sri Yantra, twelfth to fifteenth century
Rock crystal
H. 2 3/4 x W. 1 11/16 in. (6.9 x 4.3 cm)
Anthony d'Offay, London

FIG. 50 ❊
Kubera
Lapis lazuli, brass
H. 3 3/16 x W. 2 3/8 x D. 5/8 in. (8 x 6 x 2.2 cm)
Private collection

influence, in the neighboring state of Chamba in Himachal Pradesh, where impressive brass images created as far back as the eighth century are still in worship (fig. 46). Today most surviving Kashmiri metal images of significant dimensions are Buddhist. Other than the literary evidence of Kalhana, the only example of a surviving large scale metal Brahmanical sculpture is the well-known Vaishnava avatar frame recovered from Devsar (fig. 47).

Most of the sculptures are cult icons that consist of one or more figures, either standing or seated. The deities are recognizable by the emblems or gestures they display. Adherence to strict iconography and iconometry and theories of proportions were a desideratum for the artists. In both Brahmanical and Buddhist religious practice the images are tangible manifestations of verbal meditational visualizations, known as *dhyāna*, to be mentally envisioned by the devotee. Most visualizations, reflecting mystical visions, provide the basic schema for the artists to embellish with the aesthetic tastes and changing fashions of their own age. The technical differences in the materials also contributed to the final expression of the form but it must be remembered that the art does not convey the artist's personal feelings or angst. The visualizations or physical descriptions of the iconographic forms were provided by the ecclesiastical communities of brahman priests and Buddhist teachers and have been codified in the sacred literatures of the two traditions. The patron provided the financial incentive, but ultimately, the successful creation of the work was largely the result of the artist's mastery over his materials and his own aesthetic sensibilities and technical skills.

The materials used for Kashmir sculptures are a variety of chlorite, less frequently marble (fig. 5, ch. 1) and limestone (fig. 48), wood, ivory, clay, and metal. Grey chlorite is the most popular material but black and a rich green are also encountered. Apart from the two objects published here, Kalhana does mention a temple of white stone built by Queen Didda.[8] Semiprecious stones were also carved into figures or mystical diagrams (figs. 49, 50).

Almost nothing in wood from Kashmir proper has survived, but a handsome and richly carved shrine of the goddess Tara and an ivory shrine (figs. 41, 42, ch. 3) and temples in neighboring regions to the east are good indicators of Kashmiri woodcarvers' facility with this material. The timber facades of the Chamba temples are also stylistically close to Kashmiri sculptures of the Karkota period.[9] Though few in number, these objects clearly indicate the ancient Kashmiris' skill with woodcarving and timber construction.

FIG. 51 ✾
Noble Lady, about second century
H. 4 5/16 x W. 1 1/2 in. (11 x 3.8 cm)
Central Asian Museum, Srinagar
2005.9

Terra-cotta

Surviving sculptures indicate that terra-cotta was the most popular material during the early centuries of the Common Era. Most of these consist of small figurines and their religious affiliation is unknown. A typical mold-made example shows a heavily clad lady (fig. 51) in the style related to the Hellenistic type of figures found in abundance in contemporary Gandhara. As a matter of fact, a number of small stone trays carved mostly with motifs from Hellenistic mythology and art have also been found that are probably direct imports. Why so few artistic remains exist from pre-fifth century Kashmir is a mystery.

The earliest sites that have yielded terra-cotta objects, which, according to tradition, go back to the Kushan period, are Semthan, Harwan, Hutmora, Ushkur, and recently Kutbal.[9] These sites are particularly noteworthy because of the large, stamped tiles with figural and symbolic forms that represent an independent local artistic tradition (fig. 52; fig. 38, ch. 3). Although tiles for paving the floors and walls of monasteries were used in Gandhara, they are not as richly and diversely decorated as those from Kashmir. The figures in the Harwan tiles further show both Indian and foreign ethnic types, strange crouching ascetics unique in the Indian plastic tradition and convincingly rendered flora and fauna. Both the Harwan and the Kutbal finds reflect a mature and confident state of artistic skill but, strangely, the tradition did not continue. There is no certainty about the exact dates of these sites, although the consensus is between the third and fifth century.[10]

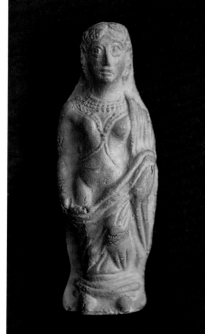
51

The excavated finds from Ushkur near Baramula, Leitpora or ancient Lalitadityapur founded by King Lalitaditya, and Akhnur in Jammu are more conventional and can be associated certainly with Buddhism, unlike the sites mentioned above. The discoveries consist mostly of divine heads that point to Gandhara as the stylistic source. Like the Gandhara figures, the Kashmiri examples were originally polychromed as well. Although Ushkur is supposedly a Kushan foundation, none of the heads can be dated that far back, while the Leitpora heads appear to be earlier than Lalitaditya's time. The two heads in Srinagar are said to have been recovered from Leitpora, one of which probably represents a bodhisattva (fig. 53) and the

Fig. 52 ❖

Tile with crouching ascetics,
fourth century
Red terra-cotta
H. 20 3/4 x W. 11 3/4 x D. 2 1/4 in.
(52.7 x 28.89 x 5.71 cm)
Los Angeles County Museum of Art,
Given in memory of Christian Humann
by Robert Hatfield Ellsworth
M.82.152

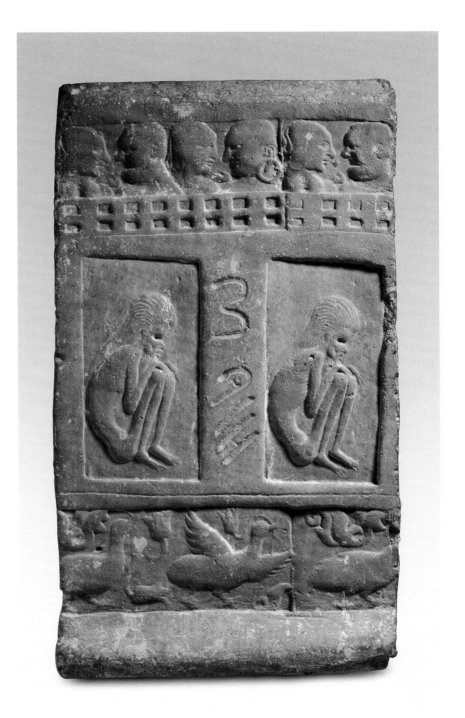

52

other an angry divinity (fig. 54). A similar bodhisattva head in a private collection (fig. 56) is stylistically close to the Srinagar head and both show physiognomies that are distinctly Kashmiri. The fourth example represents an ascetic and is remarkably expressive and portrait like in its realism (fig. 55). In contrast, the Bhairava/Mahakala head has more idealized features with rolling eyes and flaring nostrils and appears to be the earliest known example of an angry divinity in Kashmiri art. There is little evidence that terra-cotta continued to be a popular sculptural medium in the valley after the eighth century.

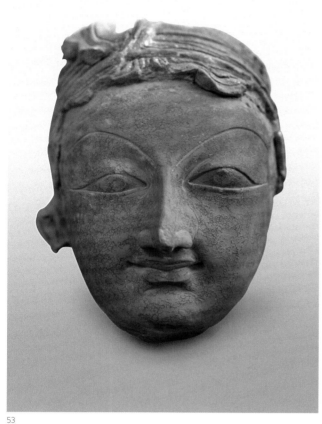

53

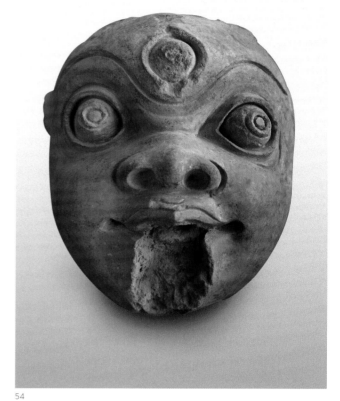

54

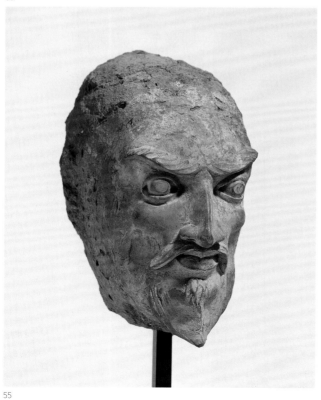

55

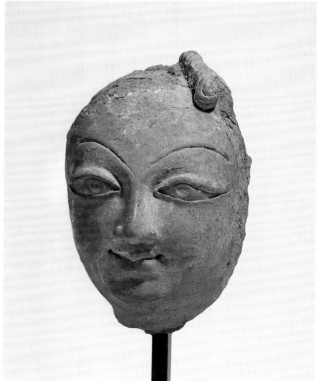

56

Ivory

A remarkable group of small ivory sculptures have survived, thanks to Tibetan piety. They are among the finest and most sophisticated examples of ivory carving, matching in their technical and aesthetic achievements the well-known ivory hoard of the Kushan period from Begram in Afghanistan. While the Begram ivories were imported and probably manufactured in the heart of India, the Kashmiri ivories are certainly local products. They correspond both in style and complexity to the rich corpus of Buddhist metal sculptures commissioned by the Gilgit royal family at the turn of the eighth century.

The themes are either narrative events from the life of the Buddha Shakyamuni, or Buddhas and bodhisattvas. The former are particularly noteworthy for their complex compositions with multiple figures, all the more admirable for their lively but disciplined organization and deep carving, especially considering their diminutive sizes (fig. 57; fig. 41, ch. 3). Again they are reminiscent of elaborate figural compositions of Gandhara stone reliefs, but are iconographically even richer and aesthetically more refined. As far as is known, no other Buddhist culture of Asia has yet yielded ivory sculptures that are so diminutive in size, so expressive in their narrative power, and so elegant in their modeling.

The god Indra's visit to the Buddha at the Indrashala cave in Rajgir is the subject of two elaborate compositions in the Rockefeller and Kanoria collections (fig. 58; fig. 41, ch. 3). The more complete Kanoria ensemble, enshrined in an elaborate timber structure and flanked by two standing Buddhas in their own niches, demonstrates how the Rockefeller piece must have been originally set. In any case, the ivories in both collections reflect extraordinary finesse in the quality of carving, especially of the surrounding figures in a variety of animated postures. The deep cutting imparts these engaging figures, as well as the meditating Buddha, with a remarkable sense of volume. Martin Lerner has suggested that the Rockefeller piece is at least a century or two later than the one in the Kanoria collection, but this is unlikely.[11] At the most there may be a generation separating the two.

The scenes in the larger object from the Metropolitan Museum of Art, identified tentatively as a reliquary (fig. 57),[12] are rendered in shallower relief and not cut through. As a result, the compositions, though with multiple figures and well carved, are less energized. However, the object is more important for iconographic than aesthetic

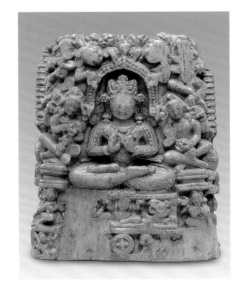
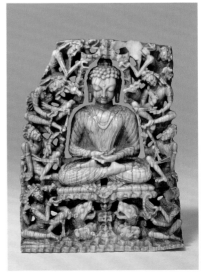

57 58

59

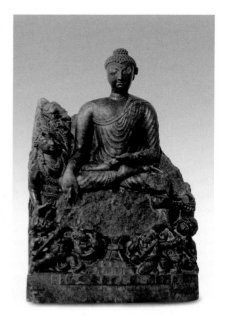

60

reasons, even if we are not certain of its exact function. On three sides of the triangle are representations of three scenes from the life of Shakyamuni Buddha: the birth scene with the graceful Mayadevi, the enlightenment, and a scene of meditation where the Buddha is crowned and bejeweled and wears a four-pointed cape. In the context of the two other narratives, this composition may well represent the symbolic consecration of Buddhahood in the heaven before his descent to earth. Like its function, the date of this is uncertain, but the figure of Maya is comparable to the females in the Avantisvar temple (fig. 59), and hence a mid-ninth century date is likely. A later date for this ivory is also vouchsafed by a comparison with the small and exquisitely carved inscribed stone stele of the Buddha's enlightenment of 729 CE, now in the National Museum, New Delhi (fig. 60). It is a key document of Kashmiri sculpture which corroborates stylistically the dating of the Patola Shahi bronzes and the early ivories.

The svelte Bodhisattva Avalokitesvara (fig. 61) with donor and angel is carved completely in the round. It was set on a base and may have been a personal icon. Originally, it had six arms but even in its incomplete condition it is an attractive example of deft modeling, restrained elegance, and finely rendered details. It should be noted that all these ivories were once polychromed like the terra-cotta figures, as is evident from the residual pigments on some of the pieces (fig. 57).

FIG. 59
Niche with figures, mid-ninth century
Avantisvar temple spandrel
Bluish grey limestone
H. 212 5/8 in. (540 cm)

FIG. 60
Enlightenment of the Buddha Shakyamuni,
729–739
Menda Village (near Poonch)
Grey chlorite
H. 12.5 in. (32 cm)
National Museum of India, New Delhi

FIG. 61 ✿
Avalokiteshvara with donor and angel
Ivory
H. 5 1/8 x W. 2 x D. 7/8 in. (13.3 x 5.1 x 2.2 cm)
The Kronos Collections

Stone Sculptures

Although some of the architectural features of the temples betray their timber origins, by the sixth century all religious structures were built in stone or brick. That Kashmiri sculptors were adept in stone carving as early as the first century BCE is evident from the large bull capital with turbaned figures at Mamal (fig. 62). Apart from the fact that it conclusively proves the existence of monumental architecture, it clearly is evidence of the extension of the Buddhist style of central India as far north as Kashmir and carries memories of the Ashokan building tradition. Most surviving early works, however, are of modest size (figs. 49, 50, 63, 64, 65). Some were clearly intended for personal piety or were used as charms. Most are made of gray chlorite but semiprecious stones

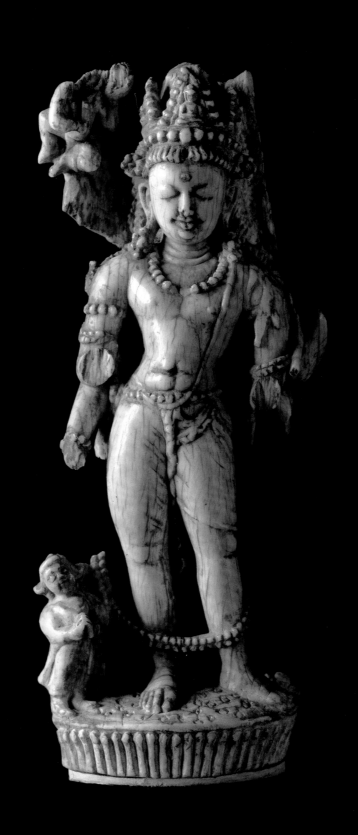

62

FIG. 62
Capital with addorsed bulls and humans,
first century BCE
Mamal
Greenish-grey limestone
H. 34 in. (87 cm)

FIG. 63 ❖
Goddess Lakshmi/Anahita seated on lions
and being lustrated by angels, fifth century
Probably Baramula
Grey limestone
H. 14 in. (36 cm)
Private collection

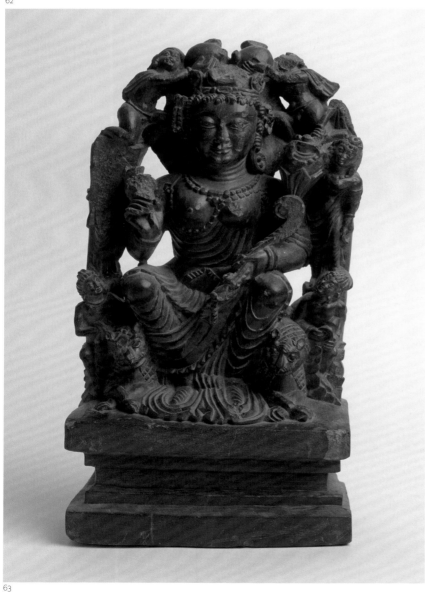

63

FIG. 64 ✣
Vishnu as Narasimha fighting the titan
Hiranyakashipu, about 600
Stone
H. 4 1/8 in. (10.4 cm)
Ashmolean Museum, University of Oxford
1996.78

FIG. 65 ✣
Plaque with Vishnu's emblems and feet
Schist, tenth century
H. 5 3/16 x W. 4 11/16 x D. 1 1/2 in.
(13.2 x 11.9 x 3.9 cm)
Private collection

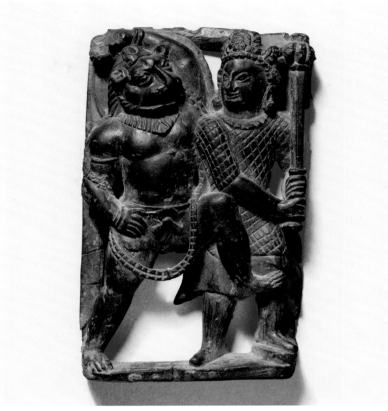

64

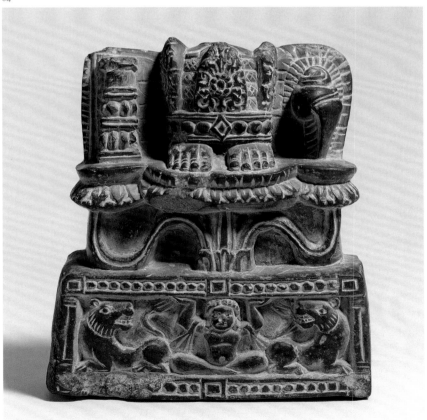

65

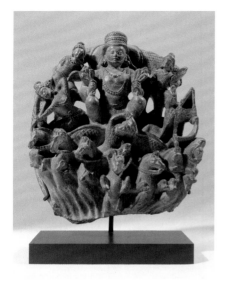

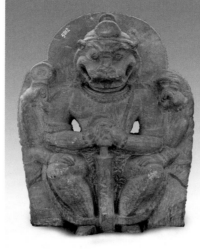

66

68

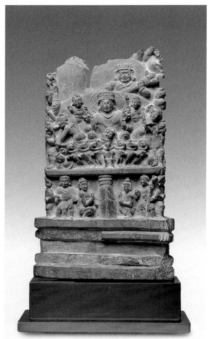

67 (front)

67 (reverse)

were also used, as is the case with the tiny crystal *yantra* (mystical diagram) and the lapis lazuli Kubera (figs. 49, 50). A larger and later *yantra* (fig. 5, ch. 1) is carved in marble, rarely used in the valley.

Along with the massively proportioned Bijbehar Kumara (fig. 7, ch. 1), a crisply carved and well-preserved sculpture depicting the lustration of Lakshmi (fig. 63) clearly demonstrates the Kashmiri artist's early dependence on Gandhara for both form and iconography. During the eclectic Kushan days, a syncretic goddess combining elements of the Persian Anahita, the west Asian Nana and the Indian Lakshmi was created. This handsome image, probably carved around the fifth century, depicts the goddess almost as a figure in the round, regally seated on her lion throne being bathed or lustrated not

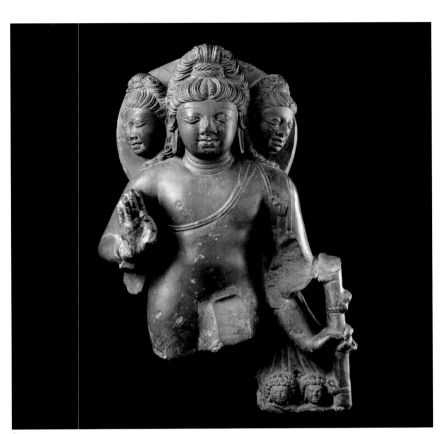

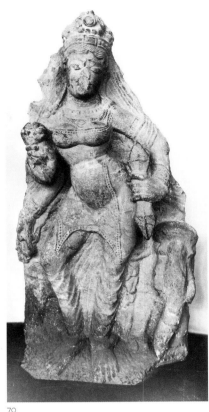

69

70

FIG. 69 ❖
Bust of the god Brahma, seventh century
Stone
H. 16 1/8 in. (41 cm)
Ashmolean Museum, University of Oxford
1995.114

FIG. 70 ❖
Dancing mother goddess Indrani,
seventh century
Limestone
H. 65 3/8 x W. 36 5/8 x D. 13 3/8 in.
(166 x 93 x 34 cm)
Sri Pratap Singh Museum, Srinagar
MC 2421/6

by the usual elephants, but by two cherubic celestials. On the other hand, the dynamic compositions of the sun god riding in a horse-drawn chariot with his retinue (figs. 66, 67), though based on Gandharan models, are more elaborate, as is also the case with the double-sided piece showing linga worship below Surya on one side and Shiva-Parvati on the reverse. How exactly it was used remains unknown. The humorous post-wedding night episode of Shiva and Parvati playing dice when Shiva loses his bull, who is being dragged away by his dwarf attendants, is rare and one of the earliest narrative representations in Kashmiri art.

The *Vishnudarmottarapurāṇa* and the contemporaneous *Nīlamatapurāṇa* texts from the sixth or seventh century are remarkable for their relevance to the early Kashmiri Brahmanical sculptures. The iconographic repertoire of these texts is rich, diverse, and discrete and the Kashmiri sculptor is now master of both technique and material to meet the challenge. Whether it is the iconic Narasimha (fig. 68) or the encapsulated myth of deadly combat between the god and the titan in miniature (fig. 64), the sculptors have rendered both with aesthetic aplomb.[13] The memory of Gandhara has faded away in such sculptures and in the partially preserved Brahma and Ardhanarishvara figures (fig. 69; fig. 15, ch. 2). The figures are no longer muscle bound, and the full, robust bodies and limbs are defined by fluid outlines and informed with elegant simplicity.

The Karkota period (about 600–855) was one of prosperity and self confidence, which is reflected in the monuments and sculptures such as the great Martand temple erected by Lalitaditya (fig. 31, ch. 3) or the group of massive sculptures both Brahmanical and Buddhist, now in the Srinagar Museum. The dancing mother goddess Indrani (fig. 70), and the fragmentary birth scene of the Buddha (fig. 71) from Pandrethan and the bejeweled Buddha from Parihaspur (fig. 16, ch. 2) are characteristic

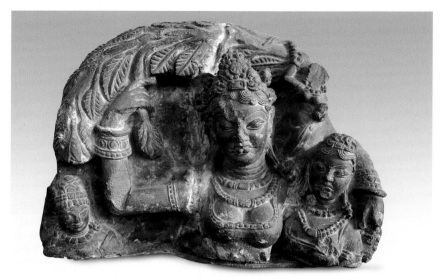

71

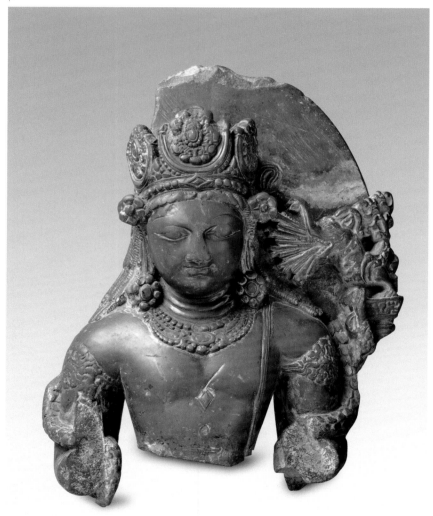

FIG. 71 �֎
Fragmentary birth of the Buddha scene
with Maya at Lumbini, seventh century
Limestone
H. 13 13/16 x W. 16 9/16 in. (35 x 42 cm)
Sri Pratap Singh Museum, Srinagar
1854

FIG. 72 ✤
Bust of Kamadeva, the god of desire,
750–800
Stone
H. 14 5/8 x W. 2 3/8 in. (37.2 x 6 cm)
The Metropolitan Museum of Art,
Purchase, Lita Annenberg Hazen Charitable
Trust Gift, 1993
1993.175

FIG. 73 ✤
Vishnu sleeping on the cosmic serpent,
ninth century
Schist
H. 24 7/16 x W. 16 1/8 x D. 6 11/16 in.
(62 x 41 x 17 cm)
Private collection

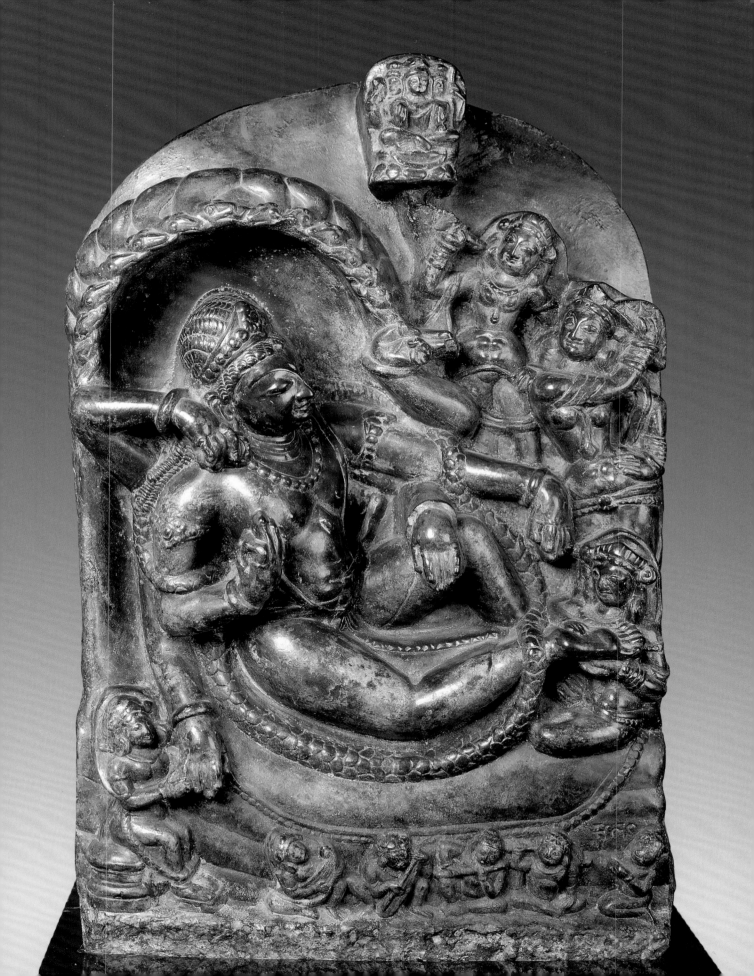

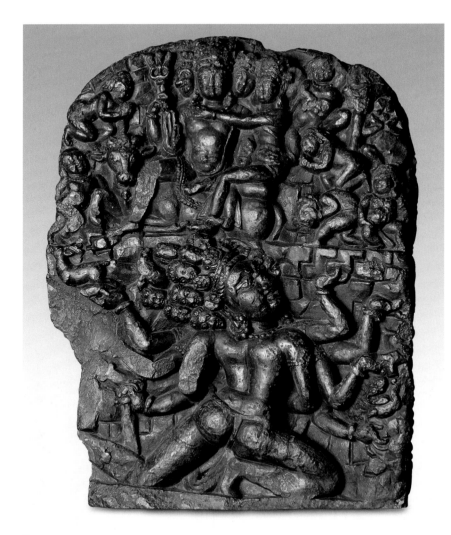

Fig. 74 ✿
Ravana shaking Mount Kailash with Shiva
and Parvati, eighth century
Stone
about 15 3/4 in. (40 cm)
Swali Collection

Fig. 75 ✿
Vishnu with lion and boar heads,
eighth century
Copper alloy
H. 13 1/2 in. (34.3 cm)
Asia Society, New York:
Mr. and Mrs. John D. Rockefeller
3rd Collection
1979.43

74

examples that may be said to mark the Kashmiri sculptor's mastery of stone and the
apogee of sculptural art. It is remarkable how nimble and realistic the Indrani is
despite her bulk. Stylistically the bust of Maya holding the branch of a tree while giving
birth to the Buddha is probably the work of the same atelier. Noteworthy is the mode
of dress the two ladies wear which became standard for Kashmiri goddesses with few
exceptions. How the complete Maya looked can be discerned from the birth scene in
the Metropolitan Museum ivory (fig. 57). Though not as large as the Indrani, the
gracefully standing regal Buddha is elegantly proportioned. The limbs and torso are
still modeled realistically but the plasticity is more nuanced than one sees in sculp-
tures from Gandhara. The transparency of the garment with its subtle delicate folds
may reflect influences from Gupta India. We do not know the names of either the
patron or the sculptors responsible for the remarkable group of mother goddess fig-
ures, perhaps the most monumentally dynamic dancing goddesses sculpted in the
round in the subcontinent. The patron of the Buddha, however, was probably
Chankuna, Lalitaditya's Tocharian minister whose devotion to the faith, as narrated by
Kalhana, was exemplary.

Two sculptures testify to the importance of the cult of Kamadeva, the god of
desire, whose spring festival was popular in the valley according to the *Nīlamata*.[14]

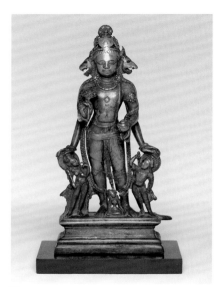

75

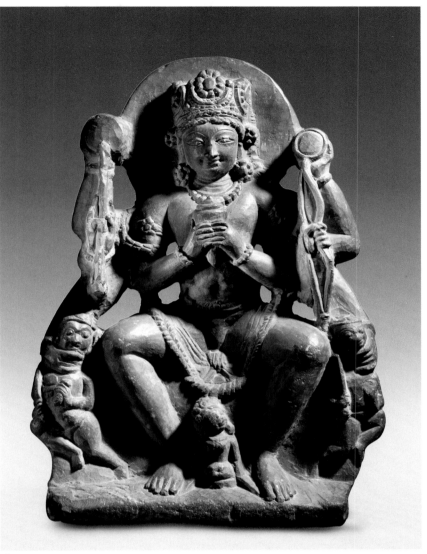

76

One is a fragmentary but robustly modeled iconic representation (fig. 72) wearing the typical Kashmiri tiara with three circular crests (fig. 198, ch. 9) and holding the *makara* emblem who spits out the five arrows of love, as described in the *Vishṇudharmot-tara*.[15] The other is a small but densely composed figural panel showing the god engaged in a convivial drinking session with his two wives, a theme that is repeated in two panels in situ in the mid-ninth century Avantisvar temple (fig. 34, ch. 3). This earlier and smaller panel from about the eighth century is as close a representation of a scene of conviviality at the Karkota court as we are likely to get (fig. 106).

Among other narrative steles of the period, few of which have survived, the most impressive is the myth of Vishnu's cosmic sleep in the cosmic ocean on the serpent Ananta (Endless) attended by four ladies (fig. 73).[16] Again this depiction of a myth could well be interpreted as a glimpse of a ruler relaxing in the inner chambers of a palace. While one lady massages his foot and another one his hands, two women perform a dance. Moreover, Vishnu's hands are empty of all emblems. The most expressive representation of a myth to have survived in Kashmiri sculpture is a relief depicting Ravana shaking Mount Kailash, the abode of Shiva and Parvati (fig. 74). While the relief is of modest size

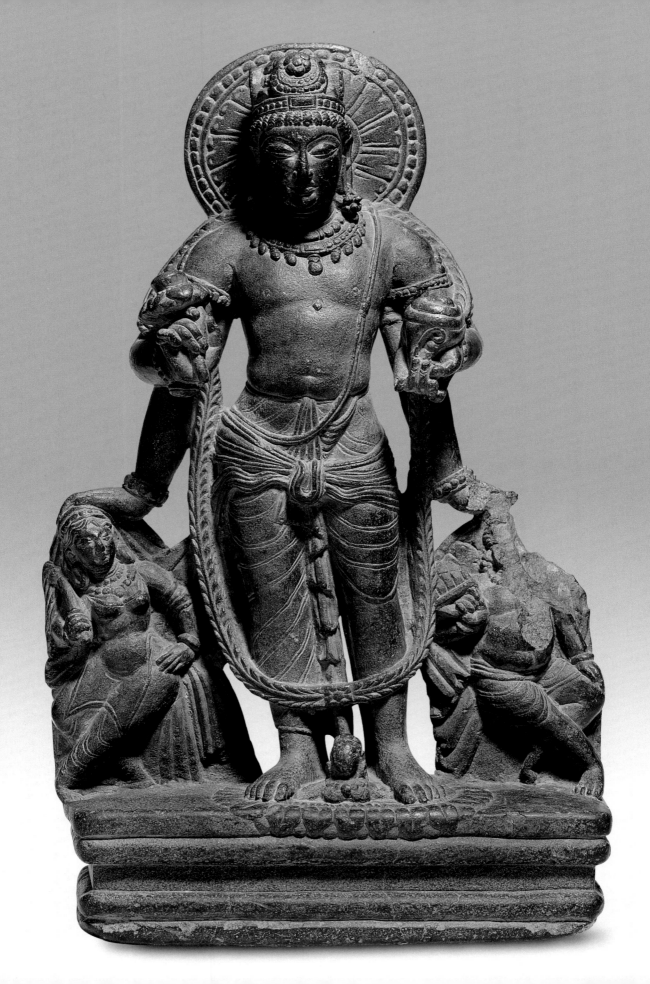

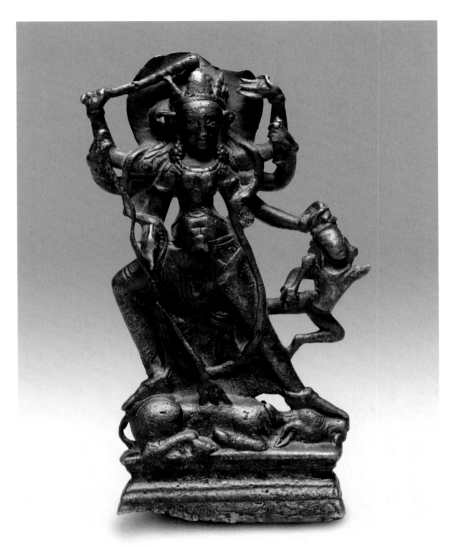

78

compared to the monumental rock cut compositions of Shaiva temples in Maharashtra, the depiction here is no less dramatic. The unknown Kashmiri sculptor has clearly emphasized the enormous physical effort of the multiarmed titan king, who dominates the composition in contrast to the more puny divine figures and their attendants above.

Less dramatic but unique is an icon with a strong narrative intent of the late Karkota period showing Vishnu killing the two titans Madhu and Kaitabha (fig. 76). Even though Vishnu's posture is formal, the combat, indicated by the two titans dangling on the side as the god grabs them by their necks, is amusingly lively. But the image is interesting in other ways. Not only does Vishnu hold the bow and the arrow but the presence of the female between his legs introduces a unique and ubiquitous feature of Kashmiri icons of the deity. She is the earth goddess, who, according to the *Vishnudharmotta*, should always be represented between his feet looking up at the deity in admiration, as may be seen in the more typical Kashmiri Vishnu icon (fig. 75). Also characteristic of Kashmiri Vishnu images (fig. 77) is the personification of two of the god's emblems, the club (*gadā*) and the wheel (*chakra*), as two attendants. They are particularly animated in the small stone sculpture as if dancing, an early representation of the form that will have a long life in the valley.

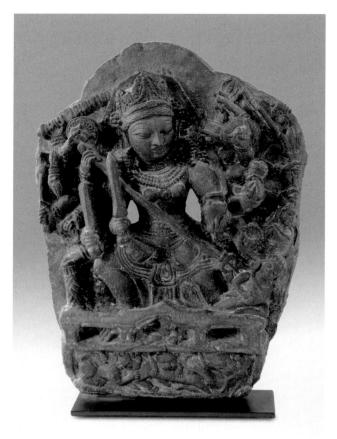

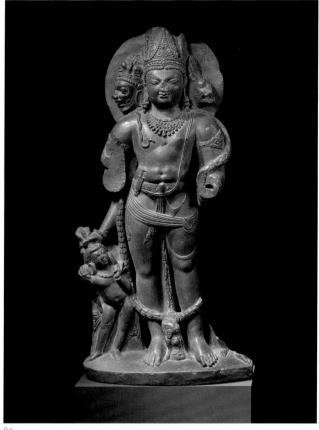

79 80

The form of Durga killing the titan Mahisha, or buffalo-headed demon, is proba-
bly the most classical and popular Brahmanical image that is the direct focus of worship
(*archā*) but has strong narrative intent. The common representation of the theme is
illustrated in a small bronze with a dramatic composition (fig. 78) where a slim and
elegant goddess engages a diminutive but aggressive adversary. But more unusual
are stone sculptures such as the one illustrated here (fig. 79). Space will not allow us
to discuss the many fascinating features of this tableau but the most distinctive element
is the fact that she fights riding a chariot rather than standing on her lion, which
viciously attacks the buffalo in the register below. Once again this is a feature
described in the *Vishṇudharmottara* where this particular eighteen-armed form is
designated as Bhadrakali.[17] What the two representations do indicate is how diverse
the compositions are even though the theme is the same, each one reflecting the
creative impulses of its individual sculptor.

Most stone sculptures surviving from the Utpala (955–1003) and later periods
represent Brahmanical subjects while Buddhism appears to have been better served by
metal sculptures and paintings. The Avantisvar temple, built by 855, still retains some
of its sculptural embellishments and some Shaiva sculptures remain attached to the
Payer temple, also of the ninth century (fig. 24, ch. 3). However, the surviving sculp-
tures do not reflect any radical iconographic or formal innovation. The impressive
Harihara (fig. 80) from the Museum für Indische Kunst in Berlin, or the seated Ganesh
from the Sri Pratap Singh Museum in Srinagar (fig. 81) are probably two of the finest
sculptures surviving from about the mid-ninth century. Although Ganesh appears as
early as the seventh century, certainly in metal (fig. 82), no Harihara image of the

FIG. 79 ✿
Durga destroying the titan Mahisha,
ninth century
Gray schist
H. 16 15/16 x W. 13 3/8 x D. 4 5/16 in.
(43 x 34 x 11 cm)
Private collection

FIG. 80 ✿
Hari (Vishnu) and Hara (Shiva)
in composite from Harihara, ninth century
Stone
H. 27 in. (68.5 cm)
Museum für Indische Kunst
(Museum of Indian Art), Berlin

FIG. 81 ✿
God Ganesh, ninth century
Chlorite
H. 20 1/2 x W. 17 5/16 x D. 7 1/2 in.
(52 x 44 x 19 cm)
Sri Pratap Singh Museum, Srinagar
3092

FIG. 82 ✿
God Ganesh, seventh century
Bronze
H. 6 x W 3 x 1 3/4 in. (15.3 x 7.6 x 4.4 cm)
The James W. and Marilynn Alsdorf Collection,
The Art Institute of Chicago
86.1998

Karkota period has yet come to light. The Berlin Harihara, in which the images of Shiva and Vishnu are combined, still retains the stylistic elegance and plasticity of Karkota sculptures. The robust figure of Ganesha, though conventional in his posture, introduces an iconographic detail that appears frequently in Kashmir and neighboring Chamba but is less commonly encountered elsewhere. Instead of his rodent, the Kashmiri Ganesha prefers to ride his mother's lion.

A diminutive but unusual sculpture of the Utpala period is a plaque depicting Vishnu's feet flanked by his club and conch-shell emblems placed on lotuses whose stems rise from a base supported by a seated nature divinity (*yaksha*) and two lions with heads turned inwards (fig. 65). While it is not uncommon to encounter Vishnu's feet (*Vishnupada*) as an object of adoration, the embellishment with a crown and the triadic composition with the two emblems are rare and once again reflects Kashmir's discrete iconography. The *yaksha* support of buildings and thrones is as old as the first century CE and may have originated in the classical Atlas motif.

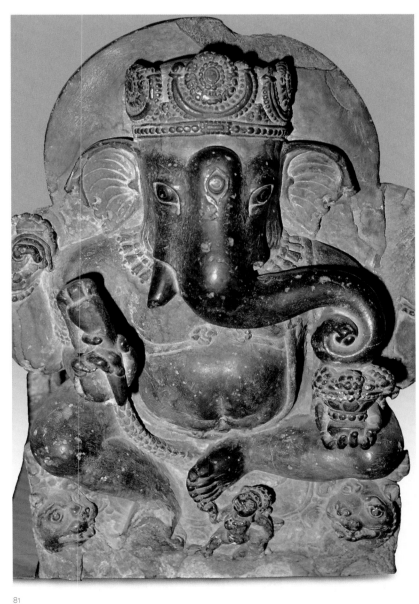

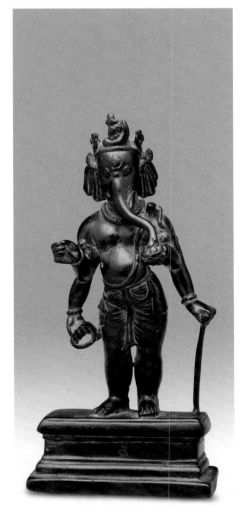

81

82

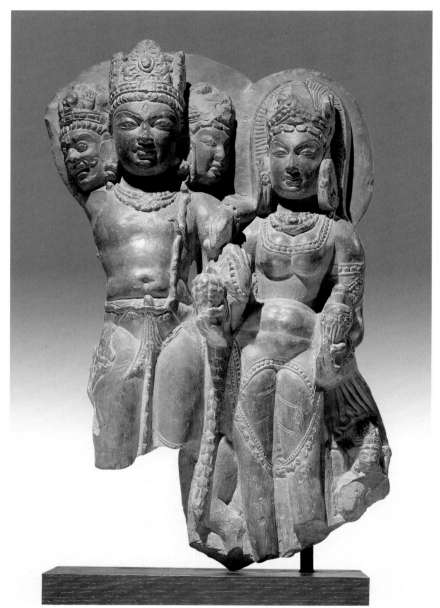

Fig. 83 ✷
Shiva and Parvati, about 900
Chlorite
H. 15 in. (38.1 cm) plus base
Private collection

83

Although damaged, a refined sculpture of the ninth century depicts Shiva and Parvati side by side (fig. 83). The theme was already introduced in the Karkota period, but no earlier representation is as expressive of intimacy as this example. As usual in such Kashmiri images of the couple, Shiva is three-headed. His angry Bhairava form, continuing the type seen in the Leitpora terra-cotta head (fig. 54), is portrayed on the right of the human head, and on the left is the feminine head of his spouse. Despite these supranormal features and his discreetly shown tumescence, the remaining left arm languidly placed on Parvati's shoulder reflects the essential humanity of the theme. Certainly there is no attempt to emphasize Parvati's divinity. Their son Kumara's head is attached below the folds of her garment. How the sculpture looked when it was complete can be discerned from a better-preserved stele rendered towards the end of the Utpala period (fig. 84). Even a casual comparison of the two sculptures makes their formal and aesthetic differences clear. The figural proportions and physiognomies are notably different as is the articulation

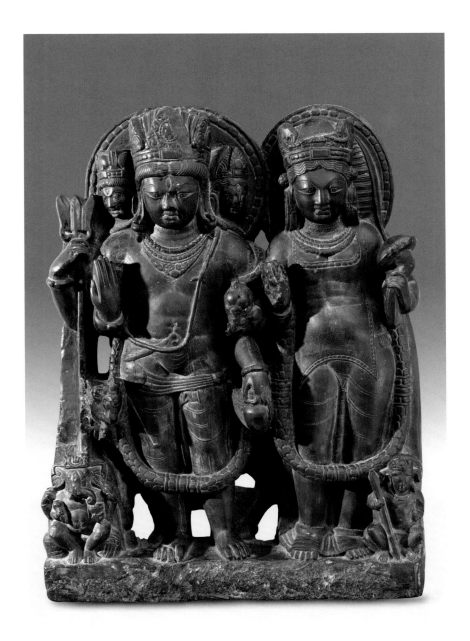

of the flesh, ornaments, and the attributes. Noteworthy and unusual is the fact that in the stele, the two figures are depicted as the same size and therefore equal.

Somewhat earlier but reflecting the same figural form with rather robust and fleshy proportions as Parvati (fig. 84) is a unique image of the goddess with two young male attendants (fig. 85). Her upper garment is more elaborately designed and is different from both other Parvatis. So also are the hairstyles and the ornaments, thereby clearly reflecting that in matters of proportions, modeling, and details of appurtenances the sculptors enjoyed considerable freedom. Of her three remaining attributes the sword and the bell with a strap are clearly recognizable, while the left hand holds the severed head of a ram.[18] She wears a long leafy garland down to her calves representing a peculiarity of Kashmiri images, both Brahmanical and (sometimes) Buddhist (fig. 39, ch. 3). While in the rest of the subcontinent the long floral garland is a discrete attribute of Vishnu and Balarama, in Kashmir it is common with Shaiva deities, irrespective of gender (fig. 84).

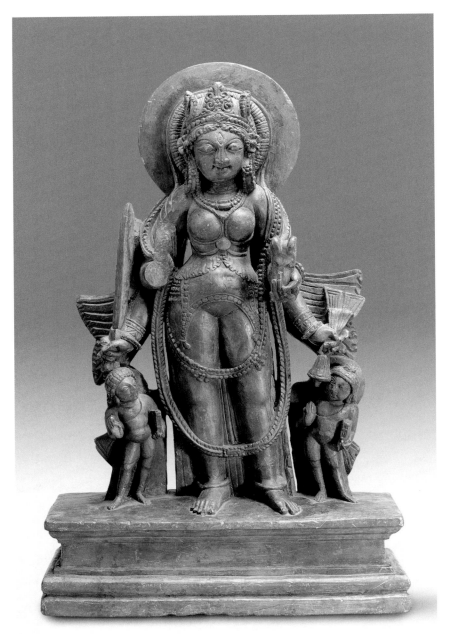

Fig. 85 ❖
Goddess Durga with two attendants,
late ninth century
Phyllite
H. 12 3/8 x W. 7 7/8 x D. 3 in.
(31.4 x 20 x 7.6 cm)
The Metropolitan Museum of Art,
Gift of Mr. and Mrs. Perry J. Lewis, 1984
1984.488

Buddhist sculptures in stone from the post-Karkota period are few, which makes a stele showing the typically Kashmiri stupa flanked by two interesting bodhisattvas (fig. 39, ch. 3). Likely an eleventh-century sculpture, it is also unique for substituting the Buddha with a stupa, as was the practice in pre-iconic days. That the cult of the stupa continued so late is also interesting, but what it demonstrates, along with the later metal images, the temples of western Tibet and Ladakh, and literary evidence, is that Buddhism was still a lively faith in the valley well into the eleventh century.

The end of the road of the lithic sculptural tradition of Kashmir is typified by the large and complete representation of the Ardhanarishvara, the conjoint form of Shiva and Parvati (fig. 86). Though awkwardly proportioned and lacking the smooth, melliflu-ous plasticity of the Karkota period image (fig. 15, ch. 2), the sculpture is important for

86

FIG. 86 ❖
Ardhanarishvara, androgynous form
of Shiva and Parvati, eleventh century
Phyllite
H. 32 x W. 7 in. (81.3 x 17.8 cm)
Kapoor Galleries Inc.

FIG. 87 ❖
Four-faced Linga, sixth century
Bronze
H. 4 1/2 x 3 9/16 in. (11.4 x 9 cm)
Anthony d'Offay, London

FIG. 88 ❖
Parvati (Uma), tenth century
Copper alloy with inlays of silver
H. 8 1/2 x W. 4 1/4 x D. 1 3/4 in.
(21.6 x 10.8 x 4.5 cm)
Rubin Museum of Art
C2005.16.5 (HAR 65427)

its historical position in the narrative of Kashmiri stone sculpture. The long Sharada inscription is difficult to read but it does provide the name of a ruler unknown in Kashmir but who perhaps ruled an adjoining territory. It was likely carved during Kalhana's lifetime. The tempo of temple-building activity had slowed down, but Ardhanarishvara was clearly the poet's titulary deity, for every canto of his chronicle begins with a benediction to the form, one of which is quoted as the epigraph to Gerald J. Larson's essay (chapter 2).

Metal Sculptures

Among the arts of ancient Kashmir the most familiar are the metal sculptures. Being portable, Buddhist bronzes from Kashmir found their way to Tibet from where they have traveled west with the Tibetan diaspora after the Chinese invasion of the region in the 1950s. Indeed, few Kashmiri bronzes have been found in the valley. In any event, because of the greater availability and interest in Kashmiri bronzes among connoisseurs and collectors, the subject is better studied both art historically and technically. Therefore, the discussion here will be brief.

Unlike some of the other major centers of metal sculpture in South Asia, such as Nepal, Bihar, and Tamil Nadu, in Kashmir brass was the preferred metal, but copper alloy was also used (figs. 75, 78, 82, 87, 88). All five of the pictured objects represent Brahmanical deities and one wonders if the Buddhists preferred brass because of their penchant for golden surfaces. Few Kashmiri-style Buddhist statues, however, are gilded; there are only two in these examples (fig. 89, 90). Another discrete feature of the Kashmiri metal sculptures is the use of silver and copper inlay, the former generally for the eyes and the latter commonly for the lips but sometimes rich inlay is used in other details such as textile components. Unlike the stone sculptures, bronzes, especially Buddhist, bear dedicatory inscriptions which often contain chronological data. The Buddha statue of Priyaruchi (fig. 45) and the Rockefeller and Pritzker bronzes (figs. 43, 44) are therefore of considerable art historical significance, apart from their aesthetic and religious import.[19]

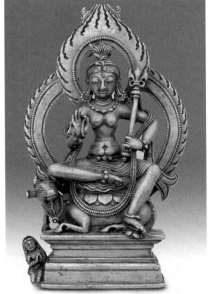

87

88

89

90

Another distinct feature of Kashmiri-style metal sculptures, especially Buddhist images, is the use of stylized rock formations on the bases below the ubiquitous lotus flower on which the gods are placed. They are found below Buddhas (figs. 43, 44, 60) as well as bodhisattvas (fig. 89) and the Vajrayana deities (figs. 91, 92). Indeed, from about the seventh century, the Kashmiri artists reveal remarkable virtuosity in the variations they use to delineate the rock formations. Such Buddhist bronzes carried to Central Asia and beyond may have been the artistic source for similar motifs in Chinese and, ultimately, Japanese Buddhist representations, especially of Achala or Fudo. While certain mountains, real (fig. 43) or cosmic, such as Mount Meru, are associated with the historical and transcendental Buddhas and the mythic Potalaka with Avalokiteshvara, their wider use for

91

the Tantric deities remains a mystery. Indeed, by and large, in no other Buddhist artistic tradition do we encounter such idiosyncratic and rich variety of bases—sometimes of enormous complexity as in the Gilgit bronzes, often imitating the shape of the *vajra* or the thunderbolt (fig. 92)—as in Kashmir, especially from the seventh century and later. How far this diversity reflects religious imperatives or the individual artist's imaginative power remains to be explored.

The earliest metal sculpture included here is a bronze mask-like head of Vishnu with the distinctive crown (fig. 93) showing strong Gandharan influence. The boar's head is still attached on his left; the lion's head on the right is missing. If this head was once attached to a body, then the figure would have looked like the well-known sixth- to seventh-century bronze Vishnu from the Museum für Indische Kunst in Berlin, or a later sculpture in the Rockefeller collection (fig. 75). The Rockefeller image has only three heads, but generally in sculptures made after the eighth century, a fourth demonic head was added to the back.[20] This is the most classic form of a Vishnu image in Kashmir representing the four-fold (*chaturmūrti*) worshipped by the followers of the Pancharatra sect and described in the *Vishnudharmottara* in great detail.

Among the few early Kashmiri bronzes that can be given a sixth- to seventh-century date, two of the most charming are a small Shiva-linga (fig. 87) and a Ganesh (fig. 82), both cast in copper alloy. The linga is unusual because it is *chaturmūkha*, or with four faces representing the four directions, while the common preference of Shaivas is the *ekamukha* (one-faced) variety (fig. 94). The style of each of the four faces is typically Kashmiri with fleshy cheeks compared to the sharper features of the human face in the Vishnu mask. The Gandhara influence survives only residually in the shape of the rectangular base of the suavely modeled and elegantly rakish Ganesh.

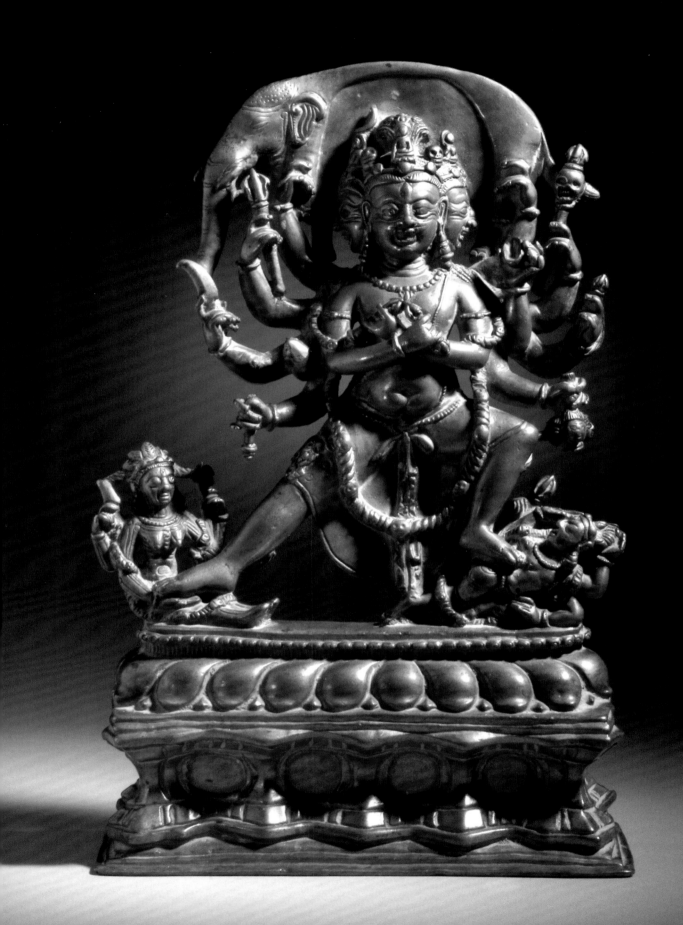

93

94

That the Kashmiri bronze tradition had reached its apogee by the time Xuanzang visited the valley during the reign of King Durlabhavardhana has become a given fact since the discovery of Priyaruchi's Buddha (fig. 45). Closely comparable is an outstanding large seated preaching Buddha with its elaborate base embellished with two *yaksha*-s and three lions (fig. 95). This must be a portable representation of a very sacred image installed in a temple in the valley, for many subsequent versions, made both in Kashmir and elsewhere, exist. By the turn of the century, thanks to the patronage of the members of the royal family of Gilgit, artists were busy creating some of the most complex and outstanding metal sculptures that have been found in the context of Indic Buddhist tradition. Two of these, in the Rockefeller and Pritzker collections, are included here (figs. 43, 44). Apart from their elaborate but orderly compositions and exquisite technical finesse, they are also interesting for the royal portraits of identifiable figures. The same technical virtuosity and artistic panache are also evident in the intricately composed aureole with an etched Buddha (fig. 96) that is tantalizingly similar to the Buddha in the Norton Simon Museum (fig. 97).[21] Although not as elaborate, an elegant image of the goddess Prajnaparamita (fig. 98) is stylistically associated with the two inscribed Gilgit bronzes. She is the earliest representation of this important Mahayana goddess in the Kashmiri tradition and iconographically one of the simplest. One wonders if this was not meant to be a posthumous portrait of a pious lady identified with the goddess.

A large, crowned, preaching Buddha, perhaps the future Buddha Maitreya (fig. 90), is a rare example of a gilded sculpture from Karkota Kashmir. In comparison with the Pritzker collection's crowned Buddha of 715 CE (fig. 44), this much larger figure may well

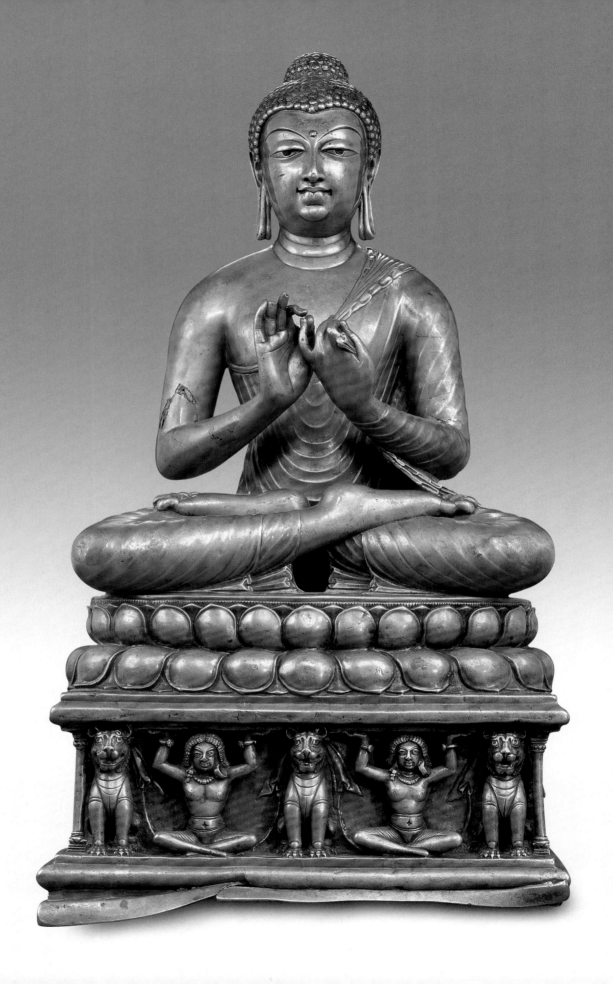

FIG. 95 ✿
Buddha, 600–650
Copper alloy with silver
H. 23 x W. 12 5/8 x D. 7 1/8 in.
(58.4 x 32 x 18 cm) (with base)
Private collection

FIG. 96 ✿
Aureole with etched Buddha and attendants,
eighth century
Brass, silver, copper
H. 14 7/8 x W. 9 9/16 x D. 3 3/8 in.
(37.7 x 24.3 x 8.5 cm)
Private collection

FIG. 97
Buddha and adorants on the cosmic mountain
with aureole (fig. 96), about 700
Bronze with silver and copper inlay
H. 13 1/4 x W. 9 1/2 x D. 4 3/4 in.
(33.7 x 24.1 x 12.1 cm)
The Norton Simon Foundation
F.1972.48.2.S

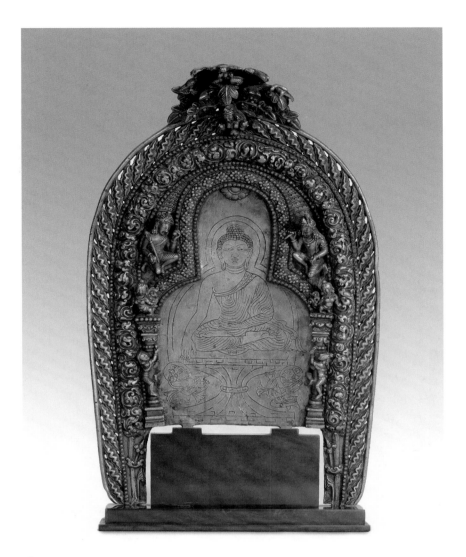

96

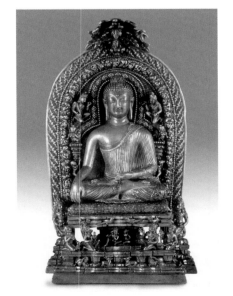

97

be a survivor from Lalitaditya's reign. One is admirable for its elaborate compositional complexity and exquisite workmanship and the other for its impressive size and elegant simplicity. Another gilded sculpture also portrays Maitreya, but this time as a bodhisattva and in the standing upright (*samabhanga*) posture rather than the preferred swaying posture of most standing figures (fig. 89). He is also distinguished by his ornaments, hairstyle, and the distinctive treatment of the dhoti, which reveals traces of silver. While its exact origin remains uncertain, the figure is certainly a noteworthy work that reflects the Kashmiri aesthetic. Other works that may be assigned to the eighth century are small images of the pensive bodhisattva (fig. 99) and a Vajrasattva (fig. 91). Both are equally attractive for their suave modeling and graceful bearing. While the pensive Avalokiteshvara epitomizes the compassionate nature of Mahayana Buddhism, the Vajrasattva with its bell and thunderbolt attributes expresses the quintessential ideology of Vajrayana Buddhism where enlightenment is achieved by the union of compassion and wisdom.

Vajrayana Buddhism, with its populous pantheon of divinities both placid (*sānta*) and angry (*krodha*), contributed enormously to the expansion of the artists' repertoires. As the mystical visualizations created more complex iconographic forms with multiple

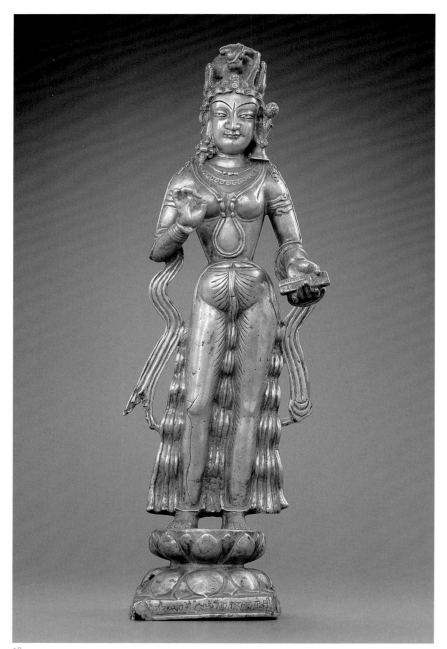

98

arms and limbs, often in militant attitudes and poses, the artists had to meet the new challenges with more diverse and dramatic representations. However, considering the importance of Kashmir and the Swat Valley in Tantric Vajrayana literature and praxis, the surviving sculptural remains are rather limited when compared to Nepal or Tibet or eastern India. Stone sculptures of Vajrayana deities are almost nonexistent. However, temples in western Tibet and Himachal Pradesh provide eloquent testimony to the imagination and expressive power of the Kashmiri artists to give form to the rich and sometimes macabre realm of Tantric imagery.

Apart from the gentle and graceful Vajrasattva (fig. 91), several other bronzes included here, such as the dramatic Chakrasamvara (fig. 92), the elegant Vajradharma Lokeshvara (fig. 100), an unidentified but suave Lokeshvara (fig. 101), and a romantic

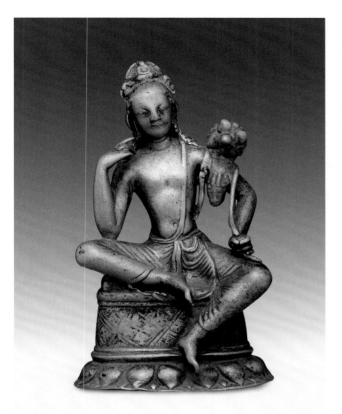

99

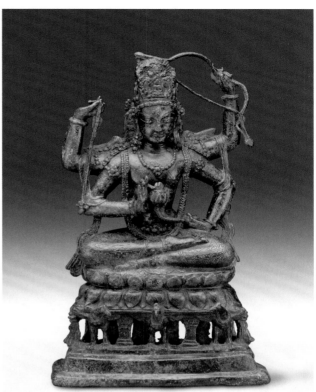

100

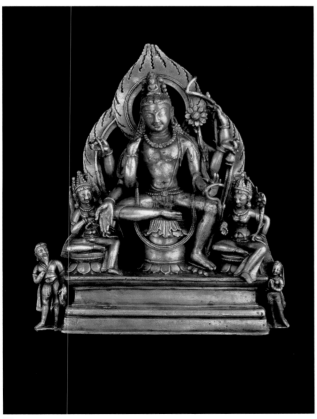

101

representation of Vajrasattva with his spouse in dalliance (fig. 23, ch. 2) give some idea of the Kashmiri sculptors' creative vitality through the eleventh century, as long as there were sympathetic patrons. Two rare bronzes from the period represent two different manifestations of the goddess, one in a placid form of mother Maheshvari (fig. 88) and the other as the more dynamic exterminator of Mahishasura (fig. 78). The latter has already been mentioned; the Maheshvari is not only an uncommon example of a metal image of the mother goddess but demonstrates the sculptor's deftness in modeling both human and animal forms. A characteristically Kashmiri expression of Pancharatra theology is portrayed in a recently excavated rare small bronze (title image) with Vishnu and four goddesses that constitute a mandala.

The greatest example of Utpala period metal sculpture is the monumental frame with images of the various avatars of Vishnu, who is said to descend on earth in various forms when the world is overwhelmed with evil (figs. 47, 96, 102). Apart from its aesthetic merits, the frame attests to the technological prowess of Kashmiri metalworkers. Represented with utmost brevity, each avatar resonates with energy. No other metal sculpture from the subcontinent is known to convey such a felicitous combination of narrative power and expressive form. The frame was found in Devsar, in the valley, but neither the master sculptor nor

102

the donor is known. If King Avantivarman himself did not commission it, certainly it was created in his reign when Vaishnavism received a fresh momentum. Two other monumental works, each of which is a distinctive creation, demonstrate both the overarching aesthetic tradition of Kashmiri religious art and the creative brilliance of individual artists. The now well-known brass Buddha from the Cleveland Museum of Art (fig. 103) was once in the collection of the pious Prince Nagaraja of Guge, which, as we now know because of the discovery of Priyaruchi's seventh-century Buddha, does not mean that it was made for the royal monk, as was surmised once.[22] The second work (fig. 104), published here for the first time, has a high copper content and its rich green patina suggests that it was buried for a considerable time. Like the Cleveland Buddha, it is slender and elegant, and although the treatment of its surface is not as nuanced as that of the other, it is strongly modeled and equally noble in its bearing.

The Rockefeller Avalokiteshvara (fig. 105) was most likely made about 1000 by a Kashmiri artist in the train of Rinchen Sangpo from Tibet. It is assertively modeled and enriched by the greater articulation of the dhoti consisting of fabric with bold floral design. Embellished with much more jewelry, he wears a long garland of flowers like the Hindu deities. By contrast, both the Cleveland Buddha and the larger Avalokiteshvara have lighter and more transparent body-hugging garments that reveal the eloquent simplicity of the plastic mass. Noteworthy is the long scarf of Avalokiteshvara (fig. 104) that falls in serpentine motion along the long legs, enhancing the sense of movement of the graceful posture. If we again compare these two Avalokiteshvara figures to the enigmatic eighth-century bodhisattva, with his erect posture and with a different but no less elegant treatment of garments (fig. 89), we realize how these sculptures express the idiosyncratic proclivities of individual artists and changing tastes of different times.

Both the Brahmanical and Buddhist sculptures of Kashmir reveal the discrete nature of form as well as iconography. While the form shows distinct aesthetic and stylistic preferences, the content is important for the understanding of the two faiths. The Brahmanical sculptures bear close relationships with textual sources, especially the *Vishṇudarmottarapurāṇa* and the *Nīlamatapurāṇa*. Although more Buddhist sculptures are inscribed, they do not help as much in the way of understanding the peculiar nature of the valley's Buddhist iconography. Kashmiri Buddhist textual sources are scarce, but the images themselves speak volumes about the development of Kashmiri Buddhism and the aesthetic sensibilities of the valley's artists.

The early source of Kashmiri sculpture was clearly Gandhara. By the fifth century, influences from the southern plains must also have reached the valley. But from the seventh century, through its monks, its artists, and portable images, Kashmir exported its artistic ideas to Central Asia, China, and in a far greater measure to

FIG. 103 ❁
Buddha Shakyamuni, about 998–1026
Brass
H. 38 5/8 in. (98.1 cm), Base: L. 11 1/8 in.
(28.2 cm)
The Cleveland Museum of Art,
John L. Severance Fund
1966.30

>>
FIG. 104 ❁
Bodhisattva Avalokiteshvara, about 900
Bronze
H. 41 1/2 x W. 15 x D. 11 5/8 in.
(108 x 38 x 29.5 cm) (with base)
Private collection

FIG. 105 ❁
Bodhisattva, late tenth century to early
eleventh century
Western Tibet
Brass with inlays of copper and silver
H. 27 1/4 in. (69.2 cm)
Asia Society, New York:
Mr. and Mrs. John D. Rockefeller
3rd Collection
1979.45

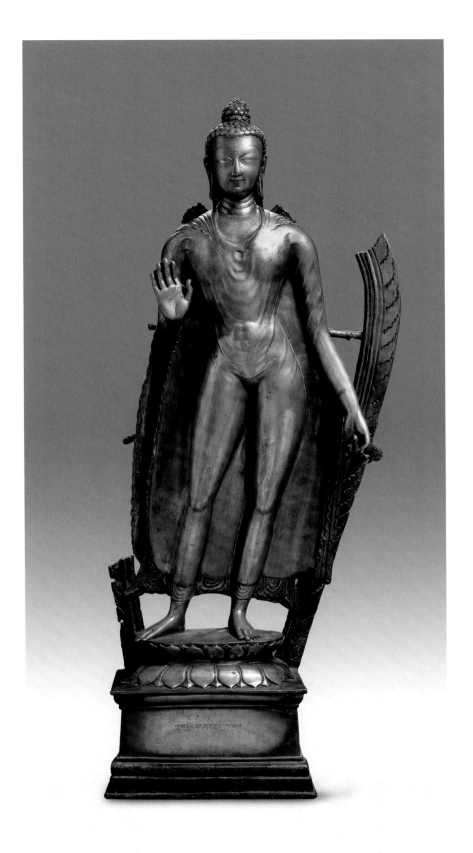

103

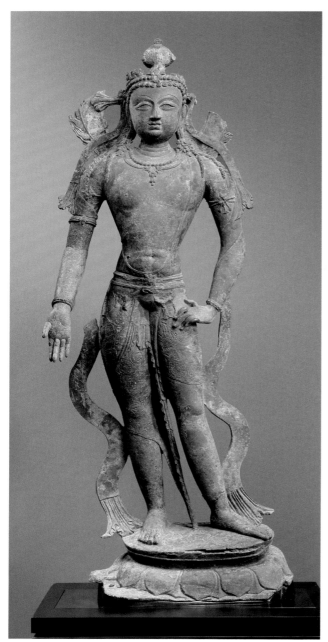

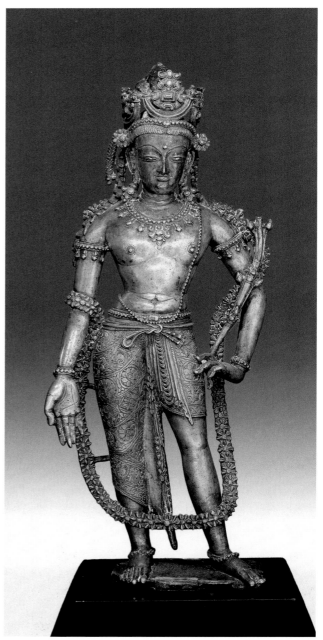

104

105

neighboring Tibet. Undoubtedly, visiting pilgrims and scholars from the north and beyond must have brought with them images produced in their native lands. The interaction between the art of Karkota Kashmir and the early Tang dynasty (618–906) in China could be a particularly exciting exercise but that must be postponed for another occasion.[23] What is clear is that the art and aesthetic of this small valley, like that of the equally small Kathmandu Valley of Nepal, exerted an enormous influence in Gilgit, Swat, Ladakh, western Tibet, and Chamba in Himachal Pradesh, all of which formed the greater Kashmir cultural mandala.

1. The only complete stylistic survey of the sculpture of Kashmir is an unpublished dissertation by John Siudmak 1994. See also Paul, *Early Sculptures of Kashmir*, and Pal, *Art and Architecture of Ancient Kashmir*.

2. The name of this sculptor is Mati (see von Schroeder, *Indo-Tibetan Bronzes*, fig. 22G.) and he is said to be from *Pan-tsa-ra*, which may be Tibetan for Panjal or the Pir Panjal region of Kashmir. The seventeenth-century Tibetan polymath Taranath mentions a Kashmiri artist called Hasuraja who was responsible for initiating a style of Buddhist art. For another sculpture commissioned by Rinchen Sangpo from Bhidaka, see von Schroeder *Buddhist Sculptures*, vol. 1, pp. 70–71.

3. For the ivory carving tradition in India see Dwivedi, *Indian Ivories*. See also Czuma, "Ivory Sculpture."

4. See Hinüber 2004 for these and other Gilgit bronzes.

5. Von Schroeder, *Buddhist Sculptures in Tibet*, vol. 1, pp. 126–29; See also the German exhibition catalogue, *Tibet Klöster öffmen ihre Schatzkammern* (Villa Hugel, Essen, 2006), pp. 164–167, nos. 13, 14 for another richly gilded Buddha.

6. Von Schroeder, *Buddhist Sculptures*, vol. 1, for a remarkable array of Kashmir bronzes preserved in Tibet. This book as well as von Schroeder 1981 are also useful sources for Swat, Gilgit, and western Tibetan metal sculpture.

7. Stein, vol. 1, p. 142. Apparently the king used roughly 33,600 ounces of gold and silver each for two Vishnu images and the same amount of copper for a statue of the Buddha. Large images were commissioned by other kings as well.

8. Stein, vol. 1, p. 261. "She also built a second [temple of Vishnu called] Diddāsvāmin, of white stones . . ."

9. See Goetz 1955. It may be remarked that an inscription of 1197 CE mentions an older wooden temple of Avalokiteshvara in the valley. See Deambi, *Kashmir and Central Asia*, pp. 107–9.

10. I am grateful to Shri M. S. Zahid for bringing the Kutbal excavation to my attention. Scholarly study of this exciting material is still awaited.

11. Lerner, *The Flame and the Lotus*, pp. 77. Nor is it likely that the panel was carved outside of Kashmir, as Sherman Lee once suggested (for reference, see Lerner, note 2). See also Leidy, *Treasures of Asian Art*, pp. 76–77.

12. See Lerner pp. 72–77 for an extensive discussion of the object.

13. The strongly modeled seated Narasimha conforms partly to the image's description in the *Vishnudarmottarapurāṇa* (Shah, *Viṣṇudharmottara-Purāṇa*, vol. 2, p. 157) where he is described as having thick shoulders, waist and neck and placing two hands on the head of the club.

14. Kumari, The "*Nīlamatapurāṇa*", vol. 1, p. 200; See also Pal, *Himalayas: An Aesthetic Adventure*, p. 155.

15. Shah, op. cit., p. 166. Since the *makara* does not have arms, the artist has put the arrows in his mouth.

16. Yogashayin Vishnu was the favored deity of Avantivarman's brilliant engineer Suyya, who is remembered by Kalhana for restructuring the water system of the valley to prevent flooding. See Stein, vol. 1, pp. 197–99.

17. Shah, op. cit., p. 151. She is said to stand in the militant posture "in her chariot drawn by four lions."

18. This attribute of a severed ram's head instead of the head of a titan held by Kali is unusual in this image. One wonders if this is a discrete feature of the form of the goddess known as Bhedadevi, whose shrine was well known in the valley. See Stein, vol. 2, pp. 273–79. The Sanskrit word *bheḍā* means "ram." She may be holding the animal's head as a sacrificial offering. On the other hand, it could be the animal head of a rhyton (fig. 63).

19. Until two decades ago, the corpus of dated Kashmiri sculptures was limited. The situation today, with new material, is much better.

20. Curiously and uniquely, here the principal head, though placid, has two small fangs protruding from the edges of the mouth. Leidy (p. 73) has suggested that this may be a discreet substitute for the fourth head.

21. A few years ago when this aureole appeared in the art market, it was brought to Pasadena to see if it fitted the rings at the back. The tangs, however, could not be inserted, being a centimeter or so off.

22. Lee ("Clothed in the Sun") had suggested an eighth-century date but most scholars since (including this writer) dated it later assuming that it was commissioned by Nagaraja in the late tenth century from one of the Kashmiri artists working in Guge. However, the discovery of the Priyaruchi bronze with its original seventh-century Sanskrit inscription, and the addition of Nagaraja's Tibetan inscription, suggest that a reexamination of the Cleveland Buddha may be necessary.

23. See Leidy, Denise Patry, 1997 "Kashmir and China: A Note about Styles and Dates" *Orientations* 28, no. 2 (February), pp. 66–70, for the most extensive discussion about Kashmir and China which, however, requires updating in view of more recent discoveries.

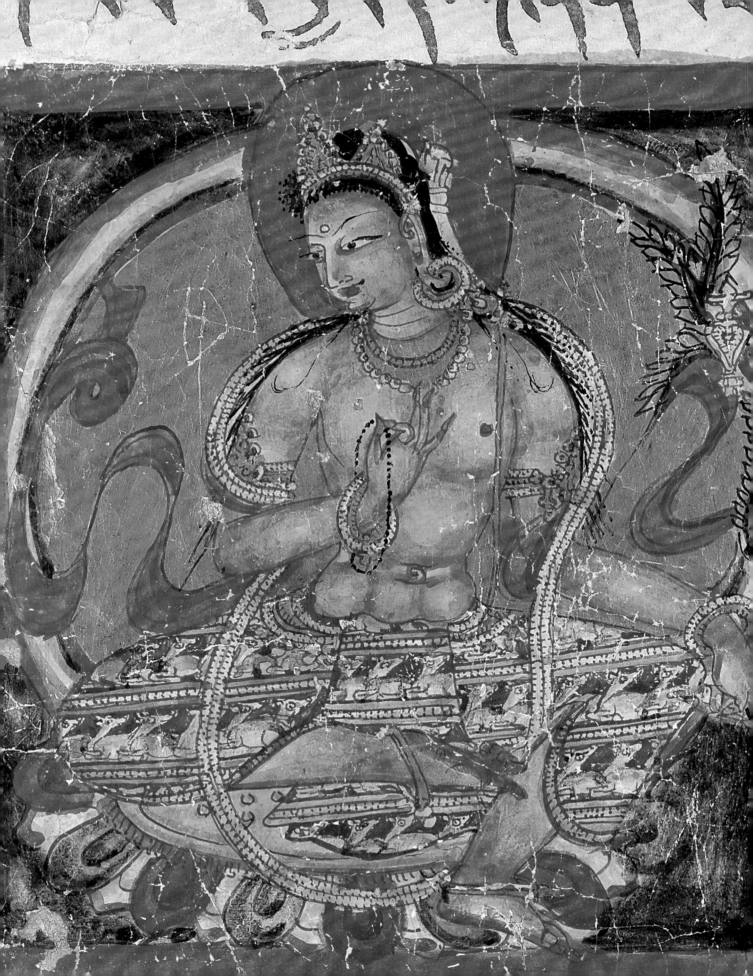

PAINTING IN ANCIENT KASHMIR
(600–1200)

By Pratapaditya Pal

No example of painting in the Kashmir valley has survived from the period under review. However, from literature and surviving circumstantial evidence in the contiguous regions in the east—Ladakh, Himachal Pradesh, and western Tibet—as well as in the north, it is possible to construct a convincing narrative. In the catalogue *Himalayas: An Aesthetic Adventure* I introduced a few examples of a painted mandala in wood for which I argued a Kashmiri origin.[1] These will again be discussed below along with additional examples as well as allusions to paintings in literature.

If Shyamilaka, the author of the *Pādatāḍitaka*, was in fact a Kashmiri who lived around the fifth century, as it is claimed, then this satiric Sanskrit work would be the earliest secular text to mention painting, and the writer the earliest teacher of the art form.[2] From this work and the earlier *Kāmasūtra* of Vatsyayana (third century) we gather that learning to paint was an essential part of the education of the courtesans and the cultured men who were their patrons. Allusions to the art of painting also occur in a later Kashmiri text devoted to the life of courtesans, the *Kuṭṭanimata* by Damodaragupta, who was a minister of the Karkota monarch Jayapida (about 780–810).[3]

Among religious works, the two most important are the *Nīlamatapurāṇa* and the *Chitrasūtra* in the third book of the *Vishṇudarmottarapurāṇa*. Both texts were compiled in Kashmir and notwithstanding later revisions and accretions, they were essentially formed between the fifth and the seventh century CE.[4] Thus, the information they provide reflects the state of the Brahmanical religion that prevailed in Kashmir during the early Karkota period. In fact, the *Nīlamatapurāṇa* throws light on the religious use of painting by the Buddhists as well.

In connection with the worship of Vishnu in his supine form on the cosmic serpent Ananta (fig. 73, ch. 4), the *Nīlamata* states that apart from images in solid material, such as stone or wood, the deity can be invoked in a picture (*chitre*) as well.[5] Similarly, the god of desire, Kamadeva (fig. 106; fig. 72, ch. 4), should also be worshipped in a cloth painting (*paṭṭastham*).[6] Another deity who can be invoked on a painting is Indra, the king of the gods.[7] In discussing the god Brahma the text provides more interesting information. Along with Ananta, Brahma should be represented in the center of a painting surrounded by the eight regents of the directions.[8] This clearly is a reference, certainly the earliest, to a painted mandala. According to the *Vishṇudarmottara*, on the ninth day of the autumnal festival, Bhadrakali should be worshipped by the king in a painted image.[9]

With regard to the Buddha, the *Nīlamata* provides an elaborate description of the master's birth festival on the *Vaiśākha* (April–May) full moon, which is still observed by Buddhists

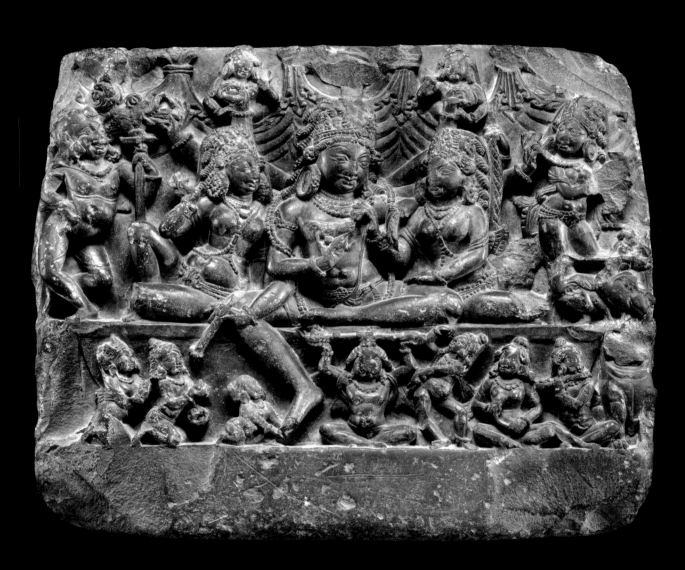

107

<<
Detail of fig. 114, ch. 5

FIG. 106 ❖
Celestial court of Kamadeva, eighth century
Gray schist
H. 8 7/8 in. (22.5 cm)
Pritzker Collection

FIG. 107
Book covers depicting bodhisattvas,
seventh century (?)
Gilgit, Pakistan
Colors on wood
H. 8 x W. 2 in. (21 x 5.5 cm)
Institute for Central Asia Studies,
University of Kashmir, Srinagar

all over the world.[10] Two elements of the elaborate ritual are relevant for us. Apart from whitewashing the monks' quarters in the monastery, the focus of worship called the *chaitya* (which could be a stupa or a shrine) should be beautified with diverse paintings. Additionally, the Shakyas, as the practitioners of the faith are called, should be honored with gifts of cloth, food and books. Books were also to be donated to brahmans in the temples of Durga.[11] In the first half of the seventh century, Xuanzang spent time in Kashmir copying and collecting Buddhist manuscripts. In fact, the earliest manuscripts found on the Indian subcontinent were recovered in 1931 from a Buddhist stupa in Gilgit (in Pakistan) which was within the cultural sphere of Kashmir. Although the manuscripts themselves are not illustrated, the wooden covers are the earliest examples of portable paintings found to date on the subcontinent (fig. 107).[12]

While some of the Gilgit manuscripts were copied as early as the seventh century during the reign of Patola Shahi rulers, the style of the paintings on the covers seems not to relate to the sculptures that are definitely associated with this royal family (figs. 43, 44, ch. 4). Moreover, because the wooden covers themselves are not dated, and there is no surviving example of painting of the period from Kashmir proper, their relevance for the history of Kashmiri painting is difficult to gauge.[13] However, in view of the recent emergence of a superbly illustrated wood panel, published here for the first time (fig. 108), the position needs to be reexamined.

From its rectangular shape, the panel was likely used as a book cover, though for a manuscript that was smaller than both the Gilgit and western Tibetan manuscripts (figs. 109 a, b). The pages would have been made of birch bark. One panel shows a single composition with the enthroned Buddha preaching before an assembly of bodhisattvas, *naga*-s, and other Buddhas (fig. 109 b). Such congregational scenes are first encountered in stone sculpture in the art of Gandhara, then among the murals at Ajanta and central Asia and in early Tibetan paintings. However, the composition on the book cover is one of the liveliest and most elaborate among portable Buddhist paintings of South Asia.

Wearing a red robe, the Buddha is seated in the center on a throne with a green triangular backrest. He sits in the classic yogic posture (*paryankāsana*), his hands forming the turning of the wheel-of-law gesture. He is immediately surrounded by a jostling group of listeners who include Buddhas and bodhisattvas. On either side of this group are two registers of figures. The upper tier depicts Buddhas with different complexions and garments of diverse hues seated on lotuses. Unusually, some hold lotuses by their stalks. In the lower register are serpent deities obviously emerging from the waters with offerings. The central Buddha's throne could have been atop a lotus also rising from the ocean in which case the scene would represent the divine assembly that begins the famous *Prajñāpāramitā* text.

The only other similar representation of such a scene is a smaller composition in a *Prajñāpāramitā* manuscript preserved in the Poo monastery (fig. 110).[14] However, both stylistically and aesthetically, the Kashmiri cover is clearly a more animated composition

108

109 a

109 b

and earlier. Although Deborah Klimburg-Salter does not suggest a precise date for the Poo illustration, from the context of her discussion and general stylistic characteristics, the eleventh century would be an appropriate date. In that case, a tenth-century date for our cover would be a reasonable assumption. One of the great mysteries has been the absence of any Kashmiri manuscript in the Tibetan monasteries, though many libraries remain to be inventoried. Could this manuscript cover point to the first missing link?[15]

Stylistic comparisons reveal a close kinship between this extraordinary cover and the murals of Tabo in Himachal Pradesh. The bodhisattvas here are adorned equally ornately with sumptuous jewelry though of different designs. The aureoles behind the Buddhas here are similarly filled with radiating rays though in a simpler form than that seen in Tabo. The central Buddha's flesh is highlighted with similar orange pigment in both. The closest similarities are in the proportions and physiognomic features of the two Buddhas (fig. 111).

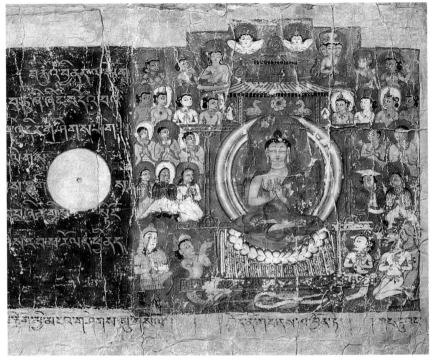

110

These Tabo murals are of the eleventh century, but the book cover probably reflects the tenth century Tabo style, now mostly lost.

In his monumental study of Tibetan thanka paintings published in 1949, Giuseppe Tucci brought a number of brilliantly illuminated pages of a *Prajñāpāramitā* manuscript to the attention of scholars. These are now in the Los Angeles County Museum of Art (LACMA) and have been frequently published as examples of western Tibetan painting (figs. 109 a, b).[16] But like the early murals of western Himalayas, these small pictures too clearly reveal close associations with contemporary Kashmiri sculptures (fig. 112; fig. 92, ch. 4) and may well have been rendered by Kashmiri artists in the train of Rinchen Sangpo.

Recently, several other isolated manuscript pages with richly colored illuminations have come to light which are clearly by different hands than the LACMA pictures but certainly reflect the same aesthetics and broad stylistic features (figs. 113–115). Other than the fact that they are surrounded by texts in the Tibetan script, the illuminations, whether in the figural forms with prominent shading to emphasize the volume, the luminous coloring with yellows and oranges for the flesh tones, the rainbow haloes, the rich and varied designs of the textiles, and the flamboyant architectural patterns, have little to do with the Tibetan ethnic or cultural milieu. Indeed, the striking representation of the deified monk with his facial features, and especially the prominent nose, can still be recognized easily in contemporary Kashmiri faces.

Another extraordinary and intriguing document of graphic art to emerge from western Tibet, but relevant for the history of Kashmiri painting, is a lightly-tinted drawing of a cosmic being on one side and symbols on the other (fig. 116). Despite the Tibetan inscriptions, the exact religious use or significance of the object is yet to be understood. What is clear, according to Amy Heller who is studying the document, is that it was part of a death-delaying ritual performed for the son of King Zhiba 'od (1016–1111) of Guge.[17] The identity of the cosmic figure is also uncertain. The boar's head attached to the human head as well as to the mantra suggests the esoteric and powerful goddess Vajravarahi but the

111

112

113

anatomy of the figure does not proclaim the gender unambiguously. However, the figural form and proportions as well as the physiognomy strongly indicate a Kashmiri association.

Among the most unusual and dynamic examples of Kashmiri painting to emerge from Tibet in recent years is a group of wood panels that were first seen in 2003 in the *Himalayas* exhibition (figs. 117 a, b; 118).[18] An additional piece in the Kronos collection (fig. 119) increases the number of panels to eight. There can be little doubt that these highly energetic images of wrathful deities closely conform to a similar figure at LACMA (fig. 109 b), to others painted in western Tibetan temples, and to Kashmiri sculptures (figs. 112; fig. 92, ch. 4). The heavy shading of the figures to convey volume, the forceful expressions on the faces, even of the bird-heads, and the transparency of the garments as opposed to the sumptuous textiles and ornaments of the Alchi compositions (now thought to have been executed in the twelfth or thirteenth century) would suggest an earlier date for these remarkable paintings, perhaps closer to the mid-eleventh century murals of Tabo.

FIG. 111
Maitreya, eleventh century
Mural painting at Tabo, Himachal Pradesh

FIG. 112 ❊
Angry form of Manjushri (?), tenth century
Brass, silver
H. 3 1/4 x W. 2 15/16 x D. 1 5/16 in.
(8.2 x 7.5 x 3.3 cm)
Private collection

FIG. 113 ❊
Prajñāpāramitā manuscript page
with three illuminations, eleventh century
Colors on paper
H. 7 1/8 x W. 25 5/8 in. (18 x 65 cm)
(ill: H. 3 1/4 x 2 15/16 in. [8 x 7.5 cm])
Mr. and Mrs. Chino Roncoroni

FIG. 114 ❊
Fragment of an illuminated manuscript page
representing a bodhisattva, eleventh century
Colors on paper
H. 4 5/16 x W. 4 1/8 in. (11 x 10.5 cm)
(ill: H. 3 3/16 x W. 2 15/16 in. [8 x 7.5 cm])
Mr. and Mrs. Chino Roncoroni

114

Originally the panels formed parts of a wooden mandala of the esoteric deity Chakrasamvara, though we cannot be sure how they were fitted together. As far as is known, no other examples of similarly painted detached pieces of a mandala have been found so far from either the subcontinent or western Tibet. Very likely, they were kept in a compact storage box to be put together when required. Their excellent condition indicates that they were treasured objects not too frequently used. That Kashmiri artists were highly skilled in painting mandalas is evident from the many mandalas that adorn the walls of Tabo and other temples built in the eleventh century in the Himalayas. The tenth-century biography of the Tibetan monk, Rinchen Sangpo, also informs us that while in Kashmir "he paid his respects to the Kashmiri scholar *Dharmaśānta* with whom he studied and translated the Vajradhatu liturgy together with the mandala?"[19] Later, upon his return to his homeland and learning about his father's death, "he arranged for seven *Durgatī-pariśodhana* mandalas to be done."[20] We do not know whether these mandalas were rendered on cloth or on wood.

Considering that vast amounts of Kashmiri bronzes have emerged from Tibetan monasteries and an enormous quantity of eleventh- and twelfth-century paintings on cloth, known as thankas, have survived in Central Tibet, the paucity of Kashmiri or western Tibetan style thankas is rather surprising. The literary evidence is also not abundant. Apart from the mandalas Rinchen Sangpo dedicated for the benefit of his father, he also commissioned others for his mother, both to extend her life and to commemorate her. Likely these were painted on cloth.

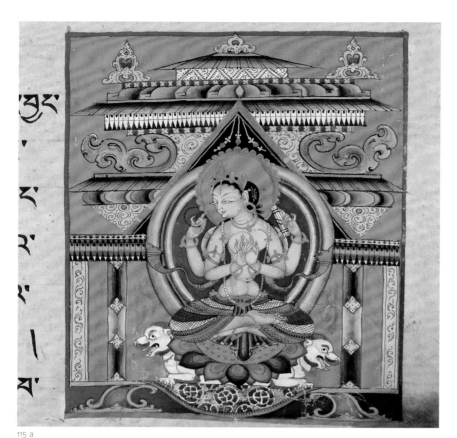

115 a

FIG. 115 a, b ❋
Two fragments of illuminated manuscript pages representing Prajñāpāramitā, twelfth century
Paper, manuscript pages
a: H. 21 11/16 x W. 7 11/16 in. (55 x 19.5 cm)
 (ill: H. 4 1/8 x W. 4 15/16 in. [10.5 x 12.5 cm]);
b: H. 7 11/16 x W. 5 15/16 in. (19.5 x 15 cm)
 (ill: H. 4 15/16 x W. 3 15/16 in. [12.5 x 10 cm])
Mr. and Mrs. Chino Roncoroni

FIG. 116 ❋
Cosmic Vajravarahi Dakini, eleventh century
Paper, painting on both sides
(one side shown here)
H. 31 1/2 x W. 11 13/16 in. (80 x 30 cm)
Mr. and Mrs. Chino Roncoroni

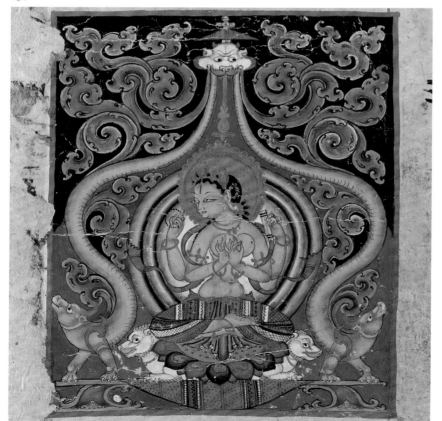

115 b

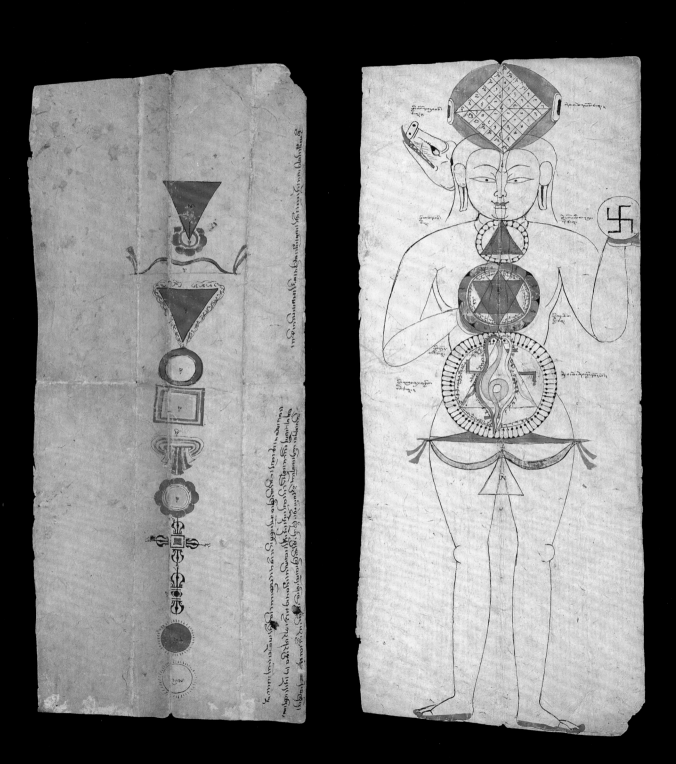

117 a 117 b

Fig. 117 a, b ❖
Two panels with divinities of the
Chakrasamvara mandala, eleventh century
Pigment on wood
a: H. 13 13/16 x W. 2 7/8 in. (9.6 x 7.3 cm);
b: H. 3 3/4 x W. 3 1/16 in. (9.5 x 7.7 cm)
Pritzker Collection
344

Of the surviving early thankas from the western Himalayas, the most cogent for us is a well-preserved example in the Pritzker collection (fig. 120). The thanka shows a meditating Buddha wearing a checkered robe within a shrine flanked by two bodhisattvas who are distinguished only by their complexions. Beyond the ornate arch with scrolling tails of ganders (*haṃsa*) are two groups of figures, mostly bodhisattvas on one side and monks on the other. At the apex is a flying Garuda grasping the tails of two semi-anthropomorphic serpents. Another group of bodhisattvas and monks sit along the bottom.

Although the Buddha is not preaching, clearly the subject and composition are reminiscent of the earlier book cover. I have discussed the stylistic traits and parallels elsewhere but a few additional points will be made here to emphasize why this may well be a work of a Kashmiri artist.[21] Noteworthy is the fact that no Tibetan, either patron or monk, is included here. The figural forms are clearly of Kashmiri types rather than Tibetan. While the central figures do not reveal the modeled forms of the Kashmiri tradition, the heavier shading of the aureoles and the architectural spaces reflect the Kashmiri manner of expressing three-dimensionality. Similar shading has also been employed in some of the seated figures at the top, but not as boldly as in the book cover or the mandala panels. The stronger emphasis on linear definition probably indicates a date after the Tabo murals or the earlier paintings included here.

Reading this chapter so far, the reader may wonder whether followers of the Brahmanical/Hindu faiths used paintings in their temples and rituals as did the Buddhists. Unfortunately, the material evidence is nonexistent. However, the textual references discussed earlier make it abundantly clear that painting was extensively employed in Brahmanical worship. The instructions and theoretical discourses in the *Chitrasūtra* about painting—among the earliest of this genre in Sanskrit literature—presuppose familiarity with artistic practice. Kashmir was also one of the most active centers for discussions about the polemics of Indian aesthetics in the ninth and tenth centuries. Most of the theoreticians, such as Anandavardhana or Abhinavagupta, belonged to brahman families.

Apart from the theological and rhetorical literature, allusions to painting are also scattered among the many literary works of Kashmiri authors. It will not be possible to compile all of them here but a few from the *Rājataraṅginī* will be appropriate. On several occasions Kalhana refers to painted images or pictures to emphasize what may be termed as "immobile realism."

118 a–e

119

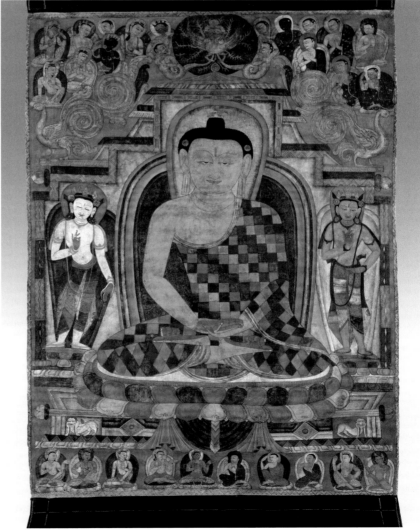

120

FIG. 118 a–e ✿
Five panels from a Chakrasamvara mandala,
eleventh century
Pigment on wood
a: 4 x 3 in. (9.7 x 7.7 cm);
b: 4 x 3 in. (9.9 x 7.9 cm);
c: 3.7 x 2.7 in. (9.6 x 7 cm);
d: 3.6 x 2.7 in. (9.2 x 7.1 cm);
e: 3.7 x 2.7 in. (9.4 x 7.1 cm)
Private collection

FIG. 119 ✿
Plaque with Tantric deity
11th century
Pigments on wood
H. 3 3/4 x 3 1/16 x 3/8 in. (9.5 x 7.8 x 3.6 cm)
The Kronos Collections

FIG. 120 ✿
Buddha with Gods and Monks, twelfth century
Pigment on cotton
H. 42 1/8 x W. 31 1/2 in. (107 x 80 cm)
Pritzker Collection

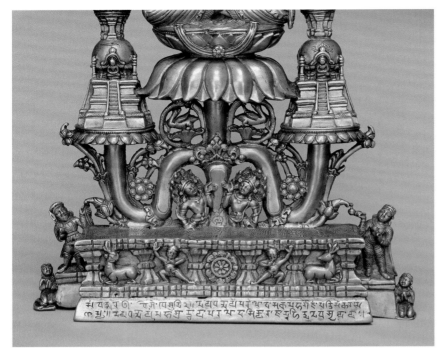

121

FIG. 121 ✤
Crowned Buddha Shakyamuni
(detail of fig. 43), eighth century
Brass with inlays of copper, silver, and zinc
H. 12 1/4 in. (31.1 cm)
Asia Society, New York:
Mr. and Mrs. John D. Rockefeller
3rd Collection
1979.44

Describing two beautiful daughters of a singer at a soiree, Kalhana writes, "His sweet-eyed daughters . . . made those assembled stretch their necks in curiosity and keep [motionless] as if painted."[22] Characterizing the generosity of King Uchchhala (1101–1111), he writes, "He, unlike a tree [which is merely] painted [and hence gives no fruit], gave his rewards on festive occasions . . ."[23] Twice in the text the historian refers to wall painting as well as to the wooden paint brush.[24] Later on in a vivid description of the assassinated king Sussala's (1112–1120) body, like an eyewitness Kalhana writes, "On his face which [in its rigidity] appeared as if painted, the mass of blood which was sticking to it like red lac, had effaced [the forehead] marks painted with sandal and saffron."[25]

Finally, while narrating the life of King Harsha (1089–1101), the poet informs us about the monarch's infatuation with the beauty of the queen of the contemporary Chalukya king, Vikramaditya of Kalyana, with the following sentence: "When [Harsha] saw a picture of Candalā, the beautiful wife of Paramādi, the lord of Karnāṭa, he was struck by the god of love."[26] It was a common practice in ancient India to exchange portraits among royalty before a marriage. This is the first instance I know of a married lady's portrait being available to a stranger. Be that as it may, the art of portraiture was practiced in Kashmir as well, as is confirmed by the discussion of portrait painting in the *Chitrasūtra*. Indeed, the long, erudite, and detailed discussion of the art of painting in all its technical, aesthetic, and formal aspects by the authors would not have been possible if they did not have intimate knowledge about the subject. However, as is clear from the surviving sculpted portraits (fig. 121), the representations were idealized rather than true to life. Painted portraits would have been similarly true to type rather than realistic.

1. Pal 2003, pp. 144–1445.

2. Schokker and Worsley, *The Pādataḍitaka of Syamilaka*, vol. 2, p. 23. "Sir, you know of course that my friend Kusumāvatika is madly in love with your beloved friend Śivasvāmin, the painting teacher." Elsewhere, the poet twice refers to painted images as comparisons: "a man is considered to be pleasing to the eye like a Yaksa in a painting" (p. 25) and again, even an ugly, deformed woman, if full of love, is compared to Lakshmi depicted in a picture (p. 29).

3. See Mitra Shastri, *India as Seen in the Kuttanimata of Damodara Gupta*, p. 230.

4. Kumari, *The "Nīlamatapurāṇa,"* and Ikari 1994.

5. Kumari, vol. 2, pp. 109, 111.

6. Ibid., p. 172.

7. Ibid., p. 192. For the *Vishṇudarmottara* evidence about the painted images of Indra and his wife Shachi, see Sanderson, A. "The Śaiva Religion among the Khmers, Part 1" *Bulletin de l'École française d'Extrême-Orient*, 90–91 (2003–2004), pp. 349–462.

8. Kumari, vol. 2, p. 198.

9. See Sanderson 2003–2004, p. 256.

10. Kumari, vol. 2, pp. 181–83.

11. Ibid., p. 208. This, of course must be the *Devīmāhātmya* which is the most germane text for the worship of Durga and compulsive reading during her ten-day festival in autumn.

12. The Gilgit covers were painted probably between the seventh and ninth centuries. For a discussion see Pal, P. and J. Meech-Pekarik 1988, Buddhist Book Illuminations (Ravi Kumar, Paris, n.d.) pp. 41–44.

13. P. Banerjee was the first to suggest that the illuminated Gilgit covers reflected the lost Kashmiri style of painting but in the discussion cited in the previous note, I had expressed my doubts, as the figural forms related neither to Kashmiri sculpture of the period nor to the tenth- or eleventh-century murals executed in monasteries such as Tabo in Himachal Pradesh. Banerjee, P. 1968 "Painted Wooden Covers of Two Gilgit Manuscripts" *Oriental Art*, (n.s.) 14, 2: 114–118.

14. Klimburg-Salter and Allinger 1998, p. 210, fig. 222.

15. Regarding Kashmiri artists and western Tibetan monasteries, the literature is extensive. See Snellgrove and Skorupski, *The Cultural Heritage of Ladakh*, especially vol. 2, pp. 85–100, for a biography of Rinchen Sangpo; Pritzker 1989 and 1996; Klimburg-Salter 1997; Thakur, *Buddhism in the Western Himalaya*; Luczanits, *Buddhist Sculpture in Clay*.

16. See Pal 1990, pp. 123–26.

17. I am indebted to Dr. Heller for her generosity in sharing her preliminary research with me.

18. Pal, *Himalayas*, pp. 144–45.

19. Snellgrove and Skorupski, vol. 2, p. 88. Note also the epigraphic evidence about the dedication of a stone mandala of Avalokiteshvara in 1236 CE. Deambi 1989; pp. 110–12.

20. Ibid., p. 90. He also had seven mandalas of Amitayus painted to prolong his ill mother's life (p. 91).

21. Pal, *Art from the Himalayas and China*, p. 150.

22. Stein, vol. 1, p. 227.

23. Ibid., vol. 2, p. 6.

24. Ibid., vol. 2, pp. 27, 40.

25. Ibid., p. 105.

26. Ibid., vol. 1, p. 335. Vikramaditya was the patron of the Kashmiri poet Bilhana and also the hero of the *Vikramāṅkadevacharita*.

BETWEEN ANCIENT AND MODERN KASHMIR:
THE RULE AND ROLE OF SULTANS AND SUFIS
(1200/1300–1600)

By Simon Digby

The historical materials for the independent sultanate of Kashmir are copious but need to be treated with caution. The high Sanskrit verse-chronicle tradition of Kalhana's *Rājataraṅgiṇī*, itself peculiar to Kashmir, was continued by Jonaraja and through the reigns of the Muslim sultans until the subjugation of the valley of Kashmir in 1587 by the emperor Akbar. This event virtually brought the tradition to an end; but it also resulted in a proliferation of chronicles in Persian of the reigns of the independent sultans of Kashmir, written by men of Kashmiri descent anxious to preserve and commemorate this portion of their heritage. This tradition, to which Kashmiri Muslims and Persians as well as Kashmiri pandits contributed, continued through the Mughal, Afghan, Sikh, and Dogra regimes down to the last decade of the nineteenth century. The contents of these chronicles have been well worked over by historians writing in English from the middle of the twentieth century to the present day.[1]

The decline which had occurred by the mid-twelfth century (when Kalhana wrote his history) of the power and stability of the Brahmanical/Buddhist kingdom of Kashmir is witnessed in this book by the scarcity of significant works of art about which we can state with confidence that they were fashioned by Kashmiri craftsmen in the valley itself during the twelfth, thirteenth, and fourteenth centuries. There is little evidence of the survival into the thirteenth century of the Kashmiri stone-masonry traditions either of Brahmanical temples or of Buddhist complexes like Parihaspura. The hoard of stone images found underwater at the spring of Verinag was probably deposited there on account of the growth of the local Muslim presence at the end of the fourteenth century.[2] They display a clumsy and mannered execution far removed from the robust and elegant sculptures of the earlier period.

In Kashmir the decline of central power and of governmental institutions under the later Hindu rulers led to the replacement of the old order with its roots in ancient Indian concepts by a state with Islamic institutions of government, ruled by Muslim sultans who had risen to power without help from outside of the valley. A portion of the local population that included influential groups rapidly showed a willingness to abandon their previous beliefs in favor of Islam. Until the Mughal annexation at the end of the sixteenth century, descendents of the royal officers and courtiers of the former Hindu kings continued to hold hereditary power over localities outside the capital city. Prominent among those who played a part in the civil wars of the sultanate were such groups as the Magres (*margiśa or margapati*)—formerly guardians at the *drang*-s (frontier posts) at the passes that gave entrance to the valley—and the Rainas (*rājanaka*), descendants of the rajas of Nagarkot (present-day Kangra), who were the kin of Kota Devi, the last Hindu queen of Kashmir.

Unlike other influential classes of the population, the brahmans of Kashmir for the most part retained their original faith, but there were cases of individuals who either from coercion or attraction converted to Islam. A notable instance in the early Sultanate period was that of Suhabhatta, minister to Sultan Sikander the "idol-breaker," who, after his conversion, actively supported the sultan in this policy. He married his daughter to Mir Muhammad Hamadani the evangelist, the role of whose family and supporters in the transformation of Kashmiri culture we are about to discuss.

<<
Detail of fig. 129, ch. 6

The Destruction of Royal Authority by Mongol Raids

There is also evidence of Chingizid Mongol raids into Kashmir from the thirteenth century onwards. There was an occupation of the valley by an imperfectly identified Mongol invader called Dalacha or Dhulchu (and variants) by the Kashmiris that is said to have lasted for eight months. Later Kashmiri sources assert that he occupied and ravaged the valley for eight months. Dhulchu caused major destruction before he attempted to leave the valley.[3] It was said that only twelve inhabitants survived in Srinagar. In the countryside the crops were left unsown.[4] When famine forced him to leave he is said to have perished in a snowfall on the Banihal Pass, together with all his followers and captives intended for slave-markets.

The valley had fallen into a state of chaos and confusion from Dhulchu's ravages, and the resulting famine and its consequences were remembered generations later. The local contenders for the throne had fled or shut themselves up in forts, and in their absence the peasantry of the villages is said to have combined in measure for its own survival:

> In each pargana, forty or fifty villages formed a group and chose one person as their leader. They procured various kinds of weapons and resolved to protect their families, their lives and their property. In due course they captured a fort in each pargana, appointed a kotwal to take charge of it and claimed to be independent. None of them felt obliged to yield to the authority of others . . . [5]

> Although some of them did recognize the authority of the governor of the City (Srinagar), and sent presents and gifts to him, yet strictly speaking they did not observe the norms of loyalty and submission . . . [6]

> They were not prepared to submit themselves to one another's authority.[7]

Such populist memories of communal self-help strengthened a perception of the inalienable rights of local groups against the overriding authority of the sultans. This was a factor in the bloody and recurrent civil wars of the next two centuries, until the Indian Mughal annexation deprived all classes of the Kashmiris of control over their country's destinies.

The Open Frontier to the Northwest

The strongest influences in the pattern of Islamization in Kashmir did not come from the Indian plains, from which Kashmir had been so long isolated by the conquests of the Arabs and Ghaznavids, but rather from Transoxania and Iran. In the eleventh century, the unsuccessful attacks of Mahmud of Ghazni on the valley of Kashmir led to a virtually complete closure of the passes from the Indian plains.

Access to Kashmir from the more open northwestern frontier or from adjacent valleys appears to have been less affected. Muslim soldiers who are mentioned as being in the employment of the kings of Kashmir in the late eleventh and twelfth centuries may have come from the northwest.[8] The early thirteenth century saw the entry and rise to power of the two already somewhat Islamicized war bands whose chieftains were the

progenitors of the successive dynasties of the sultans of Kashmir. There was also an isolated case of a defeated and fugitive prince from Ladakh who arrived in Kashmir with a few followers and converted to Islam after his arrival. At the irruption of Dhulchu the precipitate scattering of the current contenders for the throne of Kashmir brought into greater prominence two Muslim contenders for power from the peripheries, one of whom—Rinchen—was a fugitive member of the Tibetan ruling dynasty of Ladakh who converted to Islam after establishing himself within Kashmir below the Zoji-La Pass. Rinchen was the first Muslim to rise to the throne. He was converted to Islam in 1320, giving rise to a new Kashmiri era. His rule lasted for three years from 1320 under the title of Sultan Sadr al-Din. His rule was supported by the immigrant Chaks and the Magres who had a longer history in the valley.[9] The second Muslim chieftain who rose to power in Kashmir was Shah Mir. He ascended the throne in AD 1399, taking the title of Sultan Shams al-Din.

Traditions are vague regarding the origins of his group, which is said to be comprised of immigrants from Swat (Pakistan), like their later rivals the Chaks, and evidently to have come from beyond the northwestern borders of the valley. Shah Mir was of service to Suhadeva and his brother Udayadanda in their struggle with the Lavanyas and Damaras, "local chiefs...who had become the most powerful elements in the Valley."[10] Unlike the Chaks, their followers do not seem to have left numerous descendants, which may have been a cause of instability in their two centuries of rule.

Kashmir's links with older and more civilized areas of Asia were renewed further north and west than where the homelands of the newly-established tribal immigrants lay, since those areas were still recovering from the ferocity and devastation of the initial attacks of the Mongols in the early thirteenth century. It was mainly the result of influences from these directions that the conversion to Islam of the population of the valley of Kashmir proceeded. In the late fourteenth and early fifteenth century, three important groups entered Kashmir from the more distant lands to the west, where Islam had been long established. These groups were related not only by physical descent and intermarriage and common regional origin, but also by their spiritual descent in the Kubrawiyya Sufi lineage. Members of these groups also exercised great influence in the internal politics of Kashmir during the Sultanate period and at later dates.

Previous Links with Iran: The Buddhist Diaspora

By contrast, with a lack of production and patronage in the valley in the thirteenth century and later, the high literate and cultural traditions of earlier Kashmir seem at this period to have had worthy representatives in a diaspora of scholars and craftsmen who served sympathetic patrons in adjacent territories. We have evidence of their activities in superb metal images in the later Kashmir style from Ladakh and Western Tibet, matching the glories of the wall-paintings and painted clay statuary of Alchi, Spiti, and Tabo, equaled by the activities of Buddhist pandits, not only in Tibet but more surprisingly in Iran (figs. 122, 123). With the establishment of the Ilkhanid branch of the Mongol dynasty in Iran, we have evidence of the activities of Kashmiri Buddhist pandits in western Asia, arguing with Muslims about religion and providing evidence that was recorded in Persian and Arabic sources. In the early years of the thirteenth century, one such wanderer called Kamalashri provided information on India with a sketch of the life of the Buddha for a great project of universal history issued in both Persian and Arabic, the Ilkhanid minister Rashid al-Din's *Jami'al-tawarikh,* or *Compendium of World Histories* (fig. 124).[11] It is possible to see a link between this Kashmiri Buddhist diaspora and the

122

123

subsequent uncommon pattern of the Islamization of Kashmir from the lands of Iran and Central Asia. Shaykh 'Ala al-Dawla Simnani—a key Sufi figure who had connections at the court of the Ilkhan Arghun, ruler of Iran—has recorded a sophisticated dialogue that he held with an Indian *bakhshi* (from *bhikshu*, meaning "Buddhist monk").[12]

The Buddhist monk argued that violence against any living creature was against the teachings of the Buddha (Shakyamuni) that forbade violence even to the grass on which one trod. The gist of 'Ala al-Dawla's reply was that he was familiar with the teachings of Shakyamuni on the topic, but the killing of those who were not believers was like the action of gardeners, who prune the branches of fruit-bearing trees in order to improve their yield. By the act of *jihad* mankind is made more obedient to God's will. This conversation of 'Ala al-Dawla indicates a sophisticated level of religious discourse and is relevant to the subsequent course of Muslim evangelization in Kashmir. One may recall that *jihad* has the etymological sense of "striving," specifically to promote Islam.

Interfaith dialogue in these courtly circles did not endure much longer. In 1295 the Ilkhan Ghazan was converted to Islam as a prelude to ascending the throne. He told the Buddhists: "Let those among you who wish to return to India, to Kashmir, to Tibet, and to the countries whence you came do so."[13] Their temples and their images were destroyed, and many of the priests became Muslims. Mention is made of gold and silver images.[14] Art historians may regret that no fragments of these Buddhist images have come to light.

The Political and Religious Scene in Iran and Transoxania in the Fourteenth Century

After the initial ravaging by the Mongol armies of Genghis Khan and massacres of the settled urban population in Iran and Transoxania, new and relatively stable state-formations

FIG. 122
Stucco image of Avalokiteshvara
with painted murals
Sumtsek temple
Alchi Choskhor, Ladakh

FIG. 123
Image of the Buddha, eleventh century
Mural paintings, Tabo monastery,
Himachal Pradesh

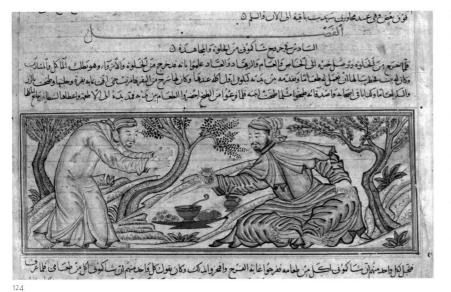

124

FIG. 124
Shakyamuni offering fruit to the Devil
From the *Jami' al-Tawarikh* (Compendium
of Chronicles) of Rashid al-Din
Iran, Tabriz, 1314
Ink and watercolors, gold and silver on paper
H. 3.7 x W. 10 in. (9.5 x 25.5 cm) (painting)
Nour Foundation, Courtesy of the Khalili
Family Trust

had come into being within a couple of generations. They were ruled by the different lines of descendents of Genghis Khan: Ilkhanids and Chaghatayids. These Mongol rulers themselves converted to Islam and governed with the help of a highly literate class of local intelligentsia employing Persian and Arabic as languages of administration.[15] The most influential figures out of those who now preached Islam in Kashmir also came from this class. The form that this conversion took was colored by the background and training of those who brought it.

In Iran the rule of the Ilkhanids broke up in civil disorder. Members of the old landholding, learned, and pious Muslim administrative class, from which such men as 'Ala al-Dawla and Ali Hamadani sprang, found themselves obliged to leave their ancestral homes, and strive to build up alternative shelters and maintenance elsewhere. This transformation was effected by Sufi shaykhs who also came from this class, themselves becoming nomadic leaders of large and well-organized bands of followers. These men often traversed great distances, imparting Islamic teaching. They endeavored to build up a following and in some cases to extend their influence simultaneously in several areas that were remote from one another.

The figure of the wandering Sufi far from home searching for a predestined place in which to settle and to exchange his religious and ritual services for the support of a clientele of devotees had been familiar for several centuries in the eastern lands of Islam and particularly along their peripheries. More characteristic of these lands in the later-fourteenth century is the presence of large migratory caravans under the chieftainship of a Sufi shaykh, associated with prestige of lineage and learning. These large bands were capable of traveling together through many months over thousands of miles, sometimes doubling as pastoralists with thousands of animals. They evidently also included migrants with urban, courtly, and religious skills and (though this is not usually dwelt upon in the hagiographies) were capable of defending themselves. We have a description of those who arrived in Kashmir with a major shaykh in the early-sixteenth century. As he traveled, Mir Shams al-Din 'Iraqi had deputies in charge of the mounts and beasts of burden, of the kitchen and food supply, and the beverages and drinking vessels. He was made custodian of all the sweetmeats and various kinds of medicinal compounds which were a specialty of the shaykh. Another hajji was placed in charge of the wardrobe of the shaykh.[16]

In the late-fourteenth century the recent political changes gave urgency to the process of migration from the old urban settlements of Iran to such distant areas as would furnish opportunities. There was a proliferation of traveling Sufi shaykhs accompanied by numerous companions over whom they exercised an authority independent of local power holders. These Sufi shaykhs enhanced their authority by repeated pilgrimages to Arabia and to other revered sites, and were on the lookout for places where they could found and build new Sufi hostels (*khanaqah*-s), with a local population of potential devotees, patrons, and clients willing to give them living space and maintenance. The most prominent and influential of those who came to Kashmir were two Sufi

shaykhs in the influential Kubrawiyya Sufi lineage, Sayyid Ali Hamadani and his son Mir Muhammad. Political changes favored their initial move from Iran to Transoxania and their later eastward migration to Kashmir, a borderland at the frontiers of Muslim government and control.

Sayyid Ali Hamadani was from the class of theological and administrative families, who had settled in Iran for several centuries. His father had been civil governor of Isfahan under the Ilkhanid rulers, and—as frequently happened to such high civil servants—had been executed. He was in the circle, and possibly the nephew, of Shaykh 'Ala al-Dawla Simnani. Shaykh Ashraf Jahangir Simnani was another nephew in whose company Ali Hamadani traveled for several years.[17] Their later courses show a parallel evolution, leading to the establishment of influential *khanaqah*-s on a frontier of Muslim rule.[18] Many others of the Simnani circle set out for Bijapur, another frontier of Islam in India.[19] Other Irani shaykhs found the prospects of establishing a new *khanaqah* in Transoxania more appealing than India. Their motives and political assessments are not always apparent from the accounts of the hagiographies.

Sayyid Ali Hamadani left deputies and disciples to maintain the *khanaqah* at Khuttalan while he was absent on his travels; but we need not doubt that Timur was distrustful of Irani sayyids setting up in Transoxania and also of what might be going on in Khuttalan.[20] A second base outside the long reach of Timur was desirable. Hence there is no cause to reject the account of a Kashmiri historian that, when Sayyid Ali Hamadani intended to visit Kashmir, he was first of all anxious to ascertain that it was a region beyond the reach of Amir Timur's influence:[21]

He sent these three personages to Kashmir to ascertain whether the land of Kashmir was free from any connection with Amīr Timur Gūrkān. In this case they should write back to him and he would come to that land with his companions.

At the end of the fourteenth century the entry into Kashmir of Sayyid Ali gave impetus to the rapid and mainly voluntary conversion to Islam of a large section of the population of Kashmir, while also contributing to the development of forms of cultural expression and of social behavior which differed markedly from those of down country India. The violence of the sectarian division between Sunnis and Shias that marked Kashmir in the following centuries also reflects the course of development of different groups among these related evangelists.[22]

The Hamadani Sufis during the Early Sultanate Period

The oldest of the surviving Persian histories of Kashmir describes the lavish welcome given by Sultan Shihab al-Din to the emissaries from Mir Ali Hamadani when they came to Srinagar. He had previously established a center for his activities at Khuttalan (Kulab) in Badakhshan (present day Tajikistan). The maintenance of such a long-distance linkage was effective and long-lasting. Sayyid Ali Hamadani's son later came to the valley at the sultan's invitation but left abruptly after years of residence to return to Khuttalan.

The visits to Kashmir of these two itinerant figures, father and son, whose Iranian background and network of influence we have discussed, had a permanent influence in consolidating the rather light Islamicization that had taken place in the previous years of the fourteenth century. It is likely that both father and son made single visits enduring several years, accompanied by a large number of followers, recorded as 700 and 300 in number. These numbers appear plausible for self-sufficing migratory caravans that were continually crossing vast areas of the so-called lands of Islam. For survival through such

125

FIG. 125
The Zainakadal bridge with the Shah Hamadan
mosque in the background, Srinagar

journeys, the leaders and their followers must have possessed specialized skills and competence as well as piety and learning. Sayyid Ali Hamadani's visit possibly lasted for four years from 1381 to 1385, and that of his son Mir Muhammad for a longer period of twelve years from 1393 to 1405.[23] Mir Muhammad was only 22 years old when he arrived to take up this authoritarian role in Kashmir. Both father and son appear to have left Kashmir in similar circumstances, as a result of the unwillingness of the sultan of the day (Sultans Qutb al-Din and Sikander) to enforce measures prescribed in Islamic sharia law discriminating against non-Muslims and prescribing the destruction of "idol houses."[24]

After extensive patronage and largesse to the Hamadani/Kubrawi immigrants, the reaction of both sultans to their demands for the implementation of Islamic sharia law with regard to discriminatory taxation of non-Muslims and destruction of their places of worship was influenced by the need to consolidate a basis of loyal adherents affording military and administrative support against rebels and rivals to their own precarious authority. Such needs dictated terms of alliance with groups of power holders, within the valley and in the tribal groups on its peripheries. One may note the remark of the Sanskrit historian Jonaraja, evidently around the time of the departure of Mir Muhammad Hamadani that Sultan Sikander "fixed with some difficulty a limit to the advance of the *yavana*s [Muslims]."[25]

Though both father and son in turn departed for another base of their network— Khuttalan in present-day Badakhshan—they left numerous kin and followers who continued to enjoy the land-assignments made by the sultans, and have continued to influence the religious and popular culture of the valley. In two respects they appear to

have exercised a decisive effect upon the evolution of popular culture in the valley. Notwithstanding the suspect hagiographic traditions with regard to Sayyid Ali Hamadani's travels and conversions in the valley, it seems likely that he and his Kubrawi Sufi group initiated the process of extending recognition of spiritual status to the Kashmiri ascetics known as *rishi*s.[26] In many cases this has led to the reappropriation of sacred sites associated with original *naga* guardians to popular tomb-cults of holy men in the medieval Sufi tradition. A nineteenth-century observer has described such structures as "pretty shrines of carved wood and roofs bright with the iris flowers where the saints of past time lie . . . When one sees the Musalman shrine with its shady chenars and lofty poplars, a little search will discover some old Hindi Asthan."[27]

Fig. 126
Interior of the prayer chamber of the Jami Masjid, Srinagar

Reinvented Architectural Forms

The adoption of the characteristic indigenous wooden style to suit Muslim religious and devotional needs dates from the critical early stage in the Islamicization of the valley. It appears to reflect the enterprise and planning of the two great Kubrawi Hamadani Sufis who played a critical part in the process. They traveled with large caravans of followers, many of whom possessed practical skills and powers of organization. On the second occasion there were two architects in the party who were capable of visualizing how to build using local workmen and traditional techniques and with local resources that included the trunks of the huge deodars and indigenous building tradition, two structures for Muslim worship that remained a pattern for subsequent generations in the valley—the Shah-i Hamadan mosque and the Jami Masjid (congregational mosque) in the "City of Kashmir" (Srinagar) (figs. 125, 126).

In 1396, Sultan Sikander began the building of the *khanaqah* of Sayyid Ali Hamadani, and it was completed in 1397. The sitting place of Sayyid Ali Hamadani is located in a corner of the site and is a place of circumambulation by great and small. After the completion of the work of building the *khanaqah*, Sayyid Muhammad Hamadani gave a ruby of Badakhshan as a blessed offering to Sultan Sikander.[28]

In 1399 Sultan Sikander, with the assistance of Sayyid Muhammad Hamadani, destroyed a large idol-house in the *mahalla* of Sikanderpura. In accordance with the

126

127

blessed tidings of Allah who "builds a house in paradise for the man who builds a mosque," he constructed a mosque which has no equal. Three hundred and seventy-two pillars were set up in it. Thirty two of these pillars were erected in the four mihrabs which were forty *shar'ī gaz* in height and 6 *gaz* in circumference.

Among the architects of the building was Khwaja Sadr al-Din, a skilled architect, who had come from Khurasan in the company of Sayyid Muhammad and Sayyid Muhammad Luristani, who had great skill in the art of construction.[29] With the help of local craftsmen in the space of three years the work of constructing the Jami Masjid was completed in the year 1402. The continuity in the observance of the original plan, in spite of at least three destructions by fire and restorations and periods of prolonged neglect, is attested by the fact that the present structure has 378 pillars in place of the 372 of this sixteenth-century account.

We have noted that the traditions of figural sculpture and painting seem to have disappeared in Kashmir about a couple of centuries before the rise of a native dynasty of Muslim sultans. "The classical, aristocratic and hierarchical development represented by the stone monuments the Buddhist-Hindu period" seems to have had no comparable successors in stone masonry in the same period of darkness (fig. 127).[30] The local vernacular architectural tradition which survived and flourished almost down to the present day was supported primarily by one of the great natural resources of the valley, the abundant supply of magnificent wood for building. "In no other part of India," Percy Brown wrote, "was serviceable timber available in greater quantities or more readily accessible.[31]" The timber normally used grew on the slopes of the high mountains that enclose the valley on either side. It was that of the deodar or Himalayan cedar (L. *cedrus deodara*; in Sanskrit, *devadāru*, "tree of the gods" or "divine tree"), that we have noted could be floated down to its destination on the waterways of Kashmir with relative ease. Another rapid innovation prompted by the influx of the Hamadanis was use of the deodar trunks of the Kashmir mountainside in the construction of the great cantilevered wooden bridges over the Vitasta that were so notable a feature in the townscape of Srinagar. The first of these was completed some decades later, in the reign of Sultan Zain-ul-Abidin (figs. 128, 129).[32]

The traditional building techniques could afford to be prodigal in the use of such a material. The wood is hard and resistant to parasites, and in cold areas adjacent to Kashmir—for example, at Alchi, Spiti, Brahmor—architectural wood carvings that are up to a thousand years old continue to survive in the open air. Leaving aside earthquakes, in Kashmir the principal agent of destruction appears to be fire, which in particular has devastated the "City of Kashmir" with great frequency. "Although the foundations of several of the more important constructions date from an early period of Muslim rule, little of their original structure remains, most of it consisting of later replacements."[33]

Wooden structures that predate Muslim rule do not appear to have survived in Kashmir, but we have evidence that such structures must have coexisted with the stone monuments of the Buddhist-Hindu period (fig. 41, ch. 3).[34] Parallels have been

drawn between the wooden mosques and *ziarats* of Kashmir and the timber con-
structions of other mountainous countries when resemblances of style—for example,
sloping roofs rising in tiers and proofing against surface water with layers of birch
bark—are obviously not due to any common origin, but one may see links of stylistic
influence and cultural transmission in the traditions of timber and brick religious and
civic architecture that stretch eastward along the Himalayas through Himachal and
Uttaranchal at least as far as Kathmandu Valley. What is clear is that the vernacular
style of the wooden Sultanate religious architecture of Kashmir is not a wholesale
import from any other area of the medieval world of Islam. It is sad that so much of
it is now in imminent danger of replacement by examples of the so-called post-
Anglo–Mughal and Wahhabi concrete styles.

128

FIG. 128
Silver coin from the reign of Zain-ul-Abidin
reads, "The Mighty Sultan Zayn al-'abidin
[year] 842 [1438–9]"
Tr. Simon Digby, 2007
Trustees, The Chhatrapati Shivaji Maharaj
Vastu Sangrahalaya Museum, Mumbai

FIG. 129 ❖
Stele with Persian inscription in Arabic Script
including the name of Zain-ul-Abidin,
about 1475
Schist
H. 20 7/8 x W. 12 5/8 x D. 2 3/4 in.
(53 x 32 x 7 cm)
Sri Pratap Singh Museum, Srinagar
5034

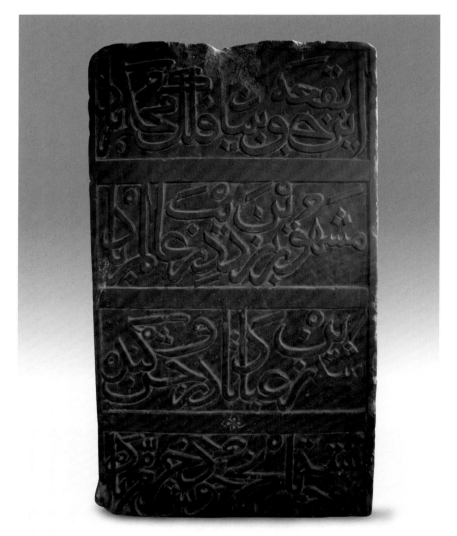

129

1. G. M. D. Sufi, Parmoo, Kapur, Mohibbul Hasan, Bajjaj and others.

2. Now mostly preserved in the Sri Pratap Singh Museum, Srinagar.

3. The name by which he was remembered in Kashmir possibly means "commander." He has recently been identified with a Mongol commander called Oqotur, said to have ravaged Kashmir for six months after 1235; see P. Jackson, *The Delhi Sultanate: a Political and Military History*, Cambridge 1999, p. 105

4. *Baharistan-e Shahi*, tr., p. 31.

5. *Baharistan-e Shahi*, tr., p. 19.

6. Ibid., pp. 31–32.

7. Ibid., p. 19.

8. Kalhana, *Rājataraṅgiṇī*, book 2, vss. 68–69; Rafiq, 2003, pp. 2–3.

9. G. M. D. Sufi, *Kashmir*, Lahore 1949, I, 120–7; Mohibbul Hasan, *Kashmir Under the Sultans*.

10. Rafiqi, 2003, p. 3.

11. Amir Iqbal Sistani, *Chihil majalis-i 'Alā al-Din Simnani*, Tehran.

12. Basil Gray, *Persian Painting* (Geneva: Skira) 1961; facsimile reprint edited by Karl Jahn, *Indien Geschichte* des *Rasid al-Din*, ed. and trans. Karl Jahn. Wien 1980, pp. 9–19, pl. 1, 43.

13. Rashid al-Din, ed. 'Alizade, In. 396–7. *Cambridge History of Iran*, V, 544; Rafiqi, *Sufism in Kashmir*, 2003, pp. 6–7 and n. 30.

14. Bar Hebraeus, cited in *Cambridge History of Iran*, vol. 5, p. 380.

15. We have already noticed the level of dialogue between a key member of this class and Sufi 'Ala al-Dawla the Ilkhanid (Chingizid) ruler and his most influential commander the Amir Chuban.

16. *Tuhfat al-ahbab*, pp. 12–13; the Persian text reproduced in M. A. Wani, in Deambi, *Kashmir and Central Asia*, p. 63.

17. Rafiqi, 2003, p. 41.

18. After years of wandering with a large band of followers Ashraf Jahangir founded his *khanaqah* at Kichhauch in eastern Awadh. From the predominantly Hindu population he converted a group of *jogi*s who were in previous occupation of the site. He left this *khanaqah* in the hands of some of his followers for several more years of travelling, but returned before there he died at advanced age. In the manuscript of the collection of his letters there are some addressed to the sultans of Jaunpur and Mandu; and at the close there is a largely fictitious history of his ancestors as "Kings of Simnan" for over many centuries, who had married daughters of the Samanid and Saffarid dynasties.

19. 'Abd al-Haqq, *Akhbar al-akhyar*, Matba``I, Delhi 1309/1891, p. 161.

20. Members of the Tajik ruling family in Khuttalan were executed by him, and in 1413 Timur's son Shahrukh put to death one of Ali Hamadani's older disciples. Khwaja Ishaq Khuttalani; Rafiqi, 2003, p. 117.

21. Sayyid Ali, *Ta'rikh-i*, Kashmir, Urdu tr. Srinagar 1994, 1. For a contrary opinion of this tradition, see Rafiqi, 2003, p. 41.

22. Sayyid Muhammad Nurbakhsh was a *khalifa* in the Kubrawi lineage of Ali Hamadani, and the son of a sister of 'Ala al-Dawla Simnani.

23. The chronology is competently discussed in Rafiqi, 2003, pp. 42–44, 49–50, 119–23.

24. Persian *but-khana*, Hindu, or Buddhist temples.

25. Dutt, *Rājataraṅgiṇī of Jonaraja*, p. 65. Rafiqi 2003, p. 123; Rafiqi (p. 123, n. 172) suggests that Jonaraja reserved the term *yavana* for the Sayyids, using *mlechcha* for Muslims in general.

26. Rafiqi 2003, pp. 159–208; Khan, 2002.

27. Lawrence, *The Valley of Kashmir*, p. 286. As in the urban architecture of Srinagar, the roofs with picturesque birch-bark flowerbeds of tulips and irises have given way to sheets of corrugated iron.

28. The *la'l-i badakhshan* is in modern jeweler's terminology a *spinel* or *'balas ruby*. Khuttalan, whence Sayyid Muhammad had come to Kashmir, is adjacent to Badakhshan.

29. The Urdu translation reads *Nuristani*.

30. Brown, *Indian Architecture (Islamic Period)*, p. 80.

31. Ibid.

32. Stein, *Ancient Geography of Kashmir*, II, 449.

33. Brown, p. 80.

34. Three surviving architectural frames housing ivory images of eighth-century date appear to be extremely accurate miniature models and raise the possibility that there may have been wooden temples of some size very similar to those built in stone; see Czuma, "Ivory Sculpture".

BUILDINGS FOR PIETY AND PLEASURE:
ARCHITECTURE UNDER THE SULTANS AND THE MUGHALS

By Pratapaditya Pal

Sultanate Period

For the average visitor to Kashmir, especially from India, the most romantic sights are the gardens built in the seventeenth century by Mughal royalty. While some do visit the grand ruins of Lalitaditya's Martand temple (fig. 31, ch. 3), even the more prominent religious structures of the Sultanate periods attract little attention except for pious Muslims. Among these, the most grandiose is the most recent edifice: A massive white marble structure beside the Nagin Lake known as the Hazratbal enshrining a hair relic of the Prophet (fig. 130).

None of the older buildings, whether they are mosques, tombs, or hospices, exist in their original forms. Neither nature nor man has been kind to Kashmiri architecture. As with secular buildings, Muslim patrons in the valley adopted the more easily perishable materials, brick and wood, for their religious edifices. Both are vulnerable to natural ravages like earthquakes and floods, that visit the valley periodically, and to fires. However, whether rebuilt soon after the disaster or more recently, as in the case of the mosque of Madin Sahib (fig. 131), the restorers were especially conscious of retaining the original forms. Even a cursory glance at the major examples of Sultanate architecture, albeit renovated, makes the discrete nature of the design clearly evident. While in the rest of the subcontinent Islamic architecture was a distinctly foreign transplant, with domes and minarets dominating the landscape, in the valley, the architectural form is rooted in native soil. As Simon Digby states in chapter six, the architects responsible were foreigners that came in the train of the early Hamadanis, but why these early champions of the faith would have adopted a native form remains unexplained.

As far as we know, not a single example of a secular building standing today in Srinagar can be dated beyond the eighteenth century. The view down river from the third bridge (replaced today by a motorable monstrosity) taken in 1865 by Samuel Bourne (fig. 132) shows the kind of architectural landscape that millions must have seen for centuries as they plied up and down the river in their boats. Such views will probably become a rarity in this century. Timber was once plentiful, especially the strong, stately, and water-resistant deodar, and so the wooden form was the natural choice as is the case elsewhere in the Himalayas. The sloping, pointed roofs also gave the structure protection against the snow. In the city the houses are often three or four stories high and are distinguished by fine lattice-work and wood carving. However because of inadequate joinery, the buildings often fail to remain perpendicular as they are "entirely dependent on the posts for stability and . . . diagonal bracing is usually omitted."[1]

130

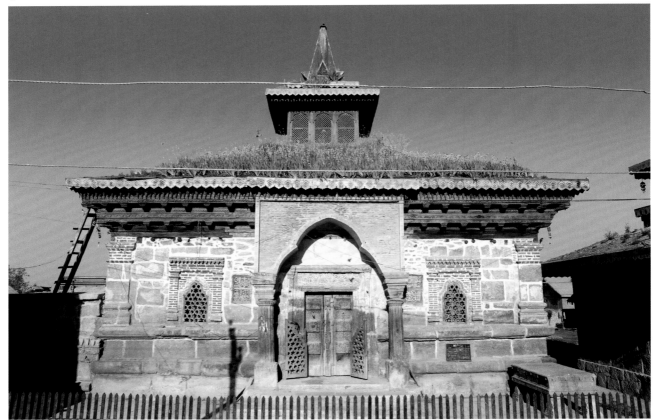

131

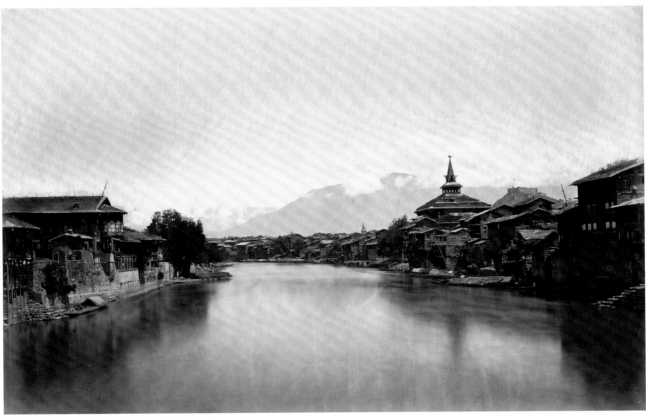

132

<<
Detail of fig. 135, ch. 7

FIG. 130
Hazratbal mosque, Srinagar, 1990s

FIG. 131
Mosque of Madin Sahib
Zadinbal, Srinagar
Completed in 1483 by Zain-ul-Abidin
(1420–1470) and renovated recently
by the Archaeology Department
of the Jammu and Kashmir Government

FIG. 132
Samuel Bourne, about 1865
*View upriver from Third Bridge showing
the Shah Hamadan Mosque*
Srinagar
H. 10 x W. 11 in. (25 x 28 cm)
Private collection

Scholars often opine that there was not much building activity in Kashmir during the reign of the Lohara dynasty (1003–1101). This is simply not true. The chronicles do note that later kings continued the tradition of their predecessors and built towns, palaces and gardens, though perhaps not as lavishly as before. One can also assume that, had they survived, we would have noticed little in the way of innovation. What is clear is that because of the adaptation of timber construction by the sultans for their buildings of piety and the steady decline of the Hindu population, the number of stone temples diminished. However, the stone masons did adapt to the new situation and worked on constructing tombs and carving gravestones in the numerous Muslim cemeteries that dot the valley.

One such gravestone carved in the first quarter of the sixteenth century is interesting because it contains inscriptions both in the Arabic and the native Kashmiri scripts (fig. 184, ch. 8). Another is a rectangular slab that was found on Zainalanka on Wular Lake recording Zain-ul-Abidin's building activity on the island (fig. 129, ch. 6). The third example is a curious shallow relief of a horseman in marble now in Philadelphia (fig. 48, ch. 4). The Sharada inscription on it is said to provide the date 1506. The style of the horse and rider, however, indicate an earlier date and one wonders if the piece was not part of an earlier building.[2]

For many of the new religious structures, the stone foundations of older temples were retained, even during the reign of the tolerant and liberal Zain-ul-Abidin. It is quite easy to spot earlier architectural sections with images of Brahmanical divinities in the new structures, such as the Badshah tomb (king's tomb) in Srinagar (figs. 133, 134). It is a noteworthy survival from the Sultanate period for several reasons. It is the most conspicuous example of a major mausoleum in a foreign style, and it is a royal tomb built for a queen rather than a king. It is Zain-ul-Abidin's mother, Queen Mera, who is buried there. The sultan was interred in an unostentatious structure to the north of the compound,

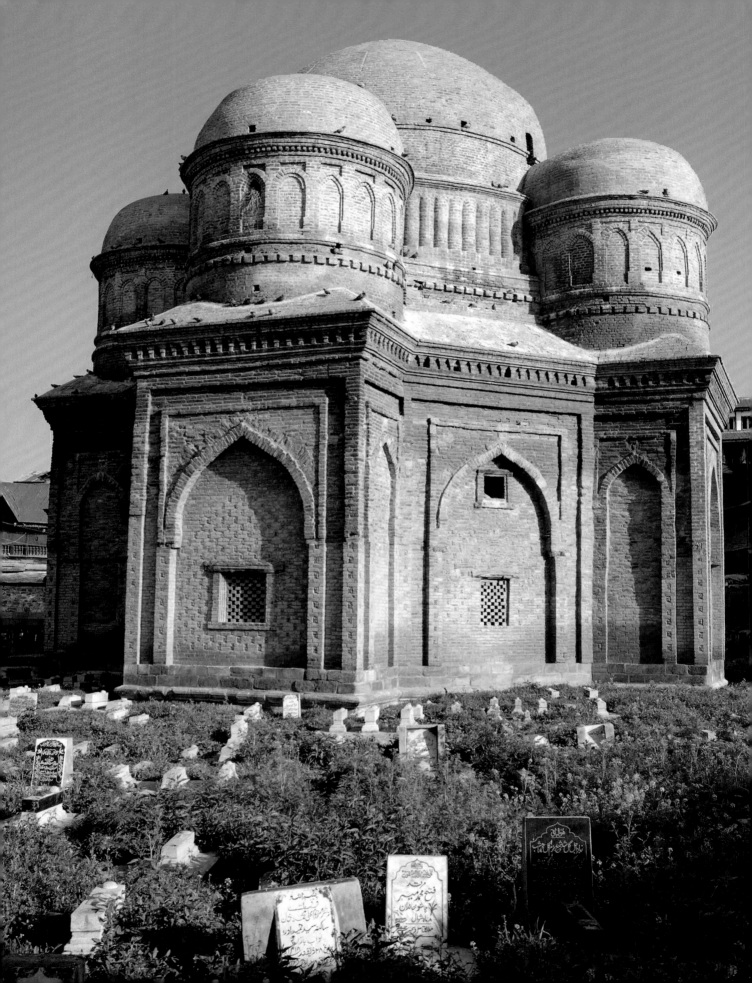

FIG. 133
Tomb of Zain-ul-Abidin's (1420–1470)
Mother Queen Miran (also called Badshah
tomb), about 1430
Zainakadal, Srinagar

FIG. 134
Badshah tomb, Srinagar

FIG. 135
Detail of Badshah tomb showing
blue glazed tiles

134

135

again, unlike the customary practice of the other Sultanates on the subcontinent. It is a brick structure with no use of timber.

Despite its picturesque location on the Jhelum's bank, the Badshah tomb is not a popular tourist destination and the enclosure looks unkempt. Stripped of its original wall cover, now only small blue tiles studded at regular intervals sparkle like gems (fig. 135). The original square chamber was converted into an octagon by the squinch method that allowed for small arches to reduce the spans making it convenient to raise the domes. The most interesting technical innovation was the use of two separate shells for the construction of the impressive central dome of the superstructures. In fact, the adoption of double domes used by Timur (1336–1406) at Samarqand in his wife Bibi Khanum's tomb and at his own mausoleum, the Gur Amir, is the earliest on the subcontinent and was later applied in Lodi and Mughal constructions. Whether or not Zain-ul-Abidin was aware of these buildings in Samarqand, he may well have invited an architect from the Timurid capital.

The structure that stands out above all the others in the Bourne photograph (fig. 132) is the Shah Hamadani mosque, commonly known as Khanquah-i-Maulla (fig. 136). At first sight and from a distance it could easily be mistaken for a Buddhist pagoda and in fact that is the source of its design. As has been noted, the design was developed by the architects who came in the train of Shah Hamadani. Built originally by Sultan Sikander (r. 1389–1413), the mosque was first destroyed by fire in 1479 and again in 1731. The first restoration was done by Sultan Hassan Shah and the second in 1733 by the deputy governor of the Mughals. The stone foundations made of older materials from a famous Kali temple have remained intact and the restoration is said to be faithful.

In the Shah Hamadani mosque, we first encounter the uniqueness of Kashmiri timber construction, the use of majestic deodar columns, and the overall distinctive design of Islamic architecture of Kashmir. The fascinating manner of using trimmed timber panels with brick filling to construct the wall is best witnessed in this structure (fig. 137). The technique imparts a pleasing and rich texture and aesthetic effect unparalleled elsewhere in the Himalayas. The distinctiveness of the style is noted not only in the manner in which the pyramidal roof rises in shallow tiers with no brackets or frills, but also in its original

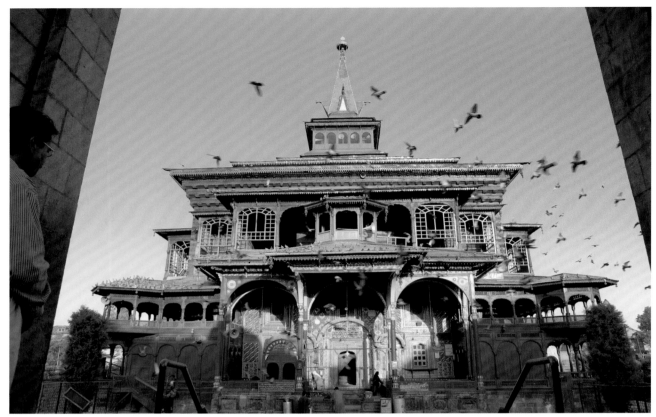

136

mode of construction. As was also the case with the secular houses, the Kashmiris invented a unique way of covering the wooden panels with water-resistant birch bark, which was given a covering of earth mixed with grass. Not only was this snow- and waterproof, but in spring it became a roof garden of tulips and irises.[3] As the Mughal emperor Jahangir noted in his memoir:

> The buildings of Kashmir are all of wood: they make them two-three-hat and four-storeyed, and covering wood with earth, they plant the bulbs of the *chaughasa* tulip, which blossoms year after year in the spring season and is exceedingly beautiful. This custom is peculiar to the people of Kashmir.[4]

Among the discreet features is the open pillared pavilion crowning the entire structure over which rises the tall, tapering steeple with finial consisting of water pots and an umbrella. Clearly these elements are reminiscent of the *harmikā* of a stupa and the *shikhara* tower of a temple. The spacious prayer hall inside uses four tall tapering columns to support the ceiling in the typically Kashmiri *khatamband* technique.[5] Painted ceilings adorn the verandah (fig. 138) and the small chambers (fig. 139), while the empty upper storey is distinguished on the outside by covered wooden balconies.

The most impressive example of timber architecture of the Sultanate period is the Jami Masjid near Nowhatta in Srinagar (figs. 140–142). This magnificent complex was also destroyed many times by fire and rebuilt since its foundations were laid in 1400, during the reign of Sultan Sikander. Its original architect was Sayyid Sadr-ud-din Khurasani. Emperor Aurangzeb (r. 1658–1707) ordered the surrounding houses destroyed to protect the mosque from future fires. This incidentally enhanced the uncluttered view and aesthetic of the monumental complex. A spacious courtyard with a water tank in the center was once shaded by great chinars that have been trimmed down now. Many writers

FIG. 136
Shah Hamadan Mosque, also known as Khanquah-i-Maulla, Srinagar
Original structure built by Sultan Sikandar (r. 1389-1413) in 1395

Fig. 137
Wall detail from the Shah Hamadan Mosque

Fig. 138–139
Painted papier mâché ceiling
in the Shah Hamadan Mosque,
about nineteenth century

137

138

139

agree with Shali that "the wide colonnades around the open courtyard are . . . reminiscent of the architectural magnificence of the stupa-courts of the Buddhist monasteries or the cellular peristyle of the Hindu temples."[6]

Be that as it may, the space inside these colonnades is dominated by unadorned but majestic pillars of single logs of deodar ranging in height between 7.6 and 15.2 meters. No less admirable is the simple grandeur of the two rows of such columns that flank the central arched *mihrab* in the sanctuary. The form of the arched portal to the hall is replicated on the three other sides. Especially noteworthy is the mosque's brickwork of exceptional quality. In order to provide stability to their enormous height, the walls have been reinforced intermittently by means of wooden beams. Although rebuilt many times, the solemn dignity of the complex, its scale and stately proportions and its austere but harmonious design make this one of the most impressive and unique examples of Islamic architecture on the subcontinent.

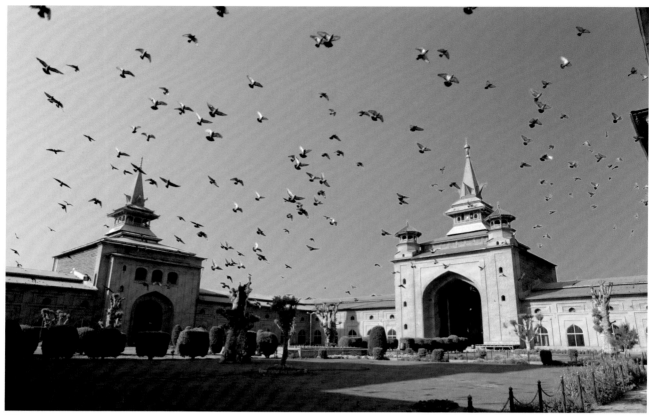

140

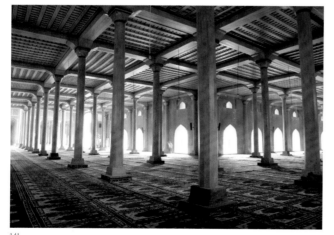

141

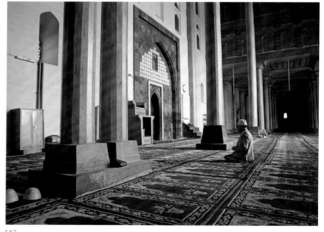

142

It should be noted that very little ornamentation, either didactic Arabic calligraphy or the ubiquitous arabesques, are used in the Kashmiri mosques made primarily with wood. Thus, by keeping its links with the past and maintaining conformity with its architectural surroundings, the brick and timber mosque of Kashmir was seemingly deliberately designed to express cultural continuity, if not harmony.

While the Jami Masjid is the most monumental mosque built for formal, congregational Friday prayers, most mosques are more modest in scale and usually include shrines associated with saints. Even at the Shah Hamadani mosque, popular piety is expressed at a small corner shrine at the back where the saint is said to have lived. As Walter Lawrence observed, "The indifference shown in the matter of mosques and

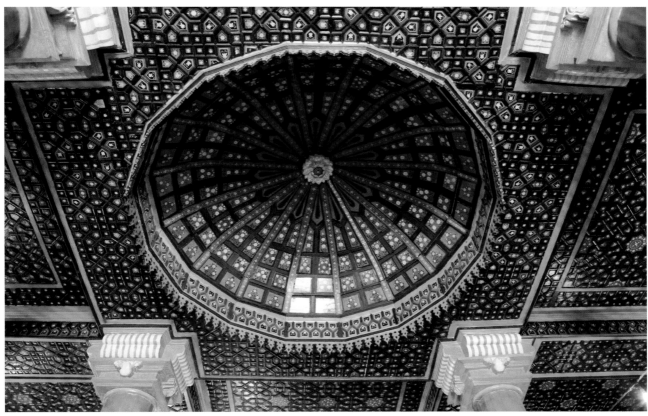

143

Mullahs may be accounted for by the fact that the Kashmiri Sunnis are only Musalmans in name." The Kashmiris, he goes on, "like to gaze on the saint's old clothes and turban and examine the cave in which he spent his ascetic life."[7] It is not surprising, therefore, that the majority of the popular shrines belong to the saints of the Rishi order of Sheikh Nur ud-Din, his own at Char Sharif being one of the holiest though not the most attractive. There are several other saints' shrines spread across the Jhelum and the Liddar valleys that are not only located in picturesque spots but contain some fine woodcarving and painted lattices.[8]

One of the oldest existing mosque-cum-*ziarat* complexes in Srinagar is that of Madin Sahib, also known as Dastgir Sahib (fig. 131).[9] Neglected and abandoned for many years, it has been recently restored by the state archeological department with due diligence. Bearing ample evidence of its non-Islamic past in its foundation, in the columns both inside and outside of the mosque, and in the carved, domed lotiform ceiling (fig. 143) it has its original carved wooden doors with an inscription recording the foundation in 1444 CE (fig. 144). The restoration has also revealed some of the original fifteenth-century tile work with inscriptions (figs. 182, 183, ch. 8) as well as those added by Dara Shikoh. Most of the decorative tiles with plant and flower motifs were removed long ago and are now in museums. Two of these, from the Ashmolean Museum in Oxford, are illustrated here (figs. 145 a, 145 b). With their bright colors, they show obvious kinship with contemporaneous Safavid tilework in Persia. The restored carved and painted ceiling inside the Madin Sahib attests to the Kashmiri woodcarver's continued skill with this craft. It is also gratifying that the roof has been reconstructed in the traditional mode rather than with modern materials so that once again the spring will brighten it with irises and tulips.

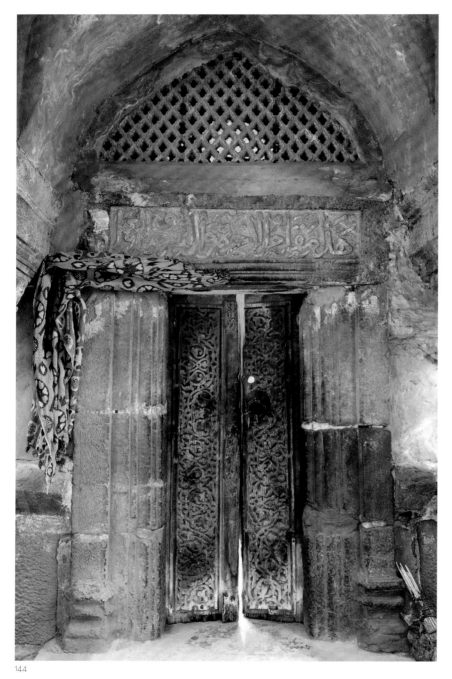

144

FIG. 144
Carved wooden doors dating from 1483,
Madin Sahib mosque

FIG. 145 a, b ✿
Two tiles from the Madan Sahib Mosque,
seventeenth century
Glazed ceramic
H. 6 5/16 x W. 7 1/8 in. (16 x 18 cm)
Ashmolean Museum, University of Oxford
1994.77

FIG. 146
Maqdoom Sahib mosque, Hari Parbat
Recently reconstructed

While the Madin Sahib has been restored by the state, the tomb of Maqdoom Sahib on the eastern side of Hariparbat is maintained privately. A sprawling complex of many buildings, the mausoleum itself is designed in the traditional Kashmiri wooden style (figs. 146, 147). The tomb inside is covered by an intricately carved wooden structure of which one gets only tantalizing glimpses through the windows. Always crowded with devotees and pilgrims, it is the most interesting shrine for witnessing the expression of Kashmiri Muslim piety. Women hang strips of colored cloth in the hope of bearing children while devotees of both genders line up at the entrance to receive blessings from the *ziarat*-'s functionaries and donate money. Unlike the sayyids, Maqdoom Sahib is a native-born saint which explains his popularity.

145 a

145 b

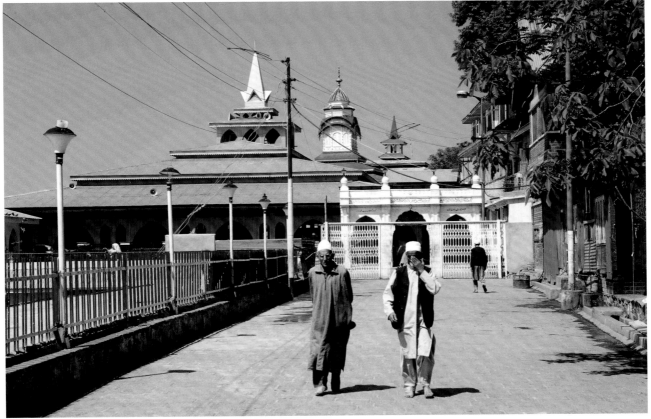

146

147

Mughal and Later Periods

On the way up to the tomb of Maqdoom Sahib, one passes the forlorn and inaccessible stone mosque of Akhun Mullah Shah (fig. 148). He was one of the mentors of Dara Shikoh who built the complex in 1649. It too has a courtyard plan with a modest prayer hall opposite the arched entryway and enclosed by arcades on the two sides. A masonry structure of fine polished limestone, inside the hall is a stone lotus finial above the pulpit.

Unlike the sultans, the Mughals reintroduced stone construction in the valley. Akbar began the tradition by building a fort at the summit of Hariparbat, which was so massive he was compelled to employ masons from outside the valley. Despite the grand effort, it was already deteriorating during the reign of Jahangir, who had to restore it. The present uninteresting and inaccessible (to the public) fort visible on top is an Afghan period construction (1748–1820). The original retaining walls with two typical Mughal gateways, striking a note of dissonance in the valley's landscape, still stand (fig. 149). Obviously, the selection of the site and the material were determined by strategic and security concerns, but the residential quarters with a garden commanded a grand view of the valley and Dal Lake as noted by Jahangir. Akbar also built a garden called Nishat Bagh (Garden of Breeze) near the Hazaratbal mosque where his grandson Shah Jahan planted over a thousand chinar trees (fig. 150).

A second mosque was built by Nurjahan in Srinagar in 1623 (fig. 151). Called the Pattar (literally, stone) Masjid, it did not capture the imagination of the Kashmiris who turned it into a storage building until its recent restoration.[10] The largest of the Mughal structures in the valley, it has an impressive façade of nine horizontally constructed arches and twenty-seven domes. Because it was not used, it is the best preserved of the Mughal edifices, unlike the ruinous complex known as the Pari Mahal high above Dal Lake (fig. 152). These masonry structures originally nestling in well laid-out flower gardens and shaded by chinars were built by Dara Shikoh.[11] It served as a place of intellectual and spiritual discourses for the prince and his circle of learned men and only incidentally as a pleasure garden. Although the Pattar Masjid is an expression of her piety, Nurjahan, along with her husband Jahangir, was an avid creator of gardens. Even though much altered today, their gardens enchant the average tourist as much as the natural beauty of the valley.

Gardens were also built by the sultans and before them by the maharajas, but unfortunately none survived, seemingly, even into Mughal times. In any event, they

148

149

150

151

FIG. 150
A watercourse leads to Dal Lake
in Nishat Bagh, laid out in 1634 by Asaf Khan

FIG. 151
Pattar Masjid, built by Nurjahan in 1623,
Srinagar

FIG. 152
Pari Mahal, built by Dara Shikoh (d. 1659),
Srinagar

FIG. 153
Samuel Bourne,1864
Spring at Verinag, Kashmir
Albumen print
H. 42 1/8 x W. 73 1/4 in. (107 x 186 cm)
The Alkazi Collection of Photography

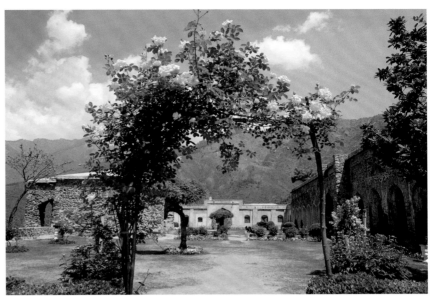

152

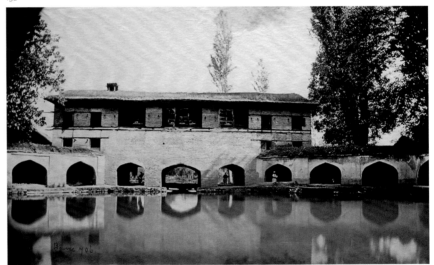

153

are likely to have been quite different than the Mughal gardens in the valley. One can surmise that the Sultanate period garden would likely have been laid out in the characteristic paradisiacal image, as was the case with the Mughal gardens on the hot, dry, and dusty plains of India. One can understand, therefore, Jahangir's exhilaration as he beheld the lush landscape and abundant sources of water in the lakes and natural springs when he first arrived in Kashmir as a prince with his father. He did visit the pleasure garden of Zain-ul-Abidin in the Zainalanka island (fig. 163, ch. 8), but had little to say about it.

Kashmir itself was a paradise and there was no need to emphasize the arcadian symbolism in the design of the garden. A great admirer of things natural, Jahangir never failed to consider the natural beauty of the topography. The lengthy description of his visit to Verinag makes clear his respect for the shape and form of the natural configuration of a place (fig. 153). His task was to enhance its attraction and ensure its stability.

"When I was a prince," he writes, "I gave an order that they should erect a building at this spring *suitable to the place* [italics ours]. It is now completed.

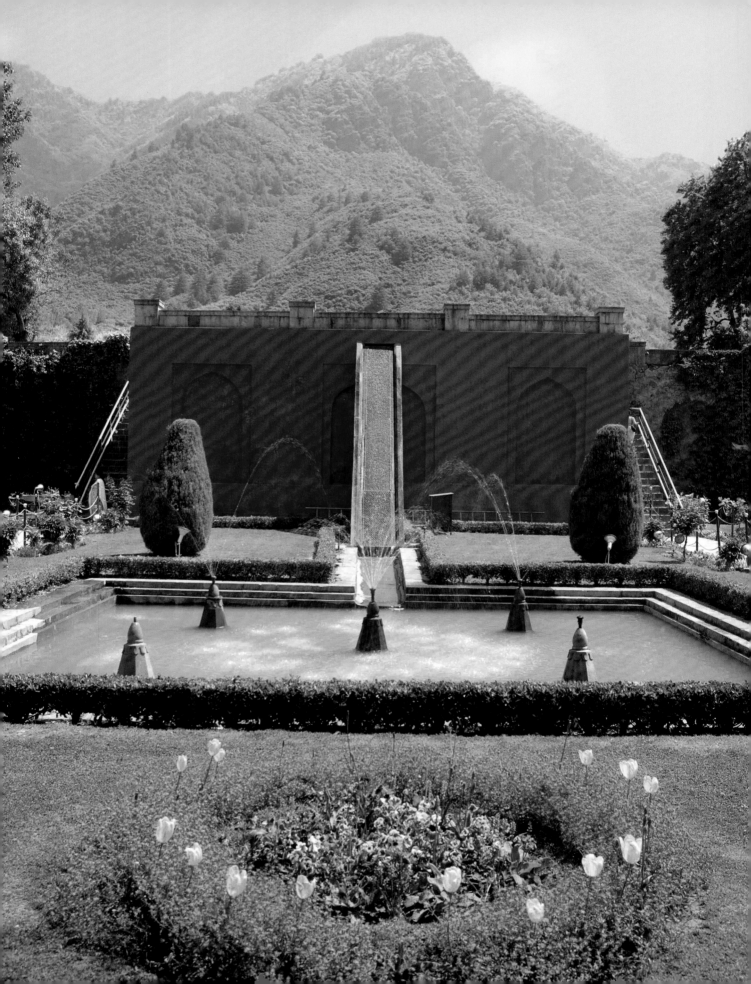

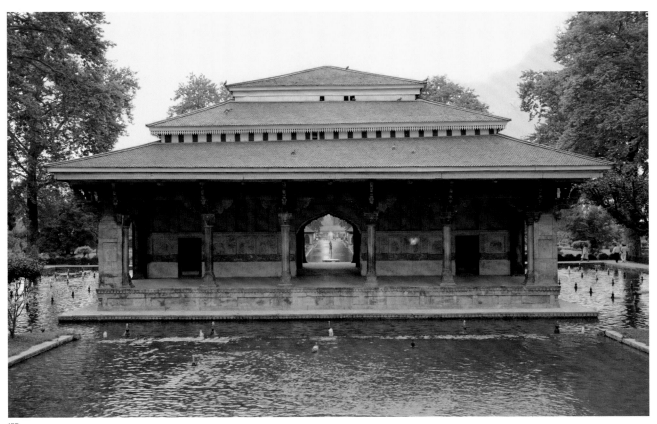

155

There was a reservoir of octagonal shape, 43 yards in area and 14 gaz [yard] in depth. Its water from the reflection of plants on the hill had assumed a hue of verdure. Many fish swim in it, around it had been erected halls with domes, and there as a garden in front of them.

Of the trimness of the canal and the verdure of the grass that grew below the fountain, what can one write? . . . In short, in the whole there is no sight of such beauty and enchanting character."[12]

He had indeed inherited his great grandfather Babur's passion for nature.

Apart from Verinag, Jahangir also admired the beauty of Achchabal which he described as a "piece of paradise" and where Nurjahan was principally responsible for an attractive garden. She also built the Jarokha Bagh garden at Manasbal Lake. Her brother Asaf Khan contributed to Akbar's Nishat Bagh, one of the more popular of the Mughal gardens (fig. 150) while Ali Mardan Khan, a governor during Shah Jahan's reign, laid out the Chashma Shahi garden on Dal Lake (fig. 154), also a favorite with today's tourists. Rather curiously, Shah Jahan, the most passionate of the builders among the Mughal emperors, left no legacy of his own though he helped his father on some projects and finished the black stone pavilions in the Shalimar garden in 1627 (fig. 155).

The Shalimar garden built by Jahangir on the Dal Lake (fig. 156) remains the most famous and popular among the Mughal pleasure gardens in Kashmir. Since none of the Mughal gardens now retains their original form and some, like the beautifully laid Achchabal garden, have been literally disfigured, we can do no better than quote François Bernier's eyewitness account of the Shalimar when he visited Kashmir in 1665 in the train of Aurangzeb:

The most beautiful of all these gardens is one belonging to the King, called *Chah-limar.* The entrance from the lake is through a spacious canal, bordered with green turf, and

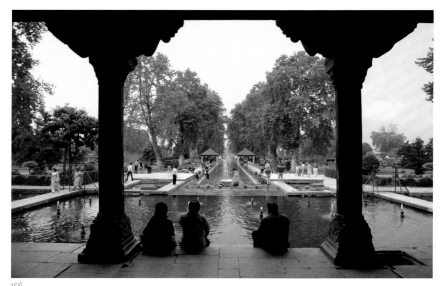

156

running between two rows of poplars. Its length is about five hundred paces, and it leads to a large summer-house placed in the middle of the garden. A second canal, still finer than the first, then conducts you to another summer-house, at the end of the garden. This canal is paved with large blocks of freestone, and its sloping sides are covered with the same. In the middle is a long row of fountains, fifteen paces asunder; besides which there are here and there large circular basins, or reservoirs, out of which arise other fountains, formed into a variety of shapes and figures.

The summer-houses are placed in the midst of the canal, consequently surrounded by water, and between the two rows of large poplars planted on either side. They are built in the form of a dome, and encircled by a gallery, into which four doors open; two looking up, or down, the canal, and two leading to bridges that connect the buildings with both banks. The houses consist of a large room in the centre, and of four smaller apartments, one at each corner. The whole of the interior is painted and gilt, and on the walls of all the chambers are inscribed certain sentences, written in large and beautiful Persian characters.[13]

A picture by Abul Hasan in the Binney collection at the San Diego Museum of Art (fig. 162, ch. 8) showing Jahangir approached by a group of mullahs may well be the only contemporary representation of the original Shalimar.

Basically, Shalimar typifies the Kashmiri gardens of the Mughals, which, because of the valley's topographical features, the verdant and colorful vegetation and the abundance of water sources, differ from all other Islamic gardens. Overlaying the paradisiacal symbolism, the Mughal gardens of Kashmir reflect the aesthetic vision of a very earthy and sensuous emperor and his immediate circle. This is also clear from all the efforts made by the Mughals to improve the infrastructure of the valley with an eye to making the long journey to and from Kashmir more comfortable. They improved the highways, built rest-houses and serais and other structures, even though, as described by Bernier in great detail, tents remained their primary form of shelter. Many of these improvements were affected by Ali Mardan Khan who was a noted engineer-cum-builder.

With the fall of Mughal power and authority, the great period of building in Kashmir also ended. Although the Afghans built a new citadel on the ruins of Akbar's fort on Hariparbat and a palace complex called Shergarh in the city, which no longer exists, no noteworthy construction was undertaken thereafter, either for piety or pleasure.

1. Lawrence, *The Valley of Kashmir*, p. 372.
2. When viewed separately from the architecture, the sculpture makes little sense. The placement of the inscription is also strange and may have been added in 1506.
3. This method is being applied today in contemporary American public buildings, especially in Chicago, both for insulation and to enhance the "greening" effect.
4. Rogers and Beveridge, *Memoirs of Jahangir*, vol. 2, pp. 144–45.
5. C. Tickell, quoted in Lawrence (p. 372), describes the technique, which he characterizes as ingenious: "'Thin panels of soft wood, generally *Picea Webbiana*, are cut into various geometric forms, and are held together by being placed in the grooves of small double-grooved battens.'" In the early 1890s when he prepared his report for Lawrence, the technique was confined to a "limited number of workmen in Srinagar and Islamabad." It may be pointed out that the wood ceilings of the small chambers (fig. 139) dates from the 1733 restoration.
6. Shali 1993, p. 249.
7. Lawrence, p. 286.
8. See ibid., pp. 287–88.
9. Sayyid Muhammad Madini came to Kashmir as an envoy from Madina in Saudi Arabia during the reign of Sikander Shah and died in that of Zain-ul-Abidin. He is particularly venerated by the boatmen who cry "Ya Pir Dastgir" as they paddle upstream.
10. Apparently the mosque was never used because Nurjahan is said to have remarked that it cost as much as a pair of her jeweled slippers. It remained a storage building until its recent restoration.
11. A beautiful painting by Bichitr in the Minto album in the Chester Beatty Library, Dublin, showing Dara in a garden with learned men and mullahs may be located in the Pari Mahal. See Leach, *Mughal and Other Indian Paintings from the Chester Beatty Library*, vol. 1, col. pl. 61.
12. Rogers and Beveridge, vol. 2, p. 173.
13. Bernier, F. *Travels in the Mogul Empire* (New Delhi: S. Chand) 3rd ed. 1972 [1891], pp. 399–400.

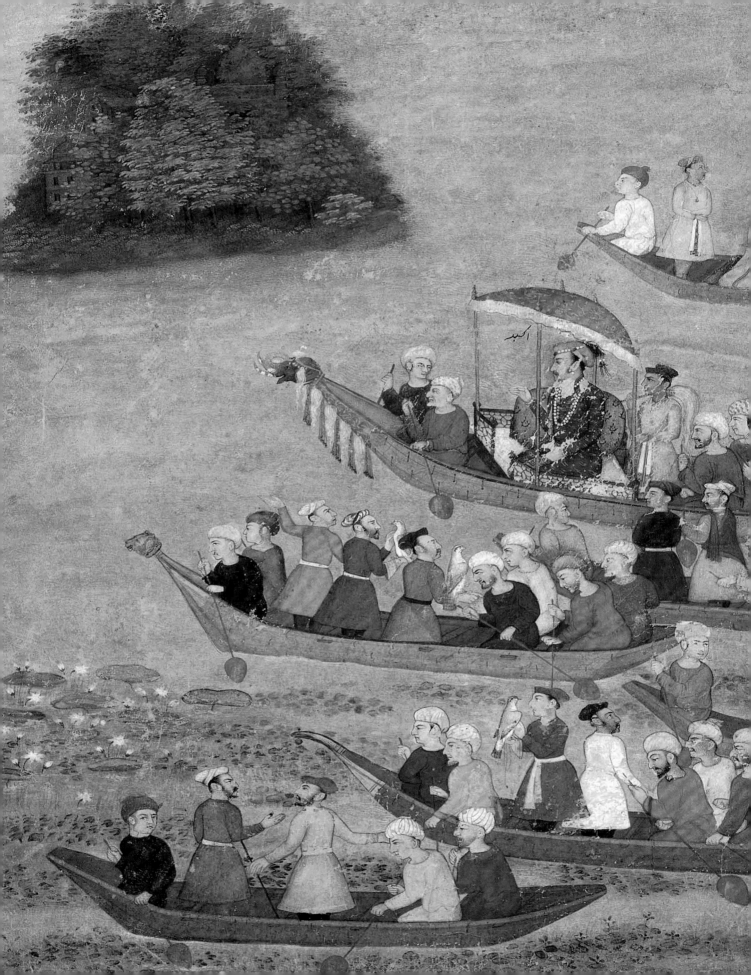

PAINTING AND CALLIGRAPHY
(1200–1900)

By Pratapaditya Pal

Sultanate Period Painting

If the narrative of Kashmiri painting in the earlier period seems sketchy, that of the Sultanate period (fourteenth to sixteenth century) will be even less distinct. Not a single document of painting has survived from the Sultanate period in Kashmir, and the literary evidence too is inchoate. There is a brief allusion to Buddhist paintings in a sixteenth century textual passage with the statement by the chronicler Shuka that, after Akbar founded his city in Hariparbat, the abandoned old city "adorned with many paintings, and its houses and buildings, was soon reduced to ashes."[1]

Tibetan sources indicate that at least through the fourteenth century, Kashmiri scholiasts were visiting the Tibetan monasteries and translating texts. One of the collaborators of the Tibetan scholar, Buton Rimpoche (1290–1364), the author of *The Blue Annals*, was the Kashmiri scholar, Sumanahsri.[2] Another contemporary Kashmiri translator was Dharmadhara who translated three texts about arts and iconography (*śilpaśāstra*).[3] Artists from the valley must still have been recruited by Tibetan monasteries, certainly in neighboring Ladakh and western Tibet, during the Sultanate period.[4] Buddhism was still active in the valley for one of Zain-ul-Abidin's (1420–1470) ministers was the Buddhist Tilakacharya.[5]

Early thirteenth-century murals of the now well known monastic complex of Alchi in Ladakh constitute a very important example of the handiwork of Kashmiri artists. Particularly relevant for us are the strange compositions that adorn the dhoti of the colossal stucco image of Avalokiteshvara in the Sumstek temple (figs. 157 are details of fig. 122, ch. 6). The consensus now is that these compositions depict shrines and pilgrimage centers of the valley. Others, especially of the royal scenes of the court and hunting, if rendered by Kashmiri artists, clearly reflect stylistic elements that are different from the earlier Buddhist paintings of the eleventh-century monuments. They evoke a cultural milieu that was both sophisticated and cosmopolitan. As Roger Goepper has remarked, "Taken as a whole, the scenes on Avalokitesvara's dhoti look like illustrations to Kalhana's *Rājataraṅgiṇī* written about half a century earlier."[6] It will not be possible to discuss these fascinating pictures at length but a few relevant remarks will not be out of place.

One of the curious features of the figures in the Alchi murals is the manner of extending the eye beyond the outline of the face which was already an idiosyncratic feature of western Indian physiognomy in two-dimensional works (fig. 158). We know that there were communities of Jains in Kashmir, and manuscripts, some illustrated, of other literary works from western India must have been familiar in the valley.[7] Textiles from distant

157 a

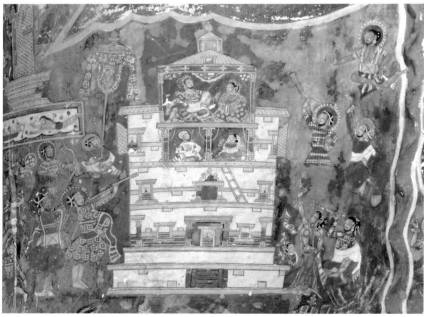
157 b

<<
Detail of fig. 163, ch. 8

FIG. 157 a, b
Painted murals
Sumstek temple
Alchi Choskhor, Ladakh

lands too must also have been available to the artists, as is clearly evident from the Alchi
ceilings where a variety of textiles are depicted (fig. 159). It should be mentioned here
that most ceilings of nineteenth-century Kashmiri buildings are painted with shawl designs.[8]
Moreover, it is relevant to quote a passage from Shrivara's chronicle about gifts sent by
foreign rulers to Zain-ul-Abidin (1420–1470):

> "The king of Kumbha presented to the monarch a cloth named Nari Kunjara and gratified
> the heart of his excellent queen . . . Muhammad Suratrana, king of Gurjara, gratified the
> monarch with presents of textile fabrics celebrated by the names of *kateha*, *sohasa*,
> and *glāta*."[9]

The murals of Alchi, especially in the Sumstek temple, are not only important documents
of the lost Kashmiri tradition of painting but also relate to the wider Indic pictorial tradition
and possibly to the Islamic aesthetics of the Ghaznavid realm. They must also be regarded

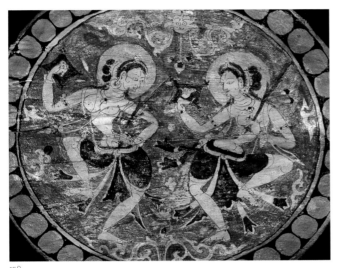

158

FIG. 158
Details of dancers from the murals at Sumstek
Alchi Choskhor, Ladakh

as harbingers of the style of painting that must have prevailed in Zain-ul-Abidin's Kashmir.

Not even the name of a single artist has survived from the Sultanate period, though Srivara speaks of foreign artists flocking to the court.[10] Zain-ul-Abidin was a passionate bibliophile and sent agents to various parts of India and west Asia to collect books, some of which must have been illustrated. To encourage local book production he sent two persons to Samarqand to learn the art of papermaking and bookbinding. Subsequently Kashmiri paper became celebrated all over India and abroad. Apart from importing books, local production was also encouraged. Works such as Firdausi's epic *Shahnama* and Nizami's romantic poems must have been copied and illustrated for the sultan, who was himself a poet, but none has been found. They were most likely illustrated in styles similar to those that flourished in fifteenth-century painting centers of Central Asia, Persia, and Sultanate India.

Apart from the literary references provided at the beginning of this chapter, one other passage by Shrivara is interesting. It is embedded in the prince's lamentation beside the body of the dead Zain-ul-Abidin. "O father!" the prince cries, "I see thy face in the portrait and in my imagination, but where shall I, who have sinned so much against thee, hear thy voice?" Could this be taken as evidence of portraiture in Zain-ul-Abidin's time?[11]

It would be very difficult to believe that Mirza Haidar Dughlat, the de facto ruler of Kashmir from 1540 to 1551 would not have encouraged the arts of painting and calligraphy. A versatile man of many accomplishments and the author of *Tārikh-i Rashidi*, he himself excelled in penmanship, painting and various kinds of handiwork.[12] Unfortunately, neither his own works nor any paintings from his times have survived. By the end of the century, after Akbar's conquest, the narrative about painting by Kashmiri artists gathers more momentum.

Mughal Period

Although Abu'l Fazl does not include Kashmiri artists among the more renowned painters, the names of at least seven are known from manuscripts and paintings.[13] Some are recognizable because of the suffix *kashmiri* (of Kashmir) added to their names. Mostly they worked with colleagues in illustrating the various manuscripts that were produced in the imperial atelier. Coloring rather than drawing seems to have been their forte. As Percy Brown remarked regarding the subtle touch of the Kashmiri painters:

> Very delicate effect is said to have been obtained by the Kashmiri painters. They allowed water to stand until it had completely evaporated, leaving a slight sediment, which they use as a background tint to the profile of a portrait, as it left a faint but charming contrast of tone between the flesh color and the ground.[14]

The double page illustration from a *Baburnama* manuscript now in the Victoria and Albert Museum by Isma'il Kashmiri (fig. 160) is a good example of the standard Mughal style that prevailed at the court. Isma'il worked alone on this double composition but other examples are collaborative efforts of two painters. This was the normal practice in the imperial atelier which had recruited a large number of artists from all over the empire as well as from abroad, some of whom were obviously better than others. Most of them worked on manuscripts for Akbar or eminent courtiers in the so-called Mughal style eschewing their regional manners.

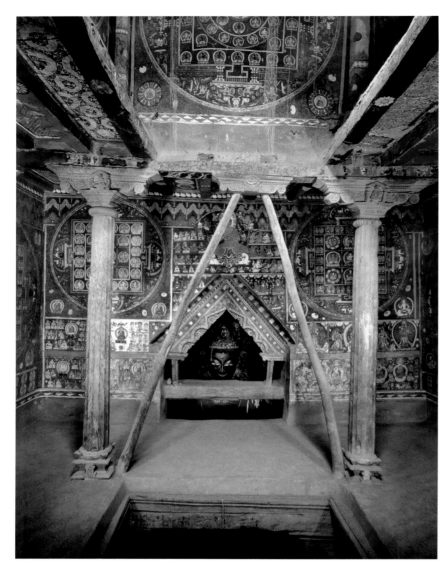

159

Fig. 159
Detail of ceiling at Sumstek temple
Alchi Choskhor, Ladakh

While some of the Kashmiri calligraphers were outstanding, the painters appear to have been less distinguished. Isma'il's effort, however, is impressive and testifies to the versatility of his talent and his sure hand. Though the subject itself is not dynamic, he has created a strong figurative composition of rhythmic elegance and restrained dignity.

Kashmir figures in Mughal paintings at least in three principal ways. Apart from Kashmiri artists and calligraphers working directly for Akbar, Mughal artists accompanied the emperors on their visits to the valley and produced pictures there. Secondly, there are a number of Mughal narrative and historical paintings that use the distinctive topographical features of the valley. Thirdly, especially under the reign of Shah Jahan, illustrated books and pictures were commissioned by enlightened Mughal courtiers from available artists in the valley, foreign as well as local.

While the Kashmiri artists attached to the Mughal court moved where the court moved, others accompanied the emperors to Kashmir. Some of them, along with local recruits, must have worked in the picture gallery in Akbar's palace on Hariparbat, first for Akbar and again when Jahangir had repairs made. Jahangir's account of this restoration is most interesting and is worth quoting in extenso.

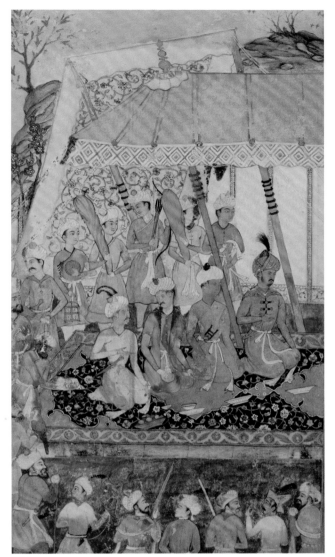

160 a

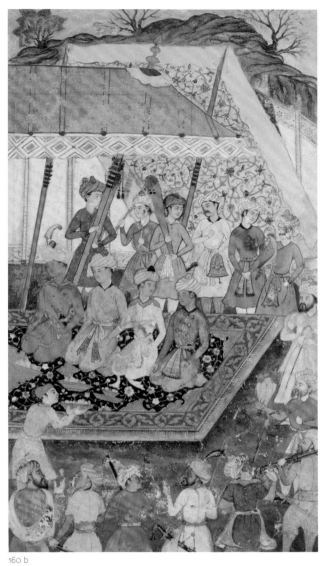

160 b

Fig. 160 a, b ✿
Isma'il Kashmiri (active 1590s)
Double page illustration of prince entertaining
guests, about 1590
From a *Baburnama* manuscript
Ink, opaque watercolor
H. 10 x W. 5 5/16 in. (25.4 x 13.5 cm) (image);
H. 10 1/2 x W. 6 2/16 in. (26.6 x 15.7 cm) (page)
Victoria & Albert Museum
IM 269.A & B—1913

The picture gallery in the garden had been ordered to be repaired: it was now adorned with pictures by master hands. In the most honored positions were likenesses of Humayun and my father opposite to my own and that of my brother Shah Abbas. After that were likenesses of Mirza Kamran, Mirza Muhammad Rahim, Ahah Murad and Sultan Daniyal. On the second how were the likenesses of the Amirs and special servants. On the walls of the outer wall the stages of the road to Kashmir were recorded in the order in which I have come to them.[15]

Under the supervision of Mutamid Khan, the repairs and the murals were completed in 1620. Pleased with the result, Jahangir commented that the gallery was "the envy of the picture gallery of China," a stock phrase in Islamic connoisseurship. What is interesting for us is that at least some of the subjects were Jahangir's own choice for his father could hardly have ordered one of Jahangir and Shah Abbas together. This portrait may have looked like either of the two portable portraits of the two monarchs together now in the Freer Gallery of Art (fig. 161). The murals were completed by 1620 which is the suggested date of the more modest picture of the seated monarchs, while the more pompous, allegorical representation by Abul Hasan is dated

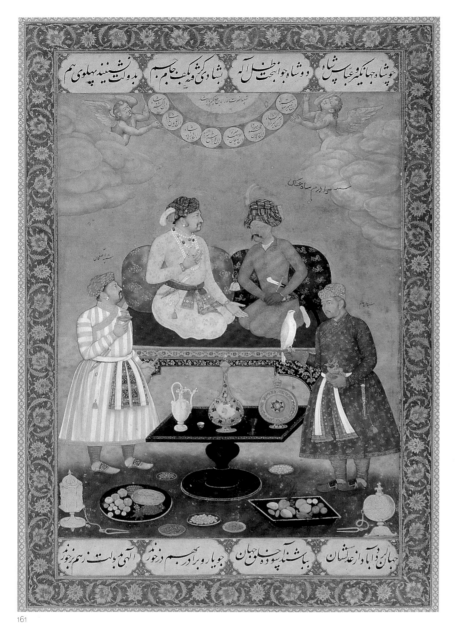

161

FIG. 161
Jahangir Entertains Shah Abbas
about 1620, Mughal dynasty
Album page from the St. Petersburg album
Opaque watercolor, gold, and ink on paper
H. 9 13/16 x W. 7 3/16 in. (25 x 18.3 cm)
Freer Gallery of Art, Smithsonian Institution,
Washington D.C.

1618. He was one of the "masterhands" who, along with Mansur, were in Kashmir with
Jahangir. Murals also once decorated the pavilions in the Shalimar garden which are
mentioned by Bernier and which were likely rendered during Shah Jahan's reign (fig. 156,
ch. 7).

A number of portable Jahangiri pictures employ the valley's topographical elements
whether or not they were rendered by Kashmiri artists or in Kashmir. A rare painting of
Jahangir in the Binney Collection in San Diego may well portray the Shalimar garden in
Kashmir, as suggested by Asok Das (fig. 162).[16] An inscription ascribes the picture to Abul
Hasan, one of Jahangir's favorite artists. Although the event cannot be identified, its
specificity, both in its subject—a conversation between the emperor and a group of
sheikhs before a large boiling pot—and its topography, make its Kashmiri association
likely. Apart from the design of the garden, interaction with Sufis was an integral part of
the intellectual and spiritual milieu in the valley.

162

163

FIG. 162 ❖
Attributed to Abu'l Hasan (1556–1627),
about 1615, album page: eighteenth century
*The Emperor Jahangir with Holy Men
in a Garden* from a *Jahangirnama manuscript*
Opaque watercolor and gold on paper
H. 12 27/32 x W. 7 11/16 in. (32.6 x 19.5 cm)
San Diego Museum of Art,
Edwin Binney 3rd Collection
1990:345

FIG. 163
Ruler on a boat with attendants
Seventeenth century, reign of Jahangir
Album leaf
Colors on paper
The British Museum
1920.0917.01

One of the most evocative Mughal representations of Kashmiri landscapes is that showing a royal party of boats in a lake heading towards an island with a beautifully rendered chain of mountains beyond (fig. 163). The inscription gives Akbar's name but the monarch is almost certainly Jahangir who discusses his visit to the Wolur Lake and to see the structures built on the island by Zain-ul-Abidin in his memoirs.[17] The artist has clearly shown the buildings that were still standing in the seventeenth century but were in ruins by the time of Moorcroft's visit in 1822. No other Mughal picture is as topographically accurate or as expressive of Kashmir's natural beauty as this boating scene.

Jahangir was so enchanted with the beauty of the floral wealth of Kashmir that he had one of his master artists, Mansur, paint a hundred flower studies, few of which are known to have survived (fig. 164). Mansur also painted birds for Jahangir in Kashmir to be included in his *Jahangirnama*.[18] This trend of drawing birds and flowers from close observation begun by Jahangir in Kashmir certainly exerted strong influence on his grandson Dara Shikoh. Some of the beautiful flower studies included in the British Library album that he presented to his wife were probably inspired in the valley. We do not know who commissioned the lovely picture of a flower with a butterfly (fig. 165) but the artist was Muhammad Nadir Samarqandi. Mistakenly identified as a narcissus, the flower is in fact a winter daffodil that grows in Kashmir.[19] As his name implies, Nadir was from Samarqand and had settled in Kashmir after being charmed by its arcadian beauty.[20]

Around 1650 Nadir executed several paintings for a manuscript of the *Yusuf and Zuleikha* narrative from which one illustration is included here (fig. 166).[21] There is

nothing specifically Kashmiri in this composition, nor much that can be attributed to a Mughal style, except for the servant girl standing at the lower right corner holding a tray with a blue and white vase. While all the other ladies are Persian, her depiction is clearly adapted from a Shah Jahani painting. Generally, Muhammad Nadir remained faithful to his Samarqandi mode of non-naturalistic, romantic style with a soft palette occasionally employing some Indian elements, such as the servant girl mentioned, or some landscape elements, such as the hill with a shrine on top or the conceptualization of water in a couple of other paintings from the *Yusuf and Zuleikha* manuscript.

164

We do not know the artist who painted the visit of a prince to a holy man during a hunt (fig. 167) in the collection of the Art Institute of Chicago. While he uses Persian elements in rendering his landscape, most of his figures are typical of Shah Jahan period painting. The prince too remains unidentified but all the regal trappings behind him and in the foreground clearly announce his royal status. It is tempting to identify him as Dara Shikoh and the holy man with the book as a Sufi. It should be emphasized that although the tree below which he sits is the celebrated chinar, in point of fact it is rendered not from observation but in the conventional Persian mode. The persistence of Persian elements in Kashmiri pictures at this and later periods can be explained not only by the presence of Persian paintings and painters but the long established penchant for Persian culture in the valley.[22] As Linda Leach has succinctly stated, in the context of another contemporaneous picture, the Kashmiri elements in such paintings are the lush, romantic mixture of pinks, rust, purple, and maroon contrasted with shades of green. "The spicy clash of these shades and their potent impact are clearly Persian influences... The Kashmiri painter has flattened, simplified, and rendered the landscape more decorative . . ."[23]

165

Most Mughal style pictures that have been in recent years attributed to Kashmir or reflect Kashmiri topographical elements were rendered during the reigns of Shah Jahan and Aurangzeb. While Shah Jahan and his hapless, mystic son Dara Shikoh were frequent visitors to Kashmir, the austere Aurangzeb went only once. One of Dara Shikoh's spiritual guides, Mir Molla Shah, lived in Kashmir where the prince built a mosque as well as a center for intellectual discourse called Pari Mahal (fig. 152, ch. 7). Indeed, Leach may well be correct in suggesting that Dara commissioned the *Yusuf and Zuleikha* manuscript with Nadir's pictures. It is also likely that some of the paintings, especially the flower studies in the well-known Dara album, were executed in Kashmir.[24]

Significant examples of the Mughal style in Kashmir during the reign of Shah Jahan are illustrated copies of two *Mathnavi*-s, now in the Royal Asiatic Society, London. The author of the *Mathnavi*-s was Zafar Khan who was Shah Jahan's governor in Kashmir from 1633 for a long spell. A generous patron of literature and the visual arts, Zafar Khan was himself a poet. While the text was copied by the author in Lahore in 1663, the paintings were rendered in Kashmir sometime between 1644 and 1651. These pictures are remarkable for their perceptive depictions of contemporary events in Zafar Khan's life in Kashmir (figs. 168 a, b). Because of the brilliance of the portraits in these paintings, it has been suggested that the artist was Bishandas.[25] In fact, the painter may be seen in a self-portrait engaged in drawing in one of the pictures showing Zafar Khan in the company of poets and dervishes. [26]

Another important document for the history of Kashmiri painting is an illustrated manuscript of the *Shahnama* completed in 1695 in Kangra in Himachal Pradesh now in the Chester Beatty Library, Dublin. Linda Leach has recognized two different hands in the forty-one illustrations and has suggested that one artist's style can be associated with

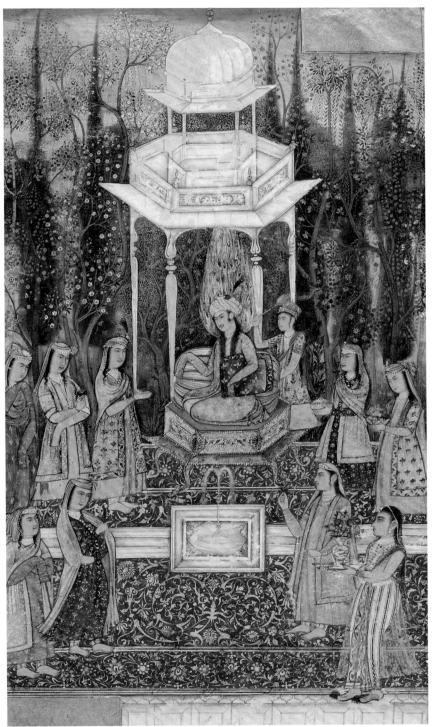

166

Kashmir (fig. 169). She writes, "Forms are quite flat, with landscape features often reduced to a decorative semicircular hill and a few flowers or fruits or grass. Figures have huge heads with wide eyes and locks of hair curling over cheeks; in general they are forerunners of what will become the stock eighteenth century Kashmiri type."[27]

This firmly dated work definitely anticipates the characteristic Kashmiri style encountered in a large corpus of material surviving from the eighteenth century.

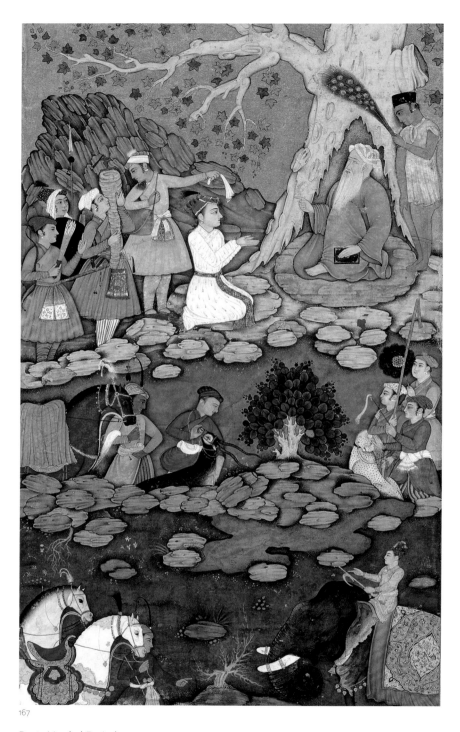

FIG. 167 ❖
Prince visits an ascetic during a hunt,
about 1650
Opaque watercolor, gold, and ink on paper
H. 16 1/16 x W. 10 7/16 in. (40.8 x 26.5 cm)
Kate S. Buckingham Endowment,
The Art Institute of Chicago
1995.267

Post-Mughal Period

It is clear that, by and large, the Kashmiri painters preferred a more archaic version of the decorative and idealized manner associated with Persian traditions, with perfunctory borrowings from the Mughal style. While the Mughal style may not have captured the Kashmiri imagination, the interest in pictures, especially in illustrated books, was rekindled by the Mughal presence. However, unlike the Mughal tradition, portraiture was not, nor was the impulse for detached pictures, nor, for that matter, was the interest in depicting courtly or mundane affairs. Some albums with paintings and calligraphy have survived

FIG. 168 a, b ✿
Bichitr (active about 1590–1640s)
a: *A Review of Troops*
Mathnavi of Zafar Khan
Folios 17b and 18a
b: *Outdoor Pleasure Party*
Mathnavi of Zafar Khan
Folios 21b and 22a
Royal Asiatic Society

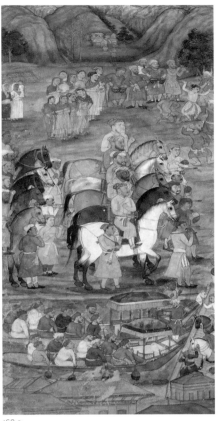
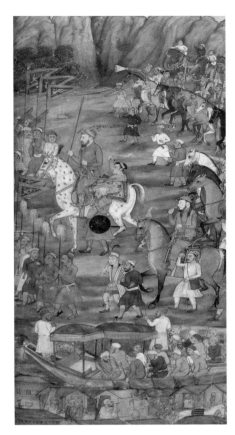

168 a

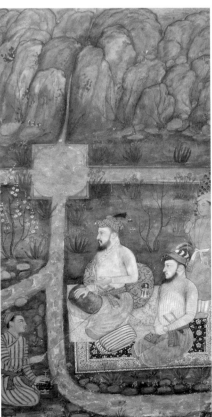

168 b

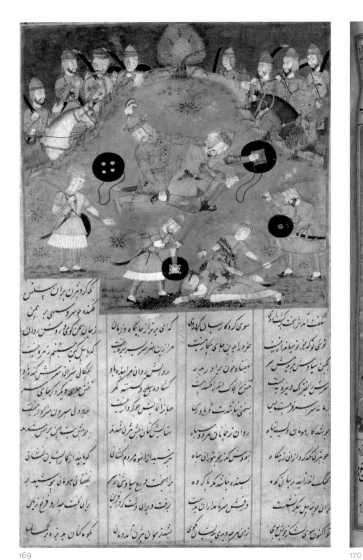

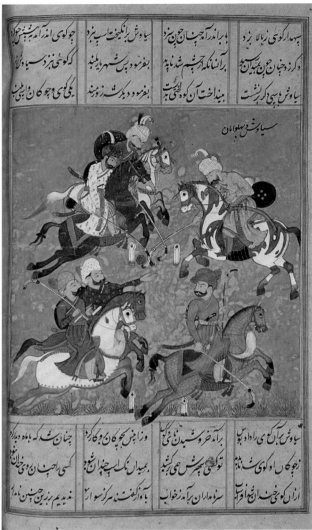

169

170

but the pictures are of mediocre quality. Apart from Muslim patrons, illustrated books were produced for Sikh and Hindu patrons as well. By contrast, detached pictures and portraits, so much in vogue in Jammu—politically aligned to Kashmir from the Sikh period—and in the neighboring hill states (now in Himachal Pradesh and Uttaranchal), are rare. Paintings also survive in buildings—especially noted on ceilings with geometric and floral designs influenced by textiles (fig. 138, ch. 7)—on furniture, as well as on utilitarian and luxury objects which will be discussed in chapter nine.

Since a considerable amount has been written about Kashmiri painting of this period, both the selection of the material and the discussion here will be limited.[28] The published material of the period reflects the Muslim patrons' penchant for illustrated manuscripts of popular Persian literature, such as Firdausi's eleventh-century epic *Shahnama*, pictorial romances such as the *Khamsa* of Nizami (1209) and other poetical and didactic works. A picture depicting a game of polo from the New York Public Library collection is a lively illustration from a *Shahnama* manuscript that was prepared about 1730 (fig. 170).[29] A comparison with the 1695 *Shahnama* illustrations demonstrates little sense of the selected realism of the Mughal manner and a preference for the simplified and archaizing Persian elements. It should be noted that the manuscript is unusual for

FIG. 169
Bijan and Human engage in a desperate hand-to-hand combat in which Human is beheaded, 1695
Shahnama by Firdausi
Kangra, Himachal Pradesh
Chester Beatty Library
In 36.185b

FIG. 170
Siyāvush plays polo before Afrāsiyāb, 1720–25
Shahnama by Firdausi
Ink and pigment on paper
Spencer Collection, The New York Public Library, Astor, Lenox and Tilden Foundations
Persian MS 62; f.176v.

Fig. 171
Isfandiyar Fighting a Simurgh, 1731
Shahnama by Firdausi
Color and gold on paper
H. 20 1/8 x W. 16 3/8 in. (51.2 x 41.5 cm)
Private collection

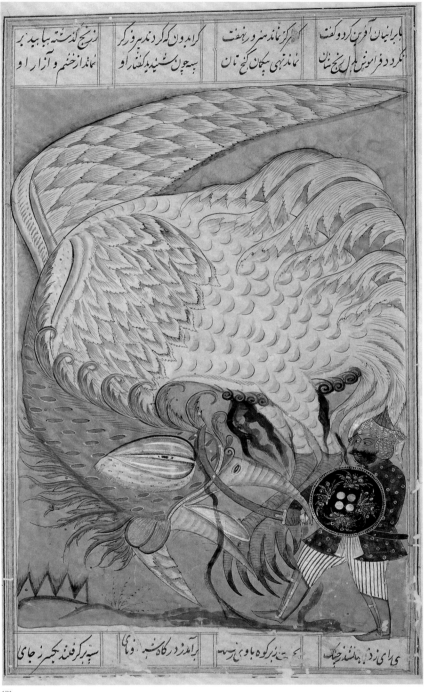

171

its large size which imparts the pictures with a sense of monumentality. This is also clearly evident in a spectacular representation of the labors of Isfandiyar when he fights a mythical bird (*simurgh*) from another large *Shahnama* manuscript completed in 1731 (fig. 171).[30] While the polo scene is animated but conventional, here we see an audacious composition where the bird captures all the attention by its fantastic form as well as exploding energy. As has been noted, in their flat, two-dimensionality, the bold figural forms and pictorial naïveté they seem to reflect memories of the fifteenth-century Sultanate style in the Indian plains.

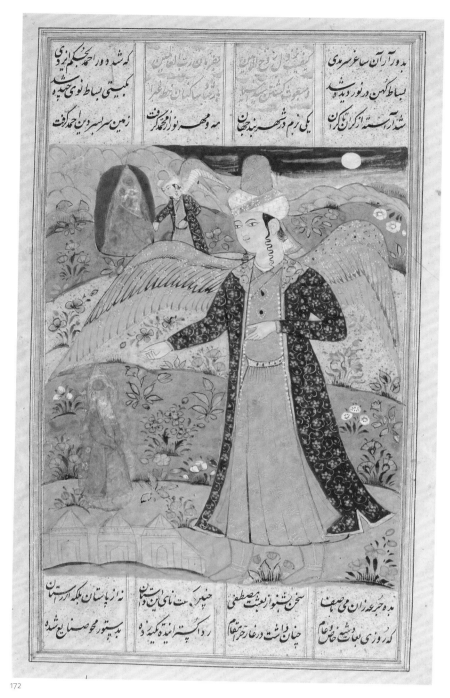

172

FIG. 172 ✤

The Archangel Gabriel (Unidentified Poetic Chronicle), eighteenth century
Opaque watercolor and gold on paper
H. 9 17/32 x 5 21/32 in. (24.3 x 14.4 cm)
San Diego Museum of Art,
Edwin Binney 3rd Collection
1990:1467

The same kind of romantic exuberance, dominant figural forms and pale, subdued colors characterize a solitary illustration of a page from an unknown poetical chronicle now in the Binney collection in San Diego (fig. 172). A work of the same vintage as the two *Shahnama*-s, the subject is the archangel Gabriel walking against a delightful landscape of layered, rising ground in multiple pastel shades adorned with vegetation. The proclivity to vivacious ornamentation and bold design reach their apogee in two pictures of the second half of the eighteenth century.[31] Enlivened with boldly scrolling robust vines, the complex compositions show angels riding a composite horse and an elephant, a variation of the *nārīkuñjara* motif noted by Shrivara in the reign of Zain-ul-Abidin mentioned earlier

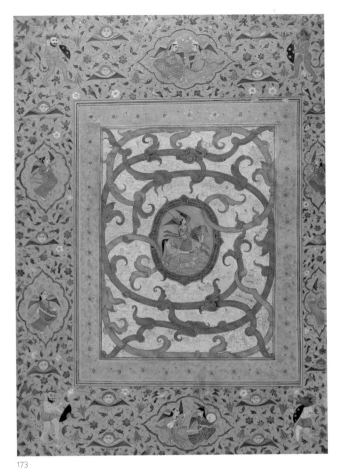

173

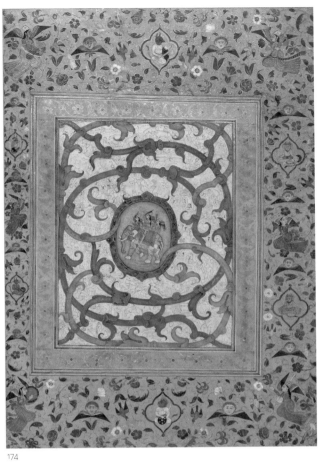

174

FIG. 173 ❖
A *peri* riding a composite horse surrounded by an acanthus-scroll border
The Pierpont Morgan Library, New York.
Gift: J.P. Morgan (1867–1943); 1924
MS M.458.14

FIG. 174 ❖
Three *peris* ride a composite elephant, surrounded by an acanthus-scroll border
The Pierpont Morgan Library, New York.
Gift: J.P. Morgan (1867–1943); 1924
MS M.458.15r

(figs. 173, 174). The surrounds too are richly adorned with lively angels, demonic figures, birds, and flowers of lush abundance. While the angels or composite animals appear to have been particularly popular among Kashmiri artists of the eighteenth century, the surrounds of these two paintings anticipate the themes and patterns that are used with unabashed abandon in luxury objects in the following century (fig. 210, ch. 9).

Paintings in a variety of media provide a rich source for the study of an Islamic graphic tradition of this period. Ceilings and furniture, luxury and tourist objects, as well as books and their covers, were produced in abundance, especially after the establishment of the Dogra dynasty and the valley's increasing popularity as a summer resort with both the British and the Indians. Manuscripts continued to be produced for the gentry, but few are aesthetically exciting. A detached picture in the Binney collection, however, is noteworthy (fig. 175), as it shows Kashmiri artists' continued fascination with the Persian visual tradition, a sense of whimsy and the complete disregard for European pictorial devices that were so deftly absorbed in the neighboring hill states.

Apart from illustrating books for the Muslims, Kashmiri artists also had commissions from the Pandit and Sikh communities. Some of these may have been produced in the Valley and others in Jammu and Lahore (now in Pakistan). Whether or not they were all rendered by Kashmiri artists, they are closely related to the Islamic manuscripts in their format as well as style. Bolder in coloring with a penchant for gold, pink and rich blue, they reveal the same taste for floral and ornamental borders as the Islamic works. J. P. Losty has noted as least one manuscript of a section of the Hindu epic *Mahābhārata* that was partially painted by a Kashmiri artist in 1692 for a Punjabi patron.[32]

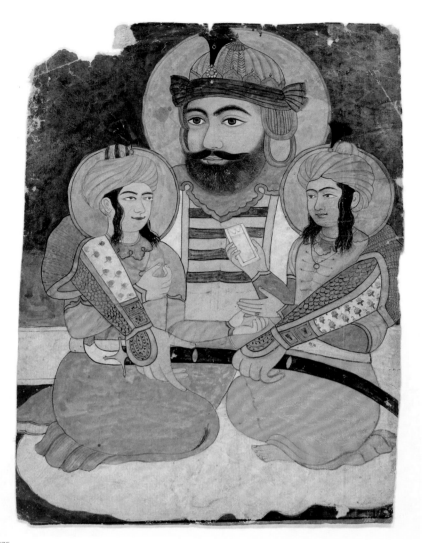

175

FIG. 175 ✿
Hazrat Ali with two sons, nineteenth century
Opaque watercolor and gold on paper
H. 9 7/8 x W. 7 5/32 in. (25.1 x 18.2 cm)
San Diego Museum of Art,
Edwin Binney 3rd Collection
1990:1468

Most surviving examples of illustrated manuscripts commissioned by the Hindus are
of religious and devotional subjects and belong to the eighteenth and nineteenth cen-
turies. Among the more interesting and attractive are a *Devimahatmya* in the Rietberg in
Zurich and a manuscript of devotional texts and divinities now in the British Library. As
perceptively noted by Losty "in Kashmir there occurred in the 18th century a spontaneous
synthesis, in which Hindu manuscript illumination came closest to Muslim".[33]

One of the most sumptuous and brilliantly illuminated manuscripts in the Kashmiri or
what has been characterized as the "Sikh-Kashmiri" style is the tenth book of the Granth
Sahib, the holy book of the Sikhs completed in 1839 (fig. 176). As a matter of fact, it is equally
interesting for its liberal inclusion of Hindu iconography as well as such ostensibly secular
subjects as the *Rāgamālā* (Garland of Ragas) in what is clearly the Pahari style. One wonders
if several artists trained both in the Kashmiri and the Pahari traditions did not work on this
fascinating and attractive manuscript.

Clearly both Sikhs and Hindu patrons in Kashmir as well as neighboring Punjab were
seduced by the dazzling decorative affects of Korans and the Islamic illustrated books.
It should be mentioned that while the Sharada, Gurmukhi, or Nagari scripts were written
by Hindu scribes, the pandits were equally deft with Arabic calligraphy as will be discussed

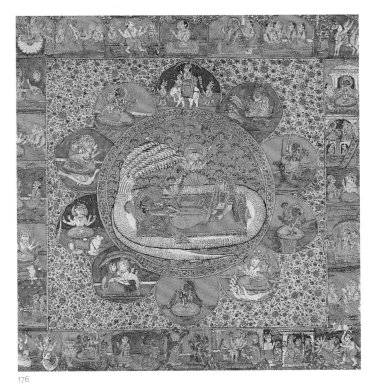

176 177

FIG. 176 ❖
Painting from the Guru Granth Sahib, 1839
(dated)
Reclining Vishnu with Avatars
H. 19 1/8 x 16 15/16 in. (48.5 x 43 cm).
National Museum of India
59.155/3

FIG. 177 ❖
Vishnu with other gods, about 1800
Colors on cloth
H. 38 x W. 29 in. (97 x 73.5 cm).
Central Asian Museum, Srinagar

below. In any event, Kashmiri style pictures and illumination are encountered in manuscripts produced in the state of Jaipur in Rajasthan. Apparently, Maharaja Jai Singh II (r. 1700–1743) eager to build up the royal library invited Kashmiri pandits to his court, "to bring the standards prevailing in Kashmir to the plains."[34] A profusely illustrated *Devimahatmya* (fig. 177) may represent an example of the illustrated manuscripts produced in Jaipur by Kashmiri pandits. The pictures are stylistically similar to those in a *Gītagovinda* manuscript copied in Kashmir by Mahtab Raya.[35]

More distinctly Kashmiri in style is a long narrow scroll of texts and pictures executed in thin but finely burnished paper for which the valley was renowned (fig. 179). While rolled illustrated texts on cloth were familiar in India from much earlier eras, the use of paper, the minute writing of the text, and the exuberant decorations reflect Islamic influences. A similar roll in the British Library represents text and illustrations form the *Bhāgavatapurāṇa* but here the subject is cosmological.[36] Both the text, written in the Sharada script, and illustrations describe and depict the various energy centers of the human body known as *chakra*-s. A luxuriant document of Hindu iconography and yoga, it is an aesthetic tour de force both for penmanship and painting. The text and the illustrations are beautifully and skillfully integrated and harmonized into a rich tapestry of colors and gold.

In comparison to illustrated manuscripts, relatively few detached pictures of Hindu subjects have survived. However, they do demonstrate that a style of painting developed in Kashmir that had more to do with the paintings in the neighboring hill states to the east than to the late Mughal style of the manuscripts. One of the earliest and most attractive is an arch-shaped painting of a fairly large size depicting various forms of the goddess with Sharada inscriptions, flanking an orange panel containing a gold seed letter (*bīja*) with deities, surmounted by a crescent moon enclosing an image of Shiva (fig. 6, ch. 1).

Closely related stylistically is a large paṭa painting, similar to those seen more commonly in Nepal and Tibet (fig. 178). The center of the composition is occupied by Vishnu with two spouses seated on the outspread wings of his mount Garuda. But ecumenically

178 a

Fig. 178 a–c ❉
Folios from a *Devimahatmya* manuscript,
Nineteenth century
Colors on paper
H. 8 x 4 in. (20.3 x 10.2 cm) (each folio)
Private collection

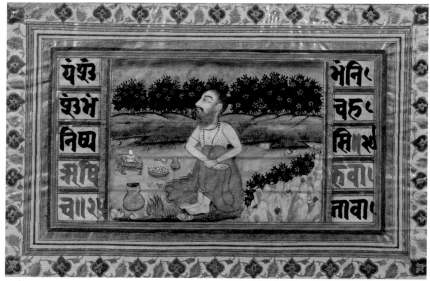

178 b

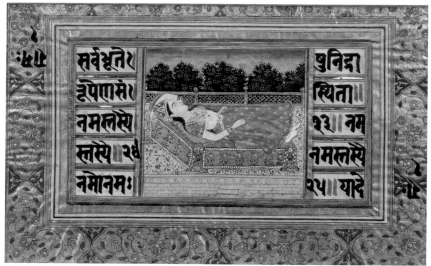

178 c

179

180

FIG. 180
Base of the Buddha, about 730
(detail of fig. 45, ch. 4)
Brass
Potala Collection, Lima Lhakhang;
inv. no. 407

FIG. 181 ✤
Holy Quran Bound with Floral Lacquer Covers,
eighteenth century
H. 15 x W. 6–8 in. (38.1 x 15.2-20.3 cm)
National Museum of India
70.29

181

the goddess with her lion mount and Shiva are included above and their sons Ganesh and the six-headed Kumara with their respected mounts the rat and the peacock below. The same *bijamantra* as in the Devi picture is above the throne's golden umbrella. Almost certainly both paintings are from the same workshop and were probably rendered around 1800. The deft drawing of the figures, the assured manner of applying the colors and gold, the attention to details and the confident rendering of the animals—the fish, the felines, and the snake—are clear indications of a master artist familiar with contemporary Pahari tradition.

— The entire issue of the relationship between Kashmiri painting and the Pahari schools need to be researched. We have mentioned that at least one if not two Kashmiri artists worked on a *Shahnama* manuscript executed in 1695 in Kangra. Evidence has also come

FIG. 182
Original carved inscription
at Madin Sahib Mosque from the time
of its foundation in 1483 (see fig. 131)

FIG. 183
Glazed tile inscriptions of the seventh
century on the Madin Sahib Mosque
(see fig. 145 a, b)

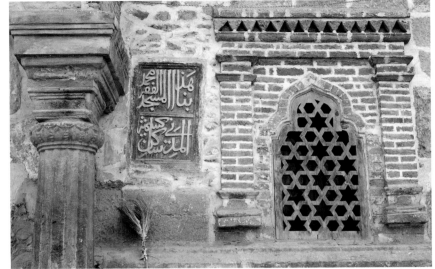

182

183

to light that Pandit Seu, regarded as the originator of the so-called Guler school of paint-
ing in the early eighteenth century, was a Kashmiri brahman.[37] Thus, even if the art of
painting in the valley did not match the brilliance of the diverse and prolific production of
the Pahari schools in this period, from the Mughal period, Kashmiri artists and scribes did
travel, like poets and writers of the ancient period, to leave their marks in distant parts
of the subcontinent.

Calligraphy

We do not know when exactly Kashmiris began writing but likely the practice was
encouraged by the needs of the Buddhists. Although the Chinese pilgrim Faxian (about 400)
is silent about copying books, his more illustrious follower Xuanzang (seventh century)
had a number of scribes at his disposal. The type of Kashmiri script his scribes used would
have been similar to that seen in the inscription on the base of the Priyaruchi's brass
Buddha (fig. 180).[38] A few years later the Tibetan mission arrived to adopt this script for
their own language (fig. 113, ch. 5). However, no early manuscripts have survived from
Kashmir or elsewhere with this early Kashmiri script, or with the later Sharada script.
Examples of Sharada script of the ancient period can be found in epigraphs and inscrip-
tions on metal images and of the Sultanate period even on Islamic tombs.[39] While these
inscriptions are sometimes visually attractive, they do not constitute conscious efforts in
the art of calligraphy that one encounters in Islamic and east Asian cultures.

It has been appositely stated that "Arabic script is the central form of Islam's arts and was the foremost of its characteristic modes of visual expression."[40] One might add that the practice of calligraphy is also a spiritual experience for the Muslim. Apart from expressing his personal piety, the calligraphic exercise combines both beauty and truth in the most graphic manner. The Quran itself encouraged the spiritual significance of penmanship when it stated,

The Lord is the Most Bounteous,
Who teacheth by the pen,
Teacheth man that which he knows not.[41]

To a pious Muslim, the revelations by Allah in the Quran constitute eternal truth for all humanity and the book itself is sacred. Its appearance, therefore, had to be aesthetically pleasing. Hence, not only is it written carefully but embellished suitably with sumptuously illuminated frontispieces and chapter headings (fig. 181).

The penchant for beautiful penmanship and exuberant decoration was extended to non-religious literary works as well. Moreover owning examples of calligraphic exercises was considered de rigueur for a cultured person, especially in Persia, and hence the preparation of albums with specimens of painting and calligraphy.[42] Indeed, penmanship was considered an essential trait of a refined person. Thus, a correctly and beautifully written page is compared to a garden in full bloom and fine handwriting is said to be "jewelry fashioned by the hand from the pure gold of the intellect."[43]

Although the art of calligraphy in Kashmir has yet to be thoroughly studied, even the few examples included here clearly indicate both the virtuosity and the imaginative flair of Kashmiri calligraphers. While fine penmanship is appreciated in other cultures as well,

Fig. 184
Carved tombstone of Seda Khan, dated 1484.
Cemetary attached to the *ziarat*
of Bahauddin, Srinagar

184

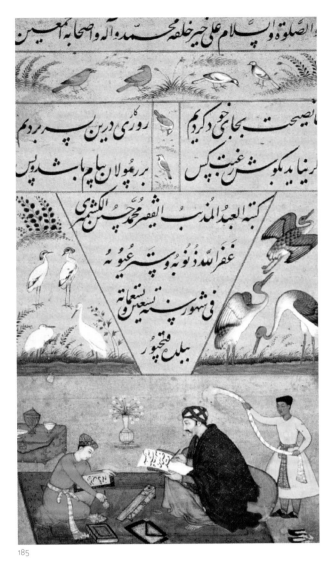

185

only in the Islamic world did the form achieve the kind of monumental grandeur that distinguishes the religious architecture. In this area, of course, the peculiarity of Kashmiri mosques and mausoleums are exceptions. However, a large stone stele from Zain-ul-Abidin's time demonstrates that, if required, Kashmiri sculptors could rise to the occasion (fig. 129, ch. 6). The inscription recording the foundation of Zainalanka is a robustly carved example of the bold *thuluth* script in high relief that matches the solidity of the stele. Divided into four horizontal registers with wide plain bands the letters twist and intertwine across the surface creating complex arabesque-like forms.[44]

Other specimens of the Sultanate period calligraphy survive on the Madin Sahib mosque.[45] Noteworthy is the stately inscription in white two-tiered *nasta'līq* script carved with elegance and clarity that is now stuck on the wall (fig. 182). A second example of calligraphy, this time in wood, adorns the lintel above the doors of the porch (fig. 144, ch. 7). Both inscriptions are from the time of the mosque's foundation. Painted inscriptions of the same date can also be discerned faintly above the brighter colored and glazed tiles with inscriptions written in bold, elegant *nasta'līq* script of the Shah Jahan period survived on the side of the porch (fig. 183). Dedicatory inscriptions in Mughal and later period structures are more abundant. But one fascinating tomb inscription in both Arabic and Sharada script among several in the Valley must be mentioned before we leave the Sultanate period. It is carved on a grave in a cemetery surrounding the *ziarat* of Bahauddin at Hariparbat in Srinagar (fig. 184). Its Hijri date corresponds to 1484 CE and it records the death of one Seda Khan—son of Ibrahim—who died in a battle in the reign of Mummad Shah (r. 1484–1537 intermittently).[46] Apart from its interesting contents, it presents fine specimens of both scripts and may have been carved by the same engraver.

In a page from the manuscript of the *Gulistan* of Sadi (fig. 185) two artists are shown seated at work on a carpet. The older person draped in a shawl is Muhammad Husayn Kashmiri and the younger pupil is Manohar the son of Basawan, one of the preeminent artists of Akbar's atelier, and responsible for the painting. Apart from the fact that one can also see a pen box, a bound book, and some food containers on a table, a servant stands behind the master with a fan. What is also interesting is that Manohar, who was a painter, should feel it necessary to take lessons in penmanship from the calligrapher.

The text was copied by Muhammad Husayn in 1581 at Fatehpur Sikri near Agra. An early recruit to the imperial atelier, his earliest known work is dated in 1560. His Kashmiri mentor was Maulana Abdal Aziz and both may have worked for Miraza Haidar Dughlat who may have brought the talented young Husayn to Humayun's attention. According to Abu'l Fazl Muhammad Husayn had surpassed his master and contemporary connoisseurs considered him to be equal to the Persian Mulla Mir Ali, the legendary inventor of the *nasta'līq* script.[47] Abu'l Fazl particularly points out that Husayn's "*maddat* [extensions] and *dawā'ir* [curvatures] show everywhere a proper proportion to each other" and he would know.[48] Indeed, so admired was Muhammad Hussain's penmanship that he was favored with the honorific *Zarrinqalam* (golden pen) by Akbar.

186

Apart from showing Zarrinqalam's delicate and elegant style of writing above the portraits, the page also demonstrates the interplay and integration of calligraphic and pictorial elements in a coherent composition. Two other examples of the master's penmanship included here reveal the extraordinary diversity of the arrangements and disposition of the letters within a composition. One of these is a gold sprinkled page meant for an album (fig. 186). In six aslant lines of *nasta' līq* the calligrapher has interposed two different sizes of letters to create a lively composition discreetly embellished with birds, floral scrolls, and gold cartouches bookending the vertically placed line. The poetry is by Amir Shahi, a well known poet of Timurid Persia.

More fascinating, however, is a second page of more elaborately arranged calligraphic panels almost like a square mandala (fig. 187). Much larger in size than the page of poetry, it also uses colors and gold besides ink to create a more sumptuous effect. All this effort is simply for a letter informing Asaf Khan of his visit to the emperor. The meeting took place in Lahore, where Jahangir usually halted on his way to and from Kashmir.

At least one other Kashmiri calligrapher worked for Akbar and was worthy of a mention by Abu'l Fazl.[49] Other than his name, Ali Chaman, I have been unable to find any information about him or samples of his work. Names of a few other Kashmiri calligraphers are known but almost certainly some of the most competent must have worked for the Mughal royalty and their governors as well as Kashmiri patrons. One was Abdal al-Rahman, the son of Ali al-Kashmiri who, while visiting Mecca, copied a manuscript of holy sites in Mecca and Medina in Arabia.[50] Unfortunately, the name of the copyist of the 1695 *Shahnama* in Kangra is unknown. Nor do we know the names of the calligraphers responsible for the beautiful specimens of calligraphy used in the Madin Sahib mosque (fig. 182). The paintings and calligraphy with which Shah Jahan adorned the stone pavilion in the Shalimar garden that Bernier admired have also disappeared. The calligraphic panels must have looked something like the fragmentary examples in the Madin Sahib or the fine *nasta' līq* on a rare lamp of the seventeenth century (fig. 199, ch. 9). A great deal of manuscripts have survived from the eighteenth and nineteenth centuries though detached calligraphic specimens are few. A nineteenth-century marriage contract (fig. 188) provides a dazzling glimpse of the art of Islamic illumination in all its golden splendor.

Like the Sanskrit poets of the ancient period, Kashmiri scribes were in considerable demand in other parts of the subcontinent. Lahore was of course geographically the closest center of patronage, but Kashmiri calligraphers sold their work as far away as Calcutta (now Kolkata) in the east and in the south. This was true of both Hindu and Muslim scribes. Significantly, the pandits were as proficient in Arabic calligraphy as their Muslim counterparts, though the reverse was not true. To cite one example, three

FIG. 186 ❖
Muhammad Husayn al-Katib (Zarrinqalam), about 1560–1620
Page of calligraphy
Album leaf; ink, colors and gold on paper
H. 8 3/4 x 4 in. (20 x 10 cm)
The Metropolitan Museum of Art, Purchase, Richard S. Perkins, Ehsan Yarshater and Patti Birch, in memory of Everett B. Birch, Gifts, 1993
1993.380

FIG. 187 ❖
Muhammad Husayn al-Katib (Zarrinqalam), about 1560–1620
Letter from the calligrapher to Asaf Khan about an interview with Jahangir, 1614–1620
Ink, colors, and gold on paper
H. 17-1/4 x W. 12-15/16 in. (43.9 x 32.7 cm) (overall dimensions)
The Metropolitan Museum of Art, Anonymous Gift, 1994
1994.360

>>
FIG. 188 ❖
Nika (Marriage) contract, nineteenth century
Ink, colors, and gold on paper
H. 16 15/16 x W. 10 5/8 in. (43 x 27 cm)
Central Asian Museum, Srinagar
95.2

manuscripts of Islamic subjects were copied in Lahore between 1869 and 1873 by Pandit Daya Ram Kaul popularly known as Tota (parrot).[51] The nexus between Lahore and Kashmir began as far back as Akbar's time and received further impetus during the Sikh occupation of the valley. However, the close cultural relationship was not confined only to carpet and shawl manufactures but extended to other areas of visual art, especially painting and calligraphy. Part of this connection is explored in the chapter on textiles in this book.

This brief excursion into the story of Kashmiri calligraphers can be brought to a close by mentioning a colophon in a manuscript of *Dīvān* (collected poems) of Nawab Yusuf Alikhan,[52] the nawab of Rampur (in Uttar Pradesh) from 1855 to 1875. However, the manuscript was copied in Lahore by Muhammad Nazir 'Ali ibn Sayyid 'Iwad 'Ali Gardizi, and illuminated by Muhammad Hasan ibn Mulla Muhammad 'Ali, called *khūshnavīs Kashmiri*. The expression *khūshnavīs* denotes a calligrapher. Interestingly, he is characterized as a great expert on lapidary work, coloring, and gold work, and regarded as a peer of Mani (a legendary instructor of painting in Persia) and equal of the greatest Persian painter, Bihzad.

So the author of the book was a nawab of Rampur, the scribe was from Gardiz (Afghanistan), and the illuminator was a Kashmiri. What a small world it was!

188

1. Dutt, *Rājataraṅgiṇī of Jonaraja*, p. 427.

2. Nadou, *Buddhists of Kashmir*, p. 258.

3. Ibid., p. 257

4. For instance, Kashmiri painters could have been recruited by Guge royal patrons for fifteenth-century murals.

5. Dutt, p. 83. "Then the king, who had gone through all the circumstances of life, and who knew all things placed Tilakacharya the Buddhist in the highest position." It would be most unusual if the minister did not support Buddhist establishments. The historian Shrivara also informs us that "the King saved the golden image of Buddha from the Yavanas by issuing severe orders." (Ibid., p. 84).

6. Goepper and Poncar 1995, p. 230. Also see Goepper 1995 for a detailed discussion of the painted textiles of the Alchi murals of about 1200 which further point to Kashmir as the likely source for these paintings.

7. See Introduction for presence of Jains in Kashmir. However, apart from religious works, literary and rhetorical texts, some illustrated, must have been familiar.

8. The tradition of painting ceilings with textile patterns so prominent in the Alchi structures and also in nineteenth-century buildings may well be reflected in the following statement of Shrivara: "Other clothes were made, on which variegated plants were produced by various methods of weaving, which painters saw and remained dumb with wonder." (Dutt, p. 151).

9. Dutt, pp. 150–51.

10. Dutt, ibid. Hasan (2005, p. 284) was incorrect in identifying Mullah Jamil, mentioned in the *Tabaqat-i-Akbari* of Nizamuddin (sixteenth century), as a painter. He was in fact a musician as pointed out to me by Simon Digby.

11. Dutt 1986, p. 177.

12. Hasan 2005, p. 284. It is interesting to note that in 1911 Vincent Smith mistook the *Hamzanama* pictures as examples of Kashmiri painting under Mizra Haider Dughlat. See H. K. Kaul 1998, p. 336.

13. See Verma, *Mughal Painters and Their Work*. Their names are Muhammad Pandit, Muhammad Kashmiri, Ismail Kashmiri, Haidar Kashmiri, Ibrahim Kashmiri, Salih Kashmiri and Yaqub Kashmiri, all of whom worked for Akbar. Only one Kashmiri painter of the Jahangiri period is known from a painting of a fighting cock in the Cleveland Museum of Art. The name is Dilram Pandit Kashmiri, which is a Hindu name. However, Linda Leach (*Mughal and Other Indian Paintings from the Chester Beatty Library*, vol. 1, pp. 374, 431) suggests that two other artists, Muhammad Khan and Jalal Quli, may also have been Kashmiris.

14. As quoted in Hasan 2005, pp. 284–85.

15. Rogers and Beveridge, *Memoirs of Jahangir*, vol. 2, pp. 161–62. See Leach, vol. 2, pp. 817–18, 927–38, 962–67. I am also indebted to Robert Skelton, Navina Haidar, and Simon Digby for sharing their ideas generously.

16. Das, 1978.

17. Rogers and Beveridge, vol. 2, p. 145.

18. See Verma 1999, pp. 12–14, fig. 2.

19. I am indebted to Dr. Kimberly Campbell and to Kathy Musial and Dylan Hannon, curators in the Botanical Division of the Huntington Library at Pasadena for identifying the flower as *Sternbergia fischeriana*, native to Kashmir.

20. Samarqandi's exact dates are unknown but he was active about 1650. For the inscription where he describes Kashmir as "paradise" see Leach, vol. 2, p. 934.

21. For a thorough discussion see Leach, vol. 2, pp. 927–38. In a recent communication (Nov. 23, 2006) Robert Skelton informed me that the date 1651 given by Leach for the Beatty *Yusuf* manuscript was based on an erroneous reading by him but that does not negate a date around 1650 in view of the Khalili *Hafez* manuscript dated 1653.

22. Leach also suggests that Muhammad Khan Abbasi was in Kashmir (see Schmitz 1992, pp. 78–79).

23. Leach, op. cit., p. 966.

24. See Falk and Archer, *Indian Miniatures in the Indian Office Library.*

25. Pinder-Wilson 1957, for a detailed study of the manuscript. Pinder-Wilson, and following him all subsequent authors, have taken the manuscript to contain a single *mathnavi*. But, as Dr. Ziauddin Desai has shown in a forthcoming article for *Marg*, it includes two separate *mathnavi*-s. The attribution to Bishandas was by Beach (1978, pp. 110–111) and concurred by Losty (1982, p. 101). Marginal notes on the manuscript discovered by Desai also confirm that Bishandas was the sole painter.

26. Pinder-Wilson 1957, pl. 7, fig. 19.

27. Leach, op.cit., pp. 1034–42.

28. Hickmann 1986; Schmitz 1992; K. Goswamy 1989

29. From a manuscript in the New York Public Library, see Schmitz 1992, p. 186 and pl. XIV.

30. This manuscript was in the collection of Sam Fogg. See Sam Fogg, *Islamic Manuscripts*, cat. 22 (London: Sam Fogg Rare Books and Manuscripts, 2000), no. 52. Present location not known. For a third *Shahnama* of 1719 in an eclectic style see Losty 1982, pp. 141–43. In some ways it is the most interesting and it was copied in Rajaur on the route to Kashmir from Sialkot via the Pir Panjal pass.

31. Schmitz 1997, pp. 158–59. See pl. 49 for another picture of a *peri* riding a composite lion of about 1775.

32. Losty, p. 119, pp. 142–45 for other eighteenth-century Kashmiri illustrated manuscripts.

33. Losty, p. 143.

34. Ibid., pp. 120, 142–143 for the eighteenth-century manuscript in the British Library and K. Goswamy, 1989, for the Rietberg Devīmāhāmtmaya manuscript. See also Goswamy 1998.

35. Ibid., p. 144, no. 28 for this manuscript.

36. Ibid., p. 121, illustration, and p. 145.

37. I am indebted to Vijay Sharma of Chamba for this information (personal communication Dec. 12, 2006).

38. See Losty, p. 29, cat. no 1 for Gilgit manuscript page.

39. Deambi 1982 for Sharada inscriptions.

40. Welch 1979, p. 32.

41. Ibid.

42. For one such Kashmiri album with better specimens of calligraphy than painting now in Dresden, see Hickmann 1986.

43. As quoted from Franz Rosenthal, "Abu Haiyan al-Tawhidi on Penmanship," *Ars Islamica.* 13–14 (1948) by Welch, op. cit., p. 25.

44. The inscription describes the foundation of one of the buildings on the Lanka island in Wular Lake discovered by Archibald Constable, the editor of the Irving Brock's translation of Bernier's work. The following translation is by H. S. Jarret.
 May this edifice be as firm as the foundations of the heavens,
 May it be the most renowned ornament of the universe.
 As long as the Monarch Zayn Ibad holds festival therein
 May it be like the date of his own reign—
 'happy.'

45. Examples of stone inscriptions are also preserved in the Sri Pratap Singh Museum, Srinagar.

46. See Deambi 1982, pp. 128–130. Ibrahim is characterized as *suratrāna* (sultan) and may have been either Ibrahim Shah who ruled briefly in 1555 or Ibrahim Lodi of Delhi, as suggested by Dr. Aijaz Bandey of Central Asian Museum, Kashmir University, to whom I am grateful for showing me the grave.

47. Bernier 1972, p. 417. The relevant passage is quoted in Seyller 2001, pp. 39–40 and 43.

48. In his inventory of the master's other known surviving examples of calligraphy, Seyller (ibid., p. 43) does not include these two documents. Jahangir also esteemed the calligrapher's work highly .

49. Blochman 1939, p. 109.

50. Schmitz and Desai 2006, p. 217.

51. Ibid., pp. 145–47.

52. Ibid., pp. 144–45.

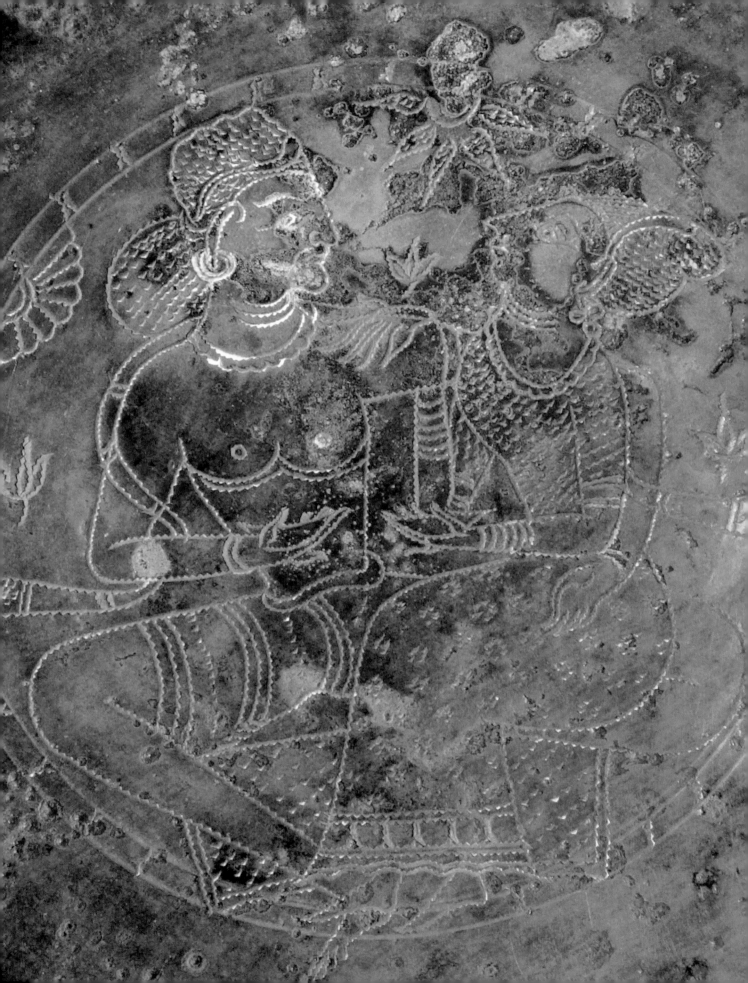

THE ROMANCE OF KASHMIRI CRAFTS

By Pratapaditya Pal

Since at least the nineteenth century, the crafts of Kashmir have been more popular both on the Indian subcontinent and abroad than any other regional crafts of South Asia. Painted, carved, or lacquered wood and papier-mâché objects, chased and enameled metalwares are still abundantly produced by Kashmiri craftsmen and are encountered in handicraft and curio shops in all Indian cities and even modest towns. Unfortunately, the history of these crafts is difficult to trace as most surviving material in public and private collections cannot be dated earlier than the nineteenth century.

What the demand of Kashmiri handicrafts was before the nineteenth century and beyond the valley cannot be properly gauged, because of a lack of both evidence and proper inventory and records. However, incidental literary references and European travelers' accounts do provide some information about handicrafts, though understandably the shawl has received the lion's share of attention. Apart from Mirza Haidar Dughlat's comments quoted by Digby,[1] there is an informative passage in the sixteenth century *Tabaqat-i-Akbari*, by Nizamuddin Ahmed that provides some idea of the crafts of the valley during Zain-ul-Abidin's reign. Pleased with the gifts sent to him by the ruler of Khurasan in Central Asia, the Kashmiri sultan reciprocated with "donkeyloads of saffron, paper, musk, shawls and cups of glass or crystal and other wonderful products of Kashmir."[2] Alas, no shawls, glass or crystal from the period have survived.

Among travelers' accounts, one of the most extensive is the following passage written in 1665 by Francois Bernier, who visited Kashmir in the train of Emperor Aurangzeb:

> They [Kashmiris] are also very active and industrious. The workmanship and beauty of their *palkeys* [litters], bedsteads, trunks, inkstands, boxes, spoons, and various other things are quite remarkable, and articles of their manufacture are in use in every part of the Indies. They perfectly understand the art of varnishing, and are evidently skillful in closely imitating the beautiful veins of a certain wood, by inlaying with gold threads so delicately wrought that I never saw anything more elegant or perfect.[3]

Two points are noteworthy in this encomium from the observant Bernier who was a person of aesthetic sensibility: That Kashmir produced a wide variety of furnishings and woodwork and that the objects were in demand across the far-flung Mughal Empire.

While only a few objects are known to have survived from the ancient period, some general information is provided by literature and the sculptural art. Although most of the ruined buildings of the valley are in stone, we do know that wood was a popular material for the construction of secular buildings and boats. As Siudmak has pointed out in chapter

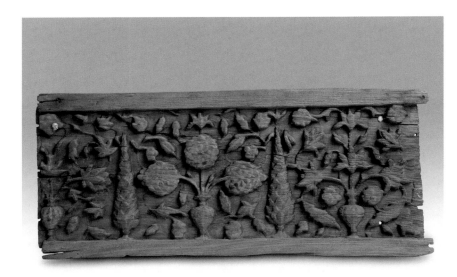

189

<<
Detail of fig. 194, ch. 9

FIG. 189 �֍
Panel with cypresses and flowering vases,
seventeenth century
Wood
H. 27 x W. 12 in. (71 x 31 cm)
Private collection

FIG. 190
Shirt sword, mid-ninth century
Avantipur
Iron
L. 13 in. (33.5 cm)
Sri Pratap Singh Museum, Srinagar

190

tthree, evidence of earlier wood structures is embedded in the lithic architecture that remains. Kalhana also provides some sketchy information about the use of timber, which was the principal material for domestic architecture, as well as for boats—the chief mode of transportation down the Vitasta, the lesser rivers and the lakes—and for building bridges. An idea of the skill and beauty of the timber structures of the valley can be formed from the fortunate survival of miniature shrines for Buddhist images (figs. 41, 42, ch. 3), from temple facades in Ladakh and Chamba. For the Sultanate period the original door of the Madin Sahib mosque (fig. 144, ch. 7) gives some idea of the fifteenth-century woodwork, while a panel from the seventeenth century is a fine specimen of typical Mughal design encountered usually in stone (fig. 189).

Another material that the ancient Kashmiris excelled in carving was ivory. Although not large, the group of surviving ivory sculptures from the valley provides ample evidence of the ivory carvers' mastery of this delicate medium as early as the eighth century (figs. 57, 58, 61, ch. 4). While Brahmanical patrons appear to have been averse to the use of ivory for sacred functions, other types of carved ivory products must have been popular with wealthy patrons. Objects such as flywhisk handles and other regalia, mirror handles

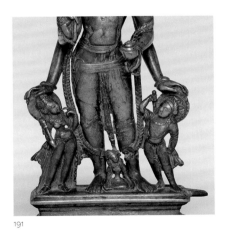

191

192

193

FIG. 191 ✤
Detail of fig. 75, ch. 4 showing short sword

FIG. 192 ✤
Detail of fig. 91, ch. 4 showing bell

FIG. 193 ✤
Detail of fig. 106, ch. 5 showing drinking cup

and combs, jewel boxes, and furnishings such as bedsteads and thrones must have used ivory in great quantities, as is known from literature and other regions of the subcontinent.[4] The absence of later ivory work in Kashmir is indeed surprising.

Material for metalwork in Kashmir is rich enough to deserve a monograph. A large body of sculpture in copper and brass, the preferred material, has survived, which has been discussed elsewhere in this book. Apart from using a wide variety of metal alloy, Kashmiri metalworkers were particularly skilled in the art of inlay.[5] That the Kashmiri metalwork technology was highly sophisticated is evident not only from the few large sculptures published here (fig 47, ch. 4), but also from Kalhana's description of colossal metal images of copper, gold and silver during the reign of Lalitaditya in the eighth century. Kalhana refers to a few other metal objects, such as daggers, lamps, golden jugs for lustrating monarchs, silver lamps, ornaments and tiaras, which is only a small fraction of the enormous quantities of domestic and ritual paraphernalia necessary for daily use. Only one metal sword of the period has been excavated which shows rather a simple form (fig. 190). The short dagger frequently worn by Vishnu, and in one instance by Surya, is also rather simple with no embellishment (fig. 191). Vishnu's club has a distinctive form peculiar to Kashmir but whether it is a true reproduction is doubtful. Other weapons and emblems held by the deities such as the bell (fig. 192) are probably realistic representations. Noteworthy are the fluted bowl and the mirror held by Parvati's left hands in two instances (figs. 83, 84, ch. 4). In the Kamadeva relief one can glimpse the shape of a drinking cup in the god's right hand which is a simple shallow bowl (fig. 193). Fortunately, a similar shallow bowl, undoubtedly meant for noble lips, has survived, with etchings on the interior depicting a couple engaged in animated conversation. Ostensibly excavated in the Gilgit region, it could well reflect Kashmiri forms (fig. 194).

From Kashmir proper, only two metal objects of the period have survived. One is a censer (fig. 195) and the other a pot (fig. 196). In view of the limited number of known Indian censers, it is certainly the most elaborate and unusual. It represents a genuflecting four-armed celestial supporting a richly decorated bowl with a lid that has an aperture at the apex for the aromatic smoke to escape. Thus, apart from showing the form of a censer, the object also exemplifies an actual bowl with cover. Because of the preponderance of floral decoration and other clues, Simon Digby has identified the figure as Pushpadanta, the chief of *gandharvas* (mythological servitors of divinities) and a devotee of Shiva.[6] Although a solitary example of a ritual implement, it certainly reflects the ingenuity of the Kashmiri artisan's ability to combine form, function, and myth.

Correctly given a Kashmiri attribution, the pot is an unusual object though more for its design than its shape.[7] The foot and the shoulder of the pot is decorated with lotus

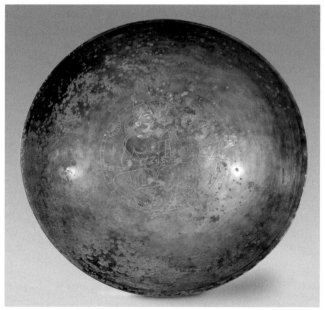

194

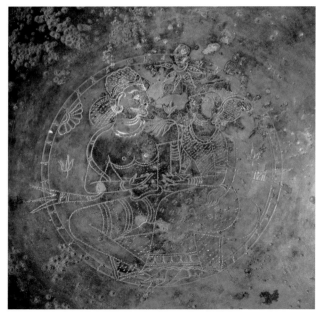

194 (detail)

petals resembling those in Kashmiri bronzes. The row of pearls or beads around the foot and the projecting rim at the top is a popular element in sculpture. More intriguing and engaging, however, is the decoration of the main globular body. The motif, resembling petals or scales or even peacock tail feathers, rises in graduated patterns increasing in size from the foot upwards. Of tawny colored copper alloy, the vessel is likely a product of the late Utpala period (855–1003).[8]

The art of jewelry must also have flourished in ancient Kashmir, for both men and women were fond of ornaments. A large amount of real jewelry also adorned the divine images in the shrines, as they still do in Hindu temples today. Indeed, raiding temple treasures for loot as well as revenue enhancement has always been popular with aggressive monarchs in all civilizations; Kashmir was no exception. So little of this vast amount of jewelry produced in ancient India has survived, we must turn to literature and the visual arts to form a picture about its manufacture. The images, both in stone and metal, are a rich source for the study of jewelers' art for there is no reason to believe that they do not reflect contemporary forms and fashions. Fortunately, two objects have survived that give us a fairly good idea of the kinds of diadems used by Kashmiri royalty. At least two varieties were in use: those with pointed or triangular crests and others with the circular or crescent shaped crests, as indeed we see in the loose pieces that once formed a tiara (fig. 197).

The complete diadem (fig. 198) is a composite of three panels unified by a mobile fringe that would have adorned the forehead.[9] The central panel is the most elaborate with two mythical composite creatures—half-human and half-avian—called *kinnarī*, holding a garland, above which is a large stone (perhaps a garnet) enclosed in a lotus. Each of the flanking panels is occupied by a solitary *kinnarī* holding the garland with both hands. Since the diadem has been discussed elsewhere at length suffice it to say that it is clearly a product showing an eclectic mixture of Indian, Persian, probably Sassanian, and local characteristics. The *kinnarī* with its scrolling avian tail is a favorite motif in Indian art; the knobs along the undulating top edge and the sun and moon symbols at the upper corners of the central panel are taken from Sassanian sources, while the hanging fringe can still be seen in regional jewelry.

FIG. 194
Metal bowl with an etched image of an animated couple
Gilgit, Pakistan
Private collection

FIG. 195 ❖
Censer, ninth century
Bronze
H. 7 9/16 in. (19.2 cm)
Private collection

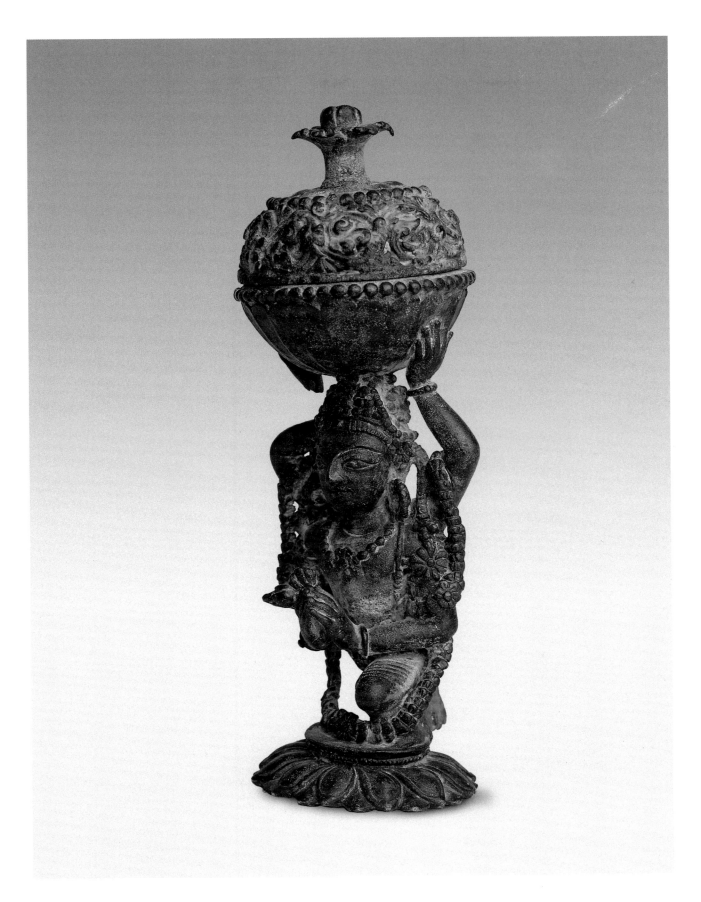

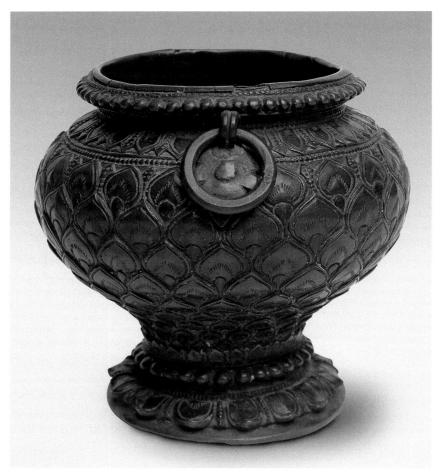

196

FIG. 196 ❀
Lotus vase, eighth century
Metal
H. 4 7/8 x D. 5 1/8 in. (12.4 x 13 cm)
Private collection

FIG. 197
Medallions from a diadem, eleventh century
Gold with glass and semiprecious stones
Larger: H. 3.5 in. (9 cm)
Smaller: H. 2.5 in. (6.5 cm)
Private collection

197

As to the detached pieces of the diadem (fig. 197), the presence of the Garuda with the pot of elixir (*amŗitakumbha*) in the central medallion would indicate that the wearer, presumably a ruler, was a devotee of Vishnu.[10] The other panels have peacocks and lotuses, which is what normally adorns the diadems of Kashmiri images. However, crests enclosing figural forms are common in Gandharan bodhisattva images, and the acanthus

198

FIG. 198 ✿
Diadem with *Kinnari-s*
(half-bird, half-human creatures),
ninth century
Gold inset with garnet
H. 4 5/8 x W. 11 1/8 in. (11.8 x 28.3 cm)
The Metropolitan Museum of Art,
Gift of The Kronos Collections, 1988
1988.395

leaf motif along the top edge also is popular. While the exact date of this gold repoussé diadem, inlaid with glass and semiprecious stones, is difficult to determine, it may well belong to the Utpala period. As Kalhana states, "Ananta's diadem was adorned with five resplendent crescents," and he was partial to Vishnu.[11]

With a few exceptions, most examples of crafts discussed here belong to the nineteenth century. One of the exceptions is a copper lamp of the seventeenth century (fig. 199). Its shape imitates the form of the simple, traditional Indian oil-lamps called *dīpa* or *dīya*, but its decorative design, consisting of arabesque and Arabic calligraphy, was inspired by Islamic culture. Apart from this kind of synthesis, typical of Kashmiri culture, the technique of using tinned copper and the text of the inscription makes a Kashmiri origin of the unique lamp certain. In translation the text reads:

Lamp and mosque and prayer—niche and pulpit—
Abu Bakar and 'Umar [and] 'Uthman and Haydar!
Thanks be to Allah my condition has grown better every moment.
Since the Shayks, Shaykh Hamza has become my guide![12]

The couplets, according to Digby, are the opening lines of a well-known didactic *qasida* in praise of Shaykh Hamza Makhdum Shah by one of his disciples Baba Dawud Khaki (d. 1586).

Typical Kashmiri tinned copper objects consists of pots with lids and dragon handles and large plates or trays. A number of bowls with covers of varied shapes and simple fluted designs are illustrated in an eighteenth-century *Shahnama* illustration (fig. 200). When decorated, the chased pattern is inevitably of very dense floral arabesques. The shapes of the jugs are of both Indian and Persian origins. While a number of specimens acquired in the second half of the nineteenth century are in the Victoria and Albert Museum, an earlier example of the eighteenth century is in a private collection (fig. 201). In 1880, Sir George Birdwood illustrated two handsome vessels belonging to the then Prince of Wales that are made of gold and decorated with "shawl design."[13] Parcel gilt silverwork was also popular with wealthy patrons and Birdwood was particularly generous with his praise. "It is an art," he wrote, "said to have been imported by the Mongols, but influenced by the natural superiority of the people of the Cashmere valley over all other Orientals in elaborating decorative details of good design, whether in metal work, hammered and cut, or enamelling or weaving."[14]

199

FIG. 199 ❖
Lamp with inscriptions,
seventeenth century
Copper
H. 3 3/8 x W. 2 9/16 in. (8.5 x 6.5 cm)
Private collection

FIG. 200
Iskandar with the Sages Illyas and Khirz
(Folio 225r)
Khamsa of Nizami manuscript,
nineteenth century
Opaque watercolor on paper
H. 7 3/8 x W. 5 1/8 in. (6.67 x 1.6 cm)
Los Angeles County Museum of Art,
The Nasli M. Heeramaneck Collection,
Gift of Joan Palevsky

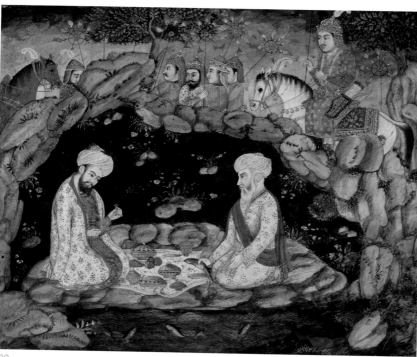

200

Coppersmiths rather than silversmiths created much of the silverware produced for the European market. Recently Wynyard R. T. Wilkinson has given us a succinct survey of Kashmiri silverwork.[15] Most of the surviving objects were made in the 1880s, though one or two specimens can be dated as far back as the 1820s. According to Wilkinson, Kashmiri silverware ranks only behind that of Cutch in northwestern India and was "different both in its style and method of manufacture and in the forms of decoration applied to it."[16] What distinguishes Kashmiri silverware is the strong influence of other local forms and designs on the silverwork. For example, a tea set imitates the form of the *kangri*, a typically favorite chafing vessel made of wicker basketwork caked and lined with clay. Filled with hot charcoal,

FIG. 201
Jug, eighteenth century
Copper
Private collection

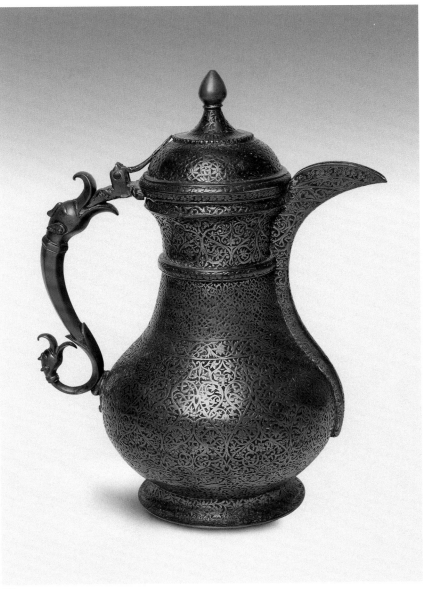

201

the container is carried beneath the garments by Kashmiris for warmth during the long winters and sometimes with disastrous consequences to their bodies. By 1883, as noted by Lockwood Kipling, the father of Rudyard Kipling, the *kangri* inspired salt-cellars and tea-sets such as that in the Paul Walter collection (fig. 202).[17] It is also noteworthy for its pierced and raised mosaic pattern of decoration as well as the complexity of design.

While the "rosette" or "coriander flower" pattern decorates the bodies of the tea-set, two other favorite motifs were the chinar leaf and the "poppy" pattern, seen here in bowls of two different shapes (figs. 203, 204). These floral motifs, as well as the ubiquitous "shawl design" dominated by the "paisley," have in fact remained the staple and discrete decorative motifs for all Kashmiri crafts, no matter what the medium. We encounter them in metal, wood, and papier-mâché, and in endless variety and combination (fig. 205). One of the most sumptuous works is a foliated tray in the Victoria and Albert Museum (fig. 206). For its dazzling gold, the intricacy of its design, and the finesse of its execution as if it is an open shawl, the tray has few equals.

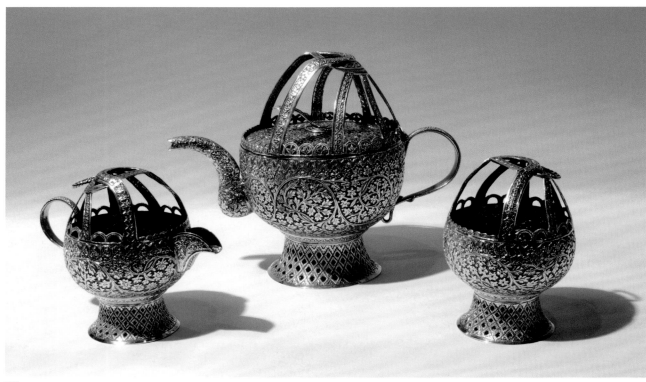

202

Most of the crafts such as enameling and papier-mâché were introduced from abroad, but the Kashmiri artists were quick to adapt them to their familiar, native resources and tastes. A spectacular example of the art of enameling is a portable shrine that was made either for a Hindu or Sikh patron (fig. 207). The design of the shrine with its curved *bangla* (Bengali) roof, imitating the form of the humble hut, has been a staple of both Mughal (e.g. the famous peacock throne of Shah Jahan) and Rajput architecture.[18] The vegetal and scrolling vines, the cypress and the *boteh* (or "paisley") that are accentuated by the brilliant shades of blues with accents of lime green, copper red, and white are all drawn from the local repertoire. That this is a tour de force of the art of enameling is indisputable and justifies the craft historian T. N. Mukherjee's observation of 1888 that "Kashmir stands next in importance [to Jaipur] in the art of enamelling."[19]

Among the most commonly seen, distinct works of arts and crafts are furnishings of a wide variety, made either in wood or papier-mâché or a combination of both. Painted and varnished, they are decorated mostly in the conventional non-figural mode as already noted, but some also show rich figural compositions of myths and stories. While tables, trays, and candlesticks (fig. 205) have survived in considerable numbers, less common are chairs. One exhibited in the 1871 Crystal Palace exhibition in London and now in the Victoria and Albert Museum (fig. 208) is one of the finest. As pointed out by Amin Jaffer, painted and lacquered chairs imitating English prototypes of the Regency period were made during the Sikh period (1780–1846) and by 1870 were stock items in Srinagar shops. Although the art of painting and varnishing was much older it was also limited in scope; in the nineteenth century the repertoire was expanded enormously due largely to the demands of Europeans.[20]

Another piece of furniture of Kashmiri manufacture to have entered the Victoria and Albert Museum from the 1871 exhibition is a table, this time imitating the typical Tibetan folding tables known as *chagtse* (fig. 209). However, the tables were not made for the

FIG. 202 ❋
Three-piece tea set formed as *kangri*, about 1885
Silver
Teapot: H. 7 3/4 in. (18 cm);
Creamer: H. 4.5 in. (11.4 cm);
Sugar: H. 5 in. (12.7 cm)
Paul F. Walter Collection

FIG. 203
Bowl with chinar leaves, nineteenth century
Paul F. Walter Collection

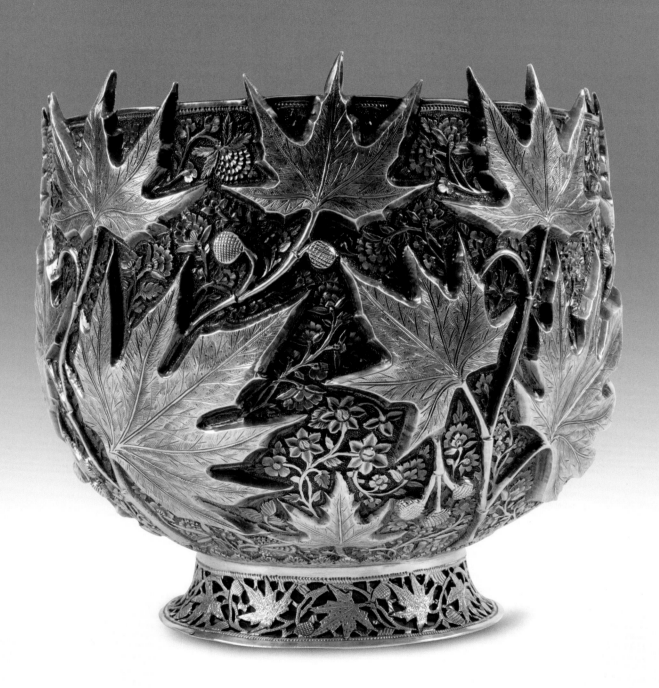

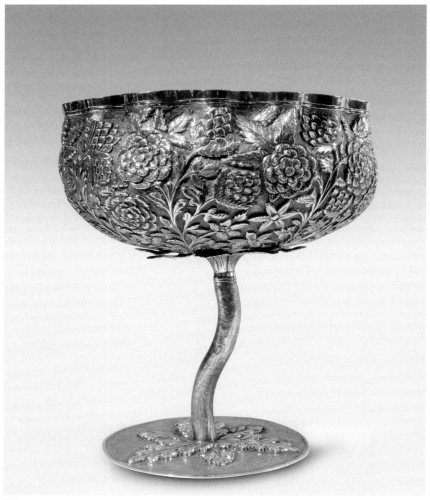

204

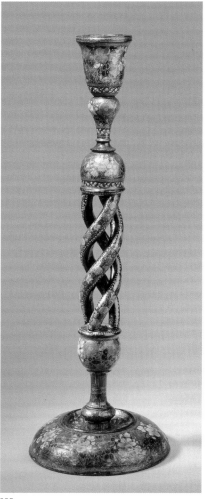

205

Tibetan market but for the British. Known in Kashmir as "Lhassa" tables, Tibetan forms inspired the overhanging tops and simulated bamboo components, but "elements such as the open grill-shaped legs, the typically Kashmiri painting and the debased interpretations of Chinese symbols, betray their origins."[21]

Finally, this rapid survey of the crafts of Kashmir can be closed with a brief notice of the use of figural forms in some of the objects. In shape, the painted tray (fig. 210) is a variation of a form that we have already encountered in a metal foliated tray (fig. 206). But here not only is the foliation different, with more rounded cusps spreading from the central medallion more boldly, but so also the decoration. The ground is covered with the "thousand flowers" (hazara) on which are superimposed figural forms. The central medallion on the mandala shows the Anantasayin Vishnu surrounded by dancers. However, they are not ordinary dancers. The repeated dark male is clearly Krishna and the milkmaids (gopi), and the dance is that known as rāsalīlā. Some of the other figures, such as the winged angels and the enthroned ruler are clearly derived from Persian visual sources. Such eclecticism was the result of specific commissions rather than reflecting the craftsmen's personal proclivities.[22]

If the tray with Vaishnava subjects were made for Hindu patrons, perhaps part of a wedding trousseau, one wonders about the paintings on another tray and box (figs. 211, 212). The subjects are drawn from other mythologies, likely Persian, but they are painted

FIG. 204 ❖
Bowl with bent stem and "poppy" pattern, about 1880
Silver
H. 6 in. (15.5 cm)
Paul F. Walter Collection

FIG. 205 ❖
Candlestick, 1850–1880
Painted and lacquered wood
H. 19.5 x W. 6 in. (49.5 x 15.2 cm)
Private collection

FIG. 206 ❖
Foliated tray, nineteenth century
Copper gilt
D. 12 in. (30.5 cm)
Victoria & Albert Museum
1483.1883

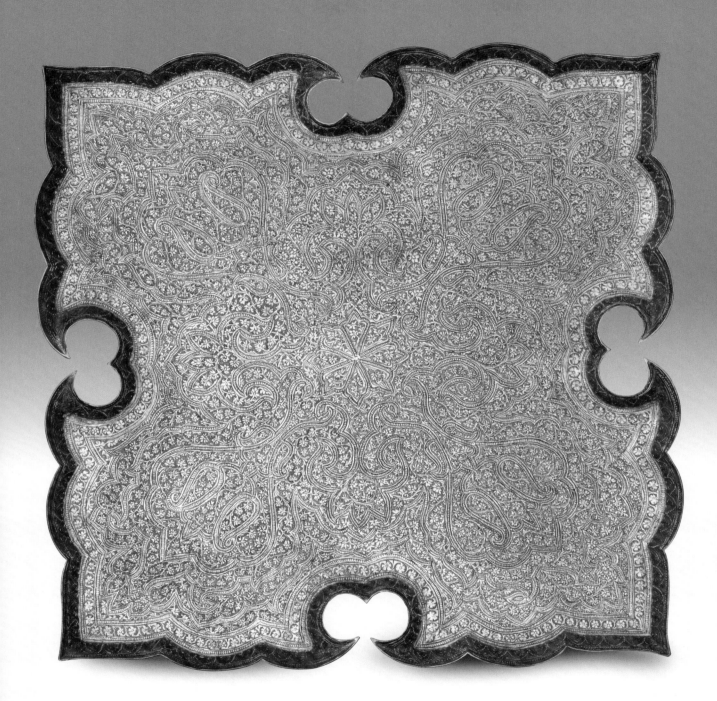

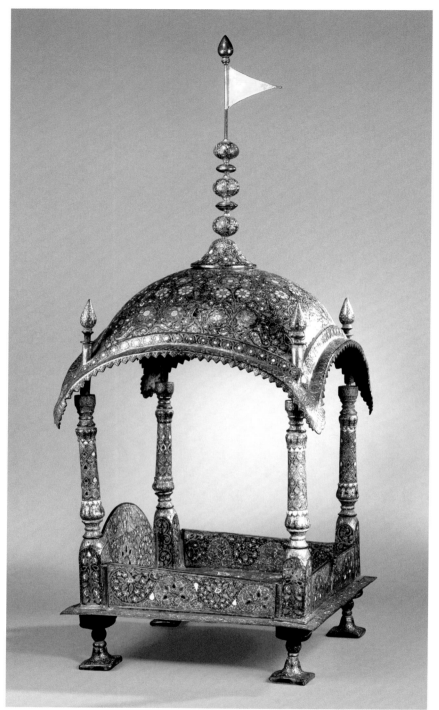

207

FIG. 207 ❖
Portable Hindu domestic shrine,
about 1880
Gilt copper and enamel
H. 35 1/4 x W. 14 x D. 14 in.
(89.5 x 35.5 x 35.5 cm)
Collection Amrita Jhaveri

with a boldness of imagination and narrative dash that are delightfully engaging. Apart from the two chairs themselves and the tables reflecting contemporary furniture, the human figures seated on them have faces that are clearly caricatures. No less fascinating are the animal-headed demons with their expressive faces and the other charming animals on the box. For their expressive power, sense of whimsy, and bright attractive colors, these strange representations reflect both the originality and vitality of the Kashmiri painter.

208

209

210

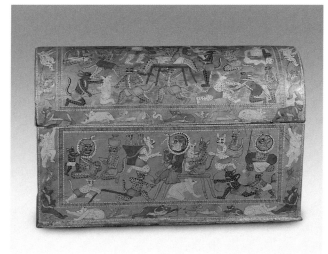

212

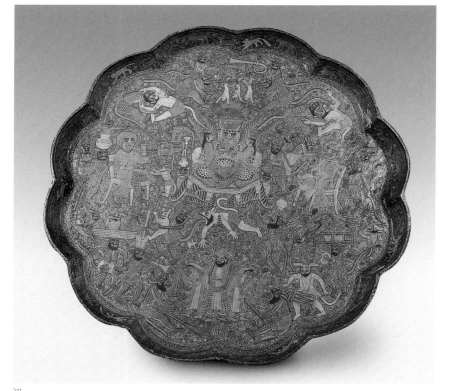

211

FIG. 210 ❖
Foliated platter with Krishnalila scene,
nineteenth century
Painted wood, papier-mâché
D. 21 in. (53.3 cm)
Paul F. Walter Collection

FIG. 211
Tray depicting fantastic animals and mythical
figures, nineteenth century
Polychromed wood and papier-mâché
D. 4 in. (12 cm)
Private collection

FIG. 212
Box with mythical imagery, nineteenth century
Polychromed wood and papier-mâché
L. 9 1/4 x H. 6 in. (23 x 15 cm)
Private collection

Despite the troubled political situation in the valley, the art of painted and lacquered papier-mâché is enjoying a recent revival. Objects are being produced in large numbers to meet demands from the Western markets. They now manufacture gift boxes, coasters and even Christmas ornaments, which are appealing both for their attractive decoration, light weight, and their durability. Throughout Kashmir's history both the adaptability and resilience of the Kashmiri craftsman has been admirable.

1. Mirza Haydar Dughlat's observations: ". . . in Kashmir one meets all those arts and crafts which are in most cities uncommon, such as stone-cutting, stone-polishing, bottle-making, window-cutting, gold-beating, etc. In the whole of Mawarannahr [Transoxania] these are nowhere to be met with except Samarqand and Bukhara, while in Kashmir they are even abundant. This is all due to Sultan Zayn al-'Abidīn." (As provided by Simon Digby, personal communication 2006).

2. De, *The Tabaqat-i-Akbari of Khwajah Nizamuddin Ahmad*, p. 559.

3. Bernier 1972 (1891), p. 402. For a general review of the crafts see Dhar, 1999.

4. For Kashmiri ivories and for other ivory products from ancient India, see Dwivedi, *Indian Ivories*; and Czuma "Ivory Sculpture."

5. See Reedy, *Himalayan Bronzes Technology, Style, and Choices*, pp. 38–40, 150, for a technical analysis of Kashmiri metalwork.

6. Digby, "Flower-Teeth and the Bickford Censer."

7. Digby, "A Medieval Kashmiri Bronze Vase."

8. As argued by Digby, ibid.

9. See Lerner, *The Flame and the Lotus*, p. 79.

10. See Pal, *Himalayas: An Aesthetic Adventure*, p. 141 for a description and discussion of this object.

11. Stein, *Kalhana's "Rājataraṅginī"*, vol. 1, p. 285.

12. As provided by Simon Digby (personal communication, 2006).

13. Birdwood 1971 (1880), pls. 3, 4.

14. Ibid., p. 149.

15. Wilkinson, *Indian Silver 1858–1947*.

16. Ibid., p. 104.

17. Ibid.

18. Ray, *Indian and Islamic Works of Art*, pp. 76–77.

19. As quoted in ibid.

20. See Jaffer, *Furniture from British India and Ceylon*, pp. 294–96, for a discussion of timber and papier-mâché crafts and p. 297 for a detailed description and analysis of the chair.

21. Ibid., p. 298.

22. Today the crafts are no longer hereditary but open to all communities under public enterprises such as schools of design and arts and crafts operatives.

WOVEN LEGENDS:
CARPETS AND SHAWLS OF KASHMIR (1585–1870)

By Frank Ames

Classical Mughal carpets (1585-1658) symbolize a golden age of kingship where wealth, opulence, and largesse were legendary, and where artistic creativity flourished in an unprecedented environment of prosperity and enlightened patronage and peace. India represented a safe haven, an escape from religious persecution, where Persians and Indians worked side by side, in a land where talent was not only appreciated but richly rewarded. The building of palaces, forts, tombs, and residences was so frenzied that the local carpet industry could barely keep up with demand. At various times the European East India Company and other trading organizations found it difficult to obtain quality carpets for export. Among them, it was the Portuguese who, in 1603 or earlier, first began exporting carpets, while records show that twelve years later, England's first shipment consisted of variously sized Lahore carpets out of Surat, those from Lahore being the most desirable.[1]

Following the demise of the imperial city Fatehpur Sikri (1571–1585), the Mughal emperor Akbar established his court at Lahore and within a few years annexed Kashmir, which then became the favorite vacation spot of the Mughal emperors. By dint of its regional proximity, Lahore might be viewed as the *plaque tournante* for commodities produced in Kashmir and beyond. For centuries, Kashmir has been celebrated for two of the finest wools in the world: pashmina and *shah tus*; the former, from the domestic goat (fig. 213), *capra hircus*, the latter, finer and rarer, from the wild antelope, the *chiru*. These precious animals graze the high mountains of Yarkand, Kyrgyzstan, and China's Chang Tang regions. The extreme importance of pashmina to the economies of Kashmir, Ladakh, and northern India was first underscored by Mughal intercession in the Tibeto-Ladakhi war (1681–1684), which guaranteed Kashmir's monopoly over the flow of pashmina via Ladakh. The lure of this "golden fleece" had changed little, when, in 1834, Raja Gulab Singh invaded Ladakh.[2]

As no document exists attributing any Mughal carpet to Kashmir, and so rare are the ones knotted with pashmina (*tus* being too delicate for pile weaving), those that are knotted with it present valid criteria for a Kashmir provenance. Indeed, of all the classical Mughal carpets known, whether sheep or goat wool, only one, the Girdlers' carpet, woven at Lahore between 1630 and 1632, possesses documentation of unquestionable provenance.[3] While literature of the past two millennia is peppered with numerous scant references to carpet making in India, it is revealed as a major industry only by Abu'l Fazl: yet his *Ain-i-Akbari* is curiously silent on carpet weaving in Kashmir, despite the fact that hardly a pashmina carpet, and therefore one of Kashmiri craft, exists that is not a weaver's tour de force.

213

«
Detail of fig. 231, ch. 10

FIG. 213 ❖
A shawl goat from Bhutan, 1779
Watercolor on paper
H. 14 1/2 x W. 5 3/4 in. (36.8 x 14.6 cm)
Victoria & Albert Museum
IS. 51-1963

FIG. 214
Kani prayer mat or niche panel,
late eighteenth century
Wool and goat hair; interlocked twill tapestry
L. 31 1/2 x W. 46 7/16 in. (80 x 118 cm)
Museum of Fine Arts, Boston;
Denman Waldo Ross Collection
99.156

Abu'l Fazl writes of cities in Iran and Turan (Central Asia) as areas from which carpets were imported, and that in India ". . . a flourishing trade . . . is found in every town, especially in Agra, Fatehpur Sikri and Lahore," and he applauds Akbar's appointment of experienced carpet makers who have "produced many masterpieces," noting also that "all kinds of carpet weavers have settled here." [4] Lahore is further mentioned by the historian Abdul Hamid Lahori (d. 1654) in his *Padshahnama*. He remarks, with obvious chauvinistic relish, that the city produced such "soft and delicate carpets that, compared with them, the carpets made in the manufactory of the kings of Persia look like coarse canvas." [5]

For carpet weaving in Kashmir, it is not until the reign of Shah Jahan that we come across the first reference. A recently uncovered imperial letter, written at Lahore in 1640, cites "two prayer carpets of rare quality made in the *karkhānā-i pādshāhi* at Lahore and Kashmir" as a gift to the Ottoman sultan. [6] Though undoubtedly they were both woven with the finest pashmina, this intriguing letter begs interpretation. Was one made in Lahore and the other in Kashmir, or did both locations work equally, teaming up to produce the same finished product? For practical reasons of climate and space, large carpets would have been woven in Lahore, with Kashmir supplying the raw materials, especially pashmina. Once removed from the loom, final preparations of washing and cleaning could have been done in Kashmir, a three-week trek away via the Pir Panjal Pass. [7]

In India, it was not unusual to ship textiles long distances for special processing. [8] This would have been particularly true of rugs knotted with pashmina, since just as the rich dyes of the pashmina shawls were brought to life by washing them in the Jhelum River, so, too, were those of pashmina carpets. Lahore too, is situated on the banks of a river, the Ravi; but the special qualities of the waters of Srinagar's Jhelum were legendary. François Bernier, witnessing the shawl industry first hand, emphasizes this point, and admits, "Great pains have been taken to manufacture similar shawls in Patna, Agra and Lahore, but notwithstanding every possible care, they never have the delicate texture and softness of the Kashmire shawls, whose unrivalled excellence may be owing to certain properties in the water of that country." [9] Supplies, such as bulk pashmina, and produce, such as saffron and rice, originating from Kashmir, were more expeditiously shipped by boat along the Jhelum and onward to Lahore.

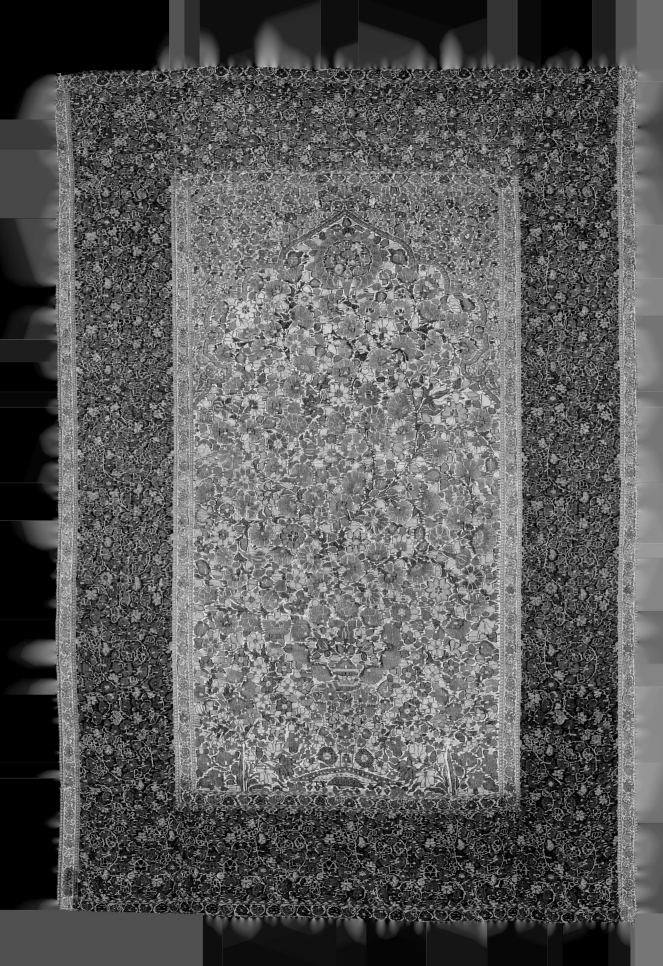

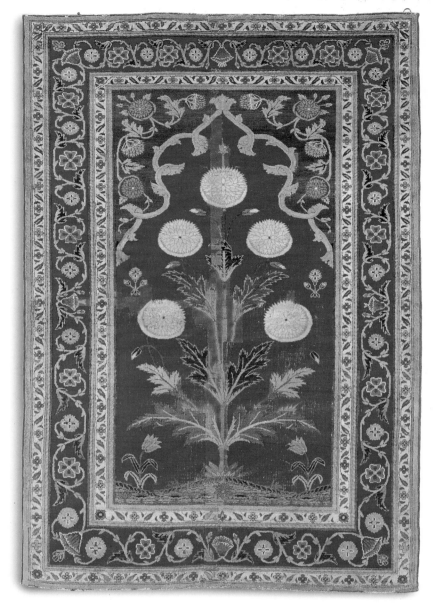

215

216

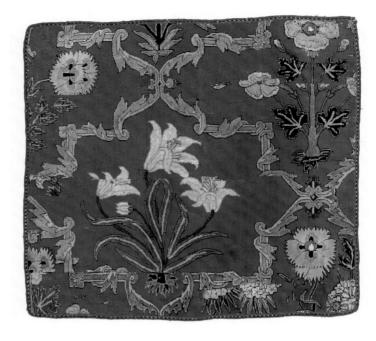

217

218

Prayer "carpets" were also woven in the *kani* technique (twill-tapestry), the same technique employed in shawl-making. The uniqueness of these special *kani* weavings and their confusion with real carpets is emphasized by Burnes, who, in 1840 wrote: "I should here mention the carpets of Mooltan, which do not equal those of Persia: but even they are far surpassed by the splendid shawl carpets of Cashmere. This manufacture is not to be purchased, and is made, I believe, only for the ruler of the country."[10] Since *kani* prayer carpets were always made in pairs, as were the long shawls known as *dochallas* (see below) the possibility that the two prayer-carpets sent to Turkey were an identical pair should not be disregarded. Indeed, the famous Thyssen-Bornemisza pashmina prayer-rug is touted by some experts largely as being part of a *saph*, a type of multiple-prayer niche carpet, used in mosques.[11] Although we know little of their structure, during the Mughal emperor Humayun's exile in Iran, for instance, pairs of carpets were ordered especially for him by Shah Tahmasp: "Each amir should present three pairs of carpets to Humayun each measuring 12 dhar . . ." [12]

Identical pairs of Mughal carpets are also found among today's extant evidence, though whether they were systematically made as such is not known. On the other hand it is more than likely that the *kani* prayer carpet was always a paired item (fig. 214). For shawl weaving, Lahore, after Kashmir, had to be one of the busiest towns in India, for Abu'l Fazl noted that ". . . more than a thousand workshops" are there; doubtless, the number of looms ran in the thousands. All this is to say that the above letter firmly establishes Lahore and Kashmir as imperial weaving centers, and further suggests that the production of an imperial carpet, at least in pashmina, involved joint efforts by both regions.

The groundbreaking exhibition at the Metropolitan Museum of Art, New York, in 1997, and its rich catalogue give further support for this "twin craft-region" idea.[13] Although the show reunited for the first time some of the world's greatest Mughal carpets, it did little to dispel the enigma of place of origin: which carpet came from what Indian city? All ten of the early Mughal pashmina carpets exhibited were assigned to Lahore or Kashmir, a

designation tending to confirm the theory of Lahore/Kashmir-centric manufacture. The exceptions were the two late eighteenth-century pashmina prayer carpets, which were appropriately assigned to Kashmir, alone, since by then, Lahore had long ceased to exist as an imperial capital.[14] Thus, without evidence of a documentary nature, it is virtually impossible to affix an unassailable Kashmiri provenance to a carpet.

The design repertoire of textiles is related to painting, which, during the Akbar period, was still immersed in, and defined by, its Persian inheritance. This is observed in the *Hamzanama* and *Baburnama*, where carpets depicted correspond to their Persian cousins. Yet, very quickly, local painting styles emerged with their own distinct characteristics and vitality, exhibiting natural rhythms of line and brilliant polychromes. This nascent style matured further under Jahangir (r. 1605–1627), whose connoisseurship of painting was renowned, as was his deep attachment to the enchanting beauty of Kashmir. During his travels there, he took with him his famed artist, Mansur, commissioning from him many works of animal and flower studies, the details of which are astonishingly photographic. The result was the development of a new so-called "Mughal style" of painting, where flowers and shrubs, which were formerly depicted as minor or inconspicuous elements, suddenly exploded onto the canvas, occupying the entire frame (fig. 215) This occurred at a time when the impact of European herbals was such that artists were either copying directly from them or reinterpreting them with their own ideas (figs. 216, 217)[15]. Similarly, European architectural designs found their way into the repertoire of Mughal carpets and textiles, especially in the rococo trellis pattern as seen in the Victoria and Albert Museum's Mughal carpet fragment (fig. 218), as well as on the ceiling of the Mahal-i-Khas at the Red Fort in New Delhi (fig. 219).

Rapidly, the interest in flora spread to other crafts, to architecture and, of course, to shawls. Art historian Robert Skelton attributes the sudden rise of this floral style to a time just following Jahangir's visit to Kashmir in 1620.[16] This "Mughal style" ushered in indigenous Indian flowers and trees, such as the lotus, peonies, wisteria, orchids, and palm tree, many of which are not ordinarily found in Persian carpet designs. Such carpets are identified by their frequent use of a crimson red field and greenish dark-blue border; a *ton-sur-ton* effect whereby one color lies upon another, without outline; by directional pattern compositions and by architectural scenes.[17] Carpet weavers excelled at creating animals with remarkable exuberance. Compared to Persian carpets, the Mughal animal carpets were drawn with freer spacing. Experts look to two famous lodestars, the Girdlers and Fremlin carpets, as exemplarily illustrating these characteristics, and especially points of structure.[18] Similar key points of reference are nonexistent among the many extant seventeenth-century shawls; but unlike the carpet industry, the Kashmir shawl weaving industry was not challenged from abroad, making the real Kashmir shawl more easily identifiable. Pre-Mughal precedents, however, are virtually unknown for, as with carpets, most of India's sixteenth-century textiles are lost in the mists of time.[19]

219

FIG. 219
Mahal-i-Khas (ceiling detail),
seventeenth century
Red Fort, Delhi

FIG. 220 ❖
Kashmir shawl fragment,
seventeenth century
Pashmina
L. 9 x W. 53/15 in. (23 x 135 cm)
Private collection

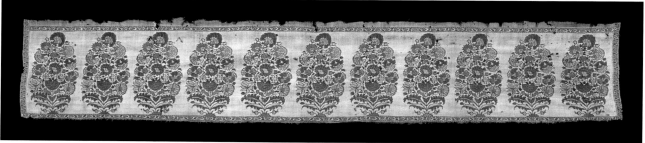

220

Fig. 221
Kashmir shawl (detail of *dochalla*),
late eighteenth century
L. 42 x W. 61 in. (107 x 156 cm)
Private collection

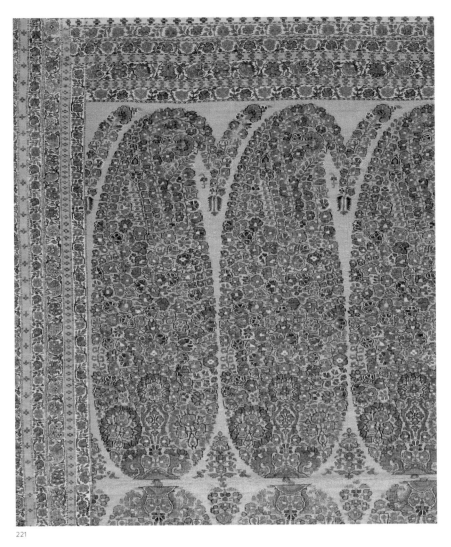

221

Among textile scholars, the antiquity of the *kani* shawl emerges as a source of contention, owing to differing textual interpretations of literary passages. Alas, one finds no clear description either of the vocabulary or of the technique employed. For example, the versatile Kashmiri writer, Kshemendra (about 990–1065), in his *Narmamala*, discusses wool spinning, drawing, and pattern weaving on strips with *tujis*. The latter are the tiny wooden sticks (still in use today) employed as needle-bobbins to insert various colored threads.[20]

Kashmir's most celebrated ruler, Sultan Zain-ul-Abidin (1420–1470), was, by far, the most instrumental in promoting not only the country's crafts, but all the arts and institutions of learning. His enlightened rule attracted talented people from afar, and his chronicler, Shrivara, specifically mentions new types of weaves that were assimilated from these new-comers: "The special woolen textiles of foreign origin, worthy of kings, are now woven by the Kashmiris . . . the painters seeing the patterns and creeper designs obtained by intricate weaving process are reduced to silence as the figures in a painting," writes the chronicler.[21] Despite these early references to a type of tapestry weave, prior to the seventeenth century, *kani* weaves seem noticeably absent from the corpus of extant material.

Akbar was exceedingly fond of the Kashmir shawl, and Abu'l Fazl mentions his master's orders to improve the industry in many ways. Among the changes, new dyes and dying techniques were developed, and the width of the fabrics was enlarged in order to

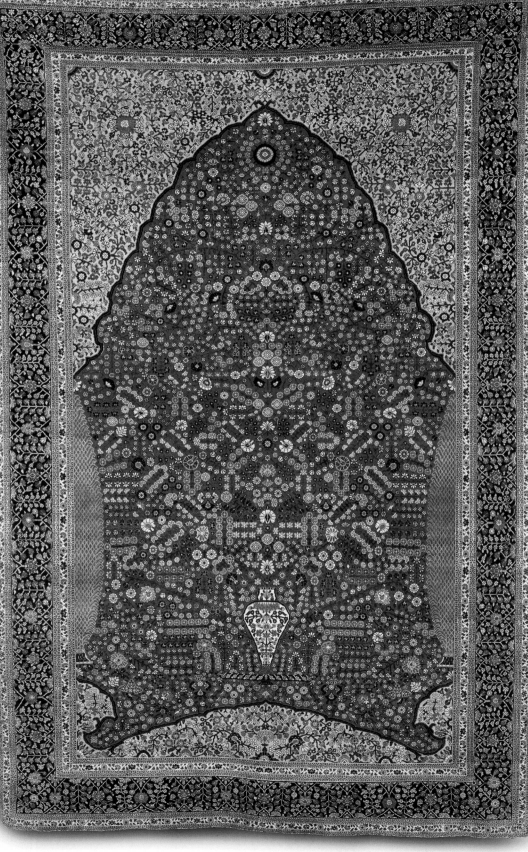

make clothing. With respect to fashion, Abu'l Fazl notes: "In former times shawls were often brought from Kashmir. People folded them up in four folds, and wore them for a very long time. Now-a-days they are generally worn without folds and merely thrown over the shoulder. His Majesty has commenced to wear them double, which looks very well."[22] Thus the term *dochalla* (two shawls) where shawls were woven in pairs, such that they could be afterwards attached back to back, hiding the ridged undersides.

Kani weaving assimilated the new trend in floral decoration with amazing ingenuity and grace, giving rise to finely wrought flowers of painterly quality. A shawl fragment from the Musée Guimet, most likely a product of imperial patronage, presents a unique example of direct European herbal inspiration, particularly with respect to its "speckled-wing" blossoms (fig. 217). Botany in the sixteenth century was at an exciting crossroad. Phytography, the language of flowers, had suddenly become a science unto itself, and Valerius Cordus (1515–1544), its greatest exponent from Germany, and the most cele-brated botanist since Dioscorides, had demonstrated that each species of flower could be so perfectly described as to be completely identifiable by its description alone. He popularized the term *papilionaceous*, or butterfly-like (from the French *papillon*, butterfly) a term found in Latin herbals of the period, and often used by succeeding botanists. Indeed, the four large blossoms appear hovering, borne aloft by their stippled wings.[23]

Aurangzeb's (r. 1658–1707) rule of strict orthodoxy created an uneasy religious ten-sion, under which patronage of the arts declined. The wonderful grace and poetry that defined the brilliantly woven carpets and shawls of his predecessors faded for the most part, into hackneyed patterns and rigid compositions. However, this imperial evanes-cence hardly diminished the great popularity of these weavings, which, by then, had achieved international fame, creating considerable wealth among Kashmiri merchants, and establishing India as a major supplier of carpets.[24] The close of the century saw a divergence in carpet and shawl patterns. Shawls retained their status as a perennially dazzling costume accessory, their patterns perpetually dancing to the whims of fashion, while carpets became merely a confined utilitarian object.

Current theory in the development of shawl patterns during the classical Mughal period holds that the floral bouquets contained lots of free spacing in the arrangement of the realistic flowers, with large unembellished spacing separating the *botehs* themselves (fig. 220).[25] Typically they were of a single botanical species, and often consisted of delicate, identifiable flowers that rose in triple flexion, a Persian stylistic legacy. As the Mughal period waned, the *botehs* closed ranks, and floral content along with *palla* (the flowered ends of the shawl) height was increased. Over time, this style gave way to a *boteh* so crowded with flowers—perhaps, a phenomenon due to heavy commercialism—that its outline shape became a bulbous curvilinear shell (cone) filled with a mosaic of tiny flowers (fig. 221). The heavily charged floral content of The Metropolitan Museum of Art's pashmina prayer carpet (fig. 222) is indeed reflective of this phenomenon and illustrates a rare dialogue between shawl and carpet designers at the dawn of the nineteenth century. [26]

223

224

FIG. 224 ❋
Moon Shawl (*Chandar*), about 1800
Pashmina, *kani* technique
L. 4 x W. 4 ft. (1.22 x 1.22 m)
Collection of David and Elizabeth Reisbord

In the 1660s, François Bernier rode into Kashmir in imperial style, accompanying Aurangzeb as his personal doctor. Yet, a hundred years later, when the valley was severely guarded by Afghans and George Forster was forced to sneak into the valley disguised as a Turkish merchant, shawl weavers were already reeling under the burden of a tax known as *dagshawl*, newly imposed by the Afghans. Forster noted that shawl looms had dropped from a count of forty thousand under the Mughals to sixteen thousand.[27] Under the harsh rule of the Afghans, few artistic innovations came about, yet it was during this time that the curvilinear *boteh* or cone motif—a shift from natural flowers to a bulbous shape, most likely came into its own. The Metropolitan Museum of Art fragment (fig. 223) is an excellent example illustrating this design shift, which, by its botanical details and spacing, renders it a critical and rare document of early- to mid-eighteenth-century shawl iconography. The red "cog wheel" flower in the upper right descends from the Turk's cap lily of the Shah Jahan period (r. 1628—1658). Similarly, the root securing device at the *boteh*'s base is found only on seventeenth-century shawls. The crocus, a source of fragrant saffron, a rich dye, and a medicinal aphrodisiac, is found in the *hashia*-s (the narrow shawl border) meander, and was one of Jahangir's favorite flowers. These observations point to one of the earliest manifestations of the cone form, dating possibly to about the eighteenth century. It is from Zand paintings that the earliest pictorial references to the curvilinear *boteh* are found.[28] One of the most striking shawl styles to emerge during Afghan rule was the striped (*Khatraaz*) moon shawl (fig. 224). In this stunning example, further embellished with rarely seen half moons, we see how the stripes remain visible through the transparency of the perfectly resolved center medallion, creating a kind of hologram effect. It is this characteristic, a brilliant testament to the ingenuity of the Kashmiri weaver that has rendered these types extremely collectable.

The Sikh population rose as a powerful and unified force under the brilliant hand of Maharaja Ranjit Singh who annexed Kashmir in 1819. Artistically, this was the start of a

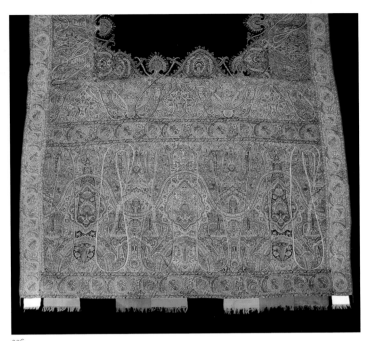

225

226

very stimulating period for shawl designs for nobody luxuriated in shawls like the Sikhs. Many of the Maharajas, princes, and sardars, etc., through agents, oversaw directly the production of their personal shawls. The Russian prince Soltykoff, visiting the valley in 1841, exclaimed "the tents were doubled with Kashmir shawls . . . we only walked on Kashmir shawls and while sitting down I perceived that all the alleys, ceilings and streets, as far as the eye could encompass were covered thusly of superb shawls—even the horses were prancing on them." [29] Unfortunately, William Moorcroft, who arrived twenty years earlier, despite recording the most detailed descriptions of shawl weaving, appears to have made few such casual observations of daily life.

The Sikh elite were extremely flashy dressers, swathing themselves in bright saffron silks, often with two or more Kashmir shawls (green and yellow were two favorite colors) wrapped rakishly around their waists. Ranjit Singh, a charismatic figure, attracted foreign mercenaries, in particular, the Generals Allard and Ventura, who arrived in 1822. Their hard efforts to raise a superior Sikh army, known as the *Fauj-i-Khas,* were lavishly rewarded with palatial homes, governorships, and with a share in the lucrative shawl industry. Thus, the industry experienced its first direct influences from the West. A radical change in the shawl's format came about: from a traditionally long, flowing, diaphanous, unembellished shawl (except for the *boteh*'s flowered ends), designs quickly expanded, overflowing toward the field's center, leaving only a small rectangular portion of the field plain.

Although traditional cone designs continued to be supplied to a conservative market, the new format was embraced by a fashionable niche. These huge, powerful "canvases" gave artistic life to a whole new repertoire of geometric, architectural, and military forms; boats, fireworks, bows and arrows, shields, daggers, quoits, soldiers, maps—it seemed like nothing was so removed from daily life that it couldn't find its way into the shawl (figs. 225, 226). With the constant surveys of new territories acquired by the expansion of Sikh hegemony, mapmakers-cum-artists, spurred on by the new Western trigonometric surveying techniques, were under pressure to keep pace with the new geography. This is reflected in the novel embroidered map shawls in various collections, of which the Victoria and Albert Museum's *rumal* (square shawl) of Srinagar is unrivaled (fig. 227).[30]

228

Artistic inspiration was drawn from the lacquer and papier-mâché industries as well as from the craft of illustrators for the *Janamsakhis* and *Adi Granths* stories of Guru Nanak and sacred scripture, respectively). After centuries of bowing to the demands of the export market with elegant floral *boteh* patterns, finally Kashmir developed its own indigenous ethnic style. The rakish Sikh costumes, "armed-to-the teeth" Alkalis, French military costumes and paraphernalia, and the Khalsa energy of Lahore's glittering darbar all found dynamic resonance in shawl artistry, and underscore once again the tight artistic nexus of Lahore and Kashmir (fig. 228).

Through the business dealings of Allard and Ventura, the new patterns—a generation after Josephine set the pace in shawl fashion—took Europe by storm. General Allard's proud return visit to Paris in 1836 and his appointment as political agent by King Louis Philippe, combined with his meeting with the Parisian shawl merchants, represented not only a political coup for France, but also a boon to Kashmir's shawl industry.[31]

Although the Punjab once again fell into chaos with the death of Ranjit Singh in 1839, the Sikh shawl took on a life of its own. The new style was here to stay, foreshadowing Europe's art nouveau and art deco styles. In 1846, Ranjit's right-hand man, Raja Gulab Singh (1792–1857), by the Treaty of Lahore with the English, became the sovereign Dogra ruler of Jammu and Kashmir, and thus achieved his great ambition of absolute control over the shawl industry.

The Universal Exhibition of London in 1851, where shawls and carpets were featured, was a major milestone for Kashmir's products.[32] As British rule quickly engulfed almost the whole of the subcontinent, carpet production drifted towards the hackneyed substitute of an industry that was once the pride of Mughal India. French agents arrived en masse in Srinagar, and soon Kashmiri weavers were patterning their shawls from Parisian sketch books. By this time, Jacquard-loom engineering had become extremely sophisticated, incorporating the enlarged Sikh designs with great ease. French shawl designers, ever fashion conscious, fused these exciting Sikh patterns with their own creative ideas, with such successful results that the new shawls returning from India mimicked those of the Jacquard loom. Nevertheless, nineteen years later, the industry finally collapsed with the Franco-Prussian War. With all the

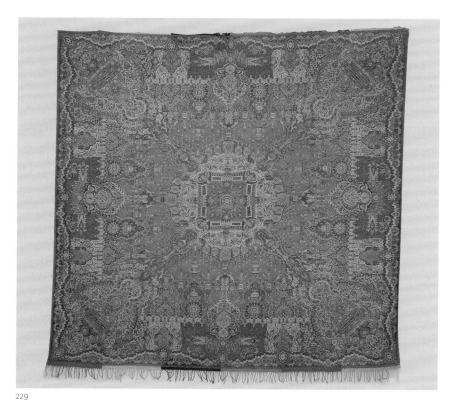

229

Fig. 229
European jacquard shawl, 1834
(signed and dated)
Designed by Amédée Couder;
woven by Gaussen
L. 72 x W. 72 in. (184 x 184 cm)
Collection of Joan Hart

Fig. 230
Kashmir shawl (detail),
with a style similar to that developed
by Antony Berrus (1840s)
about 1865–1880, Dogra period
L. 120 x W. 52 in. (306 x 134 cm)
Private collection

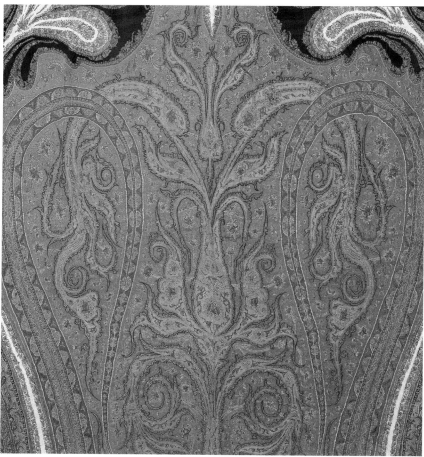

230

FIG. 231 ❋
Dragon Moon Shawl (*Chandar*), about 1860
L. 74 x W. 64 in. (190 x 165 cm)
Private collection, courtesy
of Simon Ray, London

FIG. 232 ❋
Shawl with Peacocks, nineteenth century
Pashmina wool with embroidery,
amlikar technique
L. 68 x W. 63 in. (172 x 160 cm)
Collection of David and Elizabeth Reisbord

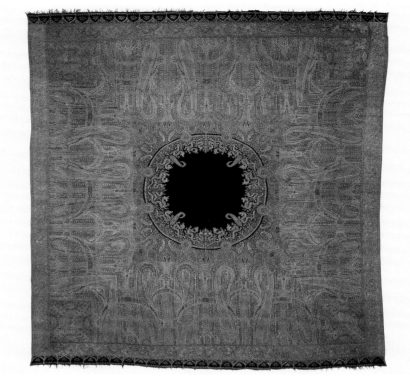

231

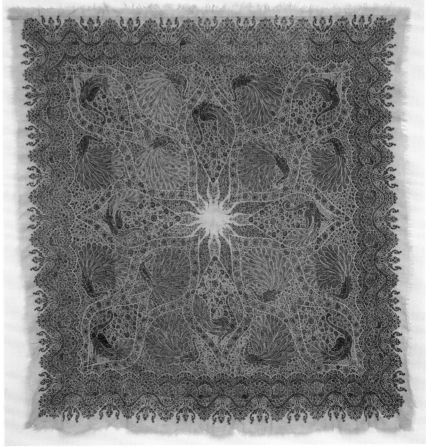

232

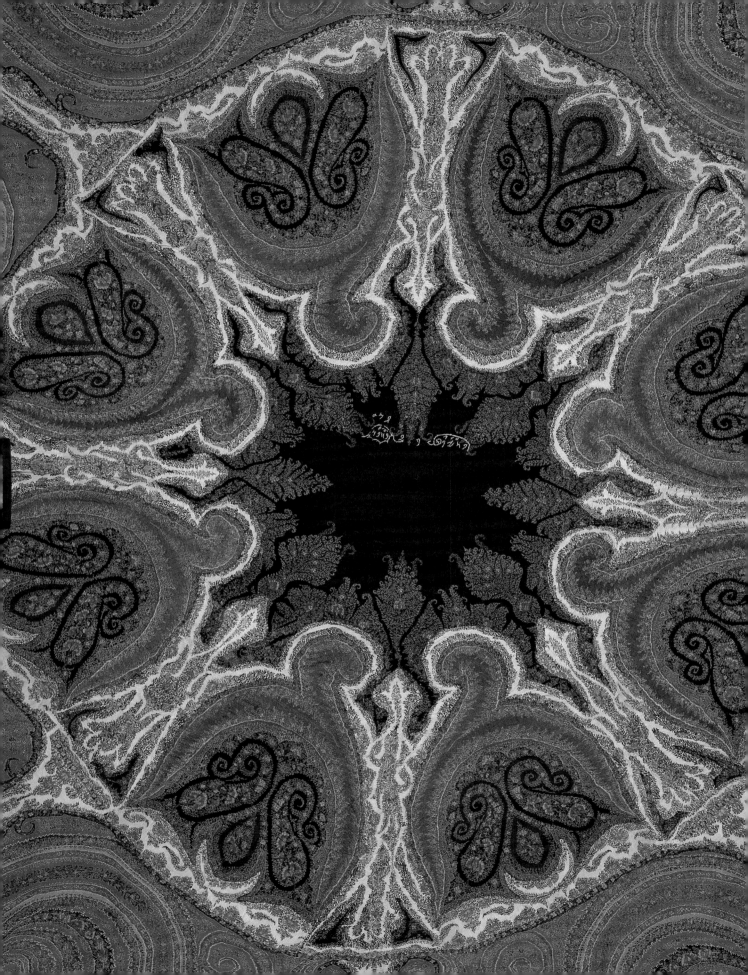

FIG. 233 ❖
Double Kashmiri shawl,
(detail of center medallion), 1867,
Dogra Period
L. 128 x W. 56 in. (325 x 142 cm)
Museum of the City of New York;
Gift of Mrs. Clarence M. Hyde

idle weavers there, opportunistic European rug merchants moved into Srinagar and opened rug factories. By the turn of the century, Kashmir had become the second largest producer of carpets in India, with Amritsar and Lahore holding first and third place respectively.[33]

Some feel the Dogra era spelled the death of the Kashmir shawl, but this view is incorrect. Kashmir was experiencing unprecedented peace, and shawl weaving was at full throttle. It was simply another style, the Indo-French style, fueled by the innovative designs of, for example, Amedée Couder (fig. 229) and Antony Berrus (fig. 230), two of France's most famous shawl designers. Enriching further this style was the palpable presence of Kashmir's proximity to Ladakh and Tibet, which manifested itself, for instance, in the form of dragons (fig. 231; see title image detail). Although dragons were often carved embellishments in Srinagar's famous walnut furniture, here we see them in this finely woven transitional Sikh-Dogra period *rumal*, arrayed menacingly in a fiery circle woven against a stark, black center pulsating with cosmic energy. From the Dogra period came some of the most beautifully embroidered shawls as seen in fig. 232. India's national bird, the peacock runs wild throughout the subcontinent, and as the vehicle for the Hindu god Kartikeya, son of Siva and Parvati, he is held by Hindus to be sacred. A veritable aviary of peacocks, this finely wrought embroidered *rumal* must have been a marriage gift. The many brilliant shawls extant of this era (for example, fig. 233), and indeed of all of the nineteenth century (including the European Jacquard shawls), remain a lasting testament to the unknown, forgotten, poor weavers of a tiny Himalayan village that had spawned one of the greatest fashion industries of the world.

NOTES

1. Walker, *Flowers Under Foot*, p. 16; Eiland, *Chinese and Exotic Rugs*, p.155.

2. C. L. Datta, *Ladakh and Western Himalayan Politics*, ch. 5.

3. J. Irwin, "Girdlers Carpets," pp. 15–18.

4. Abu'l Fazl, Ain-i-Akbari, vol. 1, p. 57.

5. Lafont, *Maharaja Ranjit Singh*, p. 27.

6. Walker, p. 12.

7. Montgomerie, *Routes in the Western-Himalayas*: see for detailed route calculations.

8. Maloni, *European Merchant Capital and the Indian Economy*. Of this, Maloni states: "The river Narmada [near Surat] possessed special properties for bleaching, and cloth was brought from several parts of the Mughal empire to this area, a practice for centuries." (p. 23)

9. Bernier, *Travels in the Mogul Empire*, pp. 402–3.

10. A. Burnes, *Travels into Bokhara*, vol 2, p. 400.

11. Also known as the *Aynard* carpet. See *Hali*, issue 28, p. 40; or Walker, p. 94

12. Islam, *A Calendar of Documents of Indo-Persian Relations*, vol 1, p. 75.

13. Metropolitan Museum of Art exhibition titled *Flowers Underfoot: Indian Carpets of the Mughal Era*, 1991–1 March, 1998.

14. See Walker, pp. 131–32. Because of the valley's long Durrani rule (1753–1819), perhaps a better rubric for these latter two exceptions might be "Afghan."

15. Basil and Gray, *Indian Painting*, p. 87: "it can be said with certainty that between 1595 and 1615 it is possible to notice in Mughal painting a "thorough assimilation of western pictorial science [author's emphasis]."

16. R. Skelton, "A Decorative Motif in Mughal Art," in *Aspects of India Art*, ed. Pratapaditya Pal (Leiden, Netherlands: Brill, 1972), pp. 147–52.

17. See for example the *shigarga* (hunting carpet), accession number 93.1480, at the Museum of Fine Arts, Boston, illustrated in Walker, p. 39.

18. For the Fremlin (at Victoria and Albert Museum) and Girdlers carpet, see p. 56 and pp. 68–69, respectively, in Walker.

19. Radio-carbon testing is a tool that has yet to be applied to shawl dating. Several early fragments at the Victoria and Albert, Textile Museum and in the Kuwait National Museum, for example, seem ripe for this type of close examination, notably accession numbers: IS 6-1972 to IS 33-1972, 6.11 and LNS59T, respectively.

20. Chandra, *Bulletin of the Prince of Wales Museum* 3: pp. 7, 8.

21. Ibid., pp. 8, 9.

22. Abu'l Fazl, vol.1, p. 92.

23. E. L. Greene, *Landmarks of Botanical History*, p. 384.

24. Eiland (p. 154) cites an important Spanish publication of a rug exhibition in 1933, based on carefully documented rug inventories from 1273 to 1833. They reveal the great amount of rugs exported from India beginning from 1603.

25. The heavy use of white in the flowers and their regimented arrangement along the raceme's axis is found on shawls only at the turn of the nineteenth century.

26. Foster, *A Journey from Bengal to England*, vol 2, p. 20.

27. Ames, "A Kashmir Paradigm Shift", pp. 70–75.

28. Soltykoff, 1853, p. 158

29. Ranjit Singh's governor of the hill states, Desa Singh Majithia, was ordered to make surveys of these new territories (Datta, p. 92). Also Zorawar Singh, Raja Gulab Singh's governor general, must have had a bevy of map makers, prior to his conquest of Ladakh. Further discussion of this is to be found in the author's book, *Woven Masterpieces of Sikh Heritage*, forthcoming in 2008.

30. Ames, *The Kashmir Shawl*, pp. 39–44.

31. A Kashmir carpet with over seven hundred knots to the inch was showcased there. See Eiland, p. 168.

32. Watt, pp. 273–74.

33. Because Irwin in his "Shawls" (1955) gave the impression that it was the Armenian merchant Kwaja Yusuf who brought in to Kashmir this special embroidery method of imitating the *kani* weave with needlework, subsequent writers have since erroneously attributed the technique to him. In fact, it is clearly stated in Moorcroft's manuscript that it was Alee Baba who was master of the technique, years before the arrival of Kwaja. In Moorcroft's account it is understood that Alee Baba's work was so good that it actually posed a threat to the farmer general (tax officer), who exclaimed "that his income would be ruined if the Ruffoogurs were permitted to execute this kind of work for strangers" (E113, British Library).

BIBLIOGRAPHY

Adamova, A, and T. Greek. *Miniatyuri Kashmirskikh Eutopisey.* [Miniatures from Kashmir in Manuscripts.] Leningrad, 1976.

Agrawal, R. C. *Kashmir and Its Monumental Glory.* New Delhi: Aryan Books, 1998.

Ahmed, I. *Kashmir Archaeology.* Srinagar: Gulshan Books, 2007.

Ahmed, S. M., and Bano Raja. *Historical Geography of Kashmir.* Delhi: Ariana, 1984.

Ames, Frank "Lost Horizons: the Stylistic development of the Kashmir Shawl," *Hali,* Vol. 4, No. 4, (1984): pp. 403-407.

—. *The Kashmir Shawl and Its Indo-French Influence.* 3rd ed. Woodbridge, Suffolk: Antique Collectors' Club, 1997.

—. "A Kashmir Paradigm Shift: Qajar and Zand Painting as Evidence for Shawl Dating," *Hali,* 139 (2005): pp. 70-75.

Asher, F. M. "Buddhist Ivories from Kashmir." *Oriental Art* 18, no. 4 (Winter 1972): 367–73.

Ataov, Turkkaya. *Kashmir and Neighbors: Tale, Terror, Truce.* Aldershot, U.K.: Ashgate, 2001.

Bamzai, P. N. K. *A History of Kashmir: Political, Social, Cultural from the Earliest Times to the Present Day.* Delhi: Metropolitan, 1962.

—. *Culture and Political History of Kashmir.* 3 vols. Srinagar: Gulshan, 2007.

Bandey, Aijaz. *Early Terracotta Art of Kashmir.* Srinagar: Centre of Central Asian Studies, University of Kashmir, 1992.

—. "Contours of Srinagar: Recent Archaeological Finds from the Capital City of Zainul-Abidin,"

The Journal of Central Asian Studies, Vol. VI, (2002), pp. 26–38.

—. "The Plastic Art of Ancient Kashmir." *The Journal of Central Asian Studies,* Vol. 15, No. 1, (2004-2005), pp. 63–78.

Banerjea, Jitendra. N. *The Development of Hindu Iconography.* Calcutta: University of Calcutta, 1956.

Banerji, Suresh C. *Cultural Heritage of Kashmir.* Calcutta: Sanskrit Pustak Bhandar, 1965.

Barnhart, Richard, ed. *The Metropolitan Museum of Art Asia.* New York: Metropolitan Museum of Art, 1987.

Baron, C., and Hugel, V. *Kashmir Under Maharaja Ranjit Singh.* Delhi: Atlantic Books, 1984.

Barrett, Douglas. "Bronzes of Northwest India and Western Pakistan," *Lalit Kala,* Vol. 11 (1962), pp. 35–44.

—. "Façade of a Miniature Shrine from Kashmir." *British Museum Quarterly* 34 (1969–1970): pp. 63–67.

—. and Basil Gray, *Indian Painting.* New York: Skira/Rizzoli, 1978.

Bates, Charles Ellison. *A Gazetteer of Kashmir.* 1873. Reprint, Srinagar: Gulshan Books, 2005.

Baumer, Bettina (ed.) and Jaideva Singh (tr.). *Parāt mimṣikā Vivaraṇa by Abhinavagupta: The Secret of Tantric Mysticism.* Delhi: Motilal Banarsidass, 2000.

Bazaz, P. N. *Daughters of the Vistasta.* Srinagar: Gulshan, 2003.

Beach, M. *The Grand Mogul: Imperial Painting in*

India 1600-1660. Williamstown: Francine and Sterling Clark Museum, 1978.

Beardsley, G. and C.M. Sinopoli. *Wrapped in Beauty: The Koelz Collection of Kashmiri Shawls*. Ann Arbor, MI: Museum of Anthropology, University of Michigan, 2005.

Bhattacharya, S. *Abhinavaguptapramīta Trantrāloka* [Bengali translation of the first twelve chapters of Trantrāloka of Abhinavagupta]. Calcutta: The Asiatic Society, 1992.

Birdwood, G.C.M. *The Industrial Arts of India*. 1880. Reprint, London: The Reprint Press, 1971.

Blochman, H. (tr.) *The Āin-i-Akbari by Abū'l-Fazal Allāmī*, Vol.1. Calcutta: Asiatic Society, 1927.

Bose, Sumantra. *Kashmir: Roots of Conflict, Paths to Peace*. Cambridge, MA: Harvard University Press, 2003.

Branch, Milo Cleveland. *Early Mughal Painting*. New York; Cambridge, MA: Asia Society in association with Harvard University Press, 1987.

Brown, Percy. *Indian Architecture (Islamic Period)*. Bombay: Taraporevala, 1942.

Buchthal, Hugo. *Indian Fables in Islamic Art*. London, [s.l.], Journal of the Royal Asiatic Society (1941), pp. 317–324.

Burnes, A., *Travels into Bokhara: Together with a Narrative of a Voyage on the Indus*. 1835. Reprint, Karachi: Oxford University Press, 1973.

Chandra, Moti. "Kashmir Shawls." *Bulletin of the Prince of Wales Museum* 3 (1954): 1–24.

Chandra, Moti, and V. S. Agrawala, "A Note on Some Cultural References in Srivara Pandita's Rājataraṅgiṇī." *Prince of Wales Museum Bulletin* 7 (1963): pp. 35-40

Chatterji, Jagadish C. *Kashmir Shaivism*. 1914. Reprint, Albany: State University of New York Press, 1986.

Chimpa, Lama, and Alaka Chattopadhyaya. *Taranatha's History of Buddhism in India*. Calcutta: K. P. Bagchi, 1980.

Chitkara, M. G. *Kashmir: A Tale of Partition*. 2 vols. New Delhi: APH, 2001.

Coomaraswamy, A. K. "A Relief and Inscription from Kashmir." *University of Pennsylvania Museum Bulletin*, Vol. 2, No. 6, (1931): pp. 202–206.

Croew, Sylvia, Sheila Haywood, Susan Jellicoe, and Gordon Patterson. *The Gardens of Mughal India*. London: Thames and Hudson, 1972.

Czuma, Stanislaw. "Ivory Sculpture." *In Art and Architecture of Ancient Kashmir*, edited by Pratapaditya Pal. Mumbai: Marg Publications, 1989, pp. 57–76.

Datta, C. L., *Ladakh and Western Himalayan Politics*. New Delhi: Munshiram Manoharlal Publications, 1973.

De, Brajendranath, trans. *The Tabaqat-i-Akbari of Khwajah Nizamuddin Ahmad by Niṃām al-Dīn Ahman ibn Muṃammad Muqīm*, Vol. 3, part 2. Calcutta: Royal Asiatic Society of Bengal, 1939.

Deambi, B.K.K. Corpus of Sharada Inscriptions of Kashmir. Delhi: Agam Kala, 1982.

—. *Kashmir and Central Asia*. Srinagar: Centre for Central Asian Studies, 1989.

Dezsö, Csaba, ed. and trans. *Much Ado About Religion* by Bhatta Jayanta. New York: New York University Press and JJC Foundation, 2005.

Dhar, D. N. *Artisan of the Paradise: A Study of Art and Artisans of Kashmir from Ancient to Modern Times*. New Delhi: Kanishka, 1999.

—. *Dynamics of Political Change in Kashmir: From Ancient to Modern Times*. New Delhi: Kanishka, 2001.

Digby, Simon. "A Medieval Kashmiri Bronze Vase." *Art and Archaeology Research Papers* 2 (Dec. 1972): pp. 99–102.

—. "Flower-Teeth and the Bickford Censer: The Identification of A Ninth-Century Kashmiri Bronze." *South Asian Studies* 7 (1991): pp. 37—43.

Dupuche, John R. *Abinavagupta: The Kula Ritual*. Delhi: Motilal Banarsidass, 2003.

Dutt, Jogesh Chunder. *Rājatarangiṃī of Joṃarāja*. 1898. Delhi: Gian, 1986.

Dwivedi, P. *Indian Ivories*. Delhi: Agam Prakash, 1976.

Dyczkowski, Mark S. G. *The Doctrine of Vibration: An Analysis of the Doctrines and Practices of Kashmir Shaivism*. New York: SUNY, 2000.

Egerton, Frank N. (ed.), *Landmarks of Botanical History*. Palo Alto: Stanford University Press, 1983.

Eiland, M. L., *Chinese and Exotic Rugs*, London: Little, Brown & Co., 1979.

Enomoto, F. "A Note on Kashmir as Referred to in Chinese Literature: Ji-bin." In *A Study of the N īlamata: Aspects of Hindusim in Ancient Kashmir,* edited by Yasuke Ikari, pp. 357–65.

Kyoto: Kyoto University Institute for Research in Humanities, 1994.

Falk, Toby, and Mildred Archer. *Indian Miniatures in the Indian Office Library*. London: India Office Library, 1981.

Fauk, Muhammed Dīn. *Mukkammal Ta'rīkh-I-Kashmīr*. In Urdu. Lahore, 1910.

Findly, Ellison Banks. *Nurjahan, Empress of Mughal India*. New York and Oxford: Oxford University Press, 1993.

Foster, George. *A Journey from Bengal to England*, 2 vols., London: Pinkerton Publications, 1798.

Frederic, Drew. *The Jummoo and Kashmir Territories: A Geographical Account*. London: Edward Stanford, 1875.

Ganju, M. *Textile Industries of Kashmir*. Delhi, 1945.

Gaur, G. S. "Samathan Excavation: A Step Towards Bridging the Gap Between the Neolithic and the Kushan Period in Kashmir." In *Archeology and History: Essays in Memory of Sh A. Ghosh*, pp. 327–37, edited by B. M. Pande and B. D. Chattopadhyay. Delhi, 1987.

Gnoli, Raneiro. *Essenza dei Tantra* [Translation of Abhinavagupta's Tantrasāra]. Turin: Boringhieri, 1960.

—. *The Aesthetic Experience According to Abhinavagupta*. 2nd ed. Varanasi: Chowkhamba, 1968.

Goepper, R. "Dressing in the Temple" *Asian Art, The Second Hali Annual*. London: Hali Publications, (1995): pp. 100–117

—. and Poncar, J. *Alchi: Ladakh's Hidden Buddhist Sanctuary*. The Sumstek. Boston: Shambhala, 1996.

Goswamy, K. *The Glory of the Great Goddess. An Illustrated Manuscript from Kashmir from the Alice Boner Collection in the Museum Rietberg Zurich*. Zurich: Museum Rietburg, 1989.

—. *Kashmiri Painting*. New Delhi: Aryan, 1998.

Granoff, P. "Maheśvara/Mahākāla: A Unique Buddhist Image from Kashmir." *Artibus Asiae* 41, no. 1 (1979): pp. 64–82.

Guy, John, and Deborah Swallow, eds. *Arts of India, 1550–1900*. London: Victoria and Albert Museum, 1990.

Haig, W. "The Chronology and Genealogy of the Muhammadan Kings of Kashmir." *Journal of the Royal Asiatic Society* (1918): pp. 451–68.

Harle, J. C. *Indian Art in the Ashmolean Museum.* Oxford [Oxfordshire]: Ashmolean Museum, 1987.

Hasan, Mohibbul. *Kāshmir Under the Sultāns.* 1959. Reprint, Delhi: Aakar Books, 1995.

Hassnain, F. M. *Buddhist Kashmir.* New Delhi: Light and Life Publishers, 1973.

—. *British Policy Towards Kashmir, 1846-1921: Kashmir in Anglo-Russian Politics.* New Delhi: Sterling, 1974.

—. *Hindu Kashmir.* New Delhi: Light and Life Publishers, 1977.

Hassnain, F. M., ed. *Heritage of Kashmir.* Srinagar: Gulshan, 1980.

Hickman, R. "Die Kashmir-Miniaturen des Staatlichen Museums für Völkerkunde Dresden," *Abbandlungen und Berichte des Staatichen Museums für Völkerkunde Dresden,* Vol. 42, pp. 211–286

Hiuen Tsiang, Si-yu-ki. *Buddhist Records of the Western World.* Translated by S. Beal. Calcutta: Susil Gupta, 1957–58.

Huttenback, Robert A. *Kashmir and the British Raj 1847–1947.* New York: Oxford University Press, 2005.

Ikari, Yasuke, ed. *A Study of the Nīlamata: Aspects of Hindusim in Ancient Kashmir.* Kyoto: Kyoto University Institute for Research in Humanities, 1994.

Inden, Ronald. "Imperial Purāṇas: Kashmir as Vaiṣṇava Center of the World." In *Querying the Medieval: Texts and the History of Practices in South Asia,* edited by R. Inden, Jonathan Walters, and David Ali. Oxford and New York: Oxford University Press, 2000.

Irwin, John, *Shawls.* London: Victoria & Albert Museum, 1955.

—. "Girdlers Carpets," *Marg* 18, no. 4 (1965): pp. 15–18.

—. *The Kashmir Shawl.* London, England: H. M. Stationery Office, 1973.

Islam, Riazul, *A Calendar of Documents of Indo-Persian Relations.* Tehran: Iranian Cultural Foundation, Vol.1, (1979–1982): p. 75.

Islamische Kunst: Meisterwerke aus dem Metropolitan Museum of Art, New York. [The Arts of Islam: Masterpieces from the Metropolitan Museum of Art, New York.] Berlin: Kunstbuch Berlin im Rembrandt Verlag; New York: Kunstbuch Berlin, 1982.

Jaffer, Amin. *Furniture from British India and Ceylon. A catalogue of the collections in the Victoria and Albert Museum and the Peabody Essex Museum.* London: Victoria and Albert Museum, 2001.

—. *Luxury Goods from India: The Art of the Indian Cabinet Maker.* New York; London: Victoria and Albert Museum in association with Harry N. Abrams, 2002.

Jha, Prem Shankar. *Kashmir 1947: Rival Versions of History.* Delhi; New York: Oxford University Press, 1996.

Joshi, L. M. "Buddhist Gleanings from the Rājataraṅginī." *Journal of Indology* 14, no. 2: pp. 155–63.

Kak, Ram Chandra. *Ancient Monuments of Kashmir.* London: India Society, 1933.

—. *Handbook of the Archaeological and Numismatic Sections of the Sri Pratap Singh Museum.* Srinagar. Calcutta and Simla: Thacker, Spink, 1923.

Kaul, Manohar. *Kashmir: Hindu, Buddhist, and Muslim Architecture.* New Delhi: Sagar Publications, 1971.

Kaul, R. N. *Kashmir's Mystic.* New Delhi: S. Chand, 1999.

Keenan, Brigid. *Travels in Kashmir.* Delhi: Oxford University Press, 1989.

Khan, M. S. *The History of Medieval Kashmir.* Srinagar: Gulshan, 2006.

Khan, Mohammad Ishaq. *Kashmir's Transition to Islam: The Role of Muslim "Rishis" (Fifteenth to Eighteenth Century).* New Delhi: Munshiram Manohar Publications, 1994.

Kilam, J. L. *A History of Kashmiri Pandits.* Delhi: Utpal Publications, 2003.

Kimburg-Salter, Deborah E. *The Silk Route and the Diamond Path.* Los Angeles: UCLA Art Council, 1982.

Klimburg-Salter, Deborah E., and Eva Allinger, eds. *The Inner Asian International Style: 12th to 14th Centuries.* Vienna: Verlag der Österreichischen Akademie der Wissenschaften, 1998.

Koul, A., and Prithivi Nath Kaul Bamzai. *Geography of Jammu and Kashmir State.* Delhi: Light and Life Publishers, 1978.

Koul, Mohan Lal. *Kashmir: Past and Present; Unraveling the Mystique.* New Delhi: Manav Publications and Sehyog Prakashan, 1994.

Kramrisch, S. *Manifestations of Shiva.* Philadelphia: Philadelphia Museum of Art, 1981.

Kumari, Ved. *The "Nīlamatapurāṇa"* 2 vols. Srinagar: J. K. Academy of Art, Culture and Languages, 1968–1973.

Lafont, Jean-Marie. *Maharaja Ranjit Singh: Lord of the Five Rivers.* New York: Oxford University Press, 2002

Lamb, Alastair. *Kashmir: A Disputed Legacy 1846–1990.* Hertingfordbury, England: Roxford, 1991.

—. *Birth of a Tragedy: Kashmir 1947.* Hertingfordbury, England: Roxford, 1994.

Larson, Gerald J. "The Aesthetic (rasāvāda) and the Religious (brahmāsvāda) in Abhinavagupta's Kashmir Saivism." *Philosophy East and West* 16, no. 4 (1976): pp. 371–87.

Lawrence, Walter R. *The Valley of Kashmir.* 1895. Reprint, Srinagar: Gulshan, 2002.

Leach, Linda York. *Mughal and Other Indian Paintings from the Chester Beatty Library.* London: Scorpion Cavendish, 1995.

Lee, Sherman. "Clothed in the Sun: A Buddha and Surya from Kashmir." *Cleveland Museum of Art Bulletin* 54 (1967): pp. 43–63.

Leidy, Denise Patry. *Treasures of Asian Art: The Asia Society's Mr. and Mrs. John D. Rockefeller 3rd Collection.* New York: Asia Society Galleries in association with Abbeville Press, 1994.

Lerner, Martin. *The Flame and the Lotus: Indian and Southeast Asian Art from the Kronos Collections.* New York: Metropolitan Museum of Art in association with Harry N. Abrams, 1984.

Lévi-Strauss, M. *Le tissage des châles au Cachemire et en France.* Paris: Musée de la mode et du costume, 1982.

Losty, J. *The Art of the Book in India.* London: British Library, 1982.

Lukens, Marie G. *Guide to the Collections: Islamic Art.* New York: Metropolitan Museum of Art, 1965.

Luczanits, Christian. *Buddhist Sculpture in Clay.* Chicago: Serindia, 2004.

Madan, T. N. *Family and Kinship: A Study of the Pandits of Rural Kashmir.* New York: Oxford University Press, 2002

Maloni, Ruby, *European Merchant Capital and the Indian Economy: Surat Factory Records*

1630–1668. New Delhi: Munshiram Manohar Publications, 1992

Metropolitan Museum of Art. *Textiles in the Metropolitan Museum of Art.* New York: Metropolitan Museum of Art, 1995.

Mikosch, Elisabeth. "Catalogue of Kashmir Shawls in the Textile Museum." *Textile Museum Journal* 24 (1985): pp. 23–55.

Mishra, Kamalakar. *Kashmir "Śaivism"* Delhi: Satguru Publications, 1999.

Mitra Shastri, Ajay. *India as Seen in the Kuttanīmata of Dāmodaragupta.* Delhi: Motilal Banarsidass, 1975.

Mitra, Debala. *Pandrethan, Avantipura and Martand (A Guide to Monuments of Kashmir).* New Delhi: Archaeological Survey of India, 1977.

Montgomerie, Lieut-Colonel T.G., *Routes in the Western-Himalayas, Kashmir, &c.,* Dehra Dun: Office of the Superintendent, G.T. Survey of India, 1874.

Moorcroft, W., and G. Trebeck. *Travels in the Himalayan Provinces of Hindustan and the Punjab: Ladakh and Kashmir 1819–1825.* London: J. Murray, 1841.

Moynihan, Elizabeth B. *Paradise as a Garden.* London: Scholar Press, 1982.

Muller-Ortega, Paul. *The Triadic Heart of Śiva: Kaula Tantricism of Abhinavagupta in the Non-Dual Shaivism of Kashmir.* Albany: State University of New York Press, 1989.

Museum of Indian Art Berlin. *Prestel Museum Guide.* Prestel, 2000.

Nadou, Jean. *Buddhists of Kashmir.* Delhi: Agam Kala Prakashan, 1980.

Pal, Pratapaditya. "Bronzes of Kashmir: Their Sources and Influences." *Journal of the Royal Asiatic Society of Arts* 121, no. 5207 (1973): pp. 726–749.

—. "A Brahmanical Triad from Kashmir and Some Related Icons." *Archives of Asian Art* 27 (1973–74): pp. 33–45.

—. *Bronzes of Kashmir.* New York: Hacker Books, 1975.

—. *Sensuous Immortals: A Selection of Sculptures from the Pan-Asian Collection. A catalogue published in conjunction with an exhibition at the Los Angeles County Museum of Art, 25 October 1977 to 15 January 1978.* Los Angeles County Museum of Art, 1977.

—. *Indian Sculpture. A catalogue of the Los Angeles County Museum of Art collection.* Los Angeles: Los Angeles County Museum of Art in association with University of California Press, Berkeley, 1986.

—. *Art of Tibet: A catalogue of the Los Angeles County Museum of Art collection.* Los Angeles: Los Angeles County Museum of Art, 1990.

—. *A Collecting Odyssey: Indian, Himalayan, and Southeast Asian Art from the James and Marilynn Alsdorf Collection.* New York: Art Institute of Chicago in association with Thames and Hudson, 1997.

—. *Desire and Devotion: Art from India, Nepal, and Tibet in the John and Berthe Ford Collection.* Baltimore: Walters Art Museum; London: Philip Wilson, 2001.

—. *Himalayas: An Aesthetic Adventure.* Berkeley, CA; London, England; Chicago: University of California Press; Art Institute of Chicago, 2003.

—. *Asian Art at the Norton Simon.* Vol. 1, Art from the Himalayas and China. New Haven, CT; Pasadena, CA: Norton Simon Museum in association with Yale University Press, 2003.

—. "The Sāmkhya Sage Kapila and Kashmiri Visnu Images." In *Theory and Practice of Yoga,* edited by Knut A. Jacobsen. Leiden: Brill, 2005.

Pal, Pratapaditya, ed. *Art and Architecture of Ancient Kashmir.* Bombay: Marg, 1989.

Pandeya, K. C. *"Abhinavagupta": An Historical and Philosophical Study.* 2nd. ed. Varanasi: Chowkhamba, 1963.

Pandit, R. S. *Kalhana's "Rājataraṅginī."* New Delhi: Sahitya Akademi, 1958.

Parmu, R. K. *A History of Muslim Rule in Kashmir 1320–1819.* Delhi: People's Publishing House, 1969.

Paul, P. G. *Early Sculptures of Kashmir.* Leiden: Privately published, 1986.

Pinder-Wilson, R.H. "Three Illustrated Manuscripts of the Mughal Period," *Ars Orientalis,* Vol. 2 (1957): pp. 413–422.

Pritzker, T.J. "The Wall Painting of Tabo" *Orientations* 20, no. 2, (1989), pp. 38–47.

—. "Tabo Monastery: The Sacred Precinct" in *On the Path to Void,* edited by P. Pal, pp. 66–82. Bombay: Marg Publications, 1996.

Qadri, S. A. *Kashmiri Sufism.* Srinagar: Gulshan, 2003.

Rahman, Mushtaqur. *Divided Kashmir: Old Problems, New Opportunities for India, Pakistan, and the Kashmiri People.* Boulder, CO: Lynne Rienner, 1996.

Rastogi, Navjian. *Introduction to the Tantrāloka.* Delhi: Motilal Banarsidass, 1987.

Ray, H. *Chinese Sources of South Asian History in Translation.* Vol. 1. Kolkata: The Asiatic Society, 2004.

Ray, S. C. *Early History and Culture of Kashmir.* New Delhi: Munshiram Manoharlal Publications, 1970.

Reedy, Chandra L. *Himalayan Bronzes Technology, Style, and Choices.* Newark, NJ: University of Delaware Press, 1997.

Rogers, A. and H. Beveridge, tr. *Memoirs of Jahangir.* London: Royal Asiatic Society, 1909.

Sachau, E. C., tr. *Al-Biruni's India.* Reprint, New Delhi: S. Chand, 1964.

Sanderson, Alexis. "Abhinavagupta." In *Encyclopedia of Religion,* edited by M. Eliade. New York: Macmillan, 1987.

—. "The Visualization of the Deities of the Trika." In *L'Image Divine: Culte et Méditation dans l'hindouisme,* edited by A. Pradoux, pp. 31–88. Paris: Editions du CNRS, 1990.

Saxena, K. S. *Political History of Kashmir.* Lucknow, 1992.

Schmitz, B. *Islamic Manuscripts in the New York Public Library.* New York and Oxford: Oxford University Press and New York Public Library, 1992.

—. *Islamic and Indian Manuscripts and Paintings in the Pierpont Morgan Library.* New York: Pierpont Morgan Library, 1997.

—. and Z.A. Desai. *Mughal and Persian Paintings and Illustrated Manuscripts in the Raza Library, Rampur.* New Delhi: India Gandhi Centre for the Arts, 2006.

Schokker, G. S., and P. J. Worsley. *The Pādataditaka of Śyāyamalika.* Dordrecht, Holland; Boston: D. Reidel, 1976.

Schroeder, Ulrich von. *Buddhist Sculptures.* 2 vols. Hong Kong: Visual Dharma, 2001.

—. *Indo-Tibetan Bronzes.* Hong Kong: Visual Dharma, 1981.

Seyller, J. *Pearls of the Parrot of India. The Walters Art Museum Khamsa of Amir Khusrow of Delhi.* Baltimore: The Walters Art Museum, 2001.

Shah, Priyabala. *Visnudharmottara-Purāna: Third Khanda.* Baroda: Oriental Institute, 1961.

Shali, S. L. *Kashmir: History and Archaeology Through the Ages*. Delhi: Indus Publishing Company, 1993.

Silburn, Lilian. *Kuṇḍalinī*. New York: SUNY Press, 1998

Simon, Ray. *Indian and Islamic Works of Art*. London: Simon Ray 2004.

Singh, Chandramani and Devaki Ahivasi. *Woollen Textiles and Costumes in the Bharat Kala Bhavan*. Varanasi: Bharat Kala Bhavan, Benaras Hindu University, 1981.

Singh, S. K. *Islamic Heritage of Kashmir*. Srinagar: Gulshan, 2000.

Siudmak, John. "The Stylistic Development of the Sculpture of Kashmir." PhD diss., Oxford University, 1989.

Skelton, Robert, "A Decorative Motif in Mughal Art," in *Aspects of Indian Art*. Edited by P. Pal, Leiden: Brill, 1972.

Snellgrove, David L., and Tadeusz Skorupski. *The Cultural Heritage of Ladakh*. 2 vols. Warminster, England: Aris and Phillips, 1980.

Soltykoff, Alexis. *Voyage dans l'Inde et en Perse*. Paris: V. Lecou, 1853.

Stein, M. A. trans. and ed. *Kalhaṇa's "Rājataraṅgiṇī": A Chronicle of the Kings of Kashmir*. 2 vols. Reprint, Delhi: Motilal, 1979.

Stronge, Susan. *Painting for the Mughal Emperor: The Art of the Book 1560–1660*. London: Victoria and Albert Museum, 2002

Sumi, Tokan D., Masato Oki, and Fida M. Hassnain. *Ladakh, the Moonland*. New Delhi: Light and Life, 1975.

Taylor, David, ed. *Kashmir*. Oxford: ABC-CLIO, 2000.

Temple, R. C. *The Word of Lalla*. Srinagar: Gulshan Books, 2005.

Tokunaga, M. "Description of the Temples and Tirthas in the Nīlamatapurāṇa." Vss. 989–1356a in *A Study of the Nīlamata: Aspects of Hindusim in Ancient Kashmir*, edited by Yasuke Ikari, pp. 399–421. Kyoto: Kyoto University Institute for Research in Humanities, 1994.

Thakur, Laxman S. *Buddhism in the Western Himalaya*. Oxford: Oxford University Press, 2001.

Ujfalvy, CH–E de. *Les cuivres ancien du Cashemire*. Paris: Ernest Leroux, 1883.

Verma, Som Prakash. *Mughal Painters and Their Work: A Biographical Survey and Comprehensive Catalogue*. Delhi: Oxford University Press, 1994.

Villiers-Stuart, Constance M. *Gardens of the Great Mughals*. London: Black, 1913.

Walker, Daniel S. *Flowers Underfoot: Indian Carpets of the Mughal Era*. New York: Metropolitan Museum of Art in association with Harry N. Abrams, 1997.

Watt, George. *Dictionary of the Commercial Products of India*. Calcutta and London: J. Murray, 1908.

Welch, Stuart Cary. *India: Art and Culture 1300–1900*. New York: Metropolitan Museum of Art, 1985.

Welch, A. *Calligraphy in the Arts of the Muslim World*. New York: Asia House Gallery, 1979.

Wilkinson, Wynard R. T. *Indian Silver 1858–1947*. London: Wynyard. R. T. Wilkinson, 1999.

Willson, Martin. *In Praise of Tara*. London: Wisdom Publications, 1986.

Witzel, Michael. "The Brahmins of Kashmir." In *A Study of the Nīlamata: Aspects of Hindusim in Ancient Kashmir*, edited by Yasuke Ikari, pp. 237?94. Kyoto: Kyoto University Institute for Research in Humanities, 1994.

Yale University Art Gallery. *The Kashmir Shawl*. Catalogue published in conjunction with an exhibition held at the Yale University Art Gallery, February 12 to April 16, 1975. New Haven, CT: Yale University Art Gallery, 1975.

Yasin, Madhavi. *British Paramountcy in Kashmir*. New Delhi: Atlantic, 1984.

Zutshi, Chitralekha. *Languages of Belonging: Islam, Regional Identity, and the Making of Kashmir*. New York: Oxford University Press, 2004.

Zwalf, W., ed. *Buddhism: Art and Faith*. London: British Museum, 1985.

List of Contributors

Frank Ames is a specialist in textiles and a published authority on Kashmiri shawls.

Simon Digby is an independent scholar and preeminent historian of the Islamic period of Indian history.

Gerald Larson is an historian of religion, in particular the Hindu and Buddhist philosophies and religions of Kashmir. He is Professor Emeritus at Indiana University, Bloomington and at University of California, Santa Barbara.

Pratapaditya Pal is a scholar and curator of South Asian and Himalayan art who has served as a curator at the Museum of Fine Arts, Boston, the Los Angeles County Museum of Art, and has been a researcher at the Norton Simon Museum in Pasadena.

John Siudmak is a specialist on ancient Kashmiri art and has written extensively on the ancient Hindu and Buddhist arts of Kashmir.

Index

Key:

—. Illustrations are indexed by page numbers, not figure numbers.

—. Page numbers followed by *q* indicate quotations.

—. Page numbers followed by *(2)* indicate two separate discussions.

—. Italic page numbers indicate illustrations (photographs).

—. Italic page numbers followed by *clg* indicate calligraphy.

—. Italic page numbers followed by *dtl* indicate illustration details.

—. Italic page numbers followed by *ptg* indicate paintings.

—. Italic page numbers followed by *rlf* indicate reliefs.

—. Italic page numbers followed by *scl* indicate sculptures.

—. Page ranges "hyphenated" by "/", as in "18/20", indicate discussions interrupted by a full page of photographs.

Cordus: Valerius, 201
courtesans, 25
courts of Kashmir:
 Brahmanical court, 24–25
 languages, 18/20, 26
 Mughal court, 29
crafts, 175–191
 enameling, 184, *188*
 historical evidence of, 175
 papier-mâché objects, 184, *190*
 popularity, 175
 See also metal objects; wood objects
cricket bats, 24, *24*
crouching ascetics plaque, 55, 66, *67rlf*
cultural foundations of the arts, 33–43
 intellectual contributions, 38–42
 traditions, 34, 36

D

Dal Lake, *16*, 25
 fort above, 138, *141*
 gardens on. *See* Nishat Bagh; Shalimar garden
dancers, *149ptg*
dancing goddesses, 23, *46scl*, 75/78, *75scl*, *77scl*, 79, *80scl*, 81
dancing in the court, 24–25
Dara Shikoh (emperor), 27, 29, 135, 138(*2*), 153, 154
Dastgir Sahib. *See* Madin Sahib mosque
death-delaying ritual, 105–106, *109*
Devil: Shakyamuni and, *119ptg*
Devimahatmya paintings, 162, 163, *164*
Dharmadhara, 147
dhoti of Avalokiteshvara, *39ptg*, 96, 147
Dhulchu, 116
dhvani theory, 37, 39
Dhvanyāloka (Anandavardhana), 37, 39
Dhvanyālokalochana (Abhinavagupta), 39
diadems, 178/180–81, *181*
 medallions from, 178, *180*
Didda (queen), 23, 38
 building projects, 45, 65
Digby, Simon, *127q*
 on the Islamicization of Kashmir, 115–125
Dīvān, 172
divine heads, 66–67, *68scl*
dochallas, 197, *199dtl*, 201
Dogra period, 209
Dogra Raja, 30
 See also Gulab Singh
dome construction, double, 131
domed ceiling, 135, *135*
doors: carved wooden, *136*
Double Kashmiri shawl, *208dtl*
Dragon Moon shawl, *192dtl*, *207*, 209
Durga:
 with attendants, *86scl*
 destroying Mahisha, *81scl*, 82, *82scl*
Durlabhavardhana (king), 21(*2*)
dynastic chronicles. *See Rājataraṅgiṇī*

E

earth goddess, *78scl*, *79scl*, 81
economy of Kashmir:
 religion and, 21

shawl industry, 30
 valley products, 17, 30
emperors. *See* Mughal emperors
enameling, 184, *188*
enlightenment of the Buddha images, *70scl*, *93scl*

F

Faxian, 21, 167
festival of lamps, 28
Firdausi. *See Shahnama*
fire as destructive in Kashmir, 123
floral motifs:
 for shawls, *196*, 198, 201(*2*)
 for silverware, 183, *184*, *185*, *186*
floral style of painting (Mughal style), 198
flower studies:
 of Mansur, 153, 154, *154ptg*, 198
 phytography, 201
fluted column, 46
folding table, 184/186, *189*
foliated trays, *Front Cover(dtl)*, 183, *187*
fort. *See* Hariparbat palace
Foster, George, 202
France and the shawl industry, 205
Fremlin carpet, 198
furniture, 184/186, *186–188*, *189–190*

G

Gabriel (archangel), 160, *160*
Gandhara influence, 21
 in architecture, 45, 46, 48, 51, 56
 in iconography, 23, 74
 in sculpture, 66, 69, 74, 75, 89, 96/98, 103
Ganesh, 82–83, *83scl*, 89
 in the Holy Family, *32scl*, *40scl*
gardens, 127, 129
 Achchabal garden, 143
 Chasma Shahi garden, *142*, 143
 Jarokha Bagh, 143
 Mughal period, 138, 141/143–144
 Nishat Bagh, 138, 143
 on roofs, 132
 Sultanate period, 138/141
Garuda. *See under* Vishnu
Gilgit, 18, 98
 manuscript cover paintings, 103, *104*
 patrons, 61, 91
Girdler's carpet, 193, 198
goat (shawl goat), *194*
goddesses:
 dancing. *See* dancing goddesses
 earth goddess, *78scl*, *79scl*, 81
 Prajnaparamita, 91, *94scl*
 veneration of, 23
 Vishnu on Garuda with four, *40scl*, *60scl*, 95
 See also Durga; Lakshmi; Parvati; Sharada; Sharika; Tara
Goepper, Roger, *147q*
Granth Sahib. *See* Guru Granth Sahib
grapes, 23
gravestones (tombstones), 129, *168*, 169
Guge patrons, 61
Gulab Singh (Dogra Raja), 18, *19ptg*, 20, 30, 205
Gulistan of Sadi calligraphy and paintings, 169, *169*

Gupta influence, 78
Guru Granth Sahib, 30
 paintings, 162, *162*

H

Hamadani Sufis. *See* Ali Hamadani; Muhammad Hamadani
Hamzanama: carpets depicted in, 198
Harihara, 82–83, *82scl*
Hariparbat palace (fort), 138
 gateways, 138, *139*
 picture gallery, 150–152
Harsha (king), 24, 112
Harwan site: terrace and wall, *54*, 55
Hasan, Mohibbul, *27q*
Hazrat Ali, *162ptg*
Hazratbal mosque, 127, *128*
Hiranyakashipu: Narasimha fighting, *73scl*, 75
history of Kashmir, 18/20
 Afghan rule, 29–30, 144, 202
 Brahmanical dynasties, 18/20, 20–25; decline, 115–116
 British rule, 30
 intellectual. *See* intellectual history
 Mughals. *See* Mughal period
 Sikh rule, 30, 158, 202–203
 sultans. *See* Sultanate period
 See also Islamicization of Kashmir
Holy Family, *32scl*, *40scl*
holy men. *See* ascetics; monks; Sufis
Holy Quran. *See* Quran
horse and rider: Sharada with, *64rlf*, 129
hostels of Sufis, 119
Humayun (emperor), 197
Hutamura site: terraces, 55

I

idol-house destruction, 122–123
implicit resonance, 39
Indo-Greek influence, 20–23, 46
Indra:
 textual allusion to paintings of, 101
 visit to the Buddha, 69
Indrani, 75/78, *75scl*
Ingres, Jean Auguste Dominique: painting by, *29*
inlay, 87, 93, 177
inscriptions, 61
 on Buddha base, *166*, 167
 on gravestones, 129, *168*, 169
 lamp with inscription, 181, *182*
 on the Madin Sahib, *167*, 169
 on metal sculptures, 87
 on Zainalanka stele, *114dtl*, 124, 169
 See also calligraphy
intellectual history:
 contributions of Kashmir to, 38–42
 major periods, 35–38
Iranian migration into Kashmir, 118–121
Isfandiyar fighting a *simurgh*, 159, *159ptg*
Iskandar with sages, 182, *182ptg*
Islamic influences: in post-Mughal paintings, 161, 162, 163
 See also calligraphy; gardens; *and under* architecture

Index by Brackney Indexing Services

PHOTO CREDITS